ultimate
papercraft
bible

ultimate papercraft bible

A Complete Reference with
Step-by-Step Techniques

**Consultant Editor
Marie Clayton**

COLLINS & BROWN

First published in the United Kingdom in 2012 by
Collins & Brown
10 Southcombe Street
London
W14 0RA

An imprint of Anova Books Company Ltd

Copyright © Collins & Brown 2012

Distributed in the United States and Canada by
Sterling Publishing Co, 387 Park Avenue South,
New York, NY 10016-8810, USA

ISBN 978-1-84340-672-3

A CIP catalogue record for this book is available from the British Library.

10 9 8 7 6 5 4 3 2 1

Reproduction by Rival Colour Ltd, UK
Printed and bound by Craft Print, Singapore

This book can be ordered direct from the publisher at www.anovabooks.com

contents

Introduction 7

Getting started 8
Colouring, decorating and texturing 38
Cardmaking 80
Envelopes, giftwrap and gift boxes 126
Scrapbooking 150
Papercutting 188
Origami 214
Other papercrafts 238

Templates 288
Websites and suppliers 300
Index 302
Contributors 304

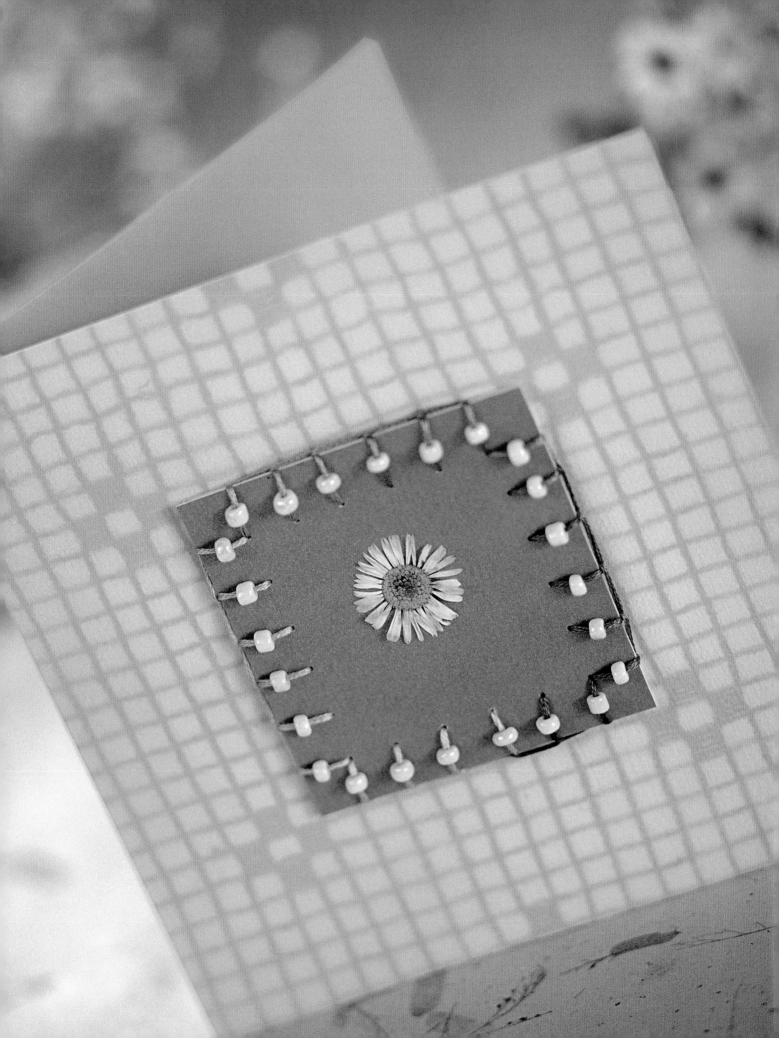

introduction

Papercraft is an exciting and absorbing pastime that offers a simple and effective way to express your creativity, without having to learn complicated skills or buy lots of expensive tools. You may not believe that you are very artistic, but the range of possible papercrafts is so wide that there is bound to be one that will appeal. You don't need extensive crafting experience or expertise to begin – a willingness to try out simple techniques and a little confidence is all that is really required.

Paper is a really great material to use; it is readily available, inexpensive and very adaptable – but also quite satisfying to work with. It comes in so many types, weights, colours and textures that it's unlikely that any two projects will look the same, even if they use the same techniques. And the range of stickers, punches, stamps and accessories that can be used is so wide that it is always possible to find something new. Some of the techniques in this book only need simple measuring and cutting skills, others require adhesive, colouring or the addition of other items. If you make a mistake you can often easily change it or cover it up, although many 'accidents' can turn out to be great design ideas!

This book covers a full selection of different papercrafts, from cardmaking to origami, decoupage to quilling. At the beginning you will find a chapter on general tools for working with paper and basic techniques, followed by a chapter of decoration ideas that will be used again and again in many of the following pages. The chapter on Cardmaking covers all types of cards, from simple designs based on colouring or sticking down motifs to more complex pop-up cards – and includes useful sections on batch cards and invitations. The following chapter is related – it covers envelopes, gift boxes, giftwrap and tags.

After this we move on to the popular craft of scrapbooking, with a collection of tried-and-tested techniques to record your precious memories – as well as decoration ideas for covers and how to make your own scrapbook pages. This chapter also includes techniques for mounting and using photographs, and other artworks, in both standard and some more unusual ways.

Papercutting is a traditional folk art that appears across history and in many cultures; this chapter covers several different types of papercutting from around the world. It is followed by a short chapter on origami techniques with some simple models to put them into practice. The final chapter features several types of papercraft: papier mâché, paper flowers, tissue paper and wire, decoupage, quilling and making three-dimensional items in paper. It also includes paper making techniques, so you can make your own hand-made paper.

The best thing you can do is just dive in and enjoy yourself – what could be more fun than to spend the afternoon surrounded by colourful paper and accessories as you bring your creations to life? And if you are making something as a gift, I am sure the time and effort you have spent in making something unique and personal will be appreciated.

Good luck!

getting started

This first chapter covers general tools, materials and basic techniques that are used in most types of papercraft – you will also find a few specialized tools and techniques at the start of a few other chapters. There are so many materials available for papercrafts that it would be impossible to cover all the different types here, but you will find the basic materials used all the time, plus handy tips and tried and tested short cuts that will save you time and effort.

measuring, folding and cutting tools

Many of these tools you may already have, but if you do need to purchase them they are widely available in craft stores. You don't need to invest in everything right at the start – make a few projects with what you have already and only buy more equipment as you find you need it.

◀ **Steel ruler**

Can be used for measuring, but mainly for cutting against with the craft knife. Never cut against a plastic knife because this will quickly damage the edge.

◀ **Pencils**

Marks from a soft B grade pencil are easy to remove, but you will need to sharpen it often to keep a fine point. Alternatively, a propelling or mechanical pencil offers a constant tip size at all times – as the lead is used you can eject a little more.

▲ **Bone folder**

Used for scoring lines and for creating sharply folded edges.

◀ **Craft knife**

These come in many different sizes, shapes and styles. For safety, the type with a retractable blade is the best option.

▲ **Eraser**

A soft, mouldable rubber can be manipulated into a point for detail erasing and is also ideal for cleaning up backgrounds.

▲ **Plastic ruler**

A ruler marked in both millimetres and fractions of an inch is most useful. Buy a good quality heavy plastic one – the really cheap rulers bend out of shape easily and often do not have accurate markings.

▶ **Set square**

The set square shown here is a fixed type, with a 30° angle, 60° angle and a right angle (90°). This type is also available with two 45° angles and a right angle.

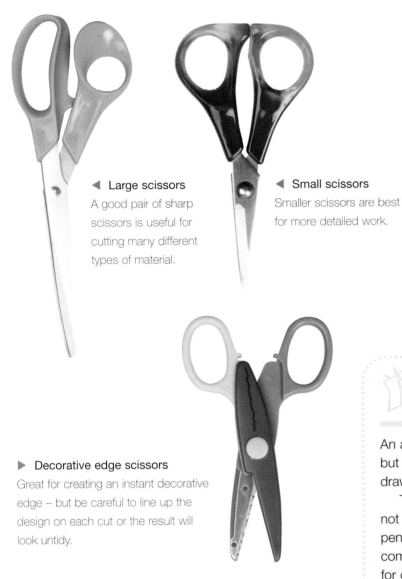

◄ Large scissors
A good pair of sharp scissors is useful for cutting many different types of material.

◄ Small scissors
Smaller scissors are best for more detailed work.

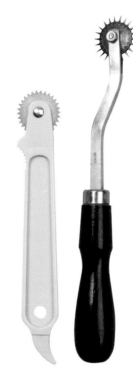

◄ Tracing wheels
Blunt-toothed and needle-toothed tracing wheels, for piercing paper and cardboard. The holes they leave cannot be erased later, so they are more useful for a decorative effect than for construction marking.

▶ Decorative edge scissors
Great for creating an instant decorative edge – but be careful to line up the design on each cut or the result will look untidy.

Setting out

An adjustable set square is much more expensive, but is worth the investment if you will often be drawing lines at many different angles.

The leads for propelling or mechanical pencils not only come in different grades like ordinary pencils but also in different thicknesses. The most common are 0.3mm for very fine work, 0.5mm for ordinary marking, and 0.7mm for heavy lines. Each pencil is marked with the thickness of lead it is designed to take – don't use the wrong size because either the lead will not drop into place properly, or it will keep breaking.

If you don't have a bone folder, the back edge of a table knife makes an acceptable substitute.

When buying a cutting mat, choose a reasonable size – A3 is fine for most papercrafts. The small A4 ones are handy if you want to carry your work with you, but are likely to prove too small for many projects. A very big cutting mat is great – as long as you have the space to leave it out, or a suitable place to store it.

▲ Cutting mat
Protects the work surface when cutting. Mats are marked with a grid to help you cut straight edges and usually have a self-healing surface so old cutting lines do not cause any problems.

stamps and punches

Stamps print a motif of some sort and are generally used with inkpads, which are available in various types and many colours. You can also stamp paint or embossing ink (see pages 15 and 20). Punches are used either to punch holes through sheets or to set eyelets (see page 167).

Good working practice

Always protect your work surface properly when using the punching or piercing tools – it is very easy to cause damage without realizing.

A single punch is quite likely to leave deep indentations in the mat itself, so it is better to use it with the special setting mat or a spare old mat and reserve your main cutting mat just for precision work.

Always keep the fingers holding the item being punched well out of the way.

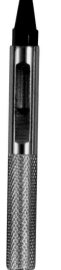

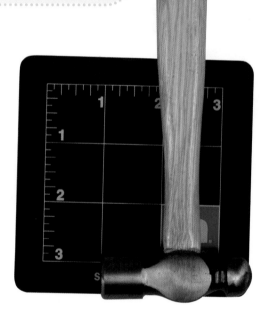

▲ **Stamps**
Rubber stamps are available in an enormous range of sizes, designs and shapes. It's best to buy what you need as you need it and build up a collection, rather than buying lots to begin with that you may end up not using.

▲ **Single punch**
This type of single punch may have interchangeable heads for holes of different sizes, or may have a fixed head. Its advantage is that you can make a hole anywhere on the page, but you will need to use it with a setting mat and a hammer.

▲ **Setting mat and hammer**
A small heavy duty mat to protect the work surface and a weighted hammer, both used with the single punch to make holes. Tap with the hammer once for each layer of cardboard you are punching through.

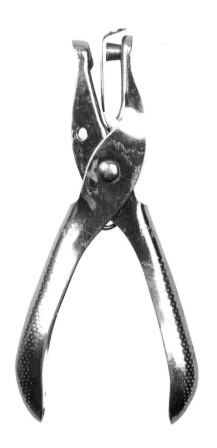

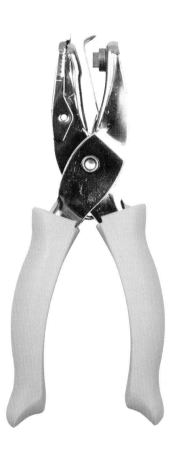

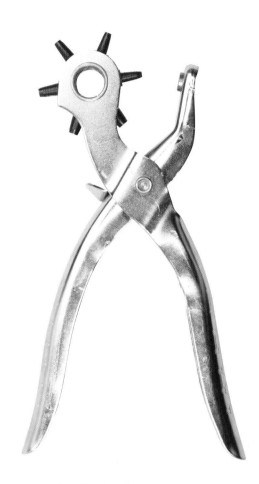

▲ **Single hole punch**

A simple hand-held punch, for making single holes of a constant size near the edge of paper or thin cardboard.

▲ **Slot punch**

Similar to the single hole punch, but cuts slots rather than holes.

▲ **Leather punch**

Ideal for making holes near the edge of cardboard or paper, this type of punch has a rotating wheel with different size heads and a built in striking plate.

▲ **Craft punch**

Also called hobby punches, these punch out a shape rather than a simple hole or slot. Again, they are available in an enormous range of sizes, designs and shapes so it's best to buy what you need as you need it and build up a collection.

A row of simple punched motifs can be very effective.

decorating tools

The items in this section are used to add colour or additional decoration to papercraft projects. Only a few of the basics are shown here – if you check out a craft or hobby store you will find a very wide range of options to choose from.

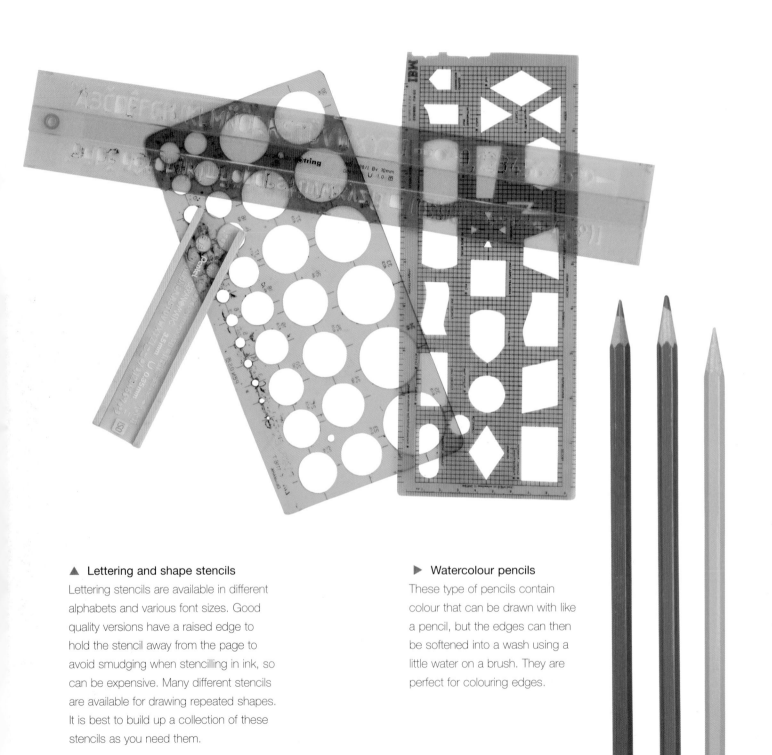

▲ **Lettering and shape stencils**

Lettering stencils are available in different alphabets and various font sizes. Good quality versions have a raised edge to hold the stencil away from the page to avoid smudging when stencilling in ink, so can be expensive. Many different stencils are available for drawing repeated shapes. It is best to build up a collection of these stencils as you need them.

▶ **Watercolour pencils**

These type of pencils contain colour that can be drawn with like a pencil, but the edges can then be softened into a wash using a little water on a brush. They are perfect for colouring edges.

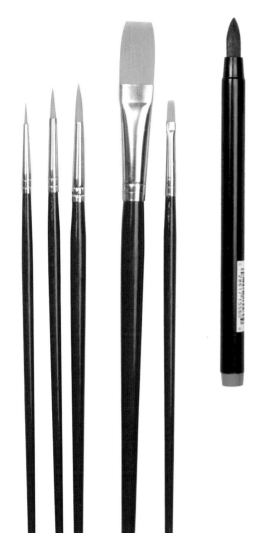

◀ **Brush pen**

An ink pen with a brush nib.
This type of pen is ideal for design
work and calligraphy, as well as for
colouring edges and embellishing
stamps and stencils.

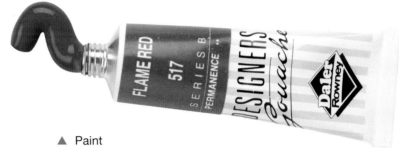

▲ **Paint**

Watercolour or gouache paint is best for most craft purposes;
watercolour is available in solid blocks or tubes, gouache only
comes in tubes. For washes and translucent colour use
watercolour, for solid or opaque colour use gouache.

▲ **Brushes**

A good selection of fine-tipped and chisel-
end brushes, in a range of sizes, will be
useful for applying paint and water.

◀ **Ink**

Craft inks are widely available
in a good assortment of
colours. Some are permanent,
others are water-soluble.

Craft inks used to create an interesting background.

paper and cardboard

Choosing the right paper or cardboard for your papercraft project is the first and most important step; it can make the difference between a stunning item and one that is just OK. Paper can be hand- or machine-made and there is an impossibly wide selection of both, so it will help if you know a little about paper characteristics.

Hand-made paper can be made of different materials and may have inclusions, such as flower petals, grasses, newsprint, plant fibres or metallic flecks. Sometimes the surface can be quite inconsistent due to the hand-made process, which is part of this paper's charm. Hand-made paper is usually not structurally strong, but can add a whole new decorative dimension to your projects. You can even make your own paper – see pages 278–287.

Even though machine-made paper is made industrially, different processes can give a very different look or feel. However, machine-made paper does have one important characteristic; it has a grain and working with the grain will give better results. As an experiment, take an ordinary sheet of photocopy paper and fold it first lengthways, then open it out and fold in widthways. Now check the creases – one of them will look cleaner and sharper; this is the one in the direction of the grain. With experience, you will be able to establish the grain without creasing the paper; hold the paper by one edge, then try bending the edge at right angles – if it bends more in one direction that is the direction of the grain. Alternatively, apply gentle pressure and the fold with least resistance is running with the grain.

Cardboard is almost invariably machine-made; the surface may be smooth, textured, metallic, matte or glossy and cardboard can be single-sided (with a good finish on only one side) or double-sided (finished on both surfaces). Working with the grain is just as important with cardboard; if it is torn you will achieve a much straighter tear in the direction of the grain.

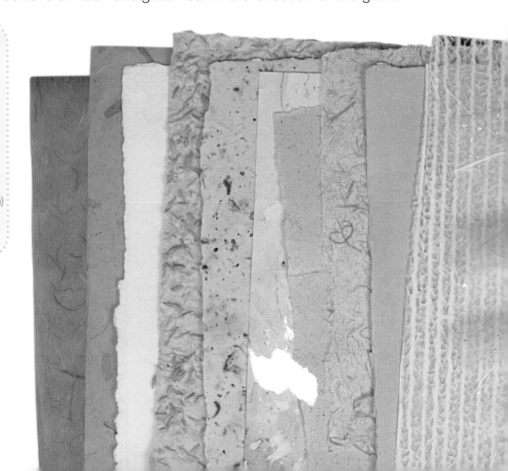

Common paper/cardboard sizes
A5 210 x 148mm (8.3 x 5.8in)
A4 297 x 210mm (11.7 x 8.3in)
A3 420 x 297mm (16.5 x 11.7in)
A2 594 x 420mm (23.4 x 16.5in)
A1 841 x 594mm 33.1 x 23.4in)
A0 1189 x 841mm (46.8 x 33.1in)

US letter 11 x 8½in (279.4 x 215.9mm)

▶ Hand-made paper
A selection of hand-made papers,
including samples with inclusions
(second, fourth and fifth from left)
and papers with long fibres (first left,
third from right).

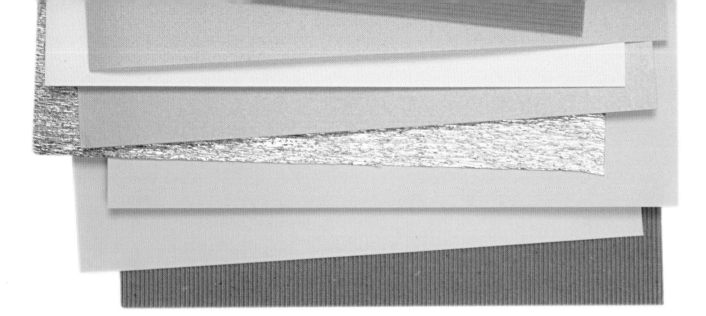

Paper and cardboard thickness

Information about the thickness of paper or cardboard is confusing. In Europe, paper thickness is generally indicated by gsm (gram weight per square metre) but cardboard thickness can be given in microns (1000 microns = 1mm), gsm or number of sheet (no of paper sheets thick). In the US, point size or calliper size may used; 8pt is .008in calliper. Thickness is also sometimes indicated by weight, but cardboard and paper are weighed using different parameters, so similar numbers may indicate different thicknesses. One or both sides may be coated, which can make the material appear thicker and stiffer than it really is. The only rule of thumb that is fairly constant in all these systems is that a higher number indicates a thicker material.

Rough conversions and suitable uses for each thickness are:
120 microns/90gsm/4.8pt *Thickness of basic photocopier paper*

160 microns/130gsm/6.2pt *A good quality letter paper*

200 microns/150 to 160gsm/2-sheet/7.3 to 7.4pt
Very thin cardboard that can be fed through a photocopier

230 microns/170 to 180gsm/3-sheet/8pt
A thin and flexible cardboard or a very thick paper

300 microns/210 to 240gsm/4-sheet/9.5 to 10pt
A good all-round cardboard weight, ideal for most cardmaking and scrapbooking

500 microns/385gsm/8-sheet/18pt
Thick cardboard, good for mounts and framing

▲ **Machine-made paper**
Some different machine-made papers, including metallic (fifth from top) and heavily textured (bottom).

▼ **Cardboard**
Gradually build up a stock of different colour sheets of cardboard in a range of the weights you use most often.

adhesives and tapes

For adding applied decoration, construction of projects and even a few creative uses. There are many different types of adhesive and it will save you both time and heartache if you choose the correct one for what you want to achieve.

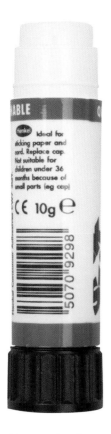

▲ **Paper adhesive**

A solid glue-stick type is usually less messy than liquid glues and is fine for a wide range of uses.

▲ **White craft glue**

A good, general-purpose glue that is suitable for most materials.

▲ **All-purpose adhesive**

The gel version of this is best, useful for sticking many different materials.

▲ **Glue pen**

Great for detail work and sticking small pieces.

▲ **Spray adhesive**

Ideal for covering large areas, fixing delicate items or finely cut motifs, and bonding layers. There are different types formulated for different materials, including one for photographs and one for vellum.

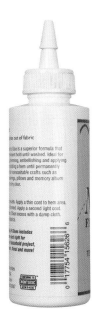

▲ Fabric adhesive
The best adhesive for sticking ribbon or fabric motifs.

▲ Double-sided tape (top) and masking tape
Double-sided tape is handy for sticking most things, but is an expensive option if used in bulk. It is available in different widths. Masking tape is generally low-tack, so can be used to hold things in place temporarily.

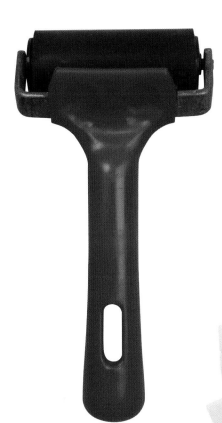

▲ Brayer
Used to roll over glued paper to be sure everything is stuck down well.

▲ Foam mounting pads
Since these have a thickness to them, they are ideal to raise pieces off the surface to give a three-dimensional quality.

▲ Adhesive dots
Quick and convenient, and ideal for keeping the glue localized.

embellishment materials

This section has details of a few general materials that you will probably use time and again across different projects. If you see something really interesting that could be used as an embellishment it is often worth buying it even if you have no specific project in mind at the time – it may even spark off a new idea.

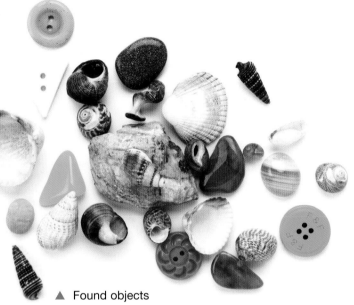

▲ **Found objects**
Collect attractive pebbles, pieces of wood, buttons, sequins – anything decorative can be combined with paper projects, particularly when scrapbooking.

◀ **Fabric and ribbon**
Scraps of attractive fabric and lengths of ribbon are always useful to add an extra decorative touch.

Building a stash

- Store paper and cardboard flat – rolling paper up can damage the fibres. An artists' portfolio is ideal to protect your stock.
- If you want to add lettering to projects but are not confident in your handwriting, a stock of standard sticker messages will be useful.
- Inexpensive stickers are an eye-catching way to seal an envelope.
- A gilding pen is ideal to add fine metallic details or for freehand designs.
- A plastic storage case with drawers – of the type sold in DIY stores for storing nails and screws – is ideal for keeping small embellishment items tidy.
- Recycle interesting ribbon, lace and buttons from old clothes.
- If there is not a good hobby store nearby, you can find everything you need on the Internet – a list of suppliers to begin with is given on pages 300–301.

◀ **Embossing powder and ink**
The fine embossing powder is applied to special wet embossing ink – which can be stamped on or drawn on freehand – and is then heated to give an embossed effect. The embossing ink is also available in a pen format.

▲ Tissue paper

Readily available in many colours – but the colour on the cheaper versions may bleed or run. Acid-free and chlorine-free tissue is available for archival scrapbooking.

▶ Threads, cords and wire

Embroidery thread and tapestry yarn are great for adding stitched embellishments. Cords come in a wide range of thicknesses and colours. Fine wire is useful for adding a three-dimensional element or twisting into shapes.

▼ Metal foils and glitter

Widely available in craft stores in different colours as well as different metallic finishes, foils and glitter add extra sparkle to catch the eye.

▲ Stickers

Many motifs are available as adhesive paper stickers in a range of designs, colours and finishes. Other types are also available; dome stickers give a three-dimensional effect, outline stickers offer a line drawing or lettering and you can also find stickers in other materials such as vellum and felt.

measuring, cutting and folding

These basic techniques will be used time and again so they are gathered together here where you can find them easily. Technique types are grouped together so if you are looking for a method of sticking something, for instance, the alternative techniques are easy to evaluate.

Scoring

Scoring fold lines before you fold thin cardboard or thick paper gives a much neater and crisper fold. Experiment with different scoring techniques on a scrap piece of the material first.

Making and cutting

When marking measurements, use light pencil marks so they can be rubbed out easily later. For many projects you will need to begin with at least two edges straight and at right angles to each other. Use a set square to check; draw a guideline and trim one edge if necessary.

For the cleanest cut, use a steel ruler and a craft knife with a new blade. Don't use a wooden or plastic edge to cut against as it will soon become damaged and will no longer be straight.

When cutting, you have the most control when cutting towards yourself. Press the blade firmly and evenly as you move the knife along the line.

You can also use a guillotine or paper trimmer to cut straight lines, but test it out on a piece of the same material first to see how it reacts. Hold the paper in position firmly with the other hand to avoid it moving as you cut.

When cutting shaped openings, draw the outline carefully in pencil first. Place the item on a cutting mat and cut around the outline with a sharp craft knife. Keep the blade as vertical as possible while you cut – take your time and try to achieve a smooth shape first time. Rub out any remaining pencil when you have finished.

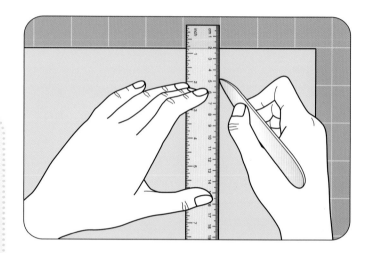

1 Mark the ends of the fold line on the cardboard or paper lightly with a soft pencil. Place a ruler between the marks as a guide and score the line along it by pressing down firmly with the point of a bone folder. Rub out the pencil marks.

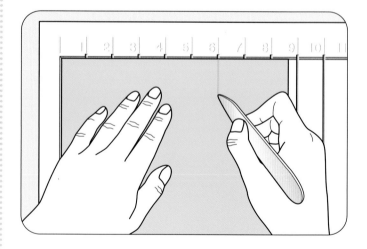

2 A scoring board can save time if you have many folds to make. Use the markings to align the piece of material to be scored, finding a groove that matches your fold position. Holding the material securely in place, run the tip of the bone folder firmly down the groove.

Folding

You will usually achieve a much crisper fold if you score the line first, although some materials will fold easily without scoring.

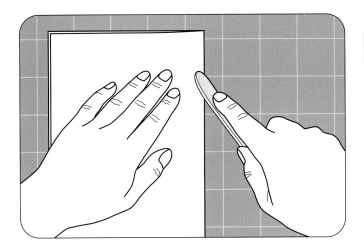

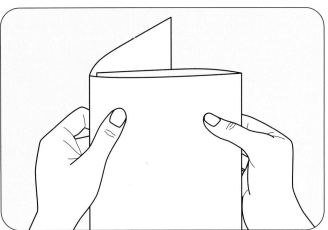

1 After scoring the fold line if necessary, fold the cardboard or paper over. Most materials will fold better with the scored 'valley' on the inside, but vellum folds better with it on the outside. For a sharp crease, flatten the fold with the broad side of a bone folder.

2 The design may call for the material to be folded several times – for instance an aperture card may have an integral backing that folds to the inside. To create a double fold card, score both lines on the same side then trim 3mm (⅛in) off the outer edge of the right-hand panel, which will fold in to cover the back of the middle panel. The left-hand panel folds the same way to make the back of the card.

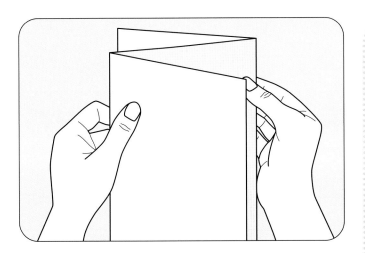

Folds and creases

Test folds on a piece of scrap material first if possible, to see how well the techniques work. Materials with loose or obvious fibres, or with inclusions, may not fold very cleanly.

Remember, it is easier to fold the paper in the direction of the grain.

3 For a concertina design, make the first score line on one side of the material and the second score line on the reverse side. Form the concertina by folding one panel forwards and one panel backwards.

decorative edges

Creating a decorative paper edge is quite easy to do but can add that extra touch to your scrapbook pages or to a card design. Some techniques just add some form of embellishment to the existing edge but others will shape a new edge and therefore make the paper size smaller, so it is important to decide on which way you wish to go right at the beginning of the project.

Cut edges

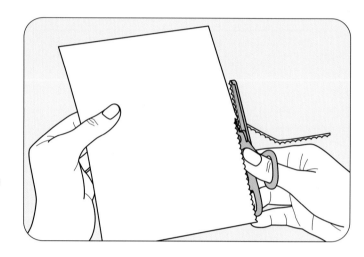

Possibly the easiest way to achieve a shaped edge is to use decorative edge scissors, which are available in many simple designs.

Cut the pattern close to the original edge of the paper. Open the scissors completely when beginning the cut, but don't close the blades completely at the end of the cut – the last segment of the pattern may not be a perfect repeat. Realign the pattern on the blades carefully with a matching repeat in the cut design and cut again. Repeat until the whole edge has been cut.

Torn edges

High-quality hand-made papers often have a distinctive deckle edge, and these tearing techniques will give a similar look. Note the direction of the grain; if the paper is torn across the grain the result can be quite ragged.

Tearing edges

This technique is ideal for most standard paper types and also for light- to medium-weight cardboard.

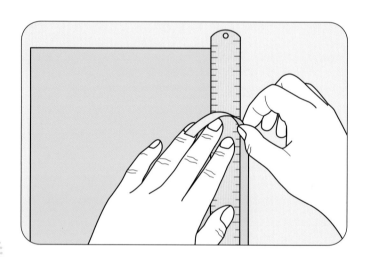

Tearing away

If you tear towards yourself, it creates a rougher edge. Tearing away from yourself creates a smoother, less dramatic deckle-edge effect.

Remember the paper grain here as well – tearing across the grain will give a more ragged result.

Lay a steel ruler around 1cm (½in) in from the existing edge of the paper. Holding the ruler firmly in place with one hand, tear off the edge of the paper with the other hand, moving your hand down as you work on short sections at a time.

Tearing edges with water

This technique works well on the thicker, less supple papers and also on papers with long, uneven fibres.

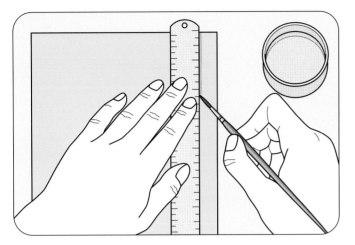
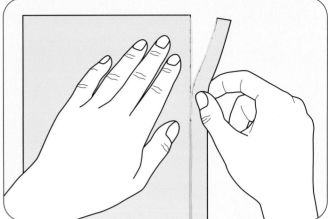

1 Lay a steel ruler around 1cm (½in) in from the existing edge of the paper. Using a fine-tipped artist's brush, paint a line of clean water along the edge of the ruler. Make the paper wet enough so the line soaks right through to the back.

2 Tearing a short section at a time, gently tear the paper along the wet line by pulling the edge of the paper away sideways. Move your hands down the ruler as you work, pulling any loose fibres out of the paper as you go.

Coloured edges

Adding colour to the edge of paper or cardboard is a simple and quick way to add extra interest. The colour will be more visible and dramatic if you create a torn edge first (see above and opposite).

Padding

inkpads are mess-free and offer a good opaque colour. There is an enormous range available in many colours, and they are useful in several different ways.

Using an inkpad

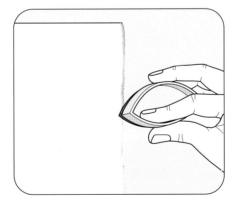

Inkpads offer a clean and simple way of applying edge colour; just gently rub the inkpad down the torn edge. Alternatively, you can dab a sponge applicator onto the inkpad and use this to apply the colour to the paper – the sponge makes it easy to achieve soft, blended shades.

Using a pen

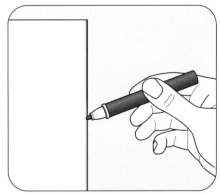

Run the end (if it is thick) or the side (if it is fine) of a coloured felt-tip pen along the edge of the paper. Try to move at an even speed and with a constant pressure. Coloured pencils are also a good option; build up the colour so it is deepest at the edge and fades to a lighter shade. If it is a watercolour pencil, soften and blend the edge of the colour with a little water using a fine brush.

Different colour edges

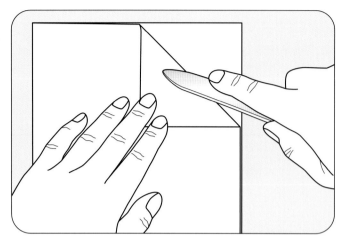
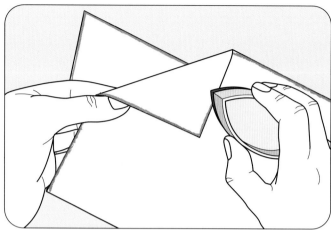

1 For the most dramatic effect with the two-colour technique, first score and fold down one of the corners of the material so both colours will be seen at the same time on one side.

2 Using your chosen method of applying the colour, add one colour along the outside edge and a contrasting colour along the inside edge. Be careful not to let the colour bleed over onto the wrong side.

Pierced edges

A decorative pierced pattern is an unusual way to add interest to an edge. The holes can be left as they are, used as a guide for tearing the edge, or as the basis for a hand-stitched design.

Perforated edge

A perforated pattern can easily be made along the edge of the paper by using a punch or one of the automatic embroidery stitches on a sewing machine.

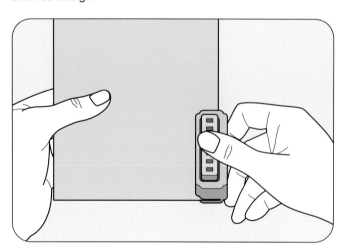
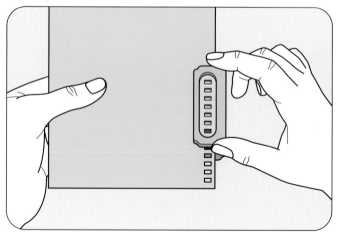

1 There are many different border punches available, some of which have guides incorporated so you can create a continuous pattern. Start punching from the bottom of the page, aligning the punch with the bottom edge.

2 If the punch does not have a built in guide, work with it upside down so you can see where you are punching each set of holes. Align the last hole on the punch with the last hole stamped previously as you work up the edge.

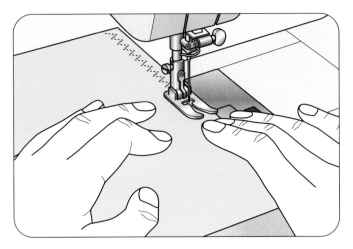

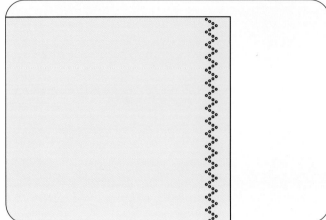

3 Alternatively, choose one of the embroidery stitches on a sewing machine and set the machine up to stitch. Place the paper under the presser foot and stitch just in from the edge, using the guidelines on the plate to achieve a straight line.

4 The perforations will make a decorative band of pattern along the edge. You can experiment with different stitch designs or combine two different stitches to make a more complex pattern.

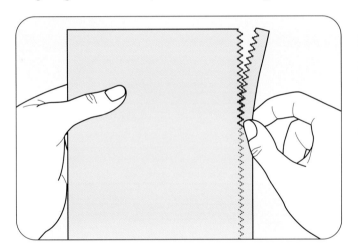

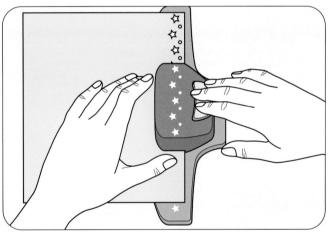

5 For a different effect you can tear the paper away along the perforations to make a new decorative edge. Hold the paper firmly and pull away the edge with the thumb and fingers of the other hand, working down short sections at a time.

Decorative edge punches

Some punches are specifically designed to create an edge design – they usually have the design repeat shown on either side of the actual punch section, so it is easy to line up the punch to create a continuous pattern.

Stitching and beading

Many different embroidery stitches can be used to decorate the edge of paper or cardboard – for some more ideas, consult a stitch pattern book. Hand stitching can also incorporate beads or sequins, either to sit along the edge or on the front face.

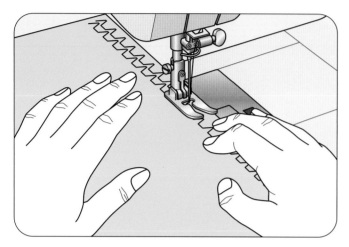

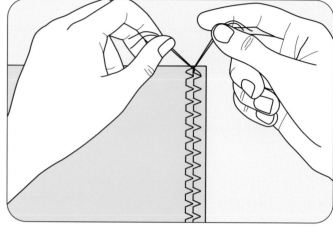

1 Set the sewing machine to the desired decorative stitch – test on a spare piece of the material first to judge the effect. Place the material under the presser foot and stitch along the edge. Use the guidelines on the machine base plate to keep the stitching in a straight line.

2 To prevent the stitching from coming undone at the ends, pull the ends of thread at each end of the stitching through to the back and knot them firmly. Trim off the excess thread close to the knot.

Keeping to the point

Machine-stitching on materials other than fabric will quickly blunt the needle, so be prepared to change it quite often if you are doing much stitching. Always replace the needle before using the machine again for sewing fabric.

Test the chosen stitch on a spare piece of the material you plan to use first, as mistakes on the final project will be impossible to erase.

Keep the stitch length fairly long because if you over-perforate the paper or cardboard it may begin to fall apart.

Stitching and beading holding a panel to the front of a card.

Hand stitching

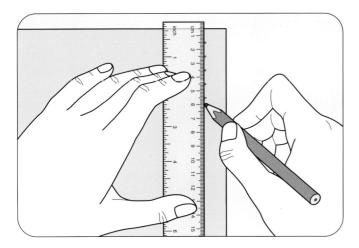

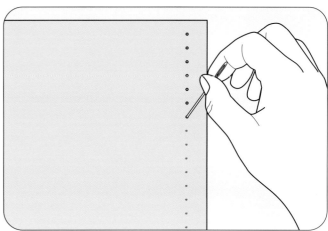

1 Marking the paper or cardboard out before you begin will make it easier to achieve even stitches. Mark the width of the stitched border lightly in pencil and divide the length into even stitches, leaving an equal gap at top and bottom of the edge.

2 Use a sharp needle to pre-pierce the stitching holes – this will give a neater result than trying to push a threaded needle through solid paper or cardboard. When all the stitching holes are made, rub out all the remaining pencil marks before starting to sew.

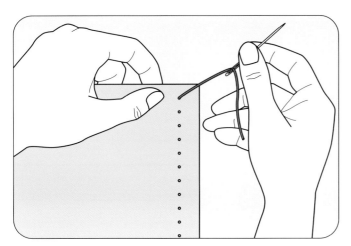

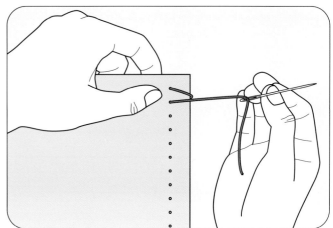

3 Thread the needle with a length of embroidery thread long enough to complete the stitching. Knot the end, then bring the needle from back to front through the first hole and pull through until the knot sits against the back surface.

4 Work the first stitch, following the instructions for the stitch design you want to create. Repeat for the length of the edge, using the pre-pierced holes at all times.

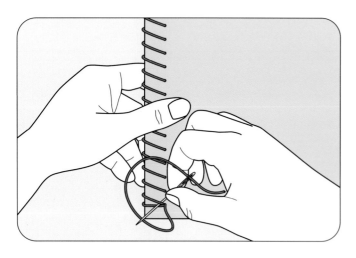

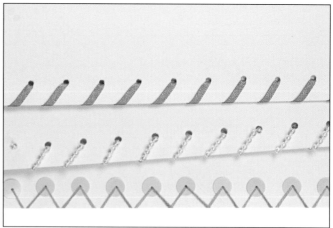

A selection of different hand stitches.

5 To finish, on the back take the needle under the last stitch and through the loop formed and pull tight. Trim off any excess thread.

Beading

These instructions are for beaded blanket stitch, with the bead sitting along the edge of the paper or cardboard, but you can use any suitable decorative stitch.

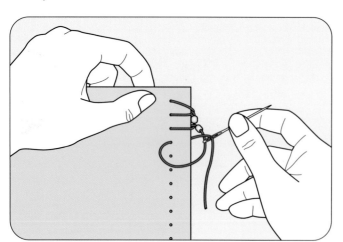

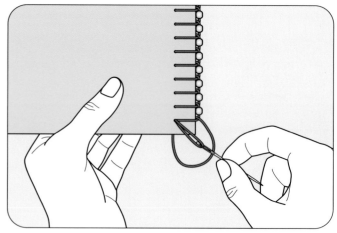

1 Mark and pierce as described in steps 1–2 on page 29 and thread the needle. Bring the needle up through the top hole leaving a long tail at the back. Go down through the second hole, but before pulling tight bring the needle through the loose stitch. Thread on a bead; take the needle down through the next hole, but before pulling tight bring it up through the loose stitch.

2 Carry on working blanket stitch (or whatever stitch you choose) to the bottom of the edge. To keep the last bead in position, bring the needle from back to front through the hole used for the final stitch. Take the thread vertically around the bottom of the sheet and bring the needle back through the same hole. Wrap it around to the back again and secure the end as described in step 5 on page 31.

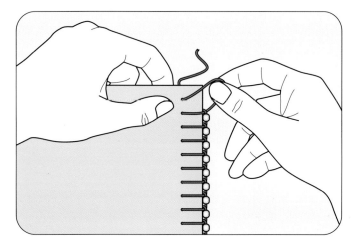

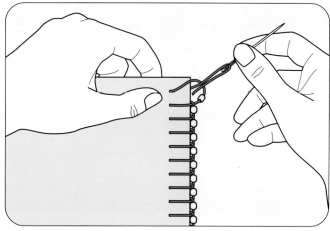

3 Now rework the top to mirror the bottom. Undo the first stitch without a bead and thread the needle with the long tail of thread. Slide a bead onto the needle.

4 Take the needle through the end hole from front to back, around the sheet to the front again and through the loose stitch above the bead.

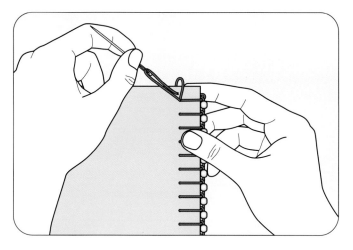

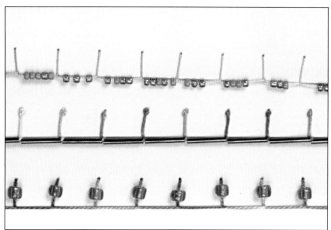

Beads can be added along the very edge of the paper or cardboard, or so they sit on the surface.

5 Anchor the beaded stitch by taking the needle from back to front through the same hole. Wrap the thread over the top edge and secure as described in step 2.

Choosing beads

Small beads are usually best for edge stitching – either groups of seed beads or bugle beads. Very large beads used on a card that is to be posted can easily wear a hole into the envelope.

Make sure the hole in the bead is large enough to take the thread.

sticking and fixing

This section shows a few techniques for best results using different types of adhesive – always check the label for compatibility with your materials before selecting which adhesive to use. Badly applied adhesive can ruin the best project, so take care at this stage.

Using adhesive

- Lay the item to be stuck face down on a scrap piece of paper – the scrap underneath will allow you to spread the adhesive over the edges so they will adhere firmly.
- Be careful not to transfer adhesive from your fingers onto the face of what you are sticking.
- Gel-type all-purpose adhesive is easy to apply and will not yellow over time.
- Double-sided tape may show through very thin paper as a raised strip, so use spray glue instead.
- Only use masking tape when it will be concealed later in the assembling process – it is not very attractive to look at.
- Hold very small items with tweezers to apply the glue.

Applying adhesives

Always try to choose the most suitable adhesive for the project; consider the materials, the finished use of the item and how long it will take the adhesive to dry.

Liquid adhesive

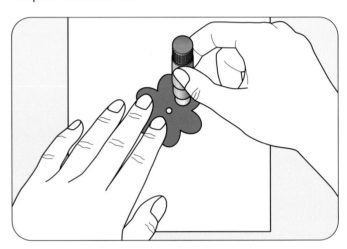

Apply a thin layer of your chosen adhesive to the reverse of the piece to be attached. With liquid adhesives, be careful not to apply too much as it may be forced out around the edges when the item is pressed into place.

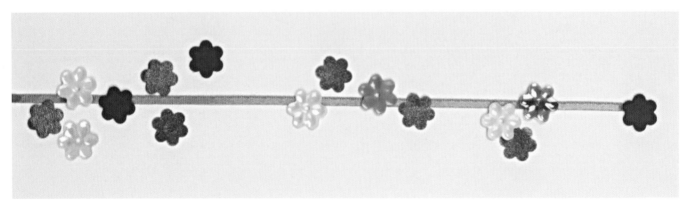

Flower sequins applied with dots of liquid adhesive.

Double-sided tape

Ideal for attaching larger pieces with straight edges, although dry adhesives rarely offer such a secure bond as wet types.

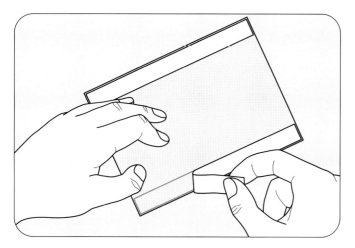

1 With double-sided tape, apply the tape near the edge of the piece to be stuck and trim the ends within the edges. Peel off a short length of each piece of backing tape and fold back at an angle.

2 Position the item, holding the exposed adhesive away from the surface until you are happy with the positioning. Press the exposed area down to hold the item in place, then pull the tags away and smooth the item down completely.

Spray adhesive

Although it can be a rather expensive option, this is the perfect solution for attaching large or very delicate pieces.

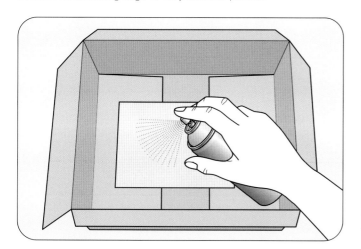

1 Spray adhesive is quite messy and it is difficult to control where the spray goes, so place the sheet to be sprayed face down inside a large plastic tub or cardboard box in a well-ventilated area. Shake the can and then spray an even layer of adhesive all over the reverse, holding the can a short distance away from the surface.

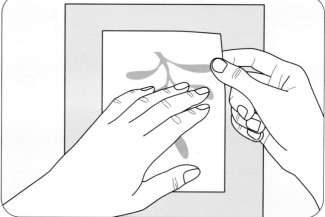

2 Position the sheet carefully over the backing material. Smooth it down at one end first, and then smooth your hand carefully over the remaining area, making sure it is firmly stuck down with no wrinkles or air bubbles. If the sheet is not too delicate, you may be able to peel it off and reposition at least once, if necessary.

Self-adhesive dots, pads and tape

Adhesive dots are also quite expensive if you need to use them in bulk, but are perfect for applying small details or awkward shapes.

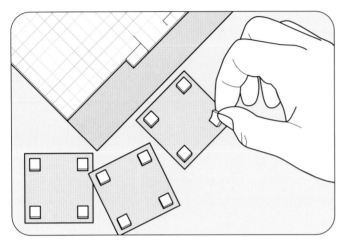

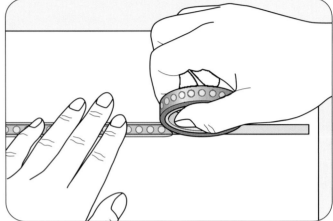

1 Self-adhesive dots are a mess-free way of applying localized adhesive – just peel them off the carrier sheet and apply where you need them. Remove the backing from each dot and press the item in place. Self-adhesive pads are slightly thicker, giving a three-dimensional effect.

2 Adhesive dots are also available on a carrier tape in a roll or dispenser, which makes them ideal for applying long thin items like ribbon. Apply the dots along the back of the ribbon, unrolling the tape or running the dispenser along as you go.

Fusible webbing

Fusible webbing is ideal for fabric or thin veneer – it is not only quick and mess free but will also stop the edges of fabric from fraying.

1 Draw the shape on the paper back of the fusible webbing. Place the adhesive coated side onto the wrong side of the fabric or veneer. Dry iron for about 5 seconds to transfer the adhesive from the paper backing to the fabric.

2 Note the fabric piece should be slightly larger than the piece of fusible webbing or the webbing will stick to the ironing board. Cut out the shape drawn on the backing paper with scissors, and then peel the backing off.

3 For a complex design, make all the motifs first. Position all pieces onto the backing sheet, adhesive side down. Cover with parchment to protect the fabric, and then dry iron over the parchment until all pieces are secured in place.

making 3-dimensional embellishments

Three-dimensional embellishments are often expensive to buy and it can be hard to find the exact one you need. Making your own is very easy following these simple techniques.

Epoxy stickers

For these hand-made stickers you will need dimensional adhesive – sometimes called dimensional glaze – which is available from most good hobby or craft stores.

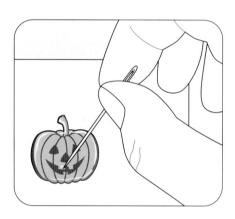

1 Punch out the shape, or stamp the design for the sticker. If it is to be self-adhesive, put double-sided tape on the reverse first.

2 Colour the design, if necessary. Apply a thick coat of dimensional adhesive to the entire shape, being careful not to go over the edges.

3 If any air bubbles form, break them with the tip of a needle while the adhesive is still wet. Allow to dry thoroughly following the manufacturer's instructions.

Page pebbles

Purchased page pebbles are a less messy alternative to dimensional adhesive, but are only available in a limited range of shapes and sizes.

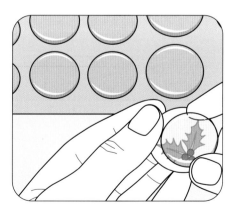

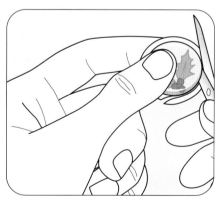

1 Cut a motif or picture slightly larger than the pebble. Peel a pebble off the carrier sheet and apply the motif, right side facing, to the adhesive back.

2 Make sure the image is firmly fixed to the back of the pebble. Trim off any excess around the edge. Stick the pebble down with a suitable adhesive.

Polymer clay embellishments

Polymer clay is a very versatile material that is easy to use and is great for making multiple copies of a shape for batch cards or invitations. Some types need to be baked and others are just air-dried, so make sure you check the instructions before you purchase if this will be an issue.

Stamped

Many designs stamp beautifully onto clay. Choose one with a clear edge as a guide for cutting out the finished motif.

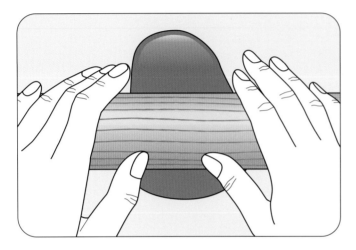

1 Prepare the clay if necessary by kneading it with your fingers until it is soft and pliable. Roll the clay out on a flat surface until it is about 2mm (1/16in) thick.

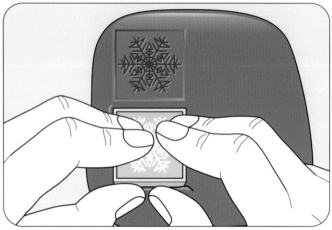

2 Check the stamp is clean and dry, then stamp the motif into the clay. Press down firmly, then lift the stamp carefully. Space motifs a little apart.

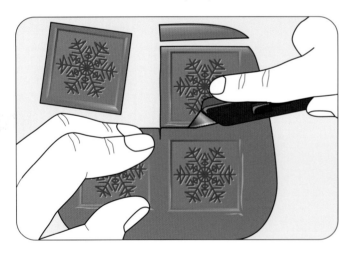

3 Cut the motifs out carefully using a craft knife or a biscuit cutter. Be careful not to damage the stamped design. Allow to harden fully before decorating.

Stamped polymer clay motifs can add a three-dimensional element to your papercraft projects.

Moulded

To make duplicate moulded polymer clay embellishments you can use a purchased mould, but it is very simple to make your own using silicone compound.

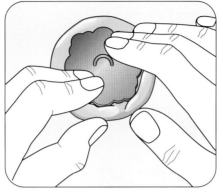

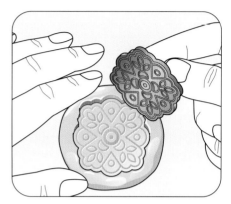

1 Take equal amounts of the two parts of the silicone compound. Knead them together until you achieve an even colour. Form the mould material into a flat, round disk large enough to take what you want to mould.

2 Press the item you want to duplicate firmly down into the mould material. Make sure the item doesn't move or twist as you press it into place or the details will become blurred.

3 Wait for a few minutes, then carefully lift the item away from the mould material – it should come away easily; if it sticks it needs to stay in place a bit longer. Removing it too early can cause damage to the moulded design.

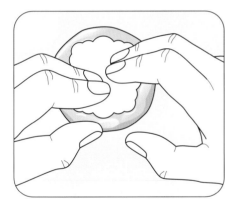

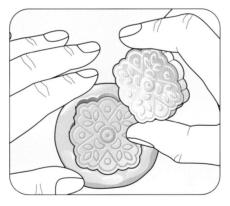

4 Allow the mould to dry thoroughly, following the manufacturer's directions. When it is ready, fill it with polymer clay, pressing down gently to make sure the clay fills every detail. Cut any excess clay from the top to create a flat surface.

5 Let the polymer clay harden enough so it is stable. Remove the clay embellishment from the mould; it is now ready for baking (if necessary), colouring or decorating. You can reuse the mould to make more identical embellishments.

Choosing clay

Look at several ranges of polymer clay before purchasing one – some have brighter or a wider selection of colours.

Check the texture, if possible – some air-drying types have a fibrous construction that means designs will not stamp cleanly.

colouring, decorating and texturing

Papercrafts often require sheets of paper with a design or decorative effect, and although these are widely available you can achieve unusual and interesting designs easily yourself. There are many techniques to decorate paper and it's well worth experimenting – even something that doesn't turn out as expected can be attractive and effective.

colouring

Paper can be coloured with watercolour, gouache, coloured pencils, felt-tip pens – it depends on the effect you are trying to achieve and if you want a fairly even colour or something a bit more random. For a simple flat wash just brush the colour as evenly as possible over the sheet, but here are a few more unusual techniques using inks and bleach to create a coloured design.

Colouring wet paper

A little different to a plain wash, this technique is known as 'wet-into-wet'; colour is added to damp paper so it bleeds. You will have little control after the colour is on the paper – the amount of water you use, how long you leave it before adding colour and the absorbency of the paper all affect the outcome. Use watercolour paper – a lighter weight paper will stretch and distort more readily when wet.

Colourwash

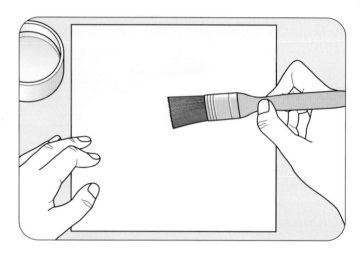

1 Use a wide paintbrush to brush water all over a piece of watercolour paper. Allow it to stand for a while so the water has a chance to soak into the fibres. Don't use too much water – over-wetting causes the paper to distort more.

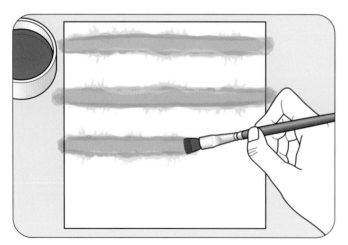

2 Using the wide paintbrush again, brush a line of colour across the paper. Keep the brush moving at a fairly even speed – if you slow down, more ink will be applied so it will bleed more. Repeat at intervals down the sheet, spacing the lines well apart.

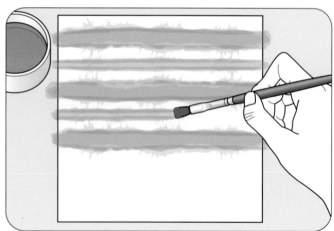

3 Repeat the process again with a second colour between the first lines; depending on the spacing and timing you will either achieve fairly separate alternate stripes, or the two colours will bleed into one another creating a tonal effect.

Using inks

When using ink over large areas, if you decant some into another container first you can dilute it with water. This often has little effect on the intensity of colour but makes the ink go further. Artist's inks come in a wide range of colours and can also be mixed. Most colours are transparent and water resistant when dry, so you can layer colours over one another.

Experiment with different colours, timings and saturation of water to achieve different effects.

If you buy inks in a dropper bottle you don't even need a paintbrush to use the colourdrip technique.

Colourdrip

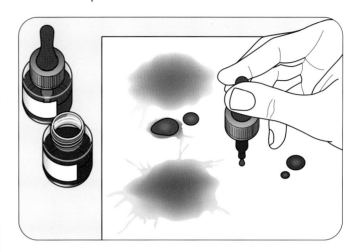

Wet the paper as described for colourwash. Drip splashes of ink over the paper at random, either using a paintbrush or the dropper of the ink bottle. Use different colours, either spacing them slightly apart or allowing them to blend with one another.

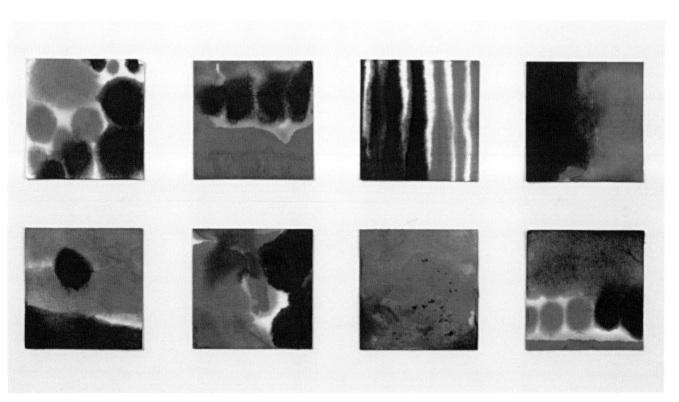

Different effects achieved with the colourdrip technique.

Folding and dipping

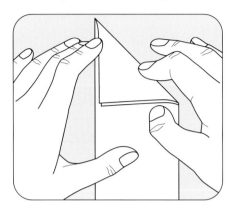

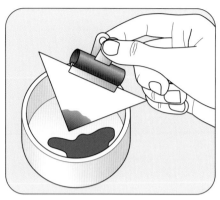

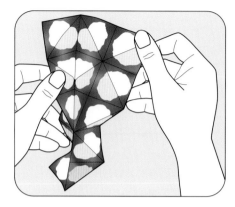

1 Fold the paper several times lengthways, then fold the top over into a triangle. Turn the whole thing over and fold the triangle the other way. Repeat down the length of the paper until the entire piece is folded into a small triangle.

2 Clamp the folds with a bulldog clip. Decant some ink into a small container. For circles, dip the point of the triangle into the ink, for stripes, dip the sides. Try using different coloured inks for the points and edges.

3 Unfold the paper to reveal the design. Allow it to dry completely before using. The best paper to use is an absorbent type such as mulberry paper – but experiment with a few different papers to get the effect you want.

Bleach

With this technique you remove pre-printed colour from sheets of paper – it works best on uncoated papers, but test a piece first because you cannot tell how a paper will react by looking at it. Be careful with the bleach – it is an irritant and will also remove the colour from fabrics.

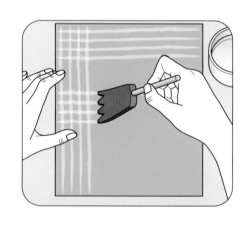

Protect your work surface with a plastic sheet. Decant some bleach into a small container wide enough to take the brush – use a notched foam brush to create the stripes as shown here. Moisten the brush with bleach and smoothly stroke it across the paper in one movement. Repeat at intervals down the page, and again in the other direction to create a plaid pattern.

The folding and dipping and bleach techniques are both ideal to create unusual giftwrap.

Printing

To print a design, all you need is something to hold the colour while it is transferred to the surface of whatever you are printing upon. You can use many found objects to print with, but if you need a specific motif creating a potato stamp is one of the quickest and easiest techniques to use. This section also covers an alternative method of transferring colour, bubble printing, in which the paper is dipped into bubbles on the surface of the ink.

Potato printing

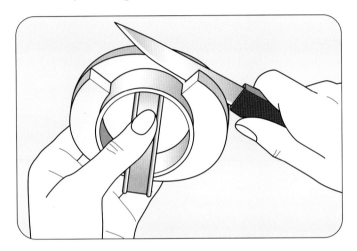

1 Cut a large potato in half. On the cut side of one half, mark out the motif you want to print and start cutting it out. You can use a pastry cutter or something similar as a guide for regular shapes such as circles.

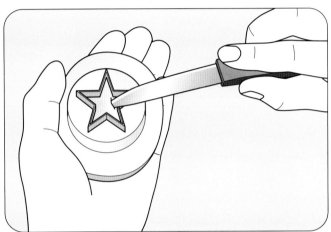

2 Add extra detail to the design by cutting out more than one shape, if you prefer – here a star is being cut out of the circle using a smaller pastry cutter as a guide. Cut to a depth of about 1cm (½in).

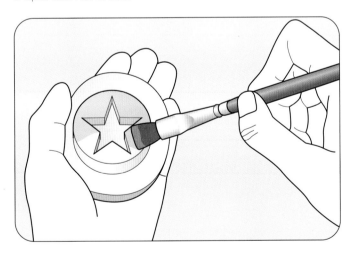

3 When the shape is finished, place the cut side of the potato down on a piece of kitchen towel to absorb the surface moisture. Either brush paint onto the raised surface or press the potato onto an inkpad.

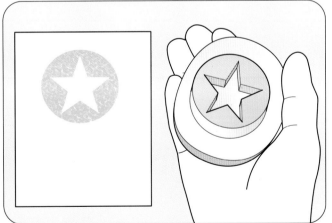

4 Press the potato onto the item to be printed, then lift it cleanly away. If you are creating an all-over pattern, allow some of the prints to run off the edge. When the print is dry, you can overprint with a different shape or colour.

Bubble printing

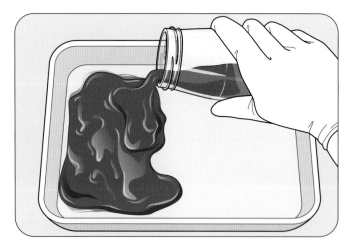

1 Make a solution of two parts water, one part ink and two parts washing-up liquid in a jar. Mix together well and then tip the solution into a flat dish wide enough to take the paper or cardboard to be printed.

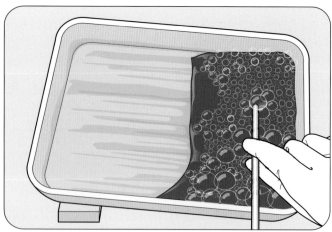

2 Tip the dish up slightly so all the solution is at one end, and support in that position. Put one end of a straw into the solution and blow through it gently to create lots of bubbles across the surface.

3 Lower one half of the paper or cardboard onto the bubbles – don't allow it to touch the solution itself, just the bubbles floating on top. Turn the sheet around and carefully dip the other end into the bubbles.

4 Turn the printed sheet right side up and leave to dry completely before using. Bubble printing is a fun technique to add interest quickly and is ideal to create an unusual overall background pattern.

Marbling

Marbling enhances the texture of paper with dramatic and colourful designs. Use an oil-based paint colour diluted with a little white spirit, so it will sit on top of the water surface.

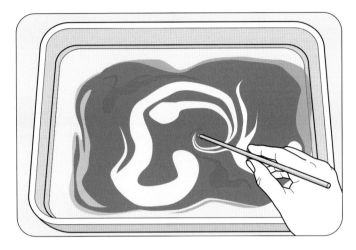

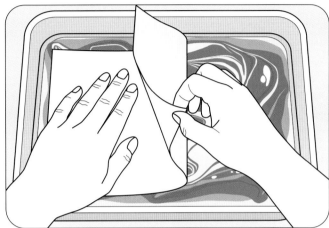

1 Fill a tray slightly larger than the sheet of paper with cold water about 7.5cm (3in) deep. Squeeze a few droplets of different colours across the surface of the water and slowly drag a chopstick across to swirl the colours into an attractive pattern.

2 Place a sheet of dry paper gently into the tray by rolling it down onto the surface of the water carefully.

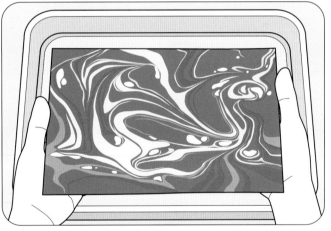

3 Make sure the paper is completely flat, floating on top of the water – don't let it go under the surface. Leave it in place for a few seconds.

4 Lift the paper out carefully and transfer it to a drying board. Remove any remaining paint in the water by dipping newsprint in to catch it. Add fresh paint to the surface of the water for each sheet of paper.

Stencilling

The basic technique of stencilling has not changed for thousands of years. There are many ways to make a stencil but here is a simple, straightforward technique that does not need special equipment.

Making a stencil

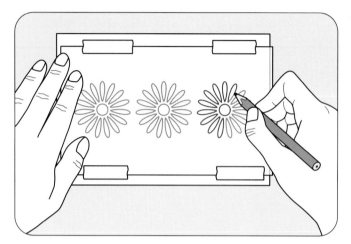

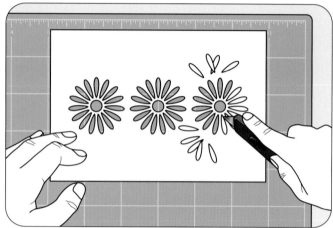

1 Lay a sheet of tracing paper over your motif and trace it using a sharp pencil. You can use almost anything with simple shapes as a stencil design – but bear in mind that each different part of the design will need to be a separate cut out.

2 Transfer the traced motif to a piece of thin cardboard (see Tracing, page 64), perhaps arranging several into a larger design. Some motifs may not work well as cut outs – if so adapt them at this stage. Cut out the areas to be printed with a sharp craft knife.

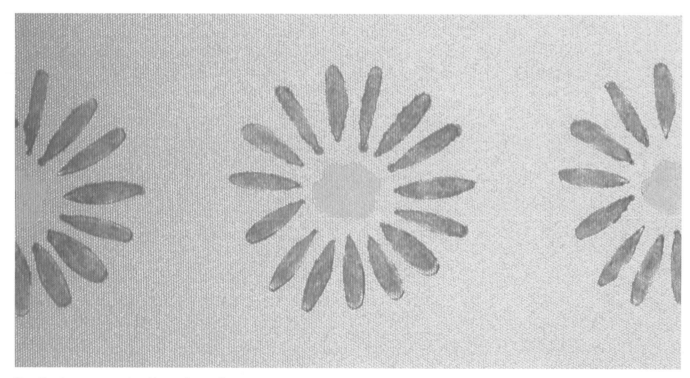

Stencilling is an easy way to add repeating motifs.

Using a stencil

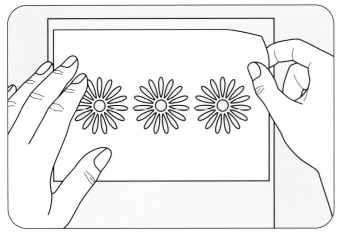

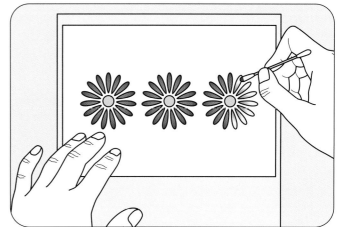

1 Position the stencil over the item to be decorated and hold it firmly in place – on some materials you may be able to fix it in place using a little spray adhesive. Using a sponge, cotton bud or a stipple brush, dab colour through the cut out areas.

2 You can use different colours for different parts of the design – or even in the same cut out shape; use a clean cotton bud for each colour. Create shading by adding more colour in some areas.

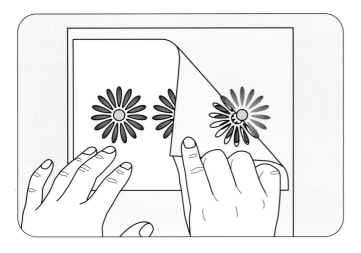

3 Carefully remove the stencil, lifting it off directly upward to avoid smudging the design. Leave the colour to dry thoroughly before adding further details. If the stencil is reusable, clean off the colour as soon as you finish using it.

Stencilling techniques

Thin cardboard is fine if you only plan to use the stencil a few times, but if you plan to keep it and reuse it many times, make it in acetate instead. Alternatively, invest in a special stencil material.

Stamping inkpads are ideal for stencilling because they offer strong, semi-dry colour that will not seep under the edges of the cut motif.

Traditionally a stipple brush is used for stencilling, but a cotton bud will allow you better control when applying colour to small areas of the design.

A complex design can be made up using several different stencils that are printed on top of one another. Allow each colour to dry thoroughly before adding the next.

To stencil a continuous border, work out the repeat and create alignment marks between repeats that can be removed later. Stencil alternate repeats first, then come back and do the missing ones in between – this will avoid having to place the stencil over wet colour and smudging it.

Stamping

Stamping is ideal to create pattern quickly across large areas, when making giftwrap for instance. Stamps come in all kinds of designs, but you can also easily make your own, as shown on pages 51–53.

How to stamp

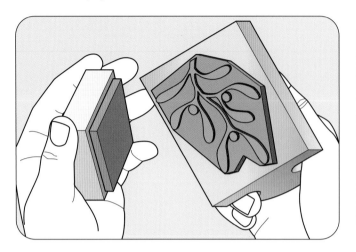

1 Apply ink evenly to the stamp with an inkpad. Smaller stamps can be pressed onto the inkpad directly to load them with colour, but with larger stamps you may need to apply colour by dabbing the inkpad across the surface of the stamp.

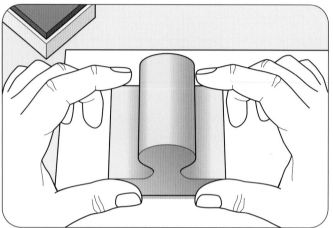

2 After applying the ink, hold the stamp securely – with two hands if it is a large stamp – and press it down firmly onto the item to be decorated. Don't rock the stamp or move it after it hits the surface – this will lead to a blurred design.

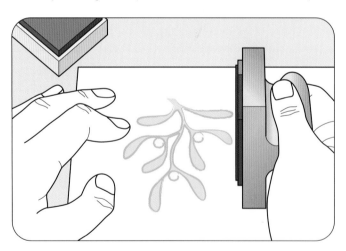

3 To avoid smudging, lift the stamp away from the surface cleanly. If the paper or cardboard being stamped is liable to move easily or has a tendency to cling to the wet ink, hold it in position as you remove the stamp.

Stamping techniques

If the ink is not applied to the stamp evenly, the stamped motif will be uneven in colour.

Apply firm pressure across the entire stamp, or parts of the design will be lighter in colour.

The two-colour stamping technique described here uses liquid paint; you can also apply each colour with a paintbrush but you will need to work quickly as the first colour may begin to dry.

You can also use different colour inkpads but apply each colour separately to the stamp with a clean cotton bud.

Stamping at random is usually very effective but if you want a regular repeat over a wider area, either lightly mark a grid on the background material or set up a method of aligning the stamp each time so the prints are equally spaced.

Two-colour stamping

1 Extra interest can be created when using simple stamp designs by using two colours. Spoon small amounts of each colour into a flat dish and spread out thinly next to one another, to cover an area slightly larger than the stamp. Press the stamp face down into the colours so it is well coated.

2 Test the stamp on a piece of scrap paper first – the second print after loading up with colour is often better anyway. Position the stamp and print as normal. To avoid mixing the colours, always press the stamp into the colour the same way around and don't move it around when it is in the colour.

Caring for your stamps

– Always clean stamps after use before putting them away.
– A damp cloth will remove most inks, but use special stamp cleaner for permanent or very dark coloured inks.
– Never wash wooden stamps under running water because the adhesive that holds the motif to the wooden base may dissolve over time.
– After cleaning the stamp, dry it carefully with soft tissue or alcohol-free baby wipes.
– If you use biscuit cutters or other food preparation items for stamping – or any other papercraft techniques – make sure you clean them very thoroughly before returning them to the kitchen. Or, better still, keep a different set just for craft.

Found objects

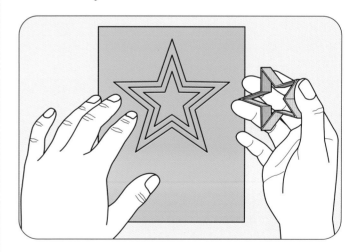

Many objects make excellent stamps so it is worth experimenting with anything you think may be suitable. The results can be surprisingly effective – here a set of star-shape biscuit cutters is used to create a concentric star design.

Embossing with stamps

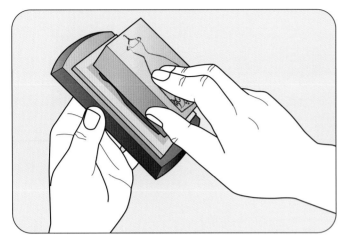

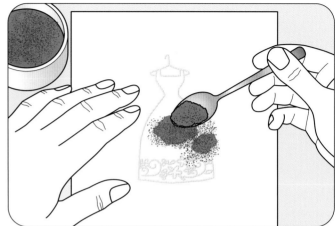

1 For this technique, use a special embossing inkpad with transparent ink or ink with only a very slight tint so you can see where you have stamped. Choose a stamp with a fairly simple design and apply the embossing ink evenly to the surface.

2 Press the stamp firmly onto the paper or cardboard as normal, and lift away cleanly. Place the printed sheet onto a large sheet of scrap paper and – while the embossing ink is still wet – sprinkle a generous amount of embossing powder over the entire motif.

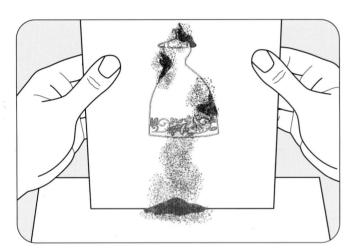

3 Tip the printed sheet up so any excess powder falls onto the scrap sheet. Tap gently on the back to remove any loose powder, and clean off any stray grains using a fine paintbrush. Put the printed sheet to one side, pick up the scrap paper carefully and pour the loose powder back into the pot – you can use it again.

4 Gently heat the powder on the motif with a heat gun to melt and seal it into place. The embossing technique adds a delicate three-dimensional effect and a slight metallic shimmer to the stamped design.

Making a small stamp 1

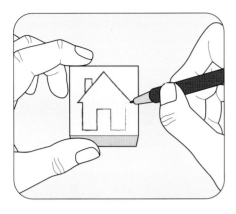 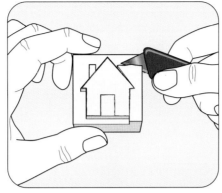 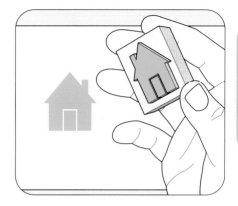

1 A simple rectangular eraser makes a great base for a stamp. First draw the design on the stamp, but don't make it too detailed because you will need to cut it out. If you prefer, you can work up the design on paper first and then transfer it to the eraser using tracing paper (see page 64).

2 Cut around the outline with a sharp craft knife, to a depth of around 3mm (⅛in). Remove the excess material around the motif by cutting into the sides of the eraser, up to the cut outline of the shape. If there are line details within the design – such as the doorway here – you can cut these as a shallow groove.

3 Apply ink evenly to the stamp as normal and make your stamped print. The finished print will be a mirror image of your original design – this is especially important to remember if you are working with letters or numbers.

Making a small stamp 2

 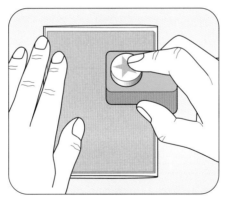 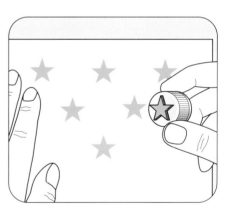

1 Small rubber stamping motifs can be made using a craft punch. Take a small piece of self-adhesive rubber sheet and wrap a piece of waxed paper around it.

2 The waxed paper allows the rubber to slide into the stamp more easily. Punch out the shape from the rubber.

3 Apply the rubber shape to a mount – a plastic bottle cap is perfect for a small motif. For larger designs, use a block of wood. Use to stamp as normal.

Making a string stamp

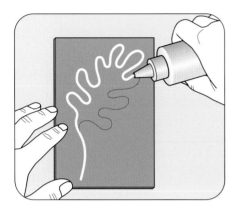
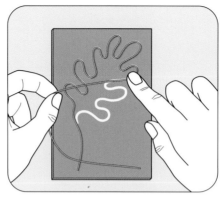
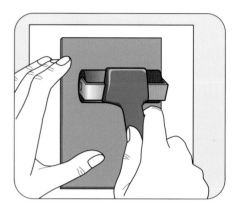

1 String is ideal for an outline stamp design. Use a piece of hardboard or thick cardboard and draw the design on one surface – you can work out the design on paper, then trace it onto the base. Apply a thin line of fabric adhesive along the outline.

2 Lay a single length of string onto the line of adhesive, butting the ends together neatly if necessary. Don't use very thin string as it will be hard to ink the design without getting colour on the base. Allow the adhesive to dry completely before using the stamp.

3 Apply ink to the design as normal – if you do get it onto the base, wipe it off carefully before beginning to stamp. Apply the stamp to the material you want to decorate and then roll across the back lightly with a brayer to make sure all the string is in contact.

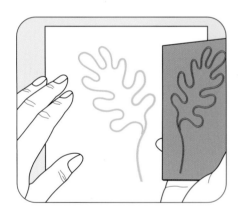

4 Carefully lift the stamp clear to reveal the image. Don't be tempted to use different thicknesses of string to vary the line weight in the design – the thicker string will hold the thinner string away from the surface and prevent it from printing.

You can stamp on plain paper, or onto pre-patterned giftwrap to add a coordinating element that can be carried over onto a card and tag.

Making a sponge stamp

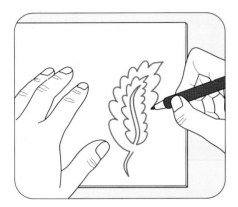

1 Flat sponge cloths make great stamps for solid shapes and can have quite detailed outlines. Draw the design with a fine-tip permanent pen.

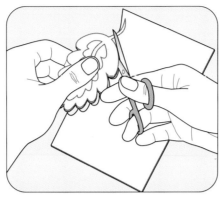

2 Use sharp scissors to cut around the outline carefully and to cut away any details in the centre of the design.

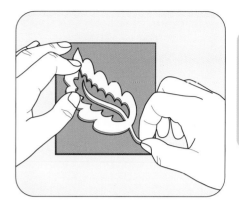

3 Stick the sponge shape to a piece of hardboard or thick cardboard as a base, using all-purpose adhesive. Allow the adhesive to dry thoroughly and then print with the stamp as normal.

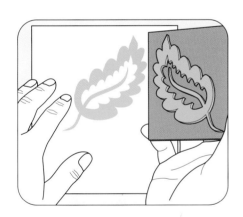

4 Use a brayer to ensure the entire area of stamp comes into contact with the surface. A flat un-textured sponge cloth – as used here – produces the cleanest stamp; if you use a cellulose type the motif will be more heavily textured.

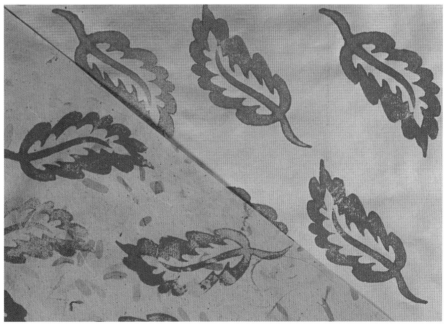

Stamped designs can coordinate or contrast with the background colour.

Using resists

Using a resist to block colour from reaching the base material is a traditional technique that is very easy to use and requires no special equipment.

Wax crayon

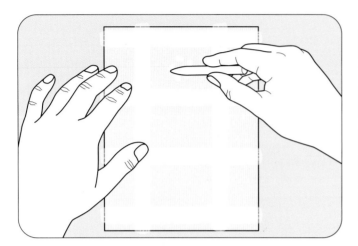

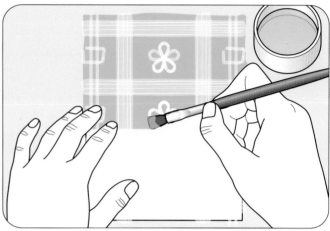

1 Protect the work surface with a large piece of scrap paper. Draw your chosen design on the base paper or cardboard with a white wax crayon or household candle. It can be hard to see what you have drawn at this stage, so keep to simple designs and shapes.

2 Decant some ink or watercolour paint into a small container. Using a wide brush, paint the surface of the paper or cardboard completely with the colour; the design drawn in wax will show up in the original base colour.

Masking fluid

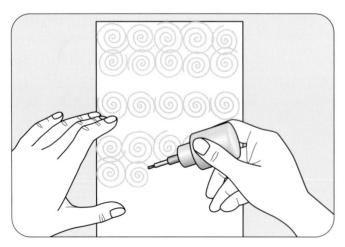

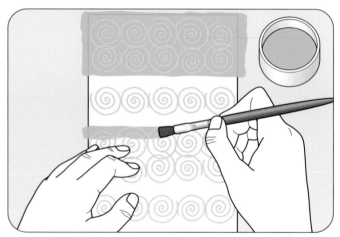

1 Protect the work surface with a large piece of scrap paper or plastic. Draw the design in masking fluid across a piece of watercolour paper.

2 Decant some ink or watercolour paint into a small container. Using a wide brush, paint the surface of the paper or cardboard completely with the colour; the design drawn in wax will show up in the original base colour.

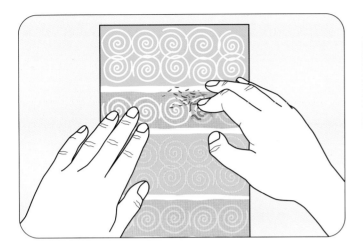

More about masking fluid

Masking fluid is latex-based and is used mainly in watercolour painting; if you cannot find it in a hobby or craft shop, try an art store.

Never use your best watercolour brushes to apply the masking fluid – although it can be removed from watercolour paper, it will ruin brushes for use in painting because they will no longer hold the paint properly.

Avoid using a paintbrush at all by buying masking fluid in a nozzle applicator.

3 Allow the design to dry completely. When all the paint is completely dry, rub away the masking fluid carefully using your fingertips. Ideally, this should be done within 24 hours of applying the fluid.

The finished paper can be further decorated with stamped designs or additional elements such as sequins.

Spraying

Spraying paint is another great way to cover a large area. Many different items can be sprayed over, or you can use a mask so only certain areas receive colour.

Silhouette spraying

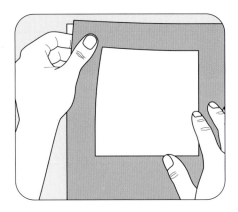 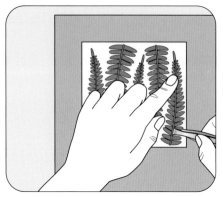 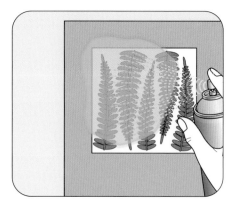

1 Use a piece of cardboard to mask off large areas that you do not want to colour. Hold the cardboard mask in place securely with a little spray adhesive.

2 Create an arrangement to be silhouetted. When you are happy with the design, stick each item in place with a little spray adhesive. Protect the work surface.

3 Spray over the entire design in a series of short, light bursts to achieve an even colour. Always follow the directions on the can and work in a well-ventilated area.

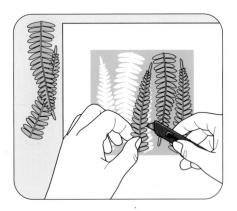

4 Before the paint is completely dry, carefully peel away the cardboard mask and the sprayed items. It may be easier to lift the edge of each item with the tip of a craft knife first.

Using lacy fabrics

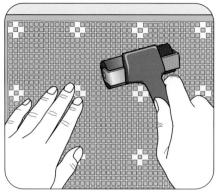

1 Secure the lace by spraying it on the reverse with spray adhesive, then lay it right side up over the paper or cardboard. Roll over the fabric with a brayer to make sure it is securely fixed down everywhere.

2 Spray with the paint, as described in step 3 above. Before the paint is completely dry, carefully peel away the lace. Here the design has been sprayed in white onto a coloured background.

Masking and spraying

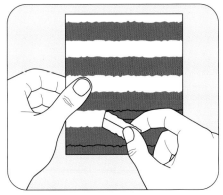

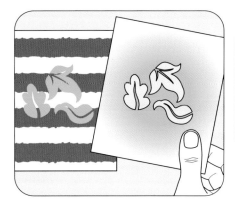

1 Create stripes with strips of masking tape – tear lengths of tape in half and apply them with the straight edges overlapping for organic wavy-edge stripes.

2 After spraying with the first colour, allow the paint to dry slightly and then remove the masking tape carefully.

3 Allow the paint to dry completely, then position the chosen stencil over the top of the sprayed lines and spray with a second colour.

Choosing a mask

Many different items can be sprayed over – you need something that is heavy enough to stay in position, or which can be held in place temporarily using a little spray adhesive.

Don't use anything valuable – it will be covered in paint at the end.

Dried botanicals work better than fresh – they are easier to stick down and are already flat so will give a crisper result.

Open-textured fabrics are ideal to create an all-over background design.

Different forms of masking and different colours can be combined to create a more complex design.

Combining techniques adds extra richness to the design.

applied decoration

Many different materials can be applied to paper and cardboard, to add both colour and texture. This section also includes some techniques for transferring images.

Glitter, metallic foils and gilding

A little sparkle to catch the eye is a great way to add extra interest to the simplest design. Both glitter and foil are very simple to use, as are gilding pens.

Making glitter paper

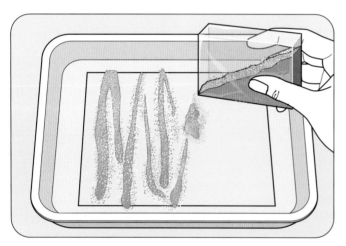

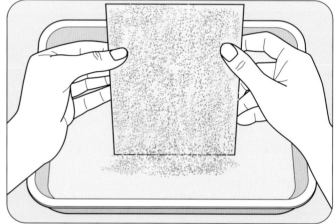

1 Protect the working area by placing the piece of paper or cardboard in a plastic tub or cardboard box. Cover one side evenly with a light coat of spray adhesive. Transfer the sheet to a clean box or tray and sprinkle glitter evenly over the adhesive while it is still wet.

2 Tip up the sheet so any excess glitter falls back into the box. Tap gently and then lightly rub over the paper with your fingertips to remove any loose glitter. Quite a bit will come off, but an even coat should remain. Tip the excess glitter back into the pot for reuse.

Using glitter

When making glitter paper, transparent or translucent glitter will work better than coloured or opaque versions – it will be harder to spot if the glitter coating is uneven.

If you want coloured glitter paper, use coloured paper and add transparent glitter – or match opaque glitters as closely as possible to the base colour.

For glitter motifs, use coloured glitter applied as thickly as possible.

Glitter motifs

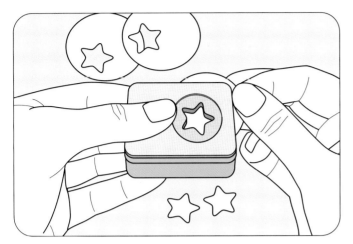

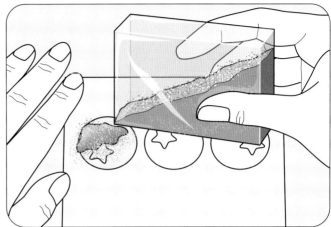

1 Punch a suitable motif from double-sided tape or film using a craft punch. You can create a more complex motif by punching out a simple circle or square, then punching another shape out of this.

2 Peel the backing from one side of the motif only and apply it to the background. Here the three motifs are to be different colours, so peel the protective cover off one motif only and sprinkle the first colour onto the sticky film.

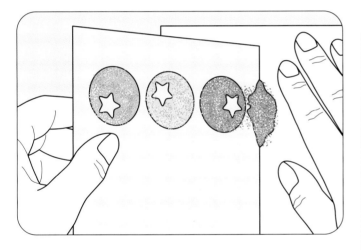

3 Tip excess glitter onto a sheet of paper, fold it into a scoop and pour the glitter back into the pot. Repeat for the other two colours, one at a time. Always apply the motif to the background before adding the glitter – the sticky film is thin and tears easily, so cannot be used for making a stock of stand-alone motifs for later use.

Size matters...

Double-sided film is mess-free and easy to apply and shapes can be cut with a punch, scissors or a craft knife. The sheets of film are wider than double-sided tape, so it is possible to make bigger glitter motifs, but if you are making small motifs the tape is more economical to use.

Glitter can vary in particle size, ranging from very fine to quite coarse. A fine type will give crisper results, particularly on small motifs.

Adding gold foil

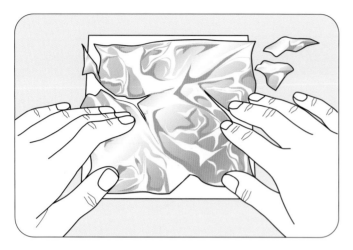 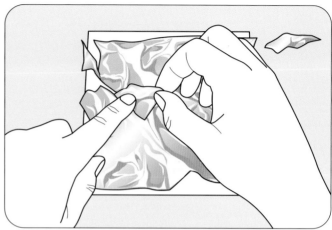

1 Double-sided adhesive film can also be used to apply areas of gold foil. Peel off the backing on one side of the adhesive film. Apply the imitation gold leaf and smooth into place with your fingertips.

2 Fill any gaps with some of the scrap pieces of foil. Use to create a rich gold background, or punch out self-adhesive gold motifs to use in your designs.

All that glitters

Real gold foil is very expensive, but imitation gold leaf gives exactly the same effect for a fraction of the cost.

Every tiny piece of gold foil can be used to fill gaps, so keep all scraps no matter how small.

If the gold leaf is sticking to your hands, dust your fingers lightly with talcum powder to absorb any moisture.

Gold foil is great for making polymer clay embellishments look like engraved gold – the foil will stick to the polymer clay before it dries without any adhesive. If necessary you can also bake the foil. The colour of the polymer clay will show through the thin foil a little, so if this is not the look you want choose a base clay of a similar gold colour.

You can cover any exposed clay on the edges of a gold foil covered motif by painting the edges with gold paint or using a gilding pen.

Metal leaf will tarnish over time – spray it lightly with hair lacquer to prevent this.

Gold embellishments can look stunning when combined with a simple strip of gold ribbon.

Making gold foil embellishments

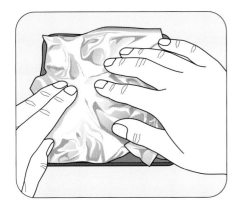

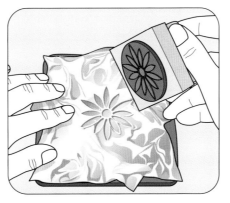

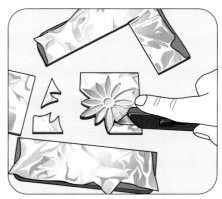

1 Roll out the polymer clay and apply imitation gold foil on top. Smooth in place with your fingers so the foil covers well and is stuck down securely.

2 Stamp the foil-covered clay with your chosen motif, which should be something quite bold and simple.

3 Use a craft knife to cut out the motif; if necessary define the edges with tweezers. Bake the clay, if necessary.

Gilding with a stamp

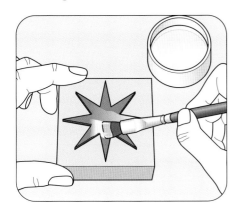

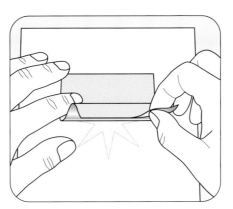

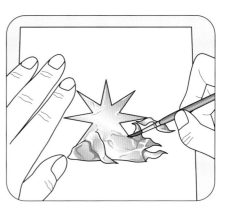

1 Paint an even thin layer of gold size (adhesive) onto the stamp and then stamp it onto the paper or cardboard. Lift off the stamp carefully and leave to allow the size to become tacky, following the manufacturer's instructions.

2 Hold the sheet of imitation gold leaf by the backing tissue. Carefully smooth the gold side over the stamped motif with your fingertips, making sure the leaf sticks securely to the size.

3 Peel off the backing tissue, being careful not to pull the leaf away from the size. Remove excess loose leaf around the edges of the motif by brushing it away gently with a clean, dry paintbrush.

Gilding with a size pen

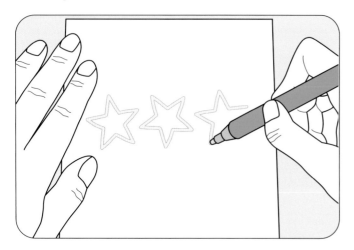

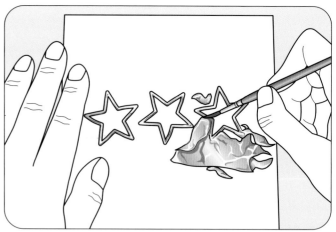

1 The size pen allows you to make original drawings rather than using a stamp. Draw the design on the paper with the pen – you can trace a design first if you like, but make sure the pencil marks are covered by the size later.

2 Leave the size to go tacky, following the manufacturer's instructions, then apply the leaf as described for Gilding with a stamp, page 61. You can use this technique to add hand-drawn extra embellishment to stamped motifs.

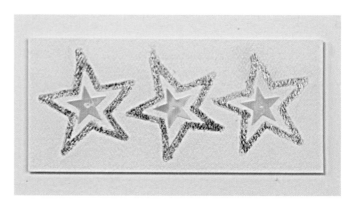

Gilded stars with pearlized sequins added for extra effect.

Fusing polythene

Polythene bags can be cut and fused to create a simple stained glass effect that looks very effective mounted in an aperture.

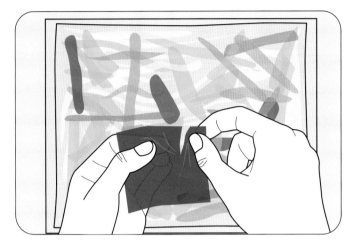

1 Take a thin, transparent polythene bag, cut it open and lay it flat over a sheet of greaseproof paper. Cut coloured plastic bags into narrow strips; tear some areas into wider pieces or different shapes.

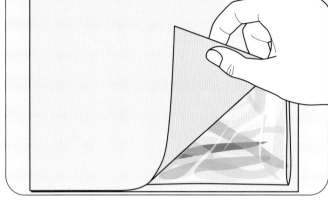

2 Build up a design in pieces of the coloured plastic on top of half the clear polythene sheet. Fold the other half of the polythene sheet over the design and top with another sheet of greaseproof paper.

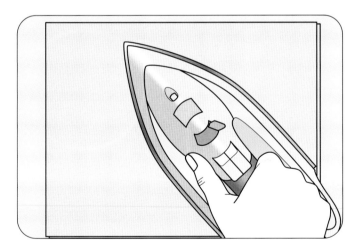

3 Set an iron to a warm heat. Place the iron on one spot over the top of the greaseproof paper and hold it there for a few seconds. Repeat until you have fused all the polythene and plastic together.

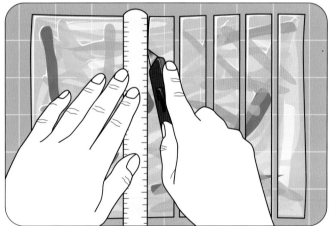

4 Remove the greaseproof paper and allow the polythene to cool. Cut the sheet of fused polythene into suitable pieces for your design.

Transferring images

Many projects will require images or motifs to be transferred; with a computer and scanner you could use special transfer paper but here are a few simple methods that don't need special equipment.

Tracing

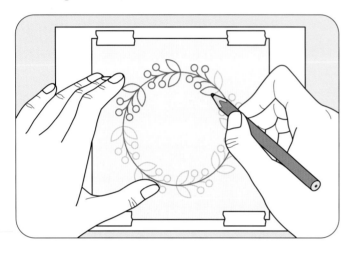

1 Lay a piece of tracing paper over the motif – if it is large and complex tape the tracing paper in position with masking tape to stop it moving. Trace the image onto the tracing paper using a sharp, fairly soft pencil.

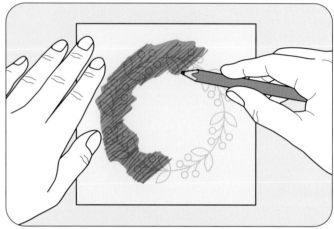

2 Turn the traced image over and lay it face down on a piece of scrap paper. Shade over the entire image area on the back of the tracing paper, using a soft lead pencil.

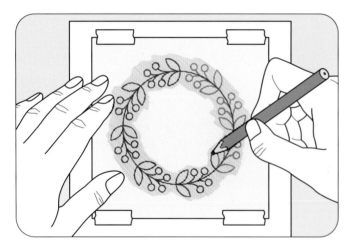

3 Turn the tracing right side up again and lay it in position where you want to add the motif. If necessary, tape in place with masking tape. Carefully go over all the lines of the design again, using a sharp pencil.

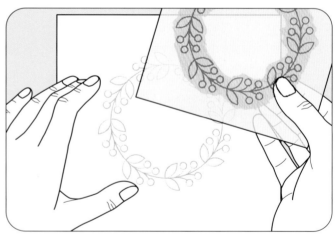

4 Lift the tracing paper off the base material to reveal the traced image. The transferred pencil lines will usually be quite faint, but if necessary you can go over them again with a pencil or fine pen.

Using thinners

To use thinners you will need a photocopied black and white image – the technique will not work on an original photograph or drawing. Thinners can be used to transfer images to paper that will not go through a photocopier and also to transfer images to fabric.

Thinners

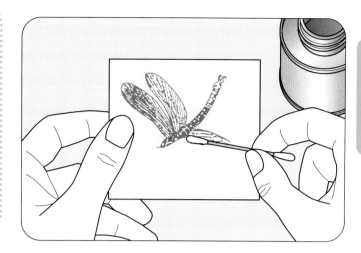

1 Photocopy the image or motif and cut it out, leaving a border of paper around the edge to hold it. Turn the image over and apply cellulose thinners to the back of the image; the paper will become translucent where the thinners soak through.

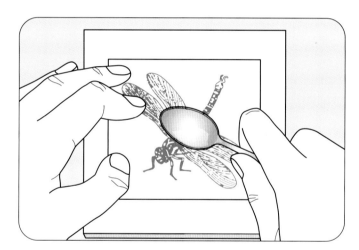

2 Position the image over the cardboard or paper and lower into place. Do not move or reposition again or the image will be blurred. Hold it down firmly while you rub all across the back with the back of a teaspoon.

3 Make sure you rub every area. If you are careful you may be able to lift a corner to check on progress. When the image is totally transferred, carefully lift off the original. You may be able to use it a second time, but the transfer will be paler.

Stitching

Hand stitching a design is a very effective way of adding both colour and texture to cardboard and heavy paper. It's not ideal for lightweight paper, because this probably won't be sturdy enough to support the thread.

Hand stitching shapes

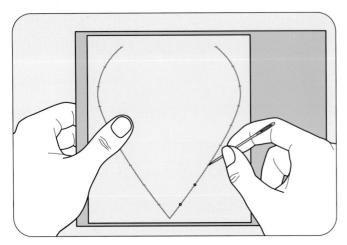

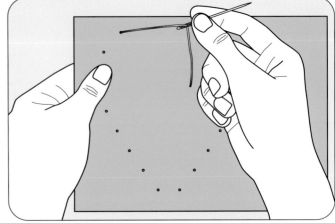

1 Draw the shape you want to stitch on tracing paper. Make small pencil marks along the outline at 1cm (½in) intervals – make sure marks on each side are directly opposite. Place the tracing paper over the cardboard and use a pin to mark holes through the cardboard at each mark for the stitching.

2 Thread a needle with a long strand of embroidery thread and knot the end. Push the needle through one of the end holes from back to front. Pull through until the knot sits against the back surface. Take the needle down again through the opposite hole.

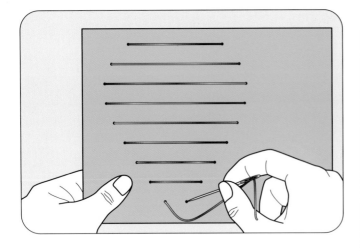

3 Repeat until you have made all the stitches. Using multi-coloured embroidery thread, as here, adds extra interest to a simple design. Fasten off the end of the thread on the reverse by looping it round an adjacent stitch and knotting tightly.

A stitch in time

If using large horizontal stitches to fill a shape, as shown here, keep the outline fairly simple. Use all six strands of the embroidery thread and keep the horizontal lines fairly close together.

You can embroider with any thread or cord that will thread into the needle – but you may need to use a punch to make the stitching holes instead of piercing them.

Embroidery

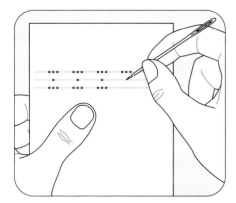

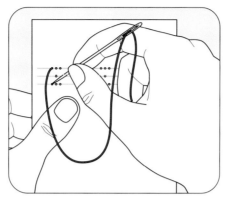

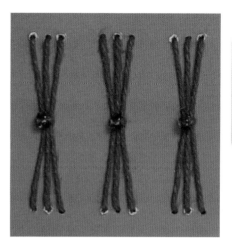

1 Choose a suitable embroidery stitch and work out the spacing for the stitch width and the distance between stitches. Mark on the cardboard lightly in pencil. Use a needle to pierce holes in the cardboard at the stitching points.

2 Thread a needle with a long strand of embroidery thread and knot the end. Push the needle through one of the end holes from back to front. Pull through until the knot sits against the back. Take the needle down through the next hole.

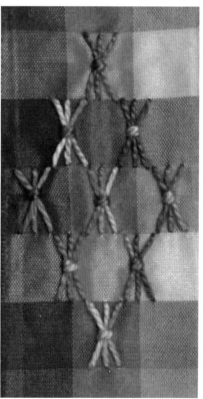

3 Continue working in your chosen stitch design – consult an embroidery book for ideas. Sheaf stitch – as shown here – has groups of three parallel stitches, with a small stitch in the middle to pull the strands into the centre.

4 Fasten off the end of the thread on the reverse by looping it round an adjacent stitch and knotting tightly. Trim any long thread ends neatly.

The same basic embroidery stitch can be used in several ways for different effects.

Adding buttons/beads

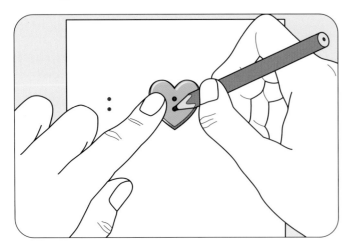

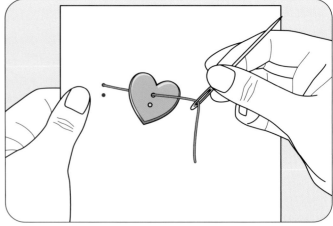

1 Mark out the positions for the buttons lightly in pencil on the surface. Position each button in place and make a mark through each stitching hole with a sharp pencil. Push the needle or a pin through each mark to make a stitching hole.

2 Thread a needle with a long strand of coloured thread and knot the end. Push the needle through one end hole from back to front. Pull through until the knot sits against the back surface. Take the needle through the button and down through the next hole.

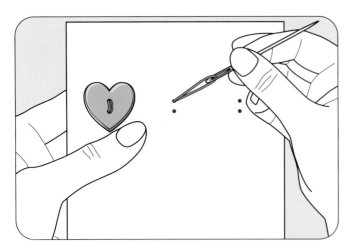

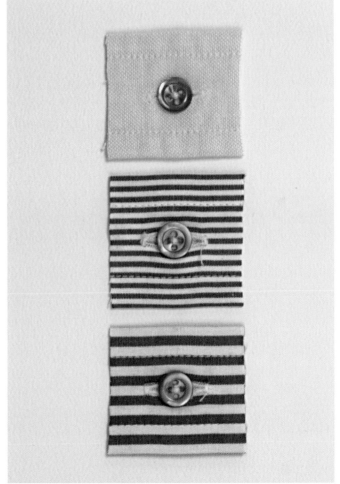

3 Make several small stitches through the button until it is secured in place, then bring the thread up through the next hole along to begin stitching on the next button. Finish by making a double knot on the back and trimming excess thread.

Use buttons to add scraps of fabric – here sections cut from the buttonhole band of three different shirts.

Appliqué

Appliqué motifs can be applied to cardboard and to heavyweight paper as well as to fabric. If you use fusible webbing, only minimal stitching will be required.

1 If the fabric you want to use will fray, begin by ironing a piece of fusible interfacing onto the back. Make a template in paper and use it to cut out the fabric shape. Cut out a slightly larger version of the same shape from plain felt, using pinking shears for a zigzag edge.

2 Pin the fabric shape on top of the felt shape. Thread a needle with embroidery thread and begin stitching the two pieces together using running stitch. Start at the centre top of the heart, leaving a long end of thread on the front.

3 When you get back to where you began, remove the needle from the thread and tie the two thread ends into a neat bow. Trim off any excess lengths of thread so the bow ends match.

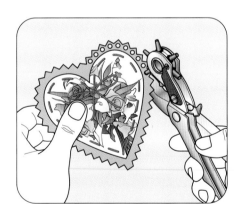

4 Using a leather punch, punch a row of holes through the felt all around the edge; for perfect spacing, measure and mark the positions first. Stick the fabric motif to cardboard or heavyweight paper using fabric adhesive.

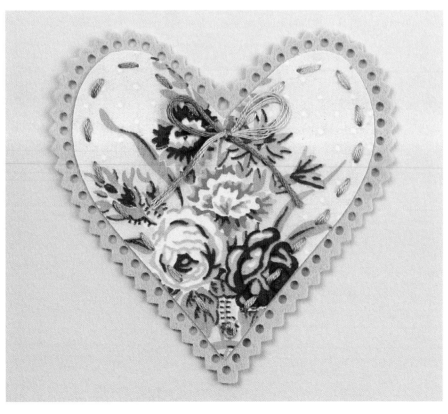

Choose the area of appliqué to highlight part of the printed fabric design.

Collage

Collage is similar to appliqué in many respects – it can be used to create a motif to be applied to a small area, using a variety of materials, or on a bigger scale to create an entire decorative background.

Collage motif

1 Begin with the largest piece that will form the base of the collage. Here, a simple strip of paper in a contrasting colour is given extra interest by cutting the edges with zigzag decorative edge scissors. Stick in place using paper adhesive.

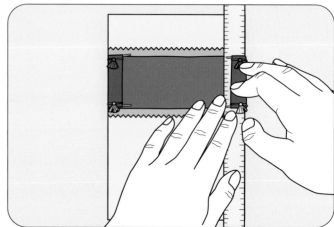

2 The next layer is a strip of wire edge ribbon. To achieve neat ends, lay the ribbon right side down on the cardboard, lay a ruler along the edge of the cardboard and fold the ribbon over it. Repeat at the other end then turn over; this makes a length of ribbon the same width as the cardboard with cut ends folded out of sight.

3 Stick the ribbon in place on the cardboard with a little fabric glue – or if the glue will soak through to the front of the ribbon, use double-sided tape. Add several sequins or small beads by dabbing with a spot of all-purpose adhesive and then putting them in place.

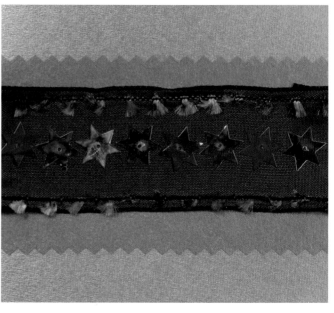

Paper, edged ribbon and sequins create a rich decorative band.

Collage background

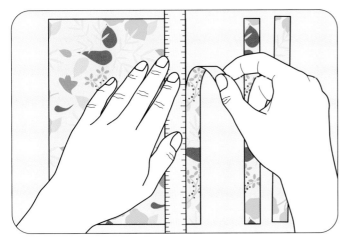

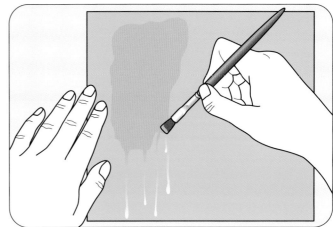

1 Select a series of plain and patterned papers that will complement each other. Using a steel ruler, tear all the different papers into a series of long strips of random widths. When tearing paper with heavy fibres, tear down to a group of fibres and then pull gently sideways to pull the fibres free.

2 Tearing the strips rather than cutting gives an attractive random effect to the strips. You will need quite a few because the strips need to slightly overlap each other to make sure the base material is fully covered. Paint a thin layer of craft glue along the left-hand edge of the base material.

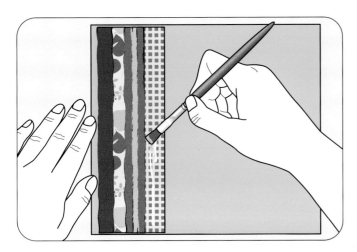

3 Start sticking the strips onto the background. Add a little more adhesive to the right-hand edge on top of each strip, then layer the next strip overlapping the adhesive so the edges will be firmly stuck down.

Different prints and textures make a very effective collage.

texture and three-dimensional decoration

One of the things that makes papercraft projects so versatile is that it is relatively easy to introduce heavier texture or to make things three-dimensional. The techniques described here are some of the simplest.

Punching

Craft and hobby shops carry a wide range of punches in many designs and sizes. Most are designed to punch paper, but more heavy duty versions will also punch thinner weights of cardboard.

Combining the negative and positive versions of the same motif in different colours creates a more complex effect.

Using paper punches

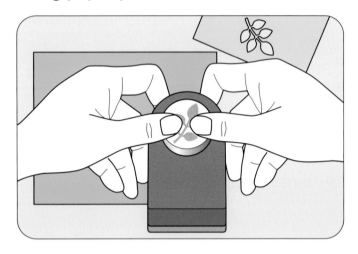

1 Insert the paper into the punch and press down quite hard – the pressure required depends to some extent on the design and what you are punching through, but some punches are quite stiff. If possible try before you buy.

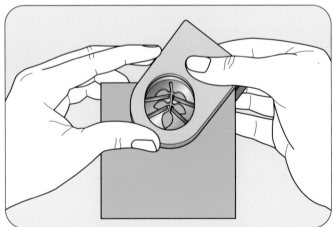

2 If the exact position of the punched hole is critical, turn the punch upside down so you can see exactly where the shape will be. Using the punch upside down will also create a mirror image of the motif on one-sided cardboard or paper.

Using a paddle punch

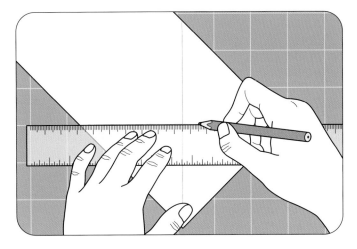

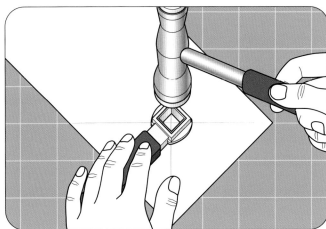

1 With this type of punch you can make a hole anywhere on the sheet, so start by marking the position of the hole to be punched lightly in pencil.

2 Place a setting mat on the worktop to protect it. Centre the punch over the mark, hold it steady and hammer smartly to punch out the hole.

Piercing

Piercing a design can be quite time-consuming but it produces quite a subtle and sophisticated result.

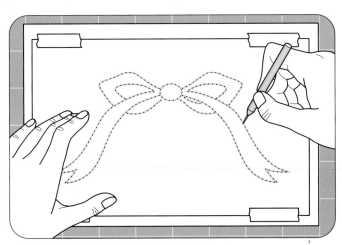

1 Copy the motif you want to pierce onto tracing paper, making any adjustments to the design at this stage. Lay the trace on top of the cardboard or paper with a protective mat beneath. Pierce evenly-spaced holes along the marked lines.

2 If you are working on a large motif, fix the tracing paper temporarily in place with low-tack masking tape. When you have finished, remove the tape and lift the tracing paper to reveal the pierced design.

Embossing

The simple sophistication of embossing means it is a classic feature of stylish papercrafts such as wedding invitations. Embossing works both on lettering and on simple motif shapes.

With a stencil

1 Place the stencil on top of very thin cardboard or fairly heavy paper – metal stencils such as this one can be used time and again. Secure it in place with low-tack tape.

2 If you are embossing cardboard, apply a little soap to the reverse of the motif area or rub through a sheet of waxed paper so the stylus will slide more easily.

3 Turn the cardboard over and place it on a lightbox or other light source so you can see the outline of the design. Using a stylus, press gently around the outline.

4 Embossing from the back gives a raised motif on the front of the sheet. You can also emboss from the front on some materials, which will give a sunken image.

Aluminium foil

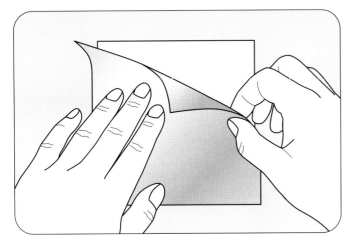

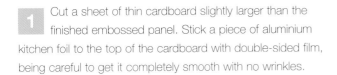

1 Cut a sheet of thin cardboard slightly larger than the finished embossed panel. Stick a piece of aluminium kitchen foil to the top of the cardboard with double-sided film, being careful to get it completely smooth with no wrinkles.

2 Lay the foiled cardboard on a couple of sheets of kitchen paper to form a yielding support. Lay a photocopy of the motif you want to emboss on the top and draw around the lines by pressing firmly with the embossing tool.

3 To add extra interest, try cutting around the edge of the motif with decorative edge scissors. You can also add more decoration freehand if you feel the motif needs it – but be careful not to tear the foil because it is quite delicate.

Embossing

If you plan to use embossing often it is worth building up a collection of metal stencils, but if it's a one-off project or you can't find the shape you want you can create your own stencil by punching the shape from thick cardboard. Use as for the metal stencil – it will probably last for a couple of projects.

If you want to add colour to the embossed design, place the stencil over the motif when you have finished embossing and use it as a mask to get the colour exactly where you want it.

Embossing with a press

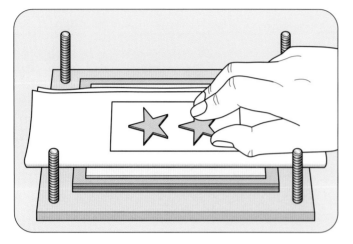

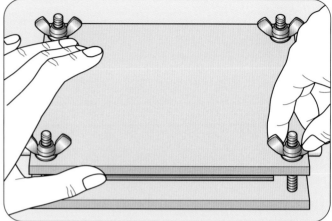

1 Cut a piece of blotting paper or lightweight watercolour paper to be embossed. Dampen the surface of the paper – don't soak it, but make sure it is thoroughly damp. Open a flower press and place a smooth piece of cardboard on the base – coated cardboard that will repel moisture is the best option. Place a piece of paper towel over the top then put the sheet to be embossed on top of that. Position the pieces to be embossed.

2 Lay another sheet of paper towel over the top and cover this with another piece of smooth cardboard. Carefully assemble the flower press, being sure not to move anything from position, and screw down tight. Leave the press for around four hours to allow the paper to dry thoroughly – if you remember, it is a good idea to tighten it further at intervals. When the embossed paper is fully dry remove it from the press.

Embossing press

With this technique the embossed shape is created by pressing the paper down around a positive shape, rather than pushing it into a negative one.

Shaped sequins are great for this technique, but may not be thick enough to make a clear impression – stick two or three together to make a thicker shape.

The best impression will be made on the surface directly against the shape, so the embossing will be sunken or negative – technically known as debossing.

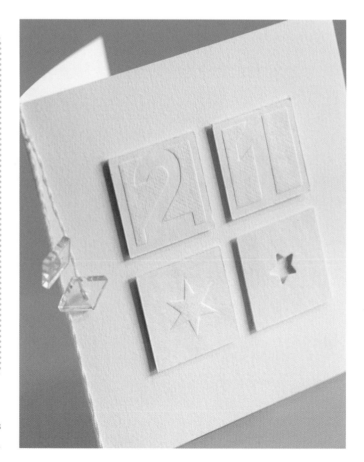

A simple contemporary card combines embossing with other relief techniques.

Embossing with a pen

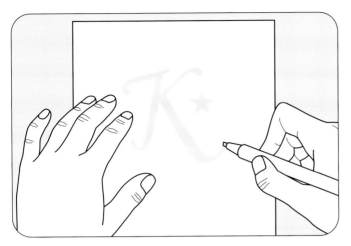

1 Using the embossing pen, draw the motif or letter to be embossed. You can either draw freehand, or trace a motif and then draw over the lines – the embossing should hide the pencil marks.

2 Sprinkle embossing powder over the design, making sure all the ink is fully coated. Tap the cardboard to remove the excess embossing powder to a scrap sheet, then tip back into the pot.

3 After removing stray specks with a brush, heat the embossing powder by holding the reverse of the cardboard over a hot iron. Do not allow the iron to actually touch the cardboard in case it scorches.

Embossing pens

Embossing with a pen is a very similar technique to embossing with a stamp, see page 50. Look for dual-end pens, which have a chisel tip at one end that can be used for calligraphy, and a fine tip at the other for detail work.

The steps here show the embossing powder being heated up with a domestic iron, but you can also use a craft heat gun.

Layering/pyramage

A three-dimensional element can also be introduced into a project by layering, either by relief mounting or by pyramage. In this latter technique a motif is duplicated and a specific part cut out several times at a reducing size; the copies are then mounted on top of one another to make a pyramid-shape relief.

Relief mounting

1 Select, stamp or draw the image to be relief mounted. Cut the image out and mount it onto a piece of cardboard (see page 162).

2 Trim the edges of the cardboard if necessary, then mount it onto the front of the item to be decorated using double-sided tape or foam mounting pads.

3 If the image is fairly small and simple it can be even more effective to cut around the edge a little way away from the outline before mounting.

In relief

Relief mounting creates a shadow line that unobtrusively frames and emphasizes the applied motif. For extra effect, raise the motif further off the page by attaching it with a foam pad.

To add a little colour, you could try colouring the edge of the relief mount – see page 25 for the technique.

Pyramage

1 Copy the image several times. Mount each copy onto thin cardboard with double-sided tape. Turn the copies over and mark out the cutting shape on the back – the first one will be the full size base layer, the next 3mm (⅛in) smaller all around, the third 3mm (⅛in) smaller all around than the second and so on.

2 Position and attach the second largest copy onto the base layer, using dot adhesive or foam mounting pads for a more three-dimensional effect.

3 Stack the next smallest copy on top of the first in the same way. Continue with the remaining copies.

Stacked up

It is possible to buy printed sheets specially designed for pyramage with sections of the image already marked out in a series of reducing sizes ready to cut out.

The pyramage stacked section can be cut in concentric squares, rectangles or ovals – or any repeating shape.

Another version of pyramage uses duplicate images that are reduced in size slightly each time and then stacked.

cardmaking

A hand-made card can be simple or complex – but the very fact that you have taken time to make something yourself will make it special to the recipient. You don't have to be 'artistic', or have years of experience or masses of materials and tools. All you need is a little confidence and to be willing to pay attention to the details; any card that is planned in advance and well made will be a success.

printed cards

These cards use printing to create the design – either using pre-printed materials, such as motifs from wrapping paper, or printing a motif or design yourself onto the card. They are usually fairly quick to make, so are suitable for creating last-minute cards or for making batches of cards (see also pages 116–121).

Using giftwrap

Giftwrap – either new or used – is an easy way to add an image to a card. It also offers the potential for coordinating card and giftwrap, or you could make a gift bag (see pages 135–137) and matching tag (see pages 146–149) to match the card.

1 Choose a giftwrap with a fairly small pattern of repeating motifs with a clear shape. Roughly cut out an area of the paper with the motif you want.

2 Spray adhesive on the back of the giftwrap piece and stick to a slightly larger piece of thick cardboard – this make the motif a bit thicker for a three-dimensional effect.

3 Cut out the sections of motif with a craft knife. Mount them onto the face of the card blank using paper adhesive or a piece of double-sided tape.

An effective greeting card that uses three motifs relief mounted onto a card blank.

Finding motifs

Using pre-printed giftwrap is a fast way to find several different coordinating motifs, but you could also recycle motifs cut from an already used greetings card.

For a really personalized card, try using copies of photographs that mean something to the recipient.

Here the motifs have been relief mounted directly onto the card blank, but to make them more impressive you could multi-mat them first, see page 160 for the technique.

Monoprint card

This technique uses acetate to produce a textural design. You can experiment on the acetate before you make a print – if you don't like the design you can wash it off and start again. The same piece of acetate can be used many times.

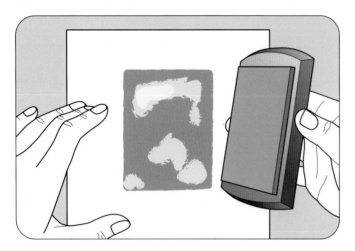

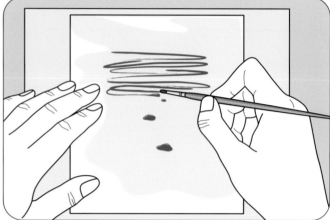

1 To add extra interest, make a coloured background for the monoprint by pressing a print pad onto the surface of the card blank to create a block of colour. Leave to dry. Alternatively, you could print onto a piece of contrast colour paper and cut out a section to stick to the front of the card.

2 Squeeze a few blobs of acrylic paint onto a piece of acetate. Use a pointed tool, such as a rubber-tipped paintbrush, to scribble lines in the paint and spread it out across the acetate. The scribbles should cover an area approximately the size of the block of colour created in step 1.

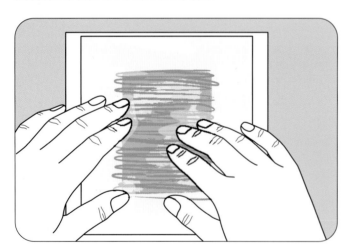

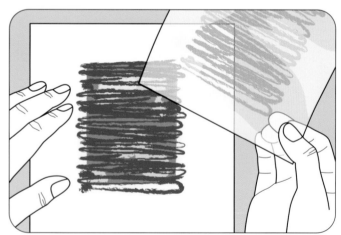

3 Position the acetate, paint side down, over the contrast colour square on the front of the card blank. When the acetate is correctly placed, smooth over the back of it with your hand, being very careful not to move the acetate in the process because this would lead to a smudged print.

4 Carefully peel off the acetate to reveal the print; lift it off vertically in one movement to avoid dragging the colour. Leave the print to dry completely before adding any further decoration to finish the card. You can wash the paint off the acetate and use it again and again.

Using monoprints

You can use this technique to create your own coordinating giftwrap and tags.

Try different tools, such as the rounded rubber end of a pencil, to make different marks in the paint – just make sure you don't use anything sharp that would scratch the acetate.

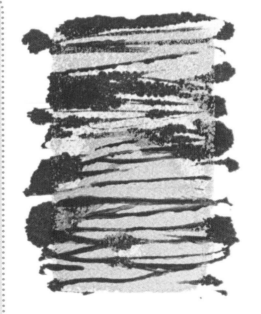

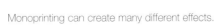

Monoprinting can create many different effects.

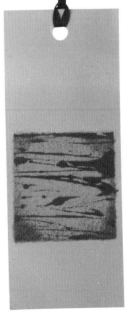

making inserts

An insert adds an extra touch of luxury to a card, but it also has a practical use; if you are using a dark colour or heavily textured paper for the card itself it may be hard to write a clearly visible message inside without using an insert.

Plain insert

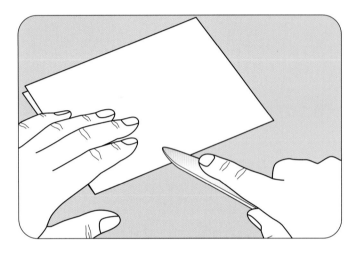

1 Open out the card blank and measure the height and full width. Cut a piece of paper for the insert that is 9mm (⅜in) smaller on each dimension. Fold the insert in half so it is ready to place in the card.

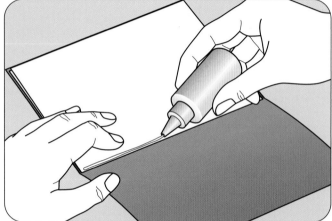

2 Tuck the fold of the insert tight against the inside fold line of the card, making sure it sits evenly between the top and bottom edges. Apply a thin line of adhesive or double-sided tape to the insert near the fold line.

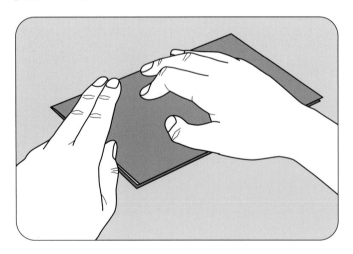

3 To hide the back of fixings on the inside front of the card, add extra lines of adhesive/tape so one side of the insert forms a backing to the inside front of the card. Fold over the front of the card and press down to secure.

Using inserts

A plain insert is useful to conceal the back of any eyelets or brads used to fix items onto the front of the card.

Inserts do not have to be ordinary paper – a vellum insert adds a sophisticated touch to the simplest card.

Decorative insert

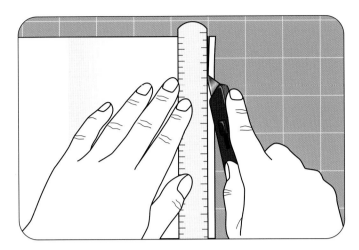

1 Open out the card blank and measure the height and full width. Cut a piece of contrast colour paper for the insert 9mm (⅜in) smaller on the height but the same width. Fold the insert in half so it is ready to place in the card. Using a craft knife and steel ruler, trim 5mm (¼in) off the leading edge of the front of the card only.

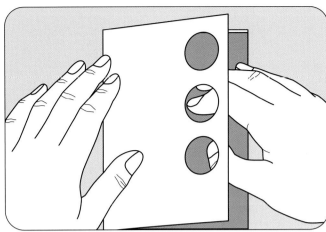

2 Using a circular punch, cut three decorative holes spaced evenly apart down the leading edge of the front of the card. Tuck the fold of the insert tight against the inside fold line of the card, making sure it sits within the top and bottom edges of the card. Apply a thin line of adhesive or double-sided tape to the insert near the fold line.

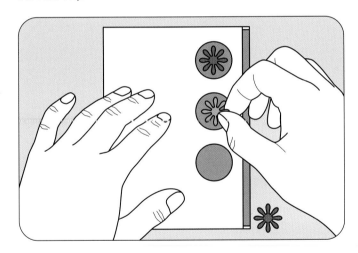

3 Using a decorative punch, such as a flower punch, cut three attractive motifs that will fit inside the circular apertures. Stick one to the insert through the centre of each aperture. You could also add additional decoration to the motifs, such as a dab of dimensional adhesive or a small contrast colour bead or sequin.

Different colour punched motifs add another layer of detail.

collage cards

Using collage is a great way to add colour and texture to hand-made cards. This section begins with a simple collage technique, and works up to more complex layered designs.

Circles card

This type of collage is so simple that it is ideal for a child to make – but it is still very effective. It's also easy to change the colours or the motifs used to make the basic design suitable for many different occasions.

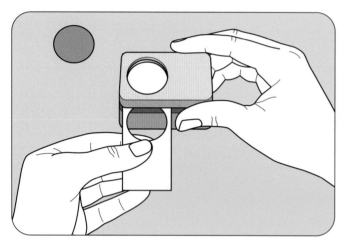

1 Use a square card blank or cut and fold a card to a suitable square size, following the instructions on pages 22–23. Cut a strip of a contrast colour thin cardboard, the height of the card blank and one third of the width. Using a circle punch upside down for accurate placement, punch three evenly spaced circles from the coloured cardboard.

2 Using paper adhesive, stick the punched strip to the front of the card blank, positioning it along the fold. Punch more circles from a selection of coloured and patterned papers and stick them in two rows aligned with the punched holes in the strip – you can also reuse one or more of the circles punched from the strip in step 1.

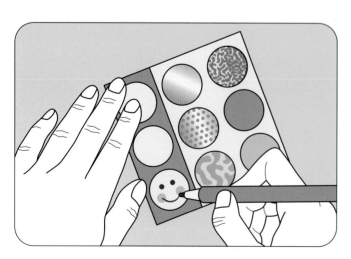

3 If you want to add extra decoration you can draw a face or a motif in one of the punched holes, as here, or add a sequin or small bead in the centre of each aperture. Make sure the spacing of the punched holes and the stuck down circles is extremely accurate, or the design will not look so effective.

Present card

Collage does not only have to be made in paper – polymer clay motifs can be used to make elements of the collage stand up in relief.

1 Roll out the polymer clay as described on page 36, but stop rolling when it is about 3mm (⅛in) thick. Sprinkle some gold leaf flakes or large glitter flakes on top. Roll again lightly to make sure the gold is firmly stuck.

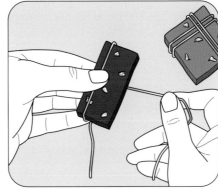

2 Using a craft knife, cut different shape rectangles and squares from the clay. Dry or bake the squares as per the manufacturer's instructions. Wrap a length of gold thread around each 'present' and knot the ends at the back.

3 Make up a piece of gold foil on double-sided adhesive film (see page 60). Cut out an oblong about 6.5 x 4cm (2½ x 1½in) using a craft knife. Peel off the backing and stick the foil rectangle to the front of a card blank.

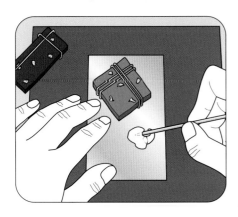

4 Using a dab of silicone glue, attach each 'present' to the front of the card, onto the rectangle of gold foil. If you don't have any polymer clay, you could make up 'presents' by sticking squares of wrapping paper to very thick cardboard.

The gold flakes on the 'presents' are highlighted by mounting them onto a rectangle of gold leaf.

Flowerpot

This is a slightly more complicated collage design since it not only uses collage and relief techniques but also incorporates a wire coil trembler and a shaped base card.

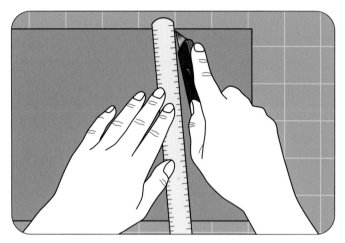

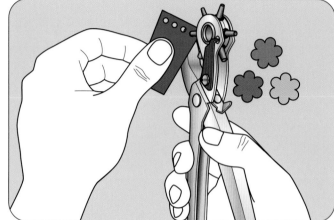

1 Use a duplex card blank – with a contrast colour on the inside – or make a two-colour card. Open the card blank out flat and cut a diagonal wedge from the front leading edge so the front is wider at the bottom than the top.

2 Cut a flowerpot shape from a scrap of the same cardboard and use a leather punch to cut a row of decorative holes across the top. Using a flower punch, cut three small flowers from different colour pieces of cardboard.

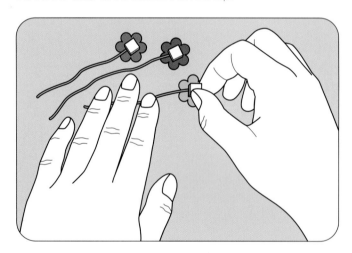

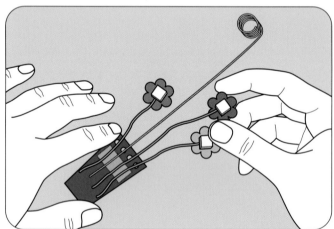

3 Cut three short lengths of embroidery thread. Lay the end of one on the back of a flower and stick in place by adding a small adhesive square on top. Repeat for the other two flowers to make 'stems'.

4 Wind one end of a length of craft wire three times around a pencil. Slide the wire off and flatten the coil. Stick a piece of double-sided tape to the back of the flowerpot, add the straight end of the wire coil and the flower stem ends, so the flowers will sit at different heights.

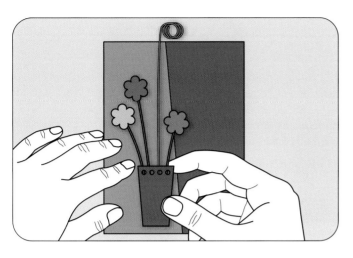

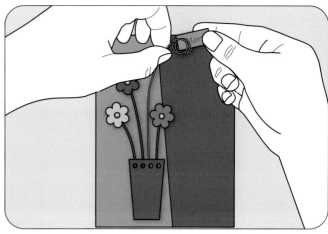

5 Stick a piece of tape on the flowerpot over the flower stems and wire end to secure them, then add a self-adhesive pad to the top and bottom of the flowerpot. Stick the flowerpot to the front of the card. Arrange the flowers at different heights, peel the backing from the adhesive square on the back and stick down.

6 Add a dot of dimensional adhesive or paint to the centre of each flower, or stick a sequin or small bead in the centre. For an extra personal touch you could also write the recipient's name on a small piece of cardboard and slide it into the wire coil, or write a short message.

Pipped at the post

If a three-dimensional card is to be posted, don't make the decoration too three-dimensional or delicate or it may get damaged in transit. Try to send highly decorated cards in a padded envelope or a pillow envelope (see page 130), although this is not always enough to protect them completely.

This greeting card could also be adapted for use as a name place card in a table setting.

shaped cards

Shaped cards are often much easier to make than they might look – and can offer an interesting and unusual way to personalize a card for a special event. This section includes three different types, which can all be adapted in many different ways.

Number card

Bold and graphic, this technique can be adapted to incorporate single or double numbers – or indeed one or more letters instead – and could be appropriate for a birthday, special anniversary or a new house.

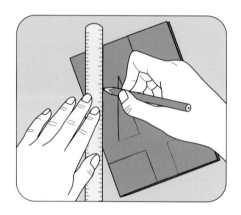

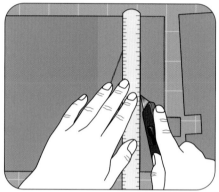

1 Draw the number you want onto the front of the card in pencil. At least part of one edge must run along the fold in the card, and with a double number the two digits need to at least partly overlap each other.

2 Open the card out and lay it flat. Use a craft knife and metal ruler on the cutting board to cut out all the straight lines in the number. Any curved lines you will have to cut carefully freehand.

Bold numbers or letters are very effective.

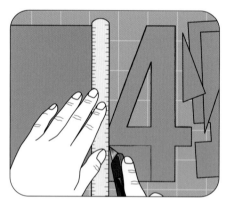

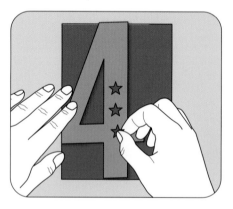

3 When cutting, remember that part of the number on the front needs to remain attached to the back of the card, so cut carefully near the fold and make sure you don't cut too far. Rub out any pencil marks.

4 For extra impact, you can decorate the number with stickers, sequins or shapes punched from a contrast colour paper. This card has been made with a duplex card blank, so the inner contrast colour adds to the design.

House card

This design could make an ideal moving home card, or welcome to a new house card, and could also be adapted for other events, such as to welcome a new baby or pet. If the house was a church instead, it could be a wedding card – perhaps add photos of the happy couple in the windows. The possibilities are endless.

1 Take a card blank and cut away the two top corners diagonally to make the sloping sides of the roof. Place the top half of the card over contrast colour paper and draw around the roof shape. Cut out the roof shape from the contrast paper.

2 Stick the roof to the top of the card to indicate contrast coloured roof tiles. Cut a shaped strip of green paper for the base of the card and stick it in place to indicate the grass. Draw on the doors, windows and plants in pencil.

3 Go over the pencil lines in a darker colour and paint in the front door, flowers and any other details. Leave the paint to dry before working on the card further. Alternatively you could decorate the card with suitable stickers.

4 Open out the card and cut carefully along the top and bottom edge of each window and down the centre to make opening shutters. Cut along the top, bottom and leading edge of the front door in the same way.

5 As an extra personal touch you can line the windows with patterned paper as curtains, or add photos behind the doors and windows as if the friends and family of the recipient are living in the house.

Matching envelopes

If you are making a really special card and have time to spare, it's always worth making or decorating an envelope – or even giftwrap or tags – to match. See pages 126–149 for some ideas and instructions.

Fan card

Complex cards were very popular in Victorian times and this pretty fan card would be sure to please someone with a love of nostalgia. If you make it in good quality cardboard it also works as a practical fan, so becomes a gift as well as a card.

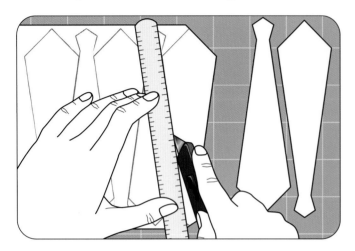

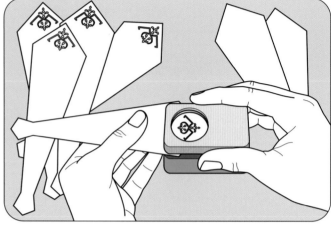

1 Using the template on page 298, cut seven fan blades from a piece of thin cardboard. Work on a cutting mat and use a sharp craft knife and a steel ruler. To minimize wastage, and save time cutting out, turn the template through 180 degrees and place it immediately next to the previous cut edge so the shapes interlock.

2 For extra decorative effect you could cut the fan blades from patterned cardboard, or stamp an overall background pattern on the cardboard before you begin cutting. With a decorative punch upside down for accurate positioning, punch a suitable motif into the top of each fan blade.

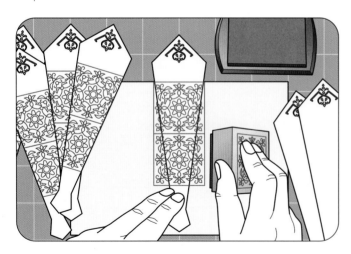

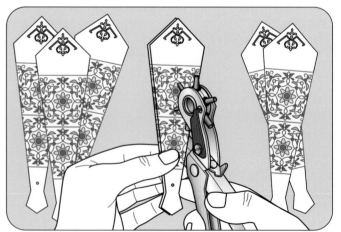

3 Lay a piece of scrap paper on the cutting mat, aligning it with one of the grid lines on the mat. Place a fan blade on top so that the tip of the blade extends above the edge of the paper and is centred on the mat grid – accurate positioning will enable you to stamp the design in the same place on the fan blade each time.

4 Stamp all the blades with an identical design and use marker pens to colour parts of it. Using the template as a guide, punch a hole in the base of one of the fan blades. Use the first fan blade as a guide to punch the others in the same place. Use the template again to punch a small hole in the centre of each blade.

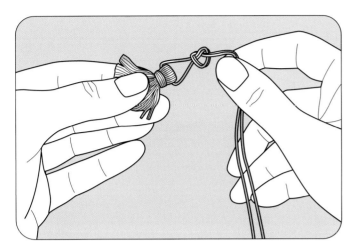

5 Make a small tassel in coloured thread (see page 182), pass a length of thin cord through the tassel head and tie the ends in a knot. Pull the circle of cord around so the knotted ends are concealed in the tassel head, then knot again above the tassel to hold in place. Thread a bead onto the loop end of the cord and push down to the knot.

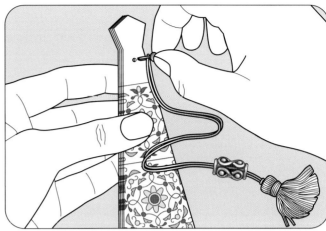

6 Push the loop of the cord between the arms of a brad. Stack all the fan blades on top of one another, with right sides facing up. Push the arms of the brad through the punched holes in the base of the blades and then open them out on the back to secure the brad and the cord in place.

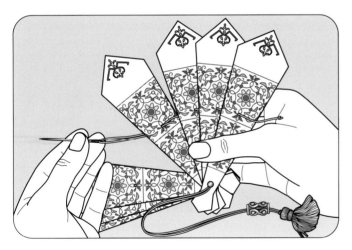

7 Thread a needle with a length of embroidery thread and tie a double knot in the end. Run the needle through the upper hole in each blade in turn, from front to back. Fan the blades out so the edge of one slightly overlaps the next. Remove the needle and tie a double knot on the back of the last blade. Secure the knots with dabs of adhesive.

The finished card can also be used as a real fan.

window cards

An aperture or window in the front of a card is an attractive way of framing a picture, or highlighting words or a motif. Pre-cut aperture card blanks are readily available, but you can cut your own or use a large paper punch – a big advantage of this is that you can make them whatever size or shape you need to suit your design.

Window: punched

For a punched window you will need a large craft punch, which are available in different shapes and sizes.

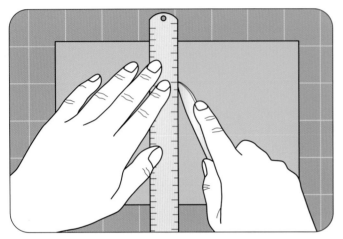

1 Use a metal ruler and craft knife to cut a rectangle of cardboard 17 x 24cm (6¾ x 9½in), working on a cutting mat to protect the work surface. Mark the centre point on each long side and score a line across, using the tip of a bone folder.

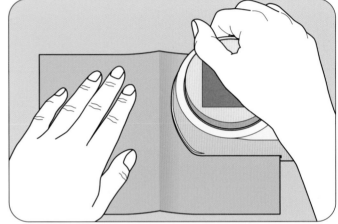

2 Open out the card blank and slide a large square hole punch over the front edge near the top, aligning one side of the punch with the top of the card. Punch a square aperture into the card.

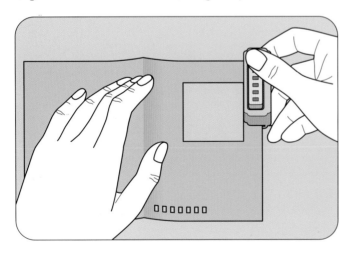

3 For additional decoration you could also use a slot border punch to punch a short row of holes at the top right and bottom left edges of the card, using the photograph of the finished card as a guide for positioning.

4 Cut down the motif or picture to be framed in the window so it is a little larger all around than the size of the aperture. Stick the motif or picture to the reverse of the aperture with strips of double-sided tape.

The punched holes create a bold, graphic design.

Window: open

An open window can be used to frame a motif or word inside the
card or on the card insert, or the window itself could be decorated
with strands of ribbon or a string of beads as shown here.

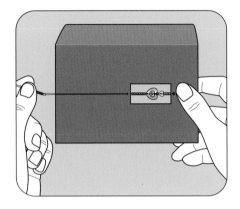

1 Take a 17 x 12cm (6¾ x 4¾in)
pre-cut card blank and use a ruler
and pencil to measure and lightly mark a
rectangle for the aperture 4 x 2cm
(1½ x ⅞in) in the upper half of the front.
Open out the card and place it on a
cutting mat. Use a craft knife and steel
ruler to cut out the aperture.

2 Thread a needle with embroidery
thread and slide on a bead. Slip the
free end of the thread through the eye of
the needle as well, so the bead sits in
a loop. Align the two thread ends in the
needle. Push the needle through the card
from front to back just above centre top of
the aperture; pull through so the bead sits
against the card.

3 Thread a selection of small beads
onto the needle, followed by a
larger flat bead or shaped sequin as the
main focal point. When there are enough
beads to run across the aperture from top
to bottom, push the needle through the
card from back to front at centre bottom
of the aperture. Pull the thread taut.

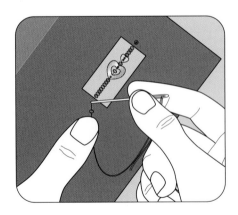

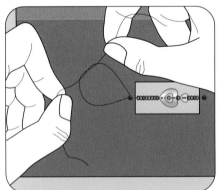

4 Slide another small bead onto the
needle and then push the needle
back through the hole it came out of. Pull
the thread taut so that the bead sits next
to the card to match the one at the top of
the aperture. Take the needle around the
thread on the back of the card to secure
and then back out to the front through the
same hole.

5 Remove the needle from the thread
and knot the ends close to the
card. Either trim the ends close to the
knot, or add a couple more beads and
trim the ends to uneven lengths so the
beads will dangle at different heights on
the front of the card. Knot the ends and
secure the dangling beads to the thread
with a dab of glue.

Stringing beads and sequins

There are many different
types and shapes of beads
and sequins available, but for
this technique make sure you
select ones that are relatively
small and flat in profile to
avoid causing too much bulk
in the envelope.

The sequin shape for the
centre of the stringing can be
chosen to fit the occasion;
sequins are available pre-cut
in a wide selection of shapes
and colours.

The beads and sequins can match or contrast with the card.

Window: backed

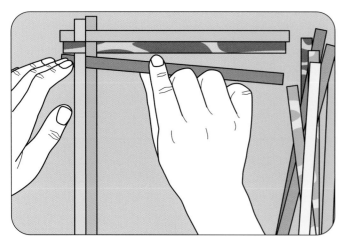

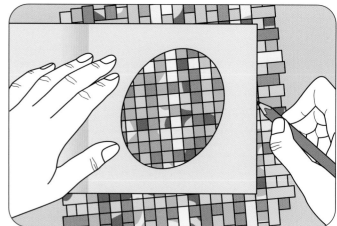

1 Cut a range of pretty papers in similar weights into 1cm (½in) wide strips. Place two strips at right angles to each other with ends overlapping. Position the next two strips, passing underneath a strip previously overlapped and vice versa. Continue weaving to complete a piece of woven paper at least 15cm (6in) square.

2 Cut a shaped window from the front of a card blank – here it's an oval. When cutting shaped openings, cut carefully by hand trying to make the outline as smooth as possible. Position the window over the woven paper and move around to find the best area. Here the weaving is positioned diagonally to emphasize the roundness of an egg.

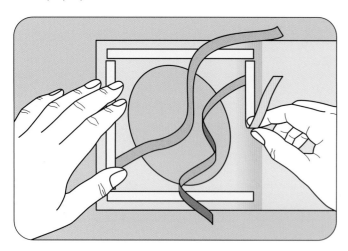

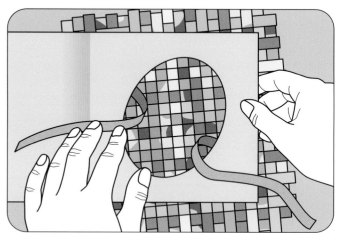

3 Cut a length of thin ribbon in half. Place the card face down and position the pieces of ribbon with the long ends pointing inwards. Stick strips of double-sided tape around the aperture, taping over the ends of the ribbon to hold them in place. Turn the card over and pull the ends of the ribbon through to the front.

4 Peel the protective backing from the double-sided tape and position the card over the area of woven paper selected in step 2. Press the card down firmly so the tape makes contact with the woven paper. Turn the card over and carefully trim any excess woven paper away.

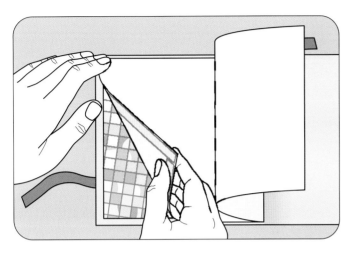

5 To conceal the back of the woven paper and neaten the inside of the card, add an insert (see page 86) or line the inside front of the card with a sheet of plain paper cut to fit and stuck down with double-sided tape. On the front of the card, tie the ribbon into a pretty bow and trim the ends.

A bright and cheerful combination of printed strips and plain paper strips.

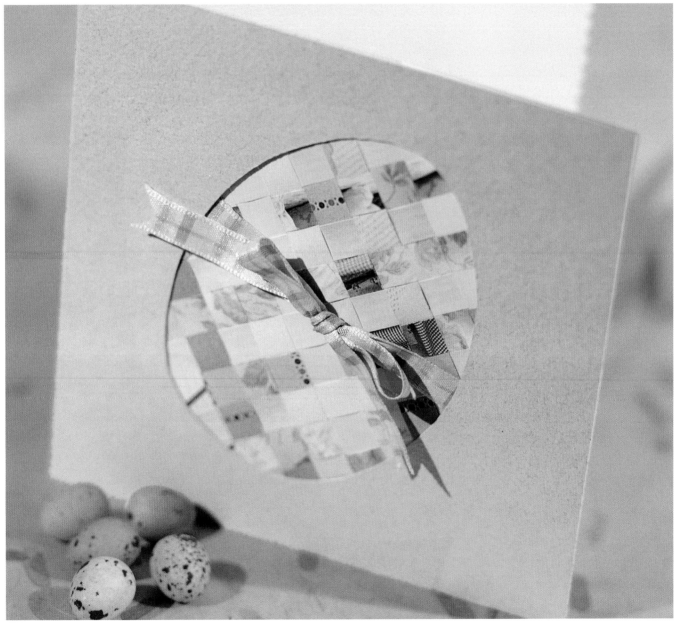

concertina cards

Instead of a simple central fold, concertina cards have several vertical folds so they open out like a folding screen. The different planes offered by the concertina effect can be utilized in various different ways.

Concertina window card

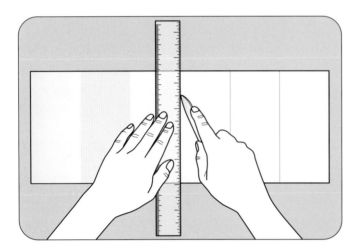

1 Cut a piece of white cardboard 20 x 57cm (8 x 22½in) and mark six 9.5cm (3¾in) wide panels across the width. Score along the lines and fold one panel one way and the next the other way to create a concertina.

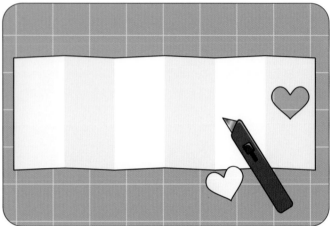

2 Trace the five concentric hearts template on page 289. Trace the largest heart onto the front panel and then open out the card and cut the heart out of the front panel only. Work carefully and slowly to achieve smooth edges.

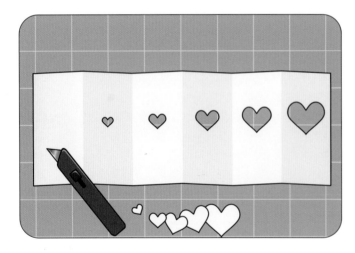

3 Trace the second largest heart onto the next panel so it will sit perfectly inside the heart aperture in the previous panel. Open out the card and cut out the second heart. Continue in this way for five panels, leaving the last panel blank.

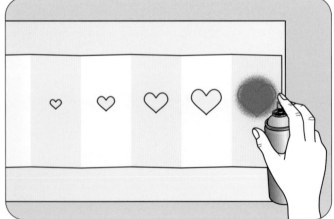

4 Open the card out and place over a large piece of paper. Spray pink paint onto the first and largest heart – the heart will be stencilled onto the paper beneath and the heart aperture will have a burst of pink around it.

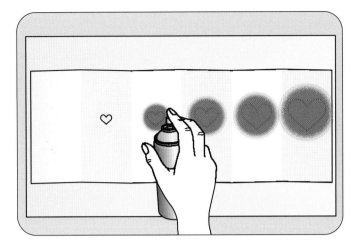

5 Spray red paint onto the second heart, pink onto the third and so on. Flip the card over and repeat the spraying in the same order of colours on the other side. Spray a burst of red on the final panel, so the smallest heart will have red behind it.

Heart to heart

The background paper you used to spray the hearts against will be covered in a random pattern of different sized hearts in red and pink – use it to make a coordinating envelope for the card (see pages 128–129).

Try the same design idea using other simple shapes, such as stars, diamonds and circles.

Even without alternate colours the simple repeating shapes are very dramatic.

Part concertina card

1 Cut a piece of heavy watercolour paper 10 x 35cm (4 x 14in) and mark two panels 7cm (2¾in) wide at the left-hand end. Score along the lines and fold one panel one way and the next the other way to create a concertina.

2 Iron fusible webbing onto the back of five fish motifs on printed fish design fabric. Cut the fish out, remove the fusible web backing and iron each fish onto a 6.5cm (2½in) gingham square.

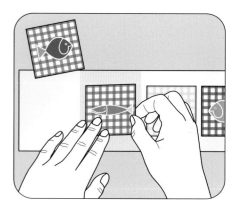

3 Using fabric adhesive, stick one gingham square to each small panel and the other three evenly spaced across the longer panel. Thread several tiny fish-shape buttons or beads onto a length of transparent elastic.

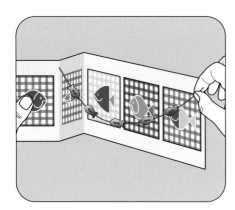

4 Pierce two holes in the card, one 1cm (½in) from the top on the fold between the two small panels and the other 1cm (½in) in from the top right corner of the long panel. Thread an end of the elastic through each hole and adjust so it does not hang below the bottom of the card when closed. Knot the ends and trim the excess.

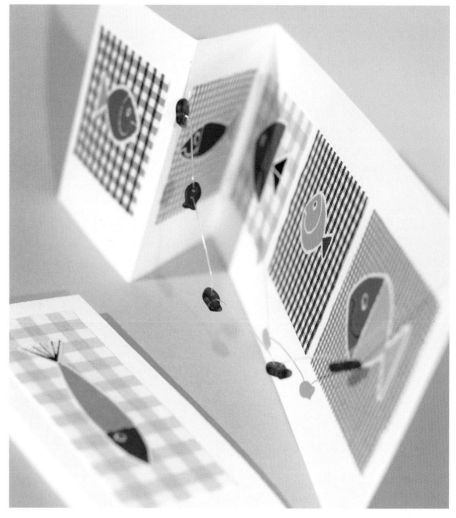

Fish card with a matching tag.

Shaped-edge concertina

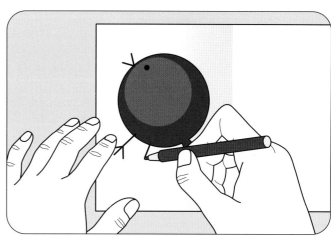

1 Open out a card blank. Spread brown acrylic paint on a plate and stamp a circle about a third of the way down and centred on the left panel. Make a tail extending from the lower right of the circle, using a wedge-shape cosmetic sponge.

2 Allow the paint to dry. Spread red acrylic paint on a second plate and stamp a smaller circle on the larger one, positioning it towards the top left. Allow the paint to dry, then draw on an eye, beak and two legs with a black marker pen.

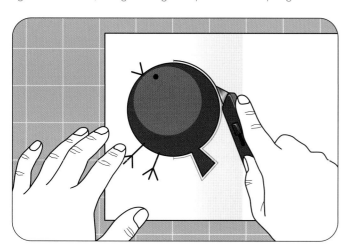

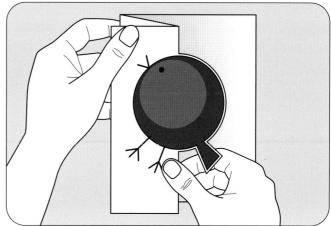

3 Measure the centre of the printed panel immediately above and below the robin and mark lightly with a pencil. Lay the card on a cutting mat and cut around the right side of the robin between the marks, leaving a 3mm (⅛in) border of white.

4 On the other side of the card, score lines from the centre top and bottom to the start of the cut line each time. Turn the card over and bend the leading half of the panel back so the robin pops forward.

three-dimensional cards

Three-dimensional cards can be much more exciting and dramatic than flat ones, but many use more or less the same techniques. One easy way to add a three-dimensional element is to use the card to carry a detachable item of some sort.

Three-dimensional flaps

The simplest version of a three-dimensional card has areas that are cut and folded up to stand slightly above the main surface.

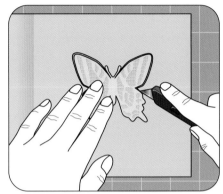

1 Stamp a butterfly onto iridescent paper using an embossing pad and stamp. Sprinkle embossing powder onto the wet butterfly image and hold in front of a hot iron. Alternatively, draw the outline of a butterfly onto a piece of coloured paper and decorate as desired. Carefully cut out the butterfly with sharp scissors.

2 Stick the butterfly to the front of a card blank with spray adhesive. Cover with scrap paper and roll over with a brayer to be sure it is firmly stuck down. Open out the card and place on a cutting mat. Carefully cut around the edge of the butterfly wings with a sharp craft knife – don't cut the body or antennae.

The iridescent embossing combined with the three-dimensional effect make the most of light and shadow.

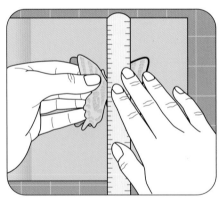

3 Place a steel ruler along the body of the butterfly, so it runs across the two ends of the cut line on one side. Press down firmly on the ruler, at the same time gently bending the wing up from the surface of the card to create a slight crease. Repeat with the other wing.

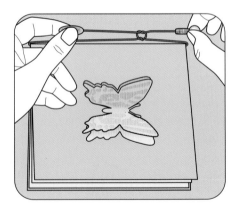

4 Add a contrast colour insert to the inside of the card (see page 87). For extra interest, make a long cord of embroidery thread, add a bead to each end and knot to hold in place. Add a dab of glue to the knot and push inside the bead. Trim ends. Place the cord inside the fold of the card and knot in position.

Double-relief

Purchased cardboard tags mounted in relief, with coloured eggs in relief on top, create real three-dimensional effect. Try other shapes for different occasions – you could stamp out stars or bells for Christmas, for instance.

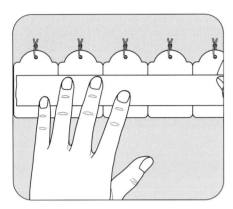

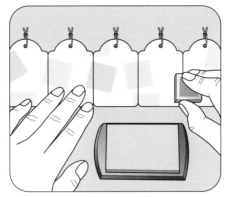

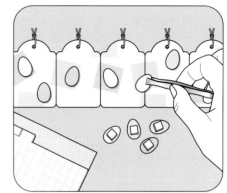

1 If they don't already have cotton ties, add one to each tag using white thread, knotting in place and then trimming the ends. Using masking tape, join a strip of tags together edge to edge – here five tags are used.

2 Using a soft eraser and pastel coloured inks, randomly stamp all over the tags. You could use a design stamp here if you prefer, but the idea is just to provide a more interesting background for the eggs.

3 Punch out a selection of eggs from different colours of thin cardboard. Using self-adhesive dots, stick the eggs randomly onto the front of the tags. Since they are quite small, you may find it easier to position them accurately with tweezers.

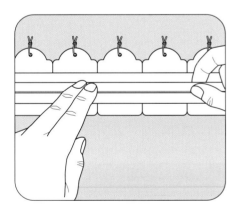

4 Using double-sided foam tape, attach the decorated tag strip to the front of a suitable size card blank.

Although this design is really simple, the three-dimensional effect adds extra interest.

Adding a separate item

This card has a scented sachet so the card will lightly perfume the room. You could also use rose petals or any other scented flower. The scented sachet could be detachable – see the tip box.

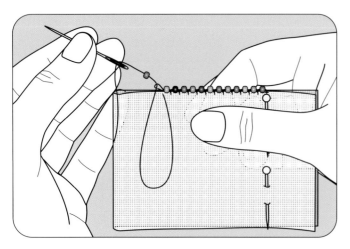

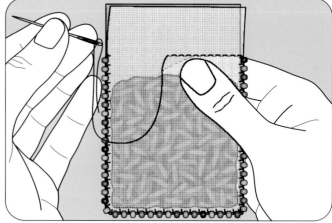

1 Fold a length of 7cm (2¾in) wide organza ribbon in half lengthways, measure 8cm (3¼in) up from the fold on each side and mark with pins. Working from a pin down, join the sides with an embroidery stitch such as blanket stitch, adding a tiny bead to each stitch to sit along the edge (see page 30). Continue across the bottom fold and up the other side to the pin. Secure the thread and trim the end.

2 Fold a sheet of scrap paper into a funnel, push the tip into the sewn bag and tip in some dried lavender to fill the bag to just below the level of the beads. Using tiny running stitches, stitch the top of the bag securely closed at the point where the beads end. You don't need to stitch that close to the lavender – allow it a little room to move. Secure the thread and trim the end.

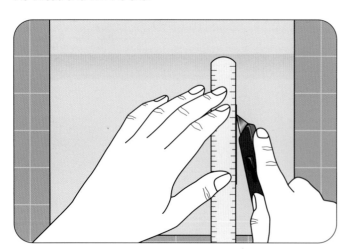

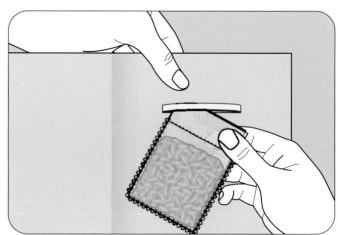

3 Take a suitable plain card blank and open out on a cutting mat. Measure 5.5cm (2¼in) down from the top edge of the card and cut a short slit in the front, 7cm (2¾in) long and centred across the width. Stick a 7cm (2¾in) long and 3mm (⅛in) wide strip of double-sided tape to the front of the card, immediately above the slit, but don't remove the backing at this stage.

4 Carefully push the raw ends of the lavender bag through the slit in the card from the front. Turn the card over and make sure the bag sits level and squarely on the card, and then trim off any excess ribbon on the inside of the card and secure the bag by adding a strip of masking tape over the top raw ends on the inside. To neaten inside, stick a lining sheet on the inside front of the card.

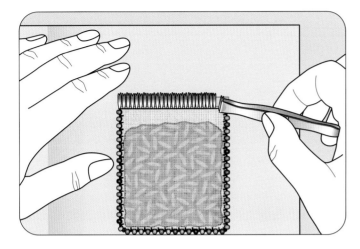

5 Remove the backing paper from the strip of adhesive tape on the front of the card. Using tweezers, carefully position a neat row of lavender buds side by side along the adhesive strip to cover it completely. Press down firmly with the tip of a finger to make sure each seed is firmly attached.

Lavender bag

If you want to make the lavender bag detachable, tuck the raw ends of the ribbon inside the bag after adding the lavender and then finish the final side with beaded embroidery stitch. Attach the bag to the front of the card with a small square of double-sided tape or with a decorative pin.

For other suitable beaded embroidery stitches, check out an embroidery book – there are many different options.

cardmaking

Other scented dried flowers would also be suitable for this technique.

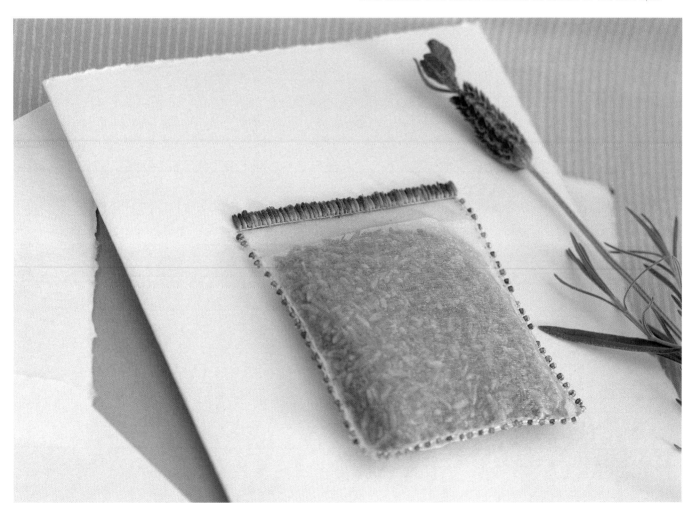

pop-up cards

These are very similar to three-dimensional cards, but the three-dimensional element is often hidden until the card is opened so it is even more of a surprise. An additional factor to be considered when designing a pop-up card is how the three-dimensional element will fold flat when the card is closed.

Regular pop-up

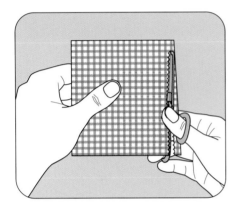

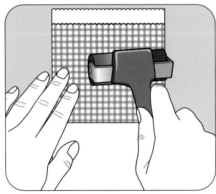

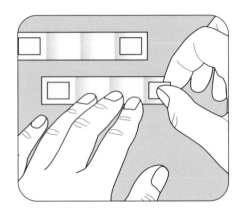

1 Trim the leading edge of a 12cm (4¾in) square card blank using decorative scallop-edge scissors. Cut a piece of gingham paper 10 x 12cm (4 x 4¾in) and trim one long edge with the decorative scallop-edge scissors.

2 Spray the back of the gingham paper with adhesive. Stick it to the inside front of the card blank, aligning the long straight edge with the fold line. Roll over with a brayer to make sure it is firmly stuck down.

3 Cut two 10 x 2cm (4 x ⅞in) strips of cardboard. Use a bone folder to score a line across each at the centre and at 2.5cm (1in) on either side of centre. Trim 1.5mm (1/16in) off each end of both strips. Stick a piece of double-sided tape to each end of both strips, within the end sections.

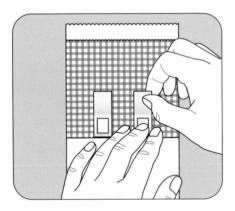

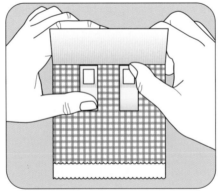

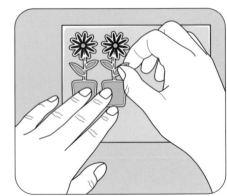

4 Fold each strip in half along the scored line. Peel off the tape backing at one end and stick the strip to the gingham paper, 3cm (1¼in) in from the edge of the card and 1.5mm (1/16in) from the fold. Place the other strip at equal distances on the other side.

5 Peel the backing off the tape on the other end of each strip. Keeping the strips folded in half, close the card on top of them. Press firmly to make sure the strips are well stuck. Open out the card again – the strips should bend up to form a box shape.

6 Make up two flowerpots with flowers on a piece of acetate, or stick any suitable sticker to the acetate. Cut out the shape carefully with sharp scissors. Stick a small piece of double-sided tape to the back of each pot and stick the pots to the card tabs.

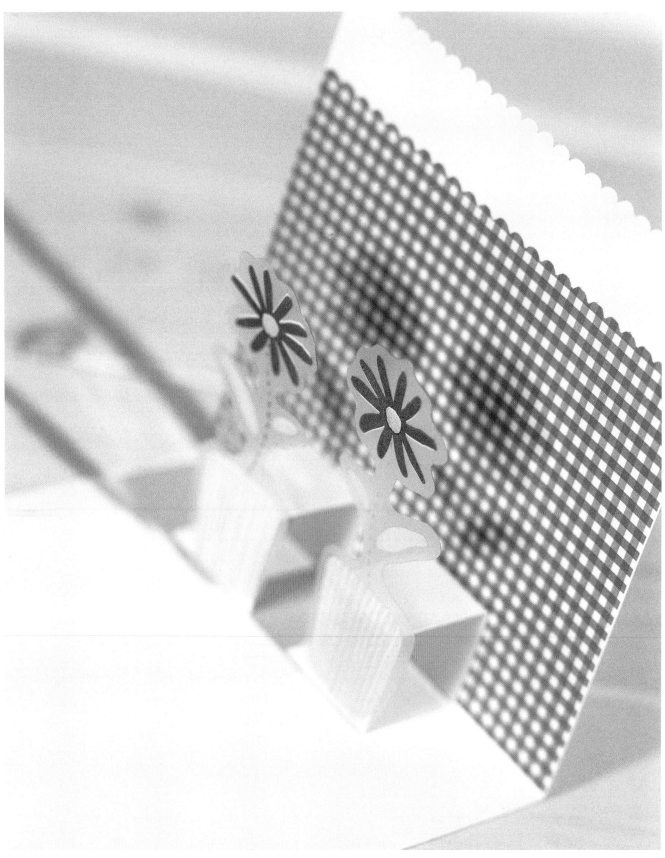

All the decoration is inside the card with this technique, leaving the outside plain.

Random pop-up

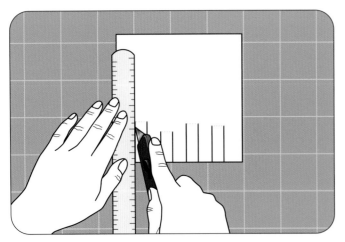

1 Using a square card blank, mark four pairs of lines 1cm (½in) apart, with each pair running in from the folded edge at different lengths from 3–4cm (1¼–1½in), and spaced roughly evenly apart. Place the folded card on a cutting mat and cut each pair of lines with a craft knife, cutting through both layers of card.

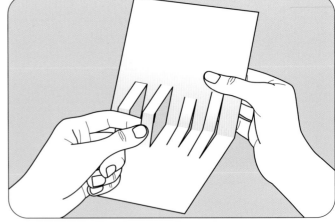

2 Score across the end of each pair of cut lines. Open the card out and push the strips forward so they stand up inside the card like individual steps. Because the strips are different lengths, the steps will be different sizes.

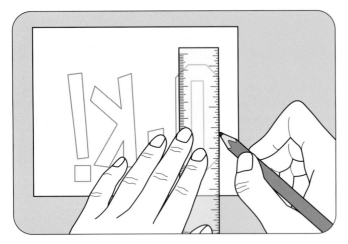

3 Cut four suitable letters or numbers from contrast colour cardboard – you could also use different motifs. If cutting letters or numbers on the reverse of fancy cardboard, remember to draw them mirror image so they will be right way round on the right side.

4 Cut the individual letters or numbers out and stick one to the front of each step. Before finally positioning them, make sure they sit above the base and will not stick out of the sides or top of the card. Also make sure they will not catch on each other as the card is opened and closed.

Folded pop-up

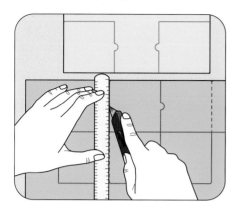

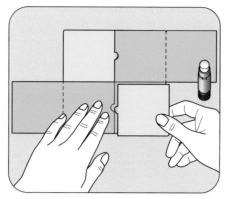

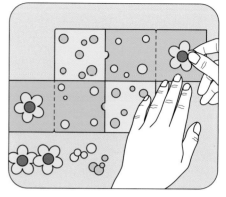

1 Copy the entire card template on page 292 onto thin cardboard. Copy just the two squares with half-circle tabs onto a contrast colour cardboard. Cut out all the cardboard shapes.

2 Using paper adhesive, stick the contrast squares down over their corresponding positions on the main card, being careful that the semi-circle tabs remain free. Score the dotted fold lines (see page 22).

3 Decorate the card with stickers or stamped flowers. Draw and cut two flower heads from spare contrast card to sit on top of the springy stems, or use stickers on thin cardboard and cut out.

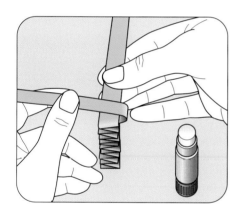

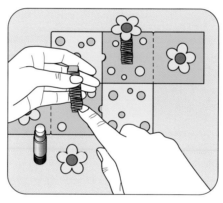

4 Cut four strips of paper in a colour to match the main card, each 1.5cm (⅝in) wide and about 30cm (12in) long. Glue two of the strips together at right angles. Fold the left strip over the right, then the right over the left. Keep going until you have made a folded paper 'spring'.

5 Make another paper spring in the same way. Glue one end of each spring to the centre of the square with the side flap, as shown. Glue a flower to the top of each springy stem. Press the flowers flat, fold over the flap and tuck the edge under the semi-circle tab to hold the springs in place.

Spring time

The concertina springs are a little fiddly to make, but they really add the fun element to this card.

This basic concept can be adapted for other themes – instead of flowers you could have butterflies or ladybirds.

To save time, use motif stickers instead of cutting and colouring your own motifs.

Since the front of the card is quite busy, write your message on the reverse of the base.

fold out cards

Fold out cards are also designed to reveal more of the design as they are opened, although they are not necessarily three-dimensional. Here are a couple of variations on the basic idea.

Folder card

1 Cut a piece of coloured cardboard 18 x 30cm (7¼ x 12in) for the folder and score two fold lines, 10cm (4in) from either end. Measure and mark 8cm (3¼in) down from the top edge along each side edge. Trim off the top corner diagonally on each side, cutting from the scored line to the mark.

2 Turn the folder over, find the centre, and measure and mark 7.5cm (3in) up from the bottom edge. Punch or cut two small vertical slots, one on each side of the centre mark, through the centre panel. Thread a narrow length of contrast colour ribbon through the slots so the ends hang out of the back of the card.

3 Cut a piece of contrast cardboard 16.5 x 9cm (6½ x 3½in). Stamp a suitable motif of your choice towards the top – it needs to be positioned in the centre and high enough to show in the V opening when the side panels of the folder are folded over. Decorate the motif with colour pens and dimensional adhesive, if appropriate.

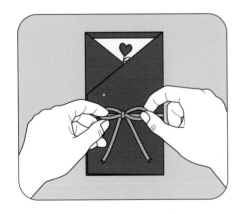

4 Centre the motif strip on the centre panel of the folder, slightly above the bottom. You can either secure it in place with double-sided tape or leave it free to slide. Fold the side flaps over the top, and then bring the ribbon ends round to the front and tie in a decorative bow to secure. Cut the ends of the ribbon into a V.

The colour of the folder has been matched to the motif.

Bag card

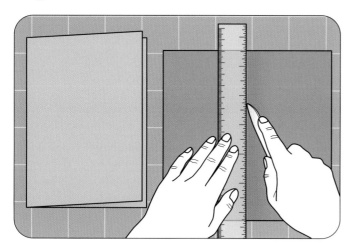

1 Cut a piece of light colour cardboard 15 x 21.5cm (6 x 8½in) and a coordinating piece of a darker colour cardboard 15 x 15cm (6 x 6in). Score each piece down the centre and fold them both in half.

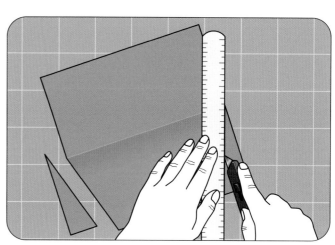

2 On the darker cardboard, measure and mark 2.5cm (1in) in from each corner along one long side. Open out and cut the two corners off diagonally, from the mark to the fold line, through one thickness only.

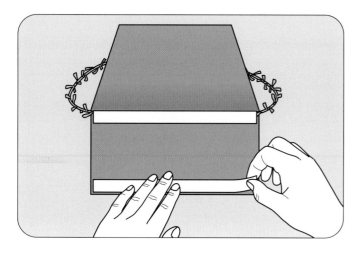

3 Cut a ribbon handle and tape the ends along the inside fold of the darker colour cardboard. Add strips of double-sided tape along the bottom edge and just below the fold line on the rectangular part of the cardboard.

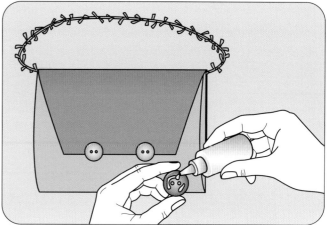

4 Remove the backing from the tape and stick the folded light colour cardboard, with the fold at the bottom, onto the darker cardboard. Fold the flap over and add extra decoration, such as buttons, with silicone adhesive.

batch cards

At some point any cardmaker needs to make several cards the same, so this section looks at techniques that can easily be repeated time and again to give the same finished result with the minimum of fuss and effort.

Fingerprint card

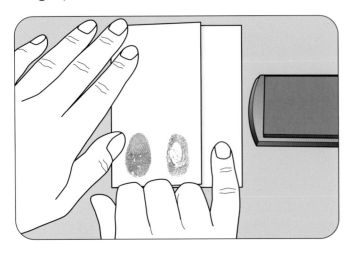

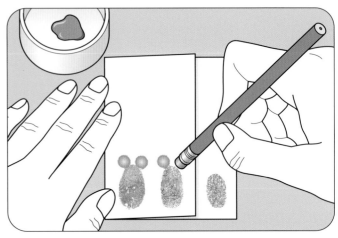

1 Trim 2.5cm (1in) from the leading edge of a card blank. Dab a forefinger onto an inkpad and make a row of three fingerprints along the bottom of the card, one in the middle and one each side – the right-hand one will fall on the inside layer of the card.

2 Spread a little pink paint on a plate. Dip the tip of a pencil eraser – or other suitable round item – in the paint and stamp two ears at the top of each of the fingerprints to create a row of mice. Leave everything to dry.

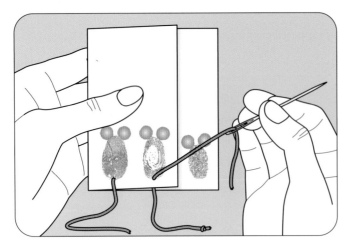

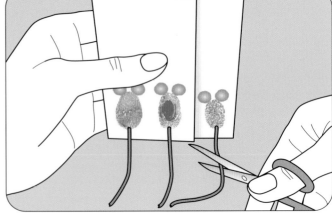

3 Pierce a hole with a darning needle at the base of each mouse body. Thread the needle with a length of pink yarn and tie a knot in the end. Push the needle through one of the pierced holes from back to front until the knot sits against the card inside.

4 Repeat to give each mouse a tail. Stand the card up and pull the tails forward, then trim each tail to a slightly different length. Secure the knots on the reverse with a dab of adhesive, if necessary.

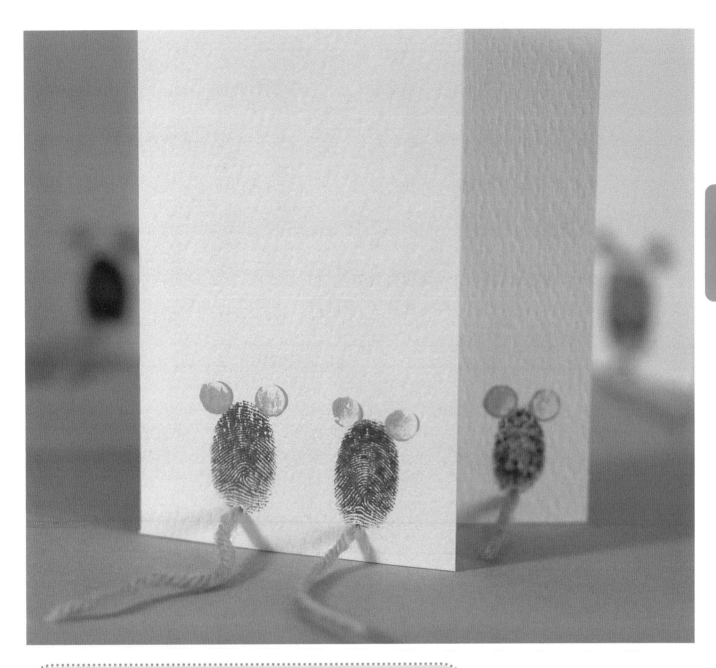

Fast and easy to make, this would be an ideal card to create with children.

Making batches of cards

Keep to a fairly simple design if you need to make many identical cards as invitations to a special event.

Work each step on all the cards in turn, rather than completing one card and then starting the next; this will help you to achieve identical-looking cards.

Change of address

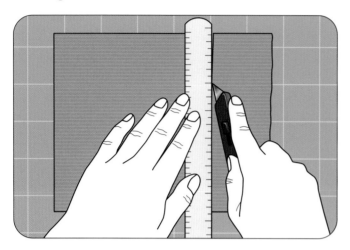

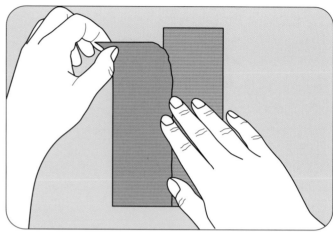

1 Take a sheet of ridged paper and create a torn edge along one long edge (see pages 24–25). Measure and cut 6.5cm (2½in) from the torn edge to get a long strip 6.5cm (2½in) wide. Repeat until you have as many strips as necessary. Cut similar width strips of brown parcel paper.

2 Stick a length of double-sided tape on the back near the torn edge of a ridged strip, from top to bottom. Peel off the backing paper and stick the ridged strip to the left-hand edge of a parcel paper strip, overlapping by about 1cm (½in). Repeat with all the remaining strips.

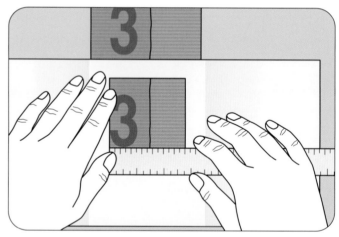

3 Make a rubber stamp of the new house number (see page 51) and stick it onto a piece of translucent plastic so you can see where you are stamping. Stamp the number onto the ridged paper, 1cm (½in) from the top edge. Repeat at around 4.5cm (1¾in) intervals all the way down each ridged strip.

4 Position one of the numbers in the aperture of a card blank. Move it around until you are happy with the positioning. Mark the position with pencil dots at each corner so you can repeat it on each card. Cut all the strips up into individual pieces each with a number, matching the positioning.

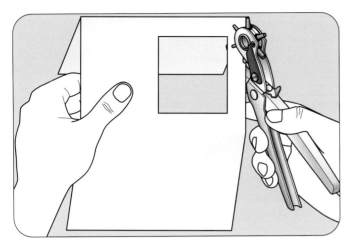

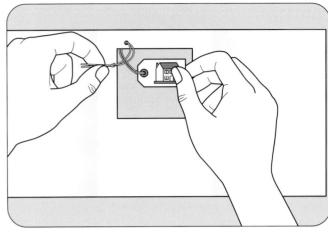

5 Punch a small hole above the top edge of the aperture, close to the left-hand corner and through only the front layer of the card blank. Open the card and stick narrow double-sided tape around the edges of the aperture, making sure you don't cover the punched hole.

6 Transfer the image of a house to a luggage tag (see pages 64–65). Repeat for as many tags as needed. Working from back to front, push both ends of the tag string through the hole, tie in a knot, and then push the tag through the loop. Pull the tag through to the front of the card.

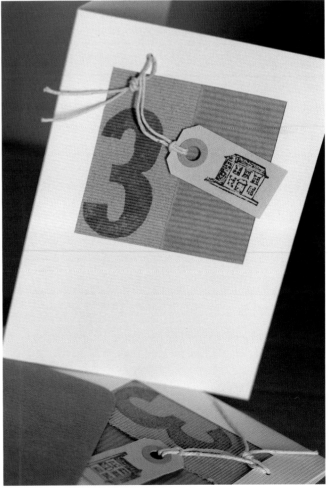

7 Peel the backing off the tape around the aperture and stick one of the numbers behind the opening in the selected position. Fold back the flap to cover the reverse of the aperture and secure with a strip of double-sided tape. Secure the luggage tag in position with a self-adhesive pad.

A card to keep so your friends will never lose your new address.

Pebble card

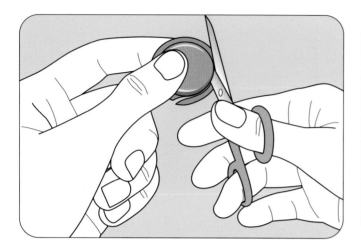

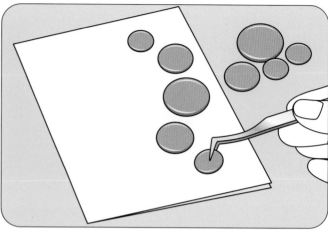

1 Choose five page pebbles of varying sizes. Cut out a motif or picture slightly larger than each pebble. Apply the motifs, right side facing, to the adhesive backs of the pebbles. Make sure the image is firmly fixed and trim off any excess.

2 Position the pebbles vertically down the leading edge of the card in an attractive pattern. Move them around until you are happy with the positioning. Make a template to mark the positioning so you can repeat it on each card.

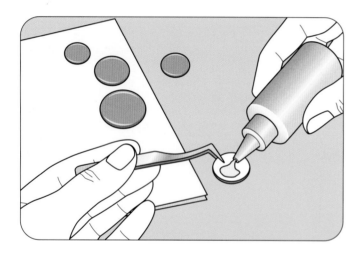

3 Remove the pebbles, one at a time, add a little dab of PVA adhesive to the reverse and then stick down in place. Leave the adhesive to dry thoroughly before moving the card or working on it further.

Different effects

As an alternative to the motif, you could put imitation gold leaf on the back of each pebble in the same way.

The pebbles could also be arranged within circular apertures cut in the front of the card – see decorative inserts on page 87.

Page pebbles of different sizes can be used in many creative ways.

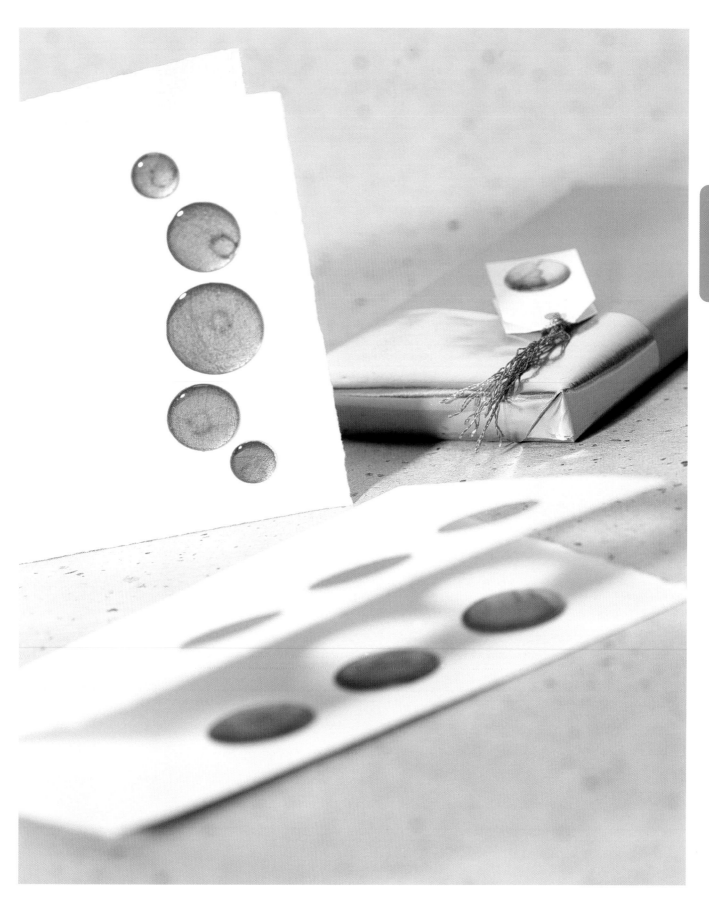

invitation cards

By their very nature, invitation cards are also batch cards since it is likely you will need more that one. However, this doesn't mean that you need to stick to boring techniques or plain shapes.

Wedding invitation

1 Print the names on thin white cardboard, spaced down the cardboard so each set will fit into a rectangle 9.5cm (3¾in) wide and 5.5cm (2¼in) deep. The names should sit towards the right side of the rectangle. Cut or tear each set out.

2 Punch a large round aperture in the left-hand side of each printed card made in step 1. Cut a length of ribbon and fold in half. Push the loop through the hole from back to front and thread the ends through the loop.

3 Place a self-adhesive pad at each corner of the printed card on the reverse. Stick the printed card onto the front of a card blank, about 2cm (⅞in) down from the top and with right-hand sides aligned.

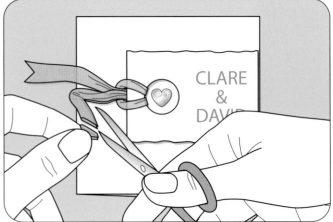

4 Stick a small heart charm, sequin or other suitable motif for the occasion onto the card blank through the circular aperture in the printed card. Trim the ends of the ribbon neatly at an angle or in a V.

Wedding scheme

If you are making the invitations for a wedding or other special event, follow the colour scheme for the cards.

You can make place cards and church service cards using the same design for a fully coordinated look.

A unique and personal invitation card.

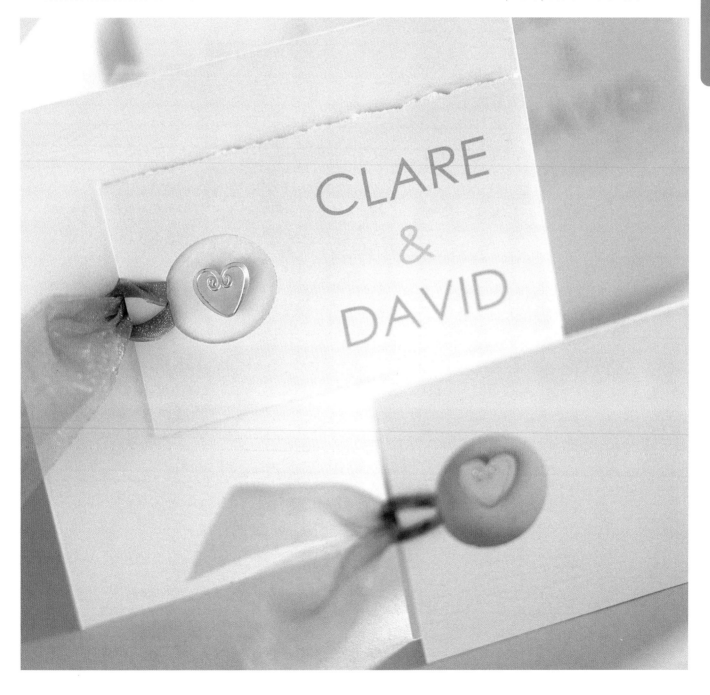

Child's party

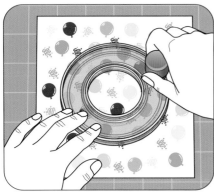

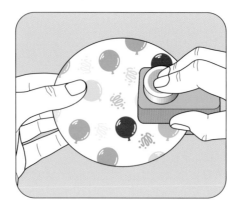

1 Stamp a piece of white cardboard with a suitable selection of motifs. Alternatively, you could stick giftwrap to the cardboard with spray adhesive. Using a circle cutter of a size that will easily fit a standard square envelope, cut out a circle for each invite.

2 Cut a circle the same size from scrap paper, find the centre and pierce a hole. Use this as a template to pierce a hole through the centre of each patterned circle. Using a medium-size hole punch, cut a circular aperture near the edge of each circle.

3 Cut a set of pastel cardboard circles exactly the same size as the stamped circles and cut slightly larger circles from dark colour cardboard. Use the same template to pierce the central hole in all the circles of cardboard.

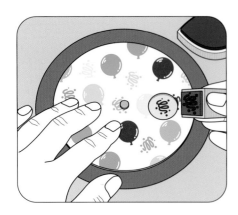

4 Stack the circles with the dark one at the bottom, pastel in the middle and patterned on the top. Secure all the layers with a brad. Write on the pastel cardboard through the aperture, so when the top circle is spun words will appear. Leave one space for a stamp motif.

Make the invitation as full of fun as the party.

Envelope invitation

1 Cut a 14cm (5½in) square of thin coloured cardboard for each invite. With a pencil, lightly draw diagonal lines from corner to corner. Fold each corner to meet the intersection of the pencil lines and press a sharp crease along the edge with a bone folder.

2 Stamp all over the outside of each envelope with a motif appropriate for the event. Stamp the same motif once for each invite, spaced near the edge of a spare piece of white cardboard. Colour in as desired.

3 Using a circle punch, punch out each coloured motif, being careful to get it in the centre of the punched circle each time. Using a sepia inkpad, colour around the edges of the punched motif.

4 Make a flat sheet as the insert for the envelope, stamping it with the same motif and adding the required information about the event. Attach this inside, then seal the invite closed by sticking the punched motif over the central join of the flaps.

Use the envelope invitation as an unusual name place card as well.

envelopes, giftwrap and gift boxes

One of the most widespread uses for paper is for the wrapping of cards or gifts and it's easy to add that final personalized touch. This chapter not only covers envelopes and giftwrap, but also a range of different options for gift bags and boxes – many of which you can adjust to fit different sizes of gift.

envelopes

A brown paper envelope may suit a rustic card, but it won't do a sophisticated modern card justice. Luckily it is easy to make an envelope to complement, and to fit, a card you have designed and made.

Envelopes from templates

A template for the most commonly used envelope shape is on page 290. Use a photocopier to enlarge or reduce as required to fit your card.

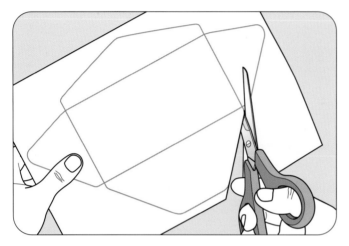

1 Trace a template and transfer it onto the wrong side of the paper (see Transferring images, page 64). Cut out the envelope using scissors for the curves and a craft knife and steel ruler on a cutting mat for the long straight edges.

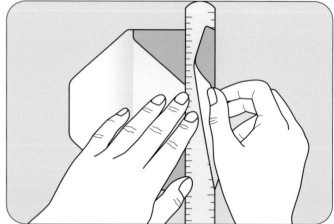

2 With the paper right side down, lay a steel ruler along one of the crease lines on the template. Lift the flap up and fold it over the edge of the ruler to make a neat crease. Repeat on all sides to make four flaps, then open all the flaps out flat again.

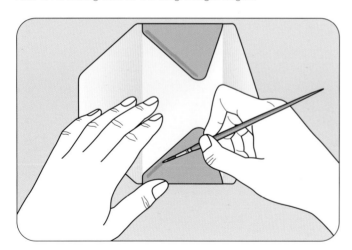

3 Fold in the two side flaps only and apply a thin line of paper adhesive along the edges that will be overlapped by the lower flap. Fold the lower flap up and press it down onto the adhesive. Leave to dry.

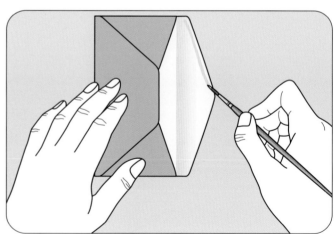

4 Paint a thin line of re-moistenable adhesive along the inside edge of the top flap and leave to dry. To seal the card in the envelope, moisten the flap to re-activate the adhesive and then stick the flap down. Alternatively, just stick the top flap down with paper adhesive once the card is in the envelope.

Copying existing envelopes

Ready-made envelopes are available in a wide range of sizes, qualities, colours and textures – but one the right size may not be the right colour. In this case, simply copy an envelope that is the right size in a paper of your choice.

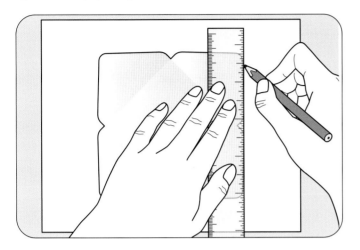

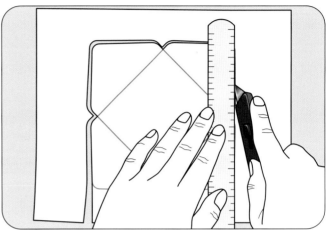

1 Carefully take the envelope apart and flatten out. Lay it on the wrong side of the paper for the new envelope. Using a pencil and ruler, draw around the edges of the envelope as accurately as possible. Mark points to correspond with crease lines, making sure the marks will be visible once the envelope has been cut out.

2 Using a steel ruler and a craft knife on a cutting mat, cut along the long straight edges. Cut around the curves freehand with the craft knife or scissors. Finish the envelope as described in steps 2–4 of Envelopes from templates, opposite.

Sealing envelopes

A sticker is not a very secure seal when posting a card, but will be fine if it is to be hand-delivered. For posting, glue the flap closed before applying the sticker. Alternatively, try sealing the envelope with traditional sealing wax and a patterned seal.

Coordinate the envelope with the card by continuing an element of the card decoration through onto the envelope.

Stickers add extra interest to the outside of the envelope.

Pillow envelopes

A card with 3-D elements will be spoiled if it is squashed in a flat envelope; a pillow envelope will protect it – although it still may be better to hand deliver.

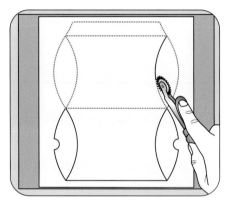

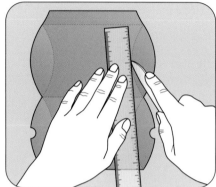

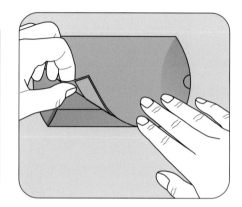

1 Enlarge the pillow envelope template on page 290 on a photocopier as required to fit the card. Lay the template on the right side of a piece of thin cardboard and run a tracing wheel over the outline and crease lines to transfer them onto the cardboard underneath. The indented lines mean there is no need to make pencil marks that might be difficult to rub out.

2 Cut out the envelope shape with scissors, following the indented lines. Using a bone folder and ruler, carefully score the curved and straight fold lines. For curved lines, move the ruler a little at a time, so it is always against the indentations and guiding the bone folder. To keep a scored line as smooth as possible, don't lift the bone folder off until the end of the line.

3 Lay the envelope face down. Stick a narrow strip of double-sided tape along the straight edge without a flap, trimming at both ends on the score lines so the tape does not overlap them. Peel the backing off the tape. Fold the extended flap in and fold the taped edge over it, pressing firmly so it sticks right along its length.

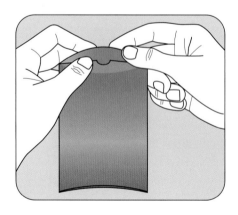

4 Use your fingers and thumbs to gently press on either side of the curved scored lines to help coax the end sections over. The sections with the indents must be folded over first, so that the envelope can be opened easily.

Pillow talk

Use the tracing wheel against a ruler along the straight edges; be careful not to make unwanted marks because you won't be able to remove them. Be especially careful around the indents, as the wheel can be tricky to manoeuvre around tight curves.

The tape to stick the pillow envelope together should be narrower than the flap or it will not be covered when the envelope is assembled.

Folder

There are so many pieces to include with an invitation to a special event, such as a wedding, that a small folder will hold them all neatly. Size the folder to accommodate the largest item – this folder is sized to hold 13 x 20cm (5¼ x 8in) pieces. The patterned paper can be printed giftwrap or any attractive paper – or make your own to match the event theme.

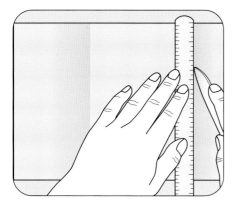

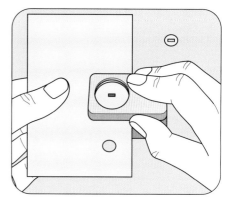

1 Cut a piece of cardboard to 20.5 x 29cm (8¼ x 11½in). Score lines 5cm (2in) from the right edge and 10.5cm (4¼in) from the left edge of the cardboard. Fold over the cardboard along the scored lines.

2 Cut two pieces of patterned paper, one measuring 20 x 10cm (8 x 4in), the other 20 x 4.5cm (8 x 1¾in). Using sticky-dots tape, attach one piece to the front of each corresponding-size cardboard flap.

3 Punch out two tiny rectangles, not too close together, through a spare piece of cardboard. Turn a circle punch over, insert the punched cardboard, centre the circle over a rectangle and punch out a circle. Repeat with a larger circle punch.

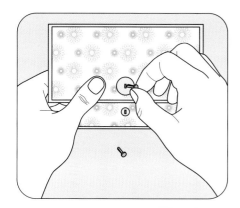

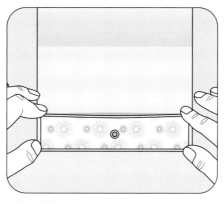

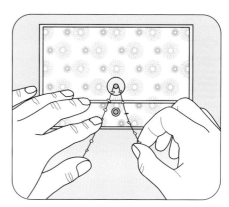

4 Find the centre of each flap, then make a mark about 2.5cm (1in) from the edge. At each mark, punch out another tiny rectangle. Put the larger punched circle over the punched hole in the top flap and the smaller on the bottom and fasten with brads.

5 Apply a fine line of PVA glue along each short edge inside the smaller flap. Using your fingers or paper clips, hold down the edges until the glue dries to make a small pocket in the folder.

6 Put all the paperwork – such as the invitation, map of the location, RSVP cardboard and envelope – into the folder. Close the flaps and wind a length of decorative fibre around the brads to seal.

giftwrap

Although there are some lovely printed giftwrap papers on the market, if you can't find just the right one it's easy to make your own. The paper can then also be coordinated with the card and gift tag.

Stamped giftwrap

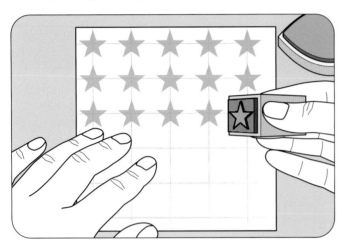

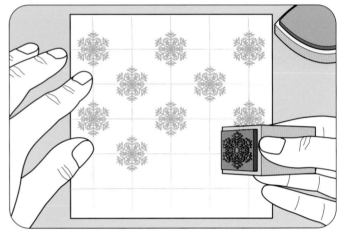

1 To stamp a motif in straight lines or in a regular grid, position the stamp by eye or lightly mark lines or a grid with a fine pencil first, then stamp each intersection. Leave to dry fully before rubbing out the lines.

2 Another regular pattern is the half-drop repeat, which is also a grid pattern but each motif in a row is centred between two in the row above and below. Again, either stamp by eye or mark out the grid lightly in pencil.

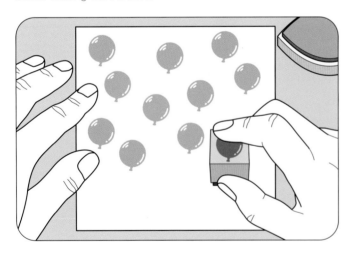

3 Sometimes a regular pattern can look at bit regimented and may not suit an asymmetric design stamp or a more playful motif; in this case randomly stamping creates a spontaneous, lively look.

Stamping paper

Keep the motif fairly simple and small, particularly if you are stamping a smaller piece of paper.

To save time, measure out the amount of paper you actually need to wrap the gift before beginning to stamp; then you only need to stamp the part of the paper that you will use.

For a more complex design stamp once, leave to dry completely and then stamp again with a second colour or different motif.

Webbing spray

Convert plain colour paper into an unusual pretty giftwrap by applying some webbing spray. To protect your work area, spread some newspaper underneath the paper before spraying. Apply the webbing spray to a flat piece of paper, spraying lightly over the surface to create a striking marble effect.

Pigment spray

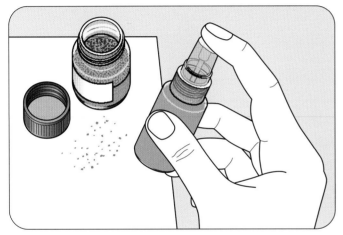

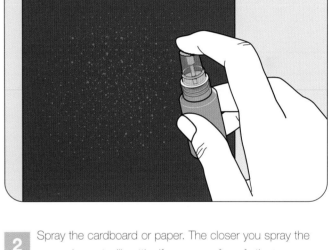

1 Put a small amount of pigment powder in an empty spray bottle. Add water until it is almost full. Screw on the top end and shake vigorously until the water and powder are thoroughly mixed.

2 Spray the cardboard or paper. The closer you spray the more pigment will settle; if you spray from farther away, the effect is more subtle. Leave to dry.

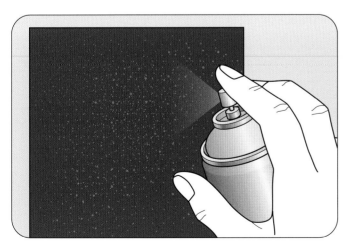

3 There is no adhesive in the mixture, so the finished result will need a fixative. Spray the surface lightly from approximately 10cm (4in) away.

How to wrap

Most crafters have a box full of scrap pieces of beautiful patterned paper, either leftovers from other present wrappings or just from craft projects. You can use these odds and ends to create a beautiful and unusual giftwrap.

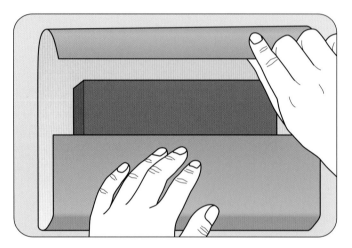

1 Cut the paper roughly to the size of the gift. As you wrap, cut off any excess paper to keep the wrapping neat.

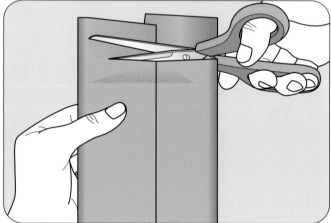

2 Use clear tape, or double-sided tape on the underside, for neater joins. Trim the ends straight, leaving just enough to cover each end of the gift.

3 Fold over each corner first, then neatly fold over the flap and trim it along the centre of the edge. Secure each flap neatly with a short length of tape.

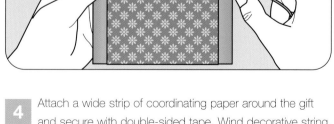

4 Attach a wide strip of coordinating paper around the gift and secure with double-sided tape. Wind decorative string, ribbon or thread around this and add a matching tag.

gift bags

These are the ideal solution for wrapping odd-shape gifts, or for presenting several small gifts in one package. It's easy to adjust the template for different sizes.

Gift bag from a template

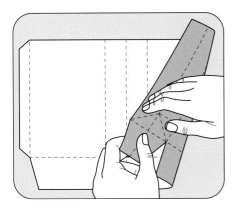

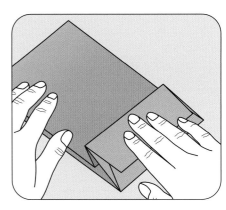

1 Use the template on page 288, enlarging and adjusting it as described in the tip box below to customize it for the item. Copy the template onto the paper, cut out the bag and score and crease all the dotted fold lines as indicated on the template. Crease the base line and the fold line across the back section first, then the side triangular sections, then the side lines, pinching the triangles together.

2 Spread adhesive along the right side of the side flap, or stick a strip of double-sided tape and remove the backing. Aligning edges and top and bottom of the bag, press the inside edge of the other side firmly to the flap. Turn the bag upside down and spread adhesive on the edges of the right side of the base side flaps and on the edge of the wrong side of the under flap. With a hand in the bag as a support, press together to stick. Add adhesive to the underside of the remaining base flap and press to stick.

3 Smooth the bag edges, making sure they are all aligned. For reinforcement, measure the base and cut a small piece of plain cardboard slightly smaller. Stick inside the bag to cover the inside base. Gently press the base section flat along the crease lines, so that the base rests flat against the bag.

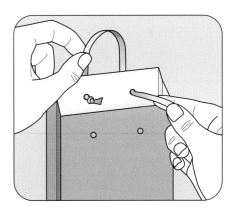

Adjusting the measurements

All measurements marked A should be equal, and all measurements marked B should be equal, so the bag will hold its shape and fold flat.

Make measurement A larger for deeper sides to accommodate a large item; make it smaller for narrow sides for flatter items.

Make measurement B larger for a wide bag to accommodate a large item; make it smaller for a narrow bag, such as for a bottle.

Make measurement C larger for a taller bag; make it smaller for a short bag.

4 Position the handles; for good balance, mark them between one third and one quarter of the front width in from each side. Punch two holes in each side of the bag, about 2cm (⅞in) down from the top. Thread a suitable length of ribbon from outside to inside and knot each end securely on the inside.

Using a scoring template

Scoring templates designed specifically for bag making are wonderful – you can make a dozen party bags quickly and easily.

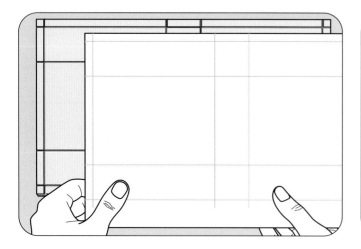

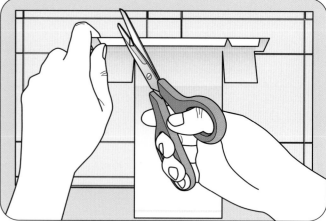

1 Cut a piece of paper larger than the template and secure it over the template with clips. Using a bone folder, score all the lines marked on the template, carefully following the layout on the board.

2 Cut along the scored lines indicated by the darker lines on the board. Fold over the edges along the other scored lines to create flaps. Cut notches at the ends of the flaps so the bag will close better.

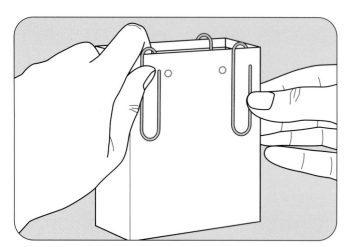

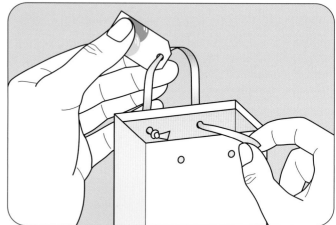

3 So the holes for the handle are even and parallel, mark them on front and back before sticking the bag together. Glue the flaps inside the bag using paper adhesive and clamp with paper clips, leaving in place until the adhesive is dry.

4 Punch the handle holes. Take a narrow ribbon from inside out to the front, through a tag, and then back in through the other hole. Adjust the loop to size and knot each end to secure. Repeat, omitting the tag, to make the back handle.

Woven gift bag

These little woven bags are very easy to make and are ideal for holding very small gifts or favours.

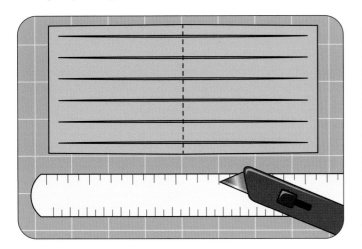

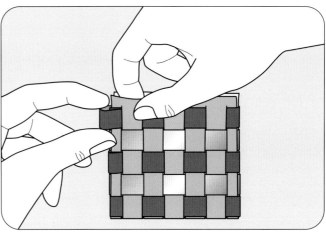

1 Cut a rectangle 7.5 x 15.5cm (3 x 6¼in) from strong coloured paper. Mark six equally-spaced parallel lines about 1cm (½in) apart, beginning each one 5mm (¼in) in from both side and end edges. Cut along all the lines with a sharp craft knife. Fold the paper in half across the cut lines.

2 Cut six strips of contrast paper, each 1cm (½in) wide and 20cm (8in) long. With the base still folded, weave one strip over and under the cut strips to the edge, around the edge and weave in back along the other side. Weave in the end on the front again to secure and cut off the excess. Repeat up the bag with another four strips.

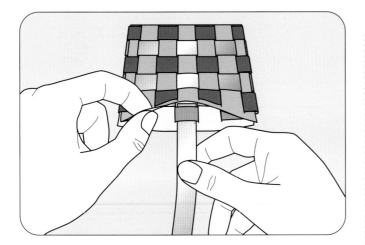

3 Use the remaining strip to make a handle by weaving the ends into the pattern at the centre, on the inside of the front and back of the bag. Secure the ends in place with a dab of adhesive.

Strip weaving

Use the same weight paper for the background as for the strips to avoid problems when weaving.

You could also use the same paper for both background and strips for a more subtle effect.

The bag will only hold small, lightweight and quite flat gifts. For larger or heavier items, use one of the gift boxes on pages 138–141.

gift boxes

You can make your own gift boxes quickly and easily, so you will always have just the right size for any item.

Square box with ribbon handle

With this clever traditional method you can make a perfect square
box with just thick paper, pencil, ruler, bone folder and scissors.
You do not even need adhesive.

1 Cut a piece of paper into a square. With a pencil, draw two diagonal lines from corner to corner. Using a bone folder, fold over each corner to the central intersection of the pencil lines, and then open out again.

2 Next, fold each corner inward again, this time to the point where the pencil line intersects the opposite corner fold line made in step 1.

3 Turn the paper over and fold the four flaps up to the nearest fold line made in step 1. You now have three parallel fold lines across each corner, two creased one way and one creased the other way.

4 Cut two opposite flaps only along their innermost side creases up to the innermost fold line, forming a house shape.

5 Fold in the two sides along all the creases, leaving the house-shaped flaps until last.

6 Fold in the house-shaped flaps to finish the box. To make a lid, start with a piece of paper that is 1.5mm ($\frac{1}{16}$in) longer on each dimension and make another box.

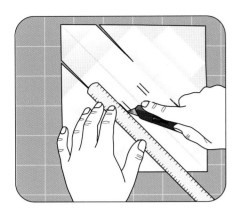

Firm folding

If you crease the fold lines firmly with the bone folder, the folded box should hold its shape without the need for any adhesive.

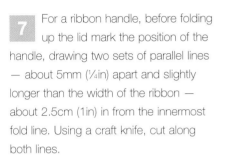

7 For a ribbon handle, before folding up the lid mark the position of the handle, drawing two sets of parallel lines — about 5mm (¼in) apart and slightly longer than the width of the ribbon — about 2.5cm (1in) in from the innermost fold line. Using a craft knife, cut along both lines.

8 When the box is finished, push the ribbon in and out through each cut, leaving a big loop of ribbon for the handle between the two sets. Take the ribbon right around the box and tie in a bow at the side. Trim excess ribbon, making a V by folding it in half lengthways, then cutting the ends diagonally.

Cone box

This little box is great for small items and could also be hung up as a decoration with favours inside.

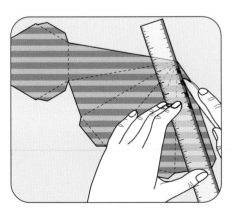

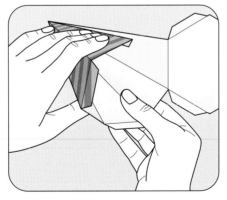

1 Trace the template on page 291 onto thin patterned cardboard, or thin cardboard backed with patterned paper using spray adhesive. Cut around the outline and score the fold lines.

2 Spread a little adhesive on the right side of the side flap, or use a strip of double-sided tape. Press to the underside of the opposite edge, aligning the fold with the edge.

3 Punch a small hole in the centre of the lid and thread through the ends of a length of ribbon or cord. Knot on the inside to secure. When the cone is filled, add a small strip of double-sided tape to each flap and stick inside the cone.

Trunk box

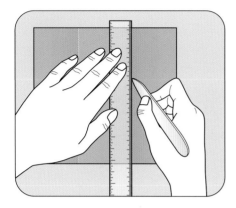

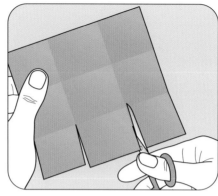

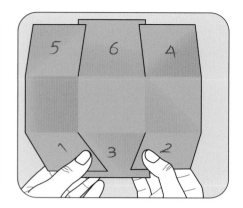

1 Cut a piece of coloured cardboard 15.5 x 15cm (6¼ x 6in). Measure 5cm (2in) in from each side and score a line parallel to each edge with a bone folder and ruler, or using a scoring board.

2 At one corner, cut along one of the scored lines to the point where it intersects another scored line to make a flap. Repeat at the opposite end of the same side, then again in the same way on the opposite side.

3 Number the flaps in the order that they need to be folded to make the box. Using PVA adhesive, attach each side of the box and clamp with paper clips until it dries.

4 To make the lid, repeat steps 1–3 using another piece of cardboard 16 x 15.5cm (6½ x 6¼in), but in step 2 cut out a complete square in two corners only on the same side. Glue the loose flap to the back of the box with PVA.

This little gift box is ideal for presenting sweets or tiny favours.

Made-to-measure box

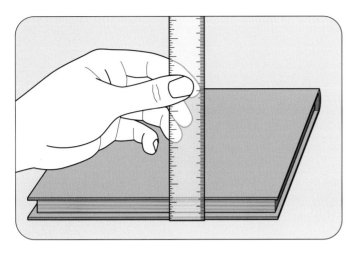

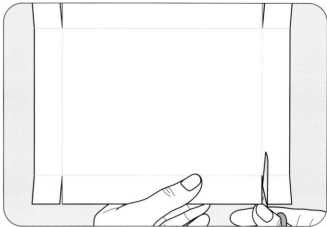

1 Measure the length and width, then measure the thickness of the item. Add twice the thickness measurement plus 3mm (⅛in) to both the length and to the width measurements, and then cut a piece of cardboard to these dimensions.

2 Measure in from each edge by the thickness measurement plus 1.5mm (1/16in) and score a line parallel with each edge of the cardboard. At each corner, cut one scored line to make a flap, as described in step 2 opposite.

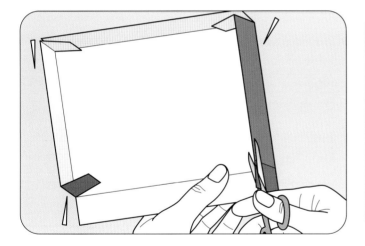

3 Fold over the edges along the scored lines. Cut the top cdgc of cach flap at an anglc. Using a wet adhesive, such as PVA, attach the flaps to the side and clamp them with paper clips while they dry.

4 To make a lid, start with a piece of cardboard 3mm (⅛in) longer and wider than the piece cut in step 1. Follow steps 2 and 3 for making the box. To make it easier to lift the lid, punch a semi-circle out of the edge at the centre of two opposite sides.

Ribbon tie

If you want to add a ribbon to close the box, cut slits in the bottom of the box before folding and gluing it, as described in steps 7 and 8 on page 139.

The top and the lid can be made in different colours for extra interest.

ribbons and bows

Tying a perfect bow is something many of us think we can do, until we try! Bows have all kinds of decorative applications and this method of tying produces a good result, but needs some practice. It's shown on a card, but can be adapted for any use.

Tying a bow

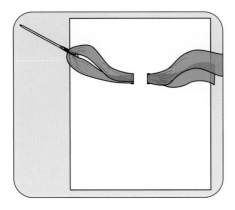

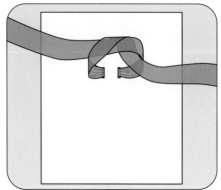

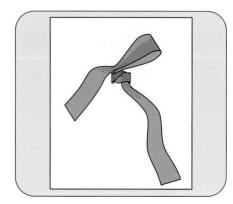

1 Pass a length of organza ribbon in and out of two slits cut in the front of a card blank. Use a large-eyed needle if you can't push it through with a fingernail.

2 Tie a single knot by passing the tail of ribbon in your left hand over and under the tail in your right hand.

3 Taking the tail on the left, form a loop that points to the top right.

4 Take the tail on the right and bring it up and over the loop, then push it to the right through the new loop just formed to tie the bow.

5 Manipulate the bow, making the loops even and balanced. Fold the tails in half widthways and cut them on a slant to make a V-shape in each end.

A simple ribbon bow makes a very effective card.

Dior bow

1 Cut 1.8m (2yd) length of ribbon into five lengths measuring 12.5cm (5in), 25cm (10in), 35cm (14in), 45cm (18in) and 55cm (22in).

2 Shape the four longer lengths into circles and overlap the ends at the centre. Glue the ends in place.

3 Flatten the four circles in the centre and glue together one above the other in descending order of size.

4 Wrap the smallest length of ribbon around the centre point of the stacked loops and glue the ends neatly to the underside of the bow.

Bow tie

Choose the type of bow to match the size and style of the present: the Dior bow is quite narrow and flat so is ideal for a small or contemporary style wrapped present, while the rosette (see page 144) is bulkier and more flashy, so would suit a larger and more traditional-looking gift.

Double bow rosette

1 Take a length of ribbon around 3m (2¾yd) long. Pinch the ribbon firmly between your thumb and index finger about 20cm (8in) from one end.

2 Make a 12.5cm (5in) loop – this will be half the size of the finished bow – and pinch together tightly. If the ribbon is finished only on one side, twist the length to the right side. Make a second loop opposite and pinch it over the first.

3 Repeat this process again, creating 2 loops on each side. Stick the loops together with a dab of adhesive. Leave to dry. Repeat twice more so you have a rosette of eight loops in total, with the loops set in a circle.

4 Make a centre knot by forming a small loop over your thumb and stick this in place to hide the centre of the rosette. Stitch two lengths of ribbon to the back of the bow for tails, if required.

Ribbon fixing

If you are using giftwrap ribbon you could staple the layers of loops together instead of gluing and then hide the staple with the centre loop.

For a full rosette, make a second, smaller round of loops on top of the first, before adding the centre loop.

Rose

1 Use about 3m (2¾yd) of fairly soft, wide ribbon for this rose. Fold the ribbon at right angles, leaving a 5cm (2in) long tail.

2 Starting at the bottom left point of the fold, roll tightly about 3 to 4 complete turns to form a centre bud and a tight base for the rose.

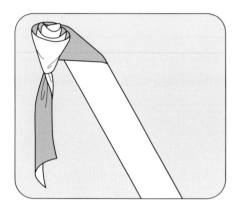

3 Holding the tail firmly in the left hand, fold the ribbon length to the outside at a sharp right angle. Roll the base area along the folded edge until it almost reaches the fold. As you near the end, fold the ribbon to the outside again at a right angle. Repeat this fold and roll process to form rose petals loosely around the bud and base. Add a dab of adhesive at intervals to hold the petals securely in shape.

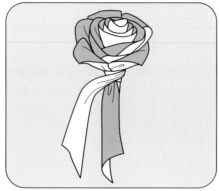

4 A gentle twist on the rolled tail will softly shape and tighten the rose. When you have about 5cm (2in) of ribbon left, twist the ends straight down and along the first tail. Secure with a dab of adhesive – or a stitch if using fabric ribbon – at the base.

Lark's head knot

This type of knot is ideal for attaching ties to tags.

1 Cut a piece of cord, string or ribbon about 30cm (12in) long. Fold it in half and push the loop through the hole in the tag, from the front to the back.

2 Pass the ends of the string through the loop and pull it tight. Make sure the loop and the ends are on the front of the cardboard, tight up against the hole.

gift tags

There are many ways of making a beautiful tag to coordinate with your card or giftwrap. Be bold and experiment with different styles and shapes.

Punched tags

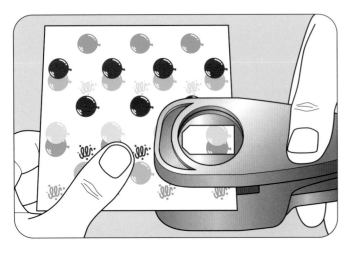

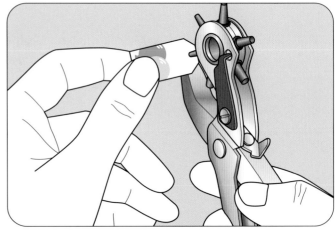

1 If you are working with patterned paper, turn the punch over to make it easier to select and punch the right section of the pattern.

2 Once the tag has been punched out, make a hole for attaching the cord or ribbon using a hole punch.

Double punched tags

1 Fold a scrap piece of thick giftwrap in half. Punch out the tag shape, making sure the folded edge is within one edge of the shape so it won't be cut.

2 Punch a hole for the cord through both layers, or just one layer if you prefer. Punch out a decorative shape from patterned paper.

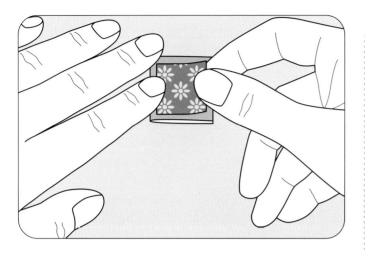

3 Using double-sided tape, attach the pattern piece to the front of the tag. You could also add stickers or other decoration to the tag.

Tag punch

If you want to make quite a few tags, a tag punch will save you a lot of time and they are available in many different sizes.

Some die-cutting machines have several different shapes or size of dies to cut many different tags.

Try making a chain of tiny tags; each one can have one word or one letter, to spell a sentence or a name.

Using a template

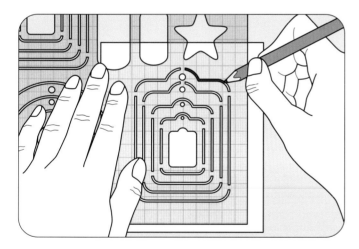

1 Place the tag template on the back of the cardboard or paper, then draw around it with a pencil (so no difficult-to-erase pencil lines will be left on the front). Make a mark where the hole should go.

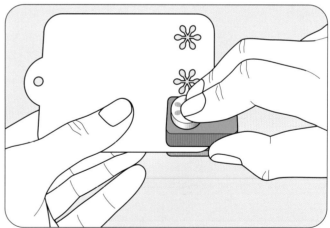

2 Cut along the marked outline. Punch the hole, then remove any remaining pencil lines using a soft eraser. Decorate the tag to match the cardboard or giftwrap, here by punching out three flowers. Add ribbon or thread using a lark's head knot (see page 145).

Covering purchased tags

This method shows two brown shipping tags put together and covered on both sides to make an opening card-type tag, but you could simply cover one side of a white tag and then write on the other side.

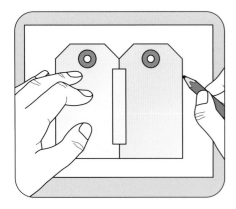

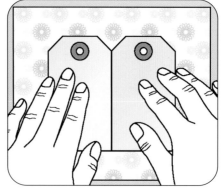

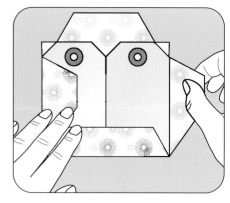

1 Edge to edge, attach two shipping tags together with masking tape on one side. Place the joined tags on a piece of white paper, and then draw around them to outline the insert. Mark the position of the fixing hole.

2 Spray an even coat of adhesive onto the back of a piece of patterned tissue paper. Position the tags, tape side down, onto the tissue paper, then use your hand to smooth them down so the tissue paper is fully attached.

3 Cut and fold excess tissue paper over the edge of the tag. Using double-sided tape, attach the insert on top. If you prefer, trim the insert down to show an even border of pattern. Punch a hole through the completed tag.

Embossed foil tags

Thin metal foil can be cut with ordinary scissors and is easy to emboss to make industrial-looking metal tags.

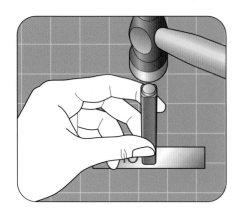

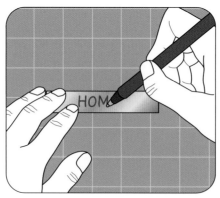

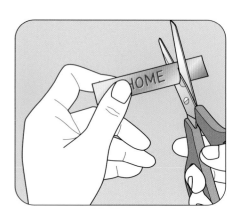

1 Stamp the name or message by positioning a letter stamp and tapping it firmly with a hammer. Letter stamps are available from most good craft stores.

2 Alternatively, lay the foil on a cutting mat or several layers of paper and write the letters firmly with a dried-up ballpoint pen.

3 When you have completed the lettering, cut the piece of foil to the required size and shape using scissors.

Faux metal tags

Make your own metal-look tags using thin cardboard and embossing powder.

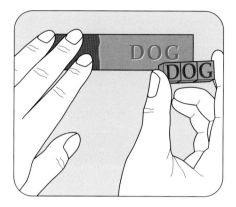

1 Cut a strip of cardboard as wide as the tag, but longer. Rub one end across a clear embossing inkpad, inking enough length of cardboard for the entire tag. Lay the cardboard inked side up and sprinkle with silver embossing powder. Tip excess powder onto scrap paper.

2 Using a heat gun, melt the powder on the tag until it melts and fuses. Repeat the inking and embossing process several times to build up a thick layer of embossing powder.

3 Select the letter stamp and line them up, holding in place with tape or firmly in your fingers. Gently reheat the embossing powder and as soon as it starts to melt firmly push the letters into it. Hold in place for a minute then remove and allow the surface to cool fully.

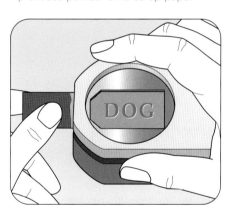

4 Slide the tag into an upside down tag punch, positioning the letters centred towards the base of the tag, and then punch out the tag. Punch the hole for the fixing with a leather punch.

Embossing tags

The faux metal look will be more convincing if you use thin metallic cardboard matching the colour of the embossing powder as a base.

The back of the tag will not be decorated, so whatever is used for the base cardboard may show on the reverse depending on how the tag is fixed.

You can also use this technique to give an embossed look to real metal tags – but be careful during the embossing process, as the heat gun will heat up the metal quickly.

scrapbooking

Scrapbooks are collections of memories in a visual form and they have been around for many years – although it is only fairly recently that making them has become an established and widely popular craft. Many of the techniques from cardmaking can also be used in scrapbooking, but it also has its own special techniques and materials.

covers and pages

There are different types of ready-made scrapbook available, some with fixed pages and others of the ring binder type, to which you can add plastic sleeves to hold your pages. With this last type you can also make up your own pages to insert. Whichever type you choose, you will probably want to personalize it by adding a cover or a title.

Jackets

A paper dust jacket will protect the cover of the scrapbook, but it is not really designed to be permanent – just replace if it becomes faded or torn. A fabric jacket takes a little more work, but it will last much longer.

Paper dust jacket

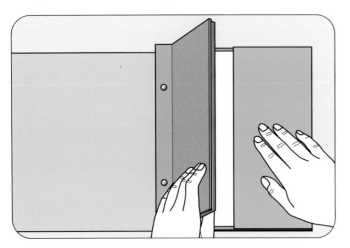

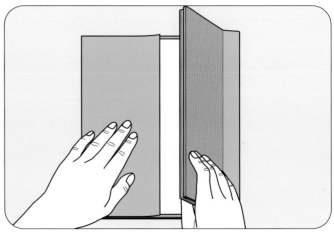

1 Cut a piece of paper for the dust jacket that is exactly the height of the album and three times the width plus the width of the spine. Fold one end over by half the width of the album and slide the back cover of the album into the fold.

2 Close the album onto the flap and wrap the rest of the paper around the spine, keeping it as taut as possible. Holding the jacket in place, turn the album over and fold the remaining paper over the inside of the front cover out flat again.

Adding titles

A title will add the finishing touch to your jacket. See pages 172–175 for some text ideas that can be used on the cover as well as on pages, and page 176 for an embroidered title for a fabric jacket.

Fabric jacket

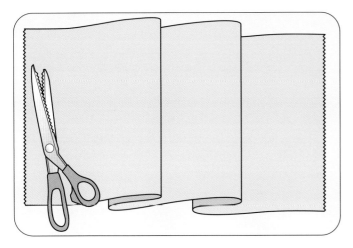

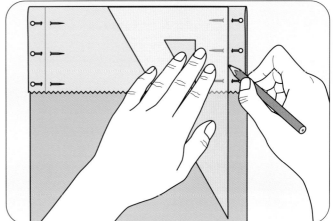

1 Measure the height of the album and add 5cm (2in) for seam allowances. Measure the width of the album and multiply by three – the extra width allows for half-width flaps front and back – then add the width of the spine. Cut a piece of fabric to this dimension and trim the two short ends with pinking shears.

2 Fold over one short end right sides together by half the album width. Align the raw edges and pin in place. Place one edge of a set square against the folded edge so the other straight edge is 2.5cm (1in) from the raw edges and mark the line. Repeat on the other side, then repeat the whole step at the other end of the fabric.

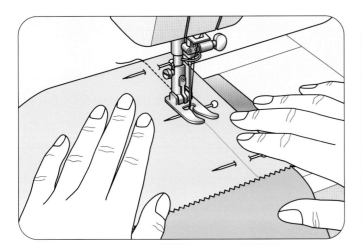

3 Thread a sewing machine with thread to match the fabric. Set the machine to a medium straight stitch then stitch along all four drawn lines, backstitching at beginning and end to secure the thread. Trim the thread ends. Trim each long edge of the fabric with the pinking shears and snip across each corner near the stitching.

4 Turn the pockets you have made at each end of the fabric right side out and gently push out the corners to square them up. Use the end of a bone folder if necessary to get a neat point, but be careful not to push through the stitching. The edges at top and bottom of the fabric will fold over to the inside; press them in place.

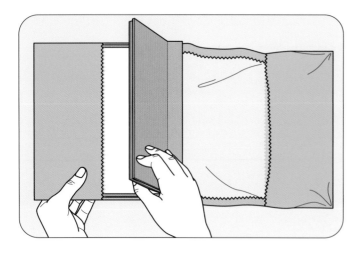

5 Slip one flap over the front cover of the album, wrap the fabric around and slide the other flap over the back cover. The fabric should be quite a snug fit so you may have to bend the back album cover backwards slightly to get it into the flap.

A fabric jacket can be embellished in many ways.

Choose a close-woven and strong fabric for the album cover – but nothing too bulky or it will be difficult to get the seams to lie flat.

If the edge of the top and bottom seam allowance does show through on the front face, reposition the cover in the flap so the seam allowance falls on the inside face.

Make sure the fabric is opaque enough before you begin if you don't want the original cover to show through.

The advantage of a fabric cover is that it can be embellished with stitching – see pages 66–69 and pages 176–179 and 183 for some ideas.

Pages and inserts

The special plastic inserts designed to hold scrapbook pages may not always be suitable – if the page has layers to be lifted, pockets to access or has high relief elements, for instance. In these cases it is better to make up a separate page that can be inserted into the binder directly.

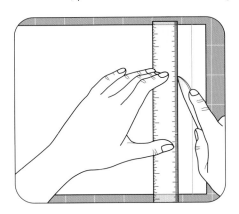

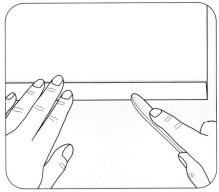

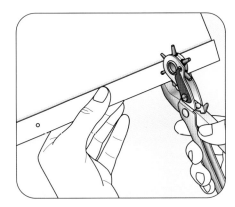

1 Measure and cut a piece of fairly heavy paper or very thin cardboard to 30 x 35cm (12 x 14in). Using a bone folder, score lines at 2.5cm (1in) and 5cm (2in) in from the left-hand short edge only.

2 Fold the paper to the front along both scored lines, then unfold. Fold over on the first line only and burnish with the bone folder to crease firmly. The folded edge acts as a spacer; if the page has high relief elements, cut a narrow strip of cardboard to sit on top of the folded edge to hold the pages further apart.

3 Use one of the plastic sleeves or an existing page as a template to measure and mark the position of holes and then punch them through the folded section at the marked points. If you are also using a cardboard spacer strip, punch matching holes in this too. If you are making several pages, use the first as a template to punch the others.

4 If you want to add an additional interleaf to protect the page, cut a 30 x 32.5cm (12 x 13in) piece of vellum or tracing paper. Slip it under the folded edge of the page before step 3 and punch holes in it at the same time as you punch the page.

Patterned backgrounds and edges

Decorate your scrapbook pages with decorative edges and patterned backgrounds – see pages 24–31 and 40–71 for some techniques.

scrapbooking

Journalling notebook

If you need to add large amounts of text to a page, a small journal is the best option. The pages can be blank sheets to hand-write, or you can bind up printed sheets of text.

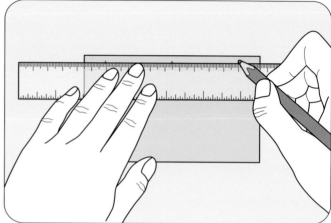

1 Cut two pieces of coloured or textured paper for the cover, each 12.5 x 7.5cm (5 x 3in). On the back of one piece, score a line with a bone folder about 1cm (½in) from one long edge. Fold the paper to the back along the scored line. Score the other piece in the same way.

2 Open out the fold on one cover piece. On the inside face of the folded strip, measure and mark three points, 1.5cm (⅝in) from the top, at the centre, and 1.5cm (⅝in) from the bottom. Each mark should be centred across the width of the strip. Cut about six pages in thin paper, each 12.5 x 6.5cm (5 x 2½in).

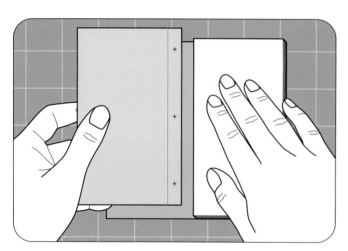

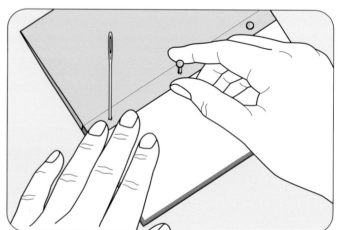

3 Open out the fold on the other cover piece and lay it face up on a foam pad or cutting mat with the fold to the right. Stack the pages and lay them with the left-hand long edge against the fold. Place the remaining cover on top, face down, aligning edges with the other cover so the marked strip overlaps the page edges by 1cm (½in).

4 Keeping everything firmly aligned, push a sharp needle through each of the marked points, right through all the layers. Leave the needle in place in the last hole to keep everything aligned while you insert a small brad through the top hole. Add brads to the other two holes, removing the needle.

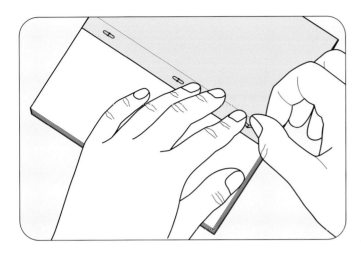

4 Turn the book over and open out the arms of the brads so they align with the spine of the book. Close the covers over the brads and trim the page edges, if necessary, so they align with the covers. If you want to bind printed pages, print them out on the computer so each block of text will fit within the page size.

Using the right materials

Many scrapbooks contain irreplaceable photographs and memorabilia – as well as representing a great deal of hard work. It is therefore important to think about the materials you want to use before you begin: many standard papers and other materials contain chemicals that either may damage – or even destroy – photographs, or which can be unstable so they fade or discolour. This is something that has already been addressed by archives that specialize in preserving photographs and other documents so there are products designed for archival use – but they do tend to be a bit more expensive than standard versions. If you are scrapbooking for fun – or with children – it's probably best to forget longevity and use whatever you feel like; but make sure you only use copies of any valuable photographs or documents. Store the originals safely in the dark in a cool, dry place. If you are aiming for a family heirloom, look for products marked 'acid-free', 'PVC-free', 'lignin-free' or 'archival quality', which have been specially formulated to contain less of the harmful chemicals that cause damage.

A route map makes an evocative cover for a journal.

photographs

Most scrapbook pages will incorporate photographs, but there are other ways of presenting these than just sticking them on the page straight from the packet. Always look at the photographs in the context of the complete design.

Sepia tinting

A colour copier will pick up the sepia tint of an old photograph quite well, but if you only have black and white copies you can imitate the effect of sepia tinting using a strong solution of instant coffee in hot water. Dampen a cotton pad with the solution and wipe it onto the black and white photocopy. Leave to dry completely before cropping – if it wrinkles place it under a heavy book overnight to flatten it.

Cropping

Cropping can transform a poorly composed or boring picture into a stronger image by focussing the eye. L-crops allow you to try different versions of the crop before beginning to trim or frame the image. They are usually made from black cardboard, but a neutral grey will also work well. Avoid strong colours, as they will influence colours in the image you want to crop.

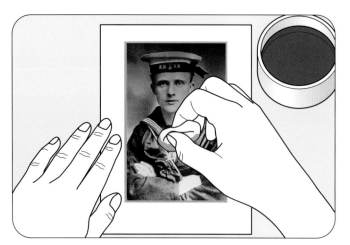

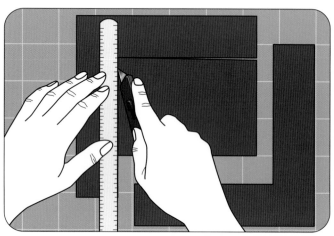

1 Draw two L-shape right angles on a piece of thin black cardboard, with each arm 5cm (2in) wide and at least 15cm (6in) long. Cut the two L-shapes out.

Using sepia tinting

You can also use this technique to age maps and other documents – always work on photocopies if the originals are not easily replaceable.

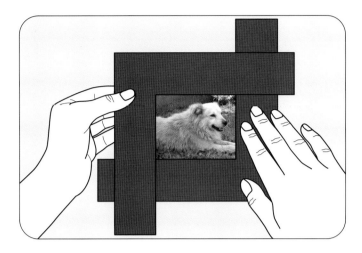

2 To decide on a crop, place the two L-crops over the image and slide them around to focus on different areas of the picture. Be bold – unusual crops can be very effective.

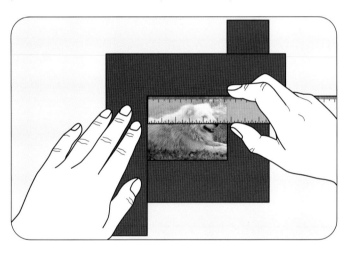

3 Carefully mark one corner of the crop on the framed image and measure from here, noting the measurements down. Remove the L-crops and trim the picture to size.

Matting

Photographs or other images can sometimes become lost against the background, but giving them a border by matting them onto a larger piece of thin cardboard can make them stand out. Make sure the colour and width of the border is sympathetic with the image in the photograph.

Using matting

Single matting gives a single contrast border, multi-matting gives two or more borders.

In window matting the photograph is mounted from behind the window – which can be cut by hand to a specific size or with a punch (see page 96).

With relief matting, there is no contrast border but the thickness of the cardboard raises the image off the surface of the page, creating a shadow line to emphasize it. You can use self-adhesive mount board – which has a thin layer of adhesive on one side covered by backing paper to peel off when used – or spray mount to mount the image.

If you only want to highlight a small part of a bigger image, use focal-point matting – a technique in which a small area is framed within a larger image to make it stand out. If you don't want to hide any of the image, try making the frame in tracing paper or vellum, which will create a border without completely obscuring the image beneath.

If using cut-out focal-point matting to highlight part of an image, choose a simple shape with fairly straight edges. Accurate drawing of the outline and precise cutting is the key to success.

Single matting

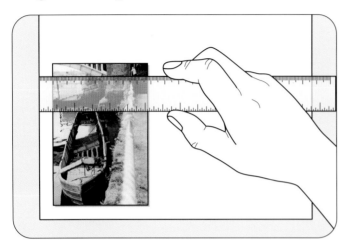 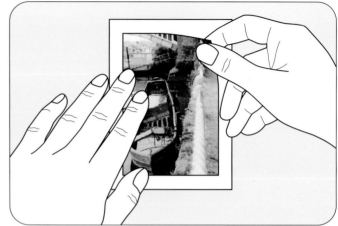

1 Lay the photograph onto a large piece of cardboard, positioning it near one corner so you can move it in and out to try different border widths. When you have decided on a width, measure the border, multiply by two and add the width of the photograph, then repeat for the height if the photo is not square.

2 Cut the cardboard to size. Stick small squares of double-sided tape or photo corners (see page 166) onto each corner of the photograph and stick it down centrally on top of the mat. If you are not confident that you can centre the image by eye, make tiny pencil positioning marks on the mat before placing the photograph.

Multi-matting

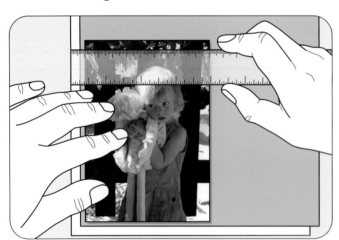

1 Lay two or more pieces of cardboard down with the photograph on top, so that one corner of all layers is visible. Adjust the width of the border on each layer until you are happy with the effect.

2 Measure and cut each mat as explained in Single matting, above. Stick the photograph onto the top mat and then stick the matted photograph onto the next layer – and so on if there are more than two layers.

Window matting

1 Do not crop the photograph or artwork before matting it. Decide on the crop you want and measure it, then use the measurements to cut the window.

2 Stick double-sided tape around the opening on the back and peel off the backing tape. Position the window carefully over the image in the correct position and stick it down.

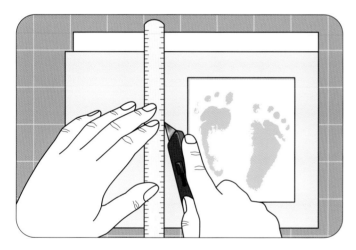

3 Decide how wide you want the frame around the image to be and trim the outer edges of the window mat down to match.

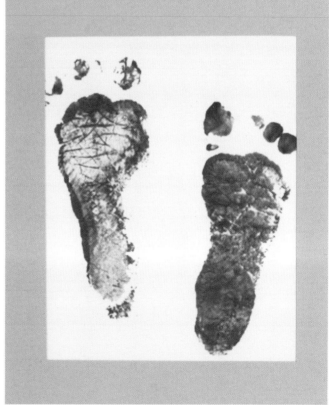

Choose a border to complement the image.

Relief matting

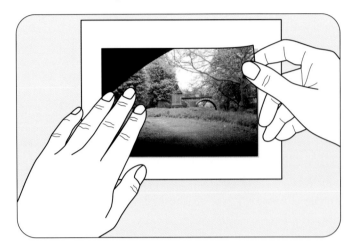

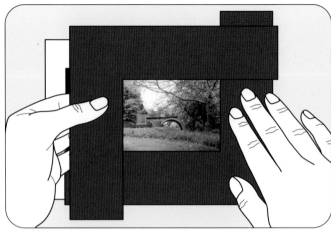

1 Do not crop the image first. Stick it onto a piece of cardboard a little bigger than the overall size of the artwork or photograph.

2 Decide on the crop using the L-crops (see page 158), and mark the position on the front of the image.

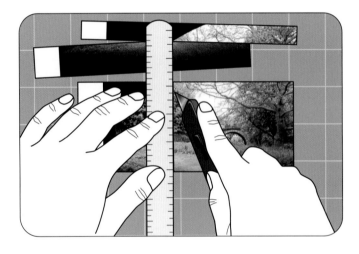

3 Crop the image down to size, cutting through the artwork or photograph and the cardboard beneath.

Cropping photographs

If you have several prints of the same image you can try out different crops to see which works best in the context of the final page.

Large photographs can often be cropped into several different, but related areas. Work out which parts you want to use before you begin cutting.

You can combine several different types of matting for a more complex effect – for instance you could relief mat a focal point for an effect similar to pyramage (see page 79).

Focal-point matting

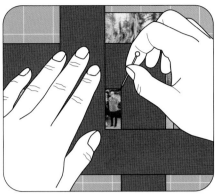

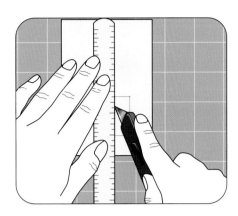

1 Using the L-crops, choose the focal point of the image. Use the grid on a cutting mat to make sure that the edges of the L-crops are parallel to the edges of the overall image. Mark each corner of the crop by piercing a tiny hole with a pin.

2 Lay the photograph face down on the cutting mat and carefully cut out the focal point between the pinholes, making sure you do not go past them and cut into the surrounding area of the photograph.

3 Single mat (see page 160) the focal point that you have removed onto contrast colour paper. Stick a wide piece of masking tape on the reverse of the main photograph under the cut out hole made in step 2.

4 Turn the photograph face up and stick the matted focal point back into place onto the masking tape, so the coloured mat overlaps the edges of the hole evenly.

5 With cut-out focal-point matting, the image is covered entirely with a layer of vellum or tracing paper onto which the outline of a single element within the image is drawn. Remove the vellum or tracing paper, cut away the shape, then replace it over the image.

scrapbooking

Photo mosaic

Several similar photographs can be combined to make a bigger image for more dramatic impact. Here two different views of the sea have been combined.

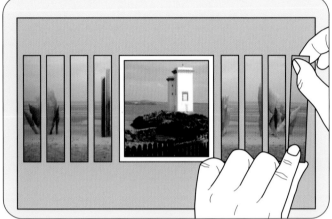

1 Stick lengths of double-sided tape over the back of the photograph that will form the background mosaic, but do not remove the backing yet. Turn the photograph over and cut it into strips for the mosaic, which can be even sizes or in different widths and lengths.

2 Single mat (see page 160) the main image and stick it in position on the page. Remove the backing on the mosaic strips and stick them on either side, keeping them evenly spaced. If there is a strong horizontal line, such as a horizon, try to keep it fairly level for best effect.

Making a mosaic

This type of mosaic works best when two related images are used. They don't have to be different views of the same scene, but they should have coordinating elements – in the example shown here, the photographs are both views of the sea.

When choosing the photographs to use, pick examples with similar colours and a similar tonal scale.

If you are taking several photographs to create a composite, try to keep the camera steady at the same level as you move it around for consecutive shots.

To make sure you have a series of overlapping photographs to work with, pick an identifying point at the edge of a shot and make sure it is included in the next one along.

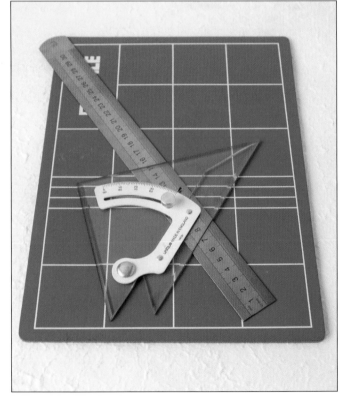

Use a set square to keep trimmed photographs square and cut with a craft knife on a cutting mat for clean edges.

Composite photographs

When shooting something very long or tall, it is often
impossible to frame it within a single image. However, a series
of photographs can be joined to look like one continuous picture.

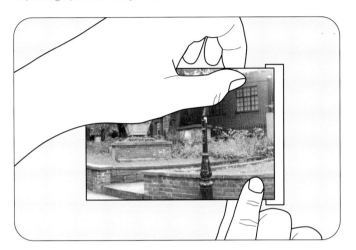

1 Select the series of photographs – if there are several
variations to choose from, pick examples that overlap in
view slightly and are similar tones. Place a strip of masking tape
sticky side up on the worktop and lay the first photograph with
the edge to be continued overlapping half the width of the tape.

2 Hold the second photograph over the first, looking for
strong vertical – or horizontal if the image is landscape –
lines in both photographs that can be used to align the image.
When it is correctly aligned, stick it down firmly onto the tape.
Continue on with any more photographs in the sequence.

3 Without removing the masking tape, fold the photographs
after the first to the back along the edge of the first – this
will leave a narrow strip of the second photograph protruding over
the edge. Stick a thin strip of double-sided tape to this, remove
the backing and fold the photographs back into position. Repeat
on any other joins.

4 Using a craft knife and metal ruler on a cutting mat,
trim the edges of the composite photograph straight and
square. When taking photographs for a composite image, try
to stand as still as possible moving only the camera as needed.
It is better to have too many overlapping images than to have
a gap in the sequence.

fixings

There are many different ways of attaching things to the scrapbook page, ranging from those that are only suitable for flat materials, such as photographs, to different pockets that can hold more bulky items.

Photo corners

1 Purchased photo corners come in a range of decorative shapes and different colours. Simply slide one onto each corner of the photograph or other flat artwork.

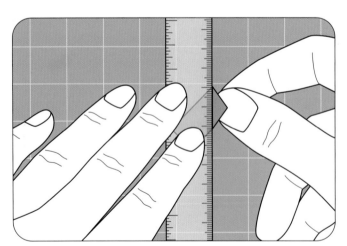

2 Either moisten the back of the photo corner, or peel off the self-adhesive backing, and press the corners to fix the item into position.

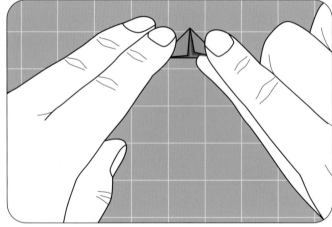

3 To make your own photo corners, cut a strip of paper 1 x 2.5cm (½ x 1in). Place a metal ruler to run from the centre point of one long edge to one of the opposite corners. Fold up the triangle of paper.

4 Repeat the process in the opposite direction to make a triangular folded corner. Press down the folds. Cut a small triangle of double-sided tape and stick it over the folded paper triangle, bridging the central join. Use as for purchased photo corners, above.

Foam pads

Foam pads come in many sizes and shapes and can be cut to size. The adhesive is strong and the pads are flexible, so they are ideal to stick rigid or hard items onto flexible cardboard – the foam acts as a buffer between the two surfaces. You can stack several pads if you want to lift the item well away from the surface of the backing.

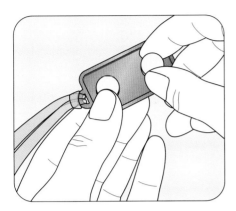

 1 Press one or more foam pads – depending on the size and shape of the item to be fixed – onto the back of the item.

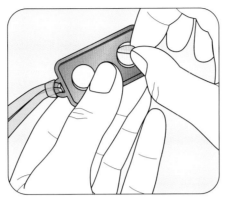

2 Peel off the backing from each pad. Position the item where it is to go and press it firmly into place.

Thread bare

Many different embroidery stitches are suitable to stitch items onto a page – see a good embroidery book for some ideas. Try using multi-colour or contrast threads to add extra interest.

Eyelets

Eyelets are simple to apply if you have the correct tools and are not only useful to fix objects down but can also be used to thread things through. They can be used on paper, cardboard and fabric and come in different colours and sizes.

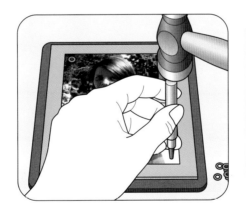

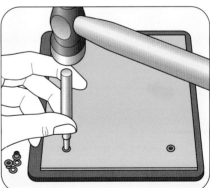

1 Align the layers to be fixed together and place them on a setting mat. Using an eyelet punch and a weighted hammer, and carefully following the manufacturer's instructions, punch a hole through all the layers where each eyelet is to be positioned. Drop a coloured eyelet into one of the punched holes.

2 Holding the eyelet in place, carefully turn the whole piece over and lay it back down on the setting mat. Using the eyelet setter and a weighted hammer, and carefully following the manufacturer's instructions, set the eyelet so the back of it opens out and grips in place.

Brads

Brads – also known as paper fasteners – are another simple adhesive-free way of fixing.

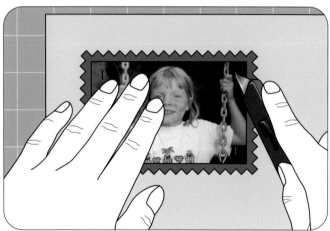

1 Align the layers to be fixed together and place them on a cutting mat. Push just the tip of a craft knife inside each corner to make a tiny slot.

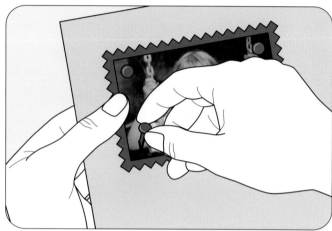

2 Push the arms of a brad through each slot. The brads are available in many sizes and colours so you can select ones that coordinate with the artwork or photograph.

3 Turn the piece over and open out the arms of each brad, pressing them back firmly to hold everything in place.

Using brads

The arms of the brads on the reverse may catch and tear if the page is taken out of the sleeve regularly for some reason, or isn't in a sleeve in the first place. Cover the opened out arms with a small square of sticky tape to prevent this.

Brads will obscure small portions of the photograph, so if this will be a problem use a different method of fixing.

You could also add just one or two brads purely as decoration and actually fix the photograph using other means.

Pockets

Pockets are ideal to accommodate an item that is to be removed and replaced several times, or is designed to be removed later and updated. The fabric pocket shown on page 171 is actually a small sealed bag to hold tiny mementoes, but it could also be made in the same way as the paper pocket so it has an open top – remember to hem or seal the edges if the fabric frays.

Paper pockets

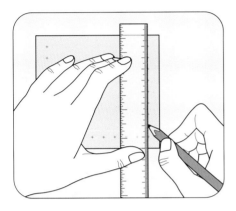

1 Cut a piece of paper 1cm (½in) deeper and 2.5cm (1in) wider than the internal pocket size required. Along both sides and the bottom, mark points 1cm (½in) in from the edge and about 1cm (½in) apart.

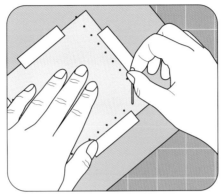

2 Position the pocket on the page and secure temporarily with pieces of low-tack tape. Lay the page on a foam mat and use a pin to pierce a hole at each mark made in step 1. Pierce a final hole just above the top edge of the pocket in line with the other holes.

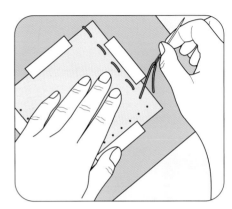

3 Thread a needle with coloured embroidery thread and knot the end. Bring the needle up through the top hole in one side of the pocket and take it down through the hole above the top edge. Bring the needle down through the second hole.

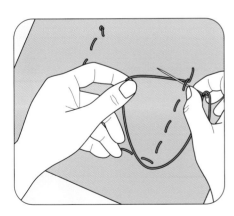

4 Continue working running stitch all around three edges of the pocket. When you reach the top of the last side, take the needle through to the back and knot the thread on the reverse.

Pockets are useful to hold removable items.

Slot pockets

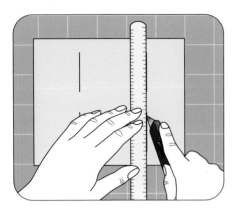
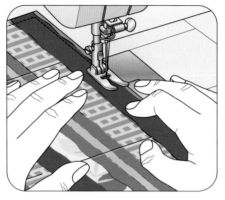
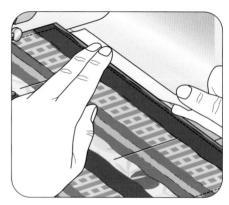

1 Mark and cut four horizontal slots on the reverse of the paper where the openings of the slots are to be. Here they are made in a wide collage strip applied to the front of the page to take tags, so the slots are 6cm (2⅜in) long, with the top two 6cm (2⅜in) from the top of the strip and the second two 10.5cm (4¼in) below the first two.

2 Lay the cut strip in position on the page, aligning the top, bottom and right-hand edges. Thread up a sewing machine and set the machine to a medium straight stitch. With the edge of the presser foot aligned with the edge of the collage, stitch along all four sides of the strip to attach it to the page.

3 To sew a straight line down the middle of the strip, place the edge under the presser foot so the needle is in the centre. Make sure the top edge is square to the presser foot then mark the right-hand edge with masking tape on the machine bed. Use the masking tape as a guide to stitch a straight line. Repeat across the strip to divide it into four.

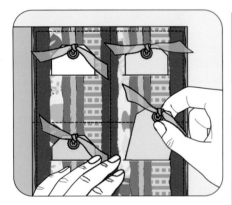

4 Finish off the rest of the page as required, and make up the tags – each of these tags has an organza bow on the top to make it easier to remove from the pocket. Slide each tag carefully into its pocket. If the size of the pocket is varied they can be adapted to take many different items.

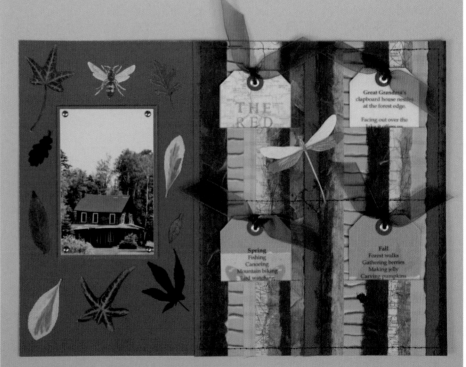

Removable tags can be updated regularly.

Fabric pockets

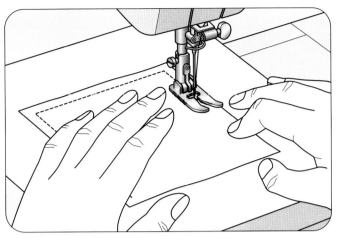

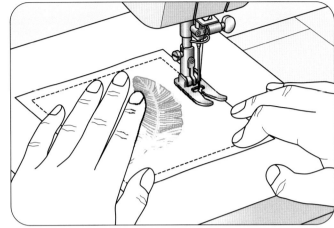

1 Cut a piece of sheer fabric, such as organza, and lay it on top of a larger piece of paper. Thread up a sewing machine and set it to a medium straight stitch. With the edge of the presser foot aligned with the edge of the fabric, stitch along all three sides.

2 Tuck a small item, such as a feather, flower petals or a pressed leaf, inside the pocket. Stitch the final side closed, stitching over a few of the original stitches at each corner to secure. Trim the thread ends.

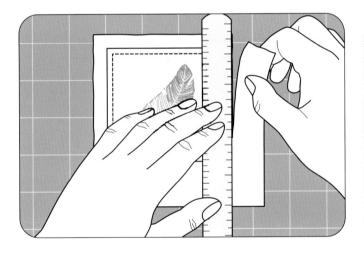

3 Using the grid on a cutting mat as a guide, tear all the edges of the paper against a steel ruler so the paper is 1cm (½in) larger all around than the fabric pocket. Stick the pocket to the page using double-sided tape.

Purchased pockets

Stationery stores sell a wide range of envelopes and files that can be adapted as storage pockets on scrapbook pages. Try using an ordinary plastic envelope file to store bulkier items – they come in a range of sizes and larger ones can be bound into the scrapbook if holes are punched along one edge.

Scrapbook stores also sell self-adhesive pockets, which are a quick and easy alternative to making them yourself.

creating text

Almost all scrapbook pages will have some form of text, even if it is only a title, a motto or a caption. Neat handwriting is perfectly acceptable, but if you are not confident about achieving a good result there are other options – there are even computer-generated fonts that look like handwriting.

Fonts

Serif fonts have fine cross-lines that finish off the strokes of each letter; sans-serif fonts do not so the letters have plain ends. Most fonts are also available in different styles, such as bold or italic, so you can introduce variety even if you stick to a single typeface. A computer generally comes pre-loaded with a selection of fonts and more can be downloaded free from some websites. As with anything else, fashion in fonts does tend to change so choosing a font for your project ultimately comes down to personal preference. Try to pick one that suits the project style – a script font will suit a heritage project better than a sans-serif, which has a more contemporary look. Don't use too many different fonts on one page – the result will probably look rather untidy unless they are combined very skilfully.

Transferring text

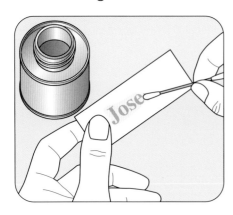

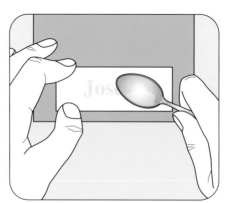

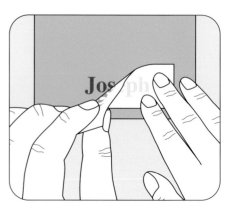

1 Photocopy the text in reverse. Dip a cotton bud into a little cellulose thinner and wipe it over the back of the photocopy – don't flood it, but make sure all the image is wet.

2 Position the photocopy face down on the page and firmly rub over the back with a teaspoon. Make sure you rub over the whole image but don't let it move on the page.

3 Carefully lift off the photocopy to reveal the transferred text. You can also transfer a photocopied motif in the same way.

Letter stickers

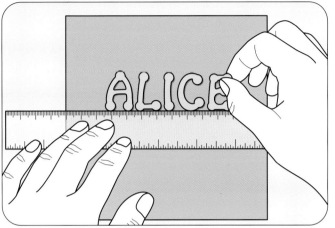 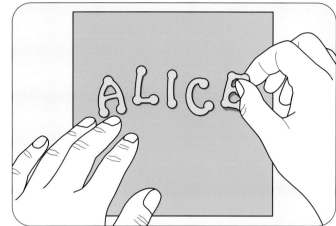

1 Before removing the backing, arrange the stickers in a straight line where they are to go, using a ruler as a guide. Peel off the backing and stick the letters down one by one. Placing the stickers in a straight line looks more formal.

2 For a more random, casual look, arrange the letters by eye on the page at slightly differing levels. When you are happy with the arrangement, peel off the backing and stick the letters down one by one.

Rub-down lettering

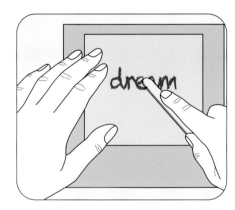 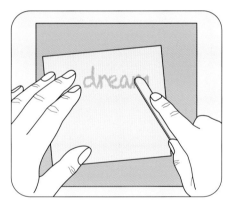

1 Rub-down lettering can be applied directly to the background of a project and is available in alphabets and as ready-made words or mottoes. Choose what you want to transfer, peel away the protective backing and rub down on the front of the carrier sheet following the manufacturer's instructions.

2 If the sheet did not come with a rubbing tool, use a wooden lollipop stick or a scoop-tip embossing tool. When the word is in place, carefully peel off the carrier sheet. Cover the word with the backing paper and lightly burnish over it with the rubbing tool – don't press too hard or you may damage the letters.

Computer printed lettering

Using a computer to generate titles and text offers endless opportunities, particularly with a colour printer. A computer with a reasonable quality printer will produce attractive looking and grammatically correct text quickly and easily. You can play around onscreen before printing, trying different fonts, sizes and colours – and often arrange text in circles or other shapes with the click of a mouse. Most printers will print on unconventional paper as long as it is not too thick, flimsy or slippery, but even conventional printer paper offers quite a few options.

Letter stamps

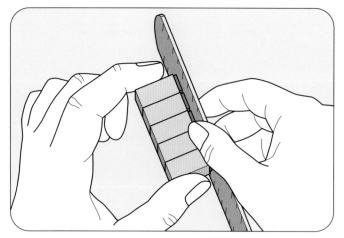

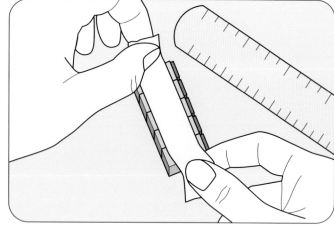

1 Alphabet stamps can be very flexible – you can use them with inkpads or embossing powder. To print in a straight line, make up the word with the individual letters and push the faces against a steel ruler to make sure all the letters are sitting level.

2 Move the ruler away carefully without moving the letters and lay a strip of masking tape along the side of the letter handles. Wrap the tape right around the handles to keep the letters together in a block as you stamp.

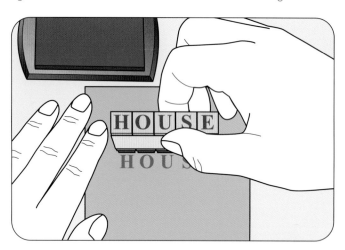

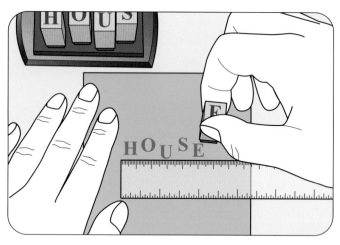

3 Use the block to stamp the word in position on the paper. To add extra interest you could try using different colours for different words or to highlight one word to make it stand out more. If you are stamping several lines, draw light guidelines in pencil.

4 To stamp an uneven line, use individual letters. Start in the centre, using the centre letter of the text, and stamp towards the ends, spacing by eye. If you are stamping under a photograph, position it but don't stick it down until you have finished stamping, so you can adjust if necessary.

Embossing foil

Letter stamps can also be used to emboss thin metal foil to make tags or title plates – see the technique on page 148.

You can also add lettering to your pages using stencils or rub-down lettering.

Found letters

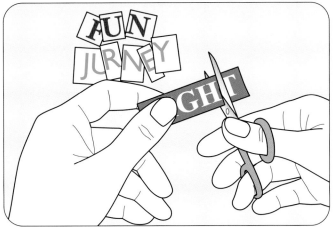

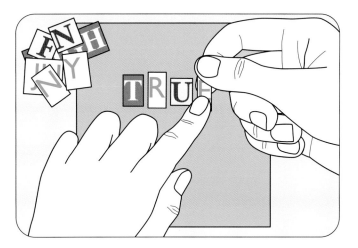

1 Letters torn or cut from magazines and made up into words using a collage technique can also be very effective. Carefully tear or cut out the letters you need.

2 Stick each letter down individually, using paper adhesive. You can either stick them direct to the page, or onto another sheet of paper that you then apply to the page.

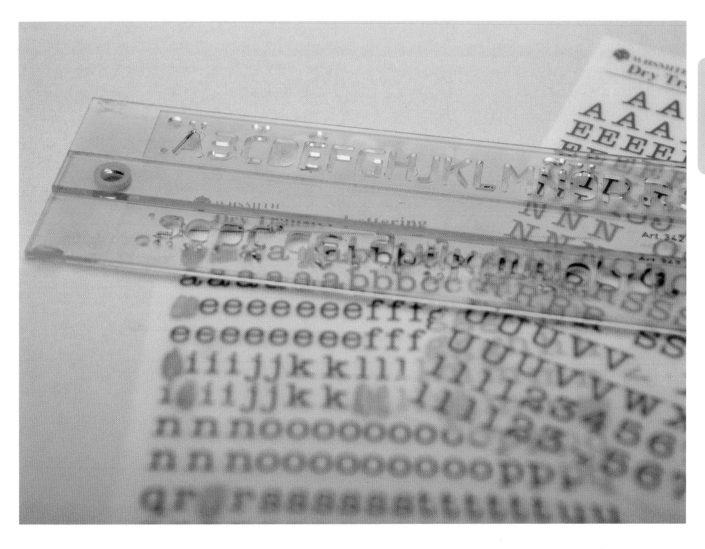

using fabric

Adding fabric to scrapbook pages not only creates additional texture but also offers the opportunity to make use of some different properties, such as frayed edges.

Felt

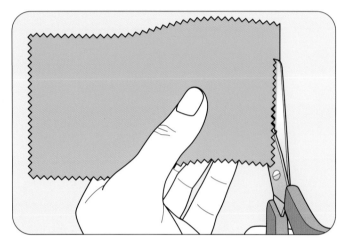

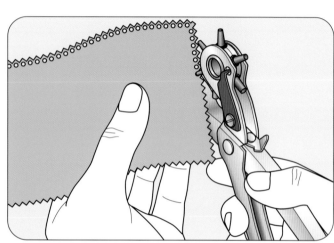

1 Felt is a very versatile fabric that can be cut or punched into shapes and stuck to the page. Since it doesn't fray, you can cut a decorative edge to a felt panel using pinking shears or other decorative edge scissors.

2 A leather punch can also be used to punch holes easily in the felt, which will stay crisp and clean. Here the holes are spaced closely together as a decorative border, but you could also space them further apart and thread with ribbon or embroidery thread.

Embroidered words make an unusual title or heading.

3 Thin felt is also a great fabric to embroider – here a title has been transferred to the felt and the letters are being embroidered using backstitch.

Woven fabric

1 Frayed edges can be exploited as a decorative border. Cut the fabric bigger than the image all around by the depth of the required frayed border.

2 Pull out the threads along each of the edges to the depth required – be careful not to fray too much.

3 Relief mat (see page 162) the photograph and stick it onto the fabric using double-sided tape.

Choosing fabric

The best type of fabric for this technique is one that is not too tightly woven so it will be easier to pull the threads. However, don't use something very loose woven or that frays badly anyway, or it will be hard to control the process.

The woven surface also needs to be flat and smooth – don't use a knobbly or textured fabric.

Image transfer

This technique is similar to the one used to transfer letters and images to paper, but is for transferring to fabric instead.

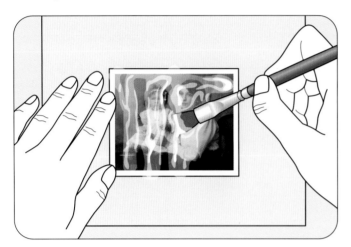

1 Photocopy the photograph in colour or black and white in reverse – don't use the original photograph as the paste won't work. Brush the transfer paste over the front of the photocopy, following the manufacturer's instructions and applying quite thickly.

2 Lay the photocopy face down on a piece of fabric a little larger than the final image required. Pat across the back gently with your fingers to make sure the photocopy is completely flat against the fabric everywhere.

3 Place a piece of kitchen paper over the photocopy and firmly roll over it using a brayer, round canister or rolling pin. Wipe away any excess paste that squeezes out and then allow the fabric and photocopy to dry, carefully following the manufacturer's instructions.

4 Place a wet sponge on the back of the photocopy and when the paper is thoroughly wet begin gently rubbing it off the fabric with the sponge; work from the centre outward to avoid lifting the image off the fabric. Allow the paper to dry, then repeat the soaking and rubbing if any paper residue is left. Seal the image by brushing a little transfer paste across it.

Pennants

A string of pennants adds a fun feeling to the page. Use coloured
fabric that doesn't fray – if it does, you will have to stabilize it with
iron-on fusible interfacing on the reverse before you cut the pennants.

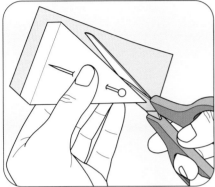 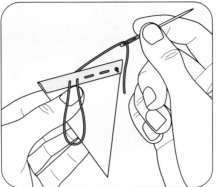 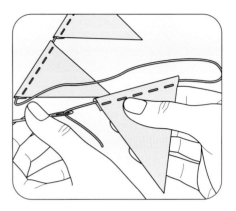

1 Draw a suitable pennant triangle and cut out to make a paper pattern. Pin the pattern to the fabric and cut as many pennants as you need.

2 Fold over the top edge. Thread a needle with coloured thread, knot the end and sew running stitch along the centre of the hem to make a casing.

3 Thread the needle with a long piece of cotton and thread through all the casings to make a string of pennants.

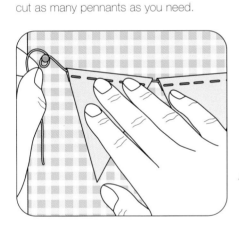

4 Fasten the string of pennants to a page by twisting each end of the thread around a brad set into the page.

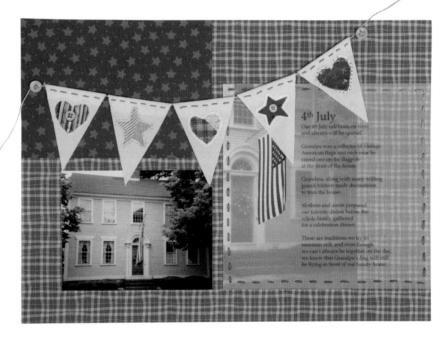

A string of pennants can be used as decoration
or lettered to add a word.

using ribbon and cord

Ribbons and cords can be used as both a purely decorative element and to hang items onto a page. There is a wide range of both available, but you can also make your own cords.

Ribbon

There are so many ways to use ribbon that it would be difficult to cover them all here, but one quick technique is to thread it through the page.

Bows

Ribbon bows are always useful, either purely as decoration or to finish off the ends of a ribbon attractively. For instructions on how to tie the perfect bow, see page 142.

Threaded

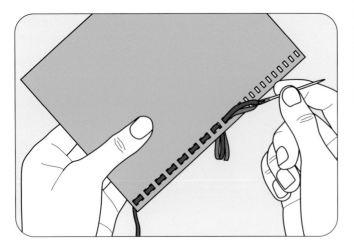

Punch or stamp a row of continuous evenly-spaced slots or holes along the edge of a page, or piece to be mounted on a page. Thread narrow ribbon in and out through the holes from top to bottom and secure the ends with all-purpose adhesive.

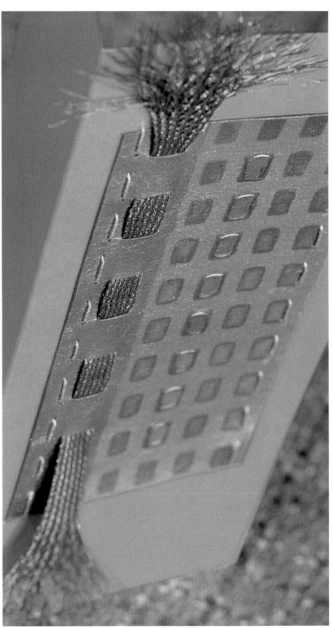

Fray the ends of the ribbon for an eyecatching effect.

Cords

When you make your own cords you can choose the thread colours to match other elements on the page and you can also make a tassel to match (see page 182) if you need to. Cords can be made by twisting or braiding embroidery thread.

Twisted cord

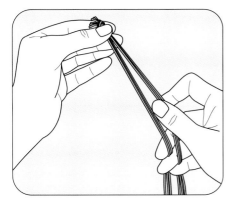
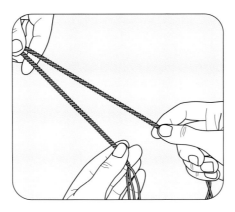
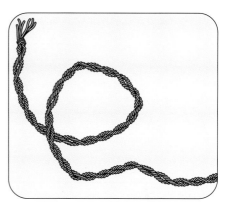

1 Cut several lengths of embroidery thread each about 30% longer than the finished cord length required. Knot the lengths together firmly at one end. Separate the threads into two groups – for an even twist there should be the same number of threads in each group.

2 Ask someone to hold the knotted end, or tie it firmly to something stable to anchor it in place. Holding one group of threads in each hand, begin to twist both groups in the same direction.

3 Continue twisting until the twisted groups start to kink. Bring the ends together and hold firmly. Release the knotted end and allow the twisted groups to coil up and twist together. Pull the cord straight and knot the loose ends. Trim and fluff each end.

Braided cord

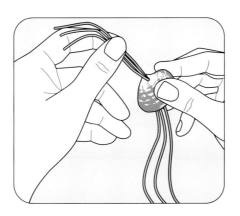
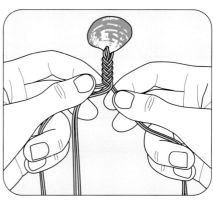

1 Cut three lengths of embroidery thread a little longer than twice the finished cord length required. At this point you could thread one end of each set of threads through an item to hang and push it halfway down.

2 Fold the threads in half – with the item sitting in the loop if applicable – and bring the ends together. Divide the six strands into three groups of two strands and tightly braid them together. When you reach the end, knot the loose ends together.

Tassels

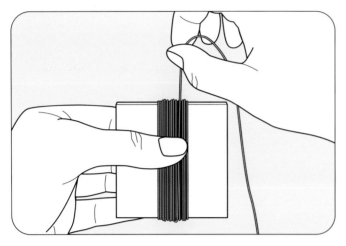

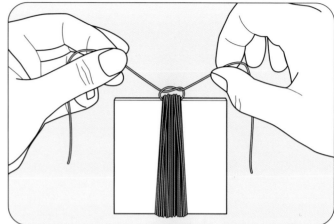

1 Cut a strip of cardboard the same height as the required length of the tassel. Wind the thread around the width of the cardboard until you have achieved the desired thickness to create a nice full tassel.

2 Slide a short length of thread under the wound loops, pull it up to the top edge of the cardboard and tie tightly to gather the tassel threads together firmly. Slide the loops off the cardboard.

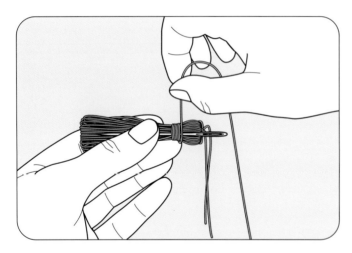

3 Hold a needle alongside the neck of the tassel with the eye towards the top. Bind around the tassel and needle, then thread the working end of the thread into the eye of the needle and pull it gently to conceal the thread end within the body of the tassel.

4 Cut through all the tassel loops at the bottom with a pair of sharp scissors. Trim the ends of the tassel level if necessary and fluff out the skirt a little to make the tassel as full as possible.

using buttons and tags

Buttons may not be an obvious embellishment for papercraft, but they can be very useful in all kinds of ways. They are available in many shapes, sizes and colours and are easy to attach with thread or with adhesive. Tags are also very versatile and here are a few more ideas on how to use them – see also pages 146–149.

Buttons stitched to page

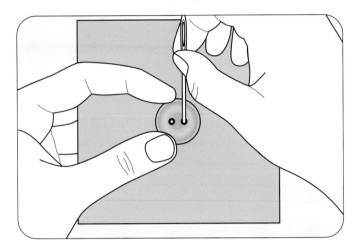

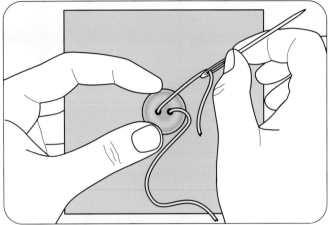

1 Lay a two-hole button in position on the page. Push the needle through the holes to pierce the page beneath with guide holes.

2 Thread the needle. Push it down through one hole and up through the other – or you can work the other way, so the knot made in the next step will be on the reverse.

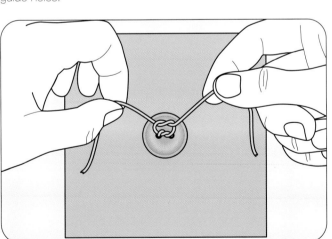

3 Knot the two ends of thread on top of the button and trim the ends short. For a four-hole button you could use a cross stitch to hold it in place.

Button box

Buttons are a wonderful way to decorate and add material to both scrapbook pages and cards, so it is worth building up a good stock to choose from.

If you plan to stitch the button to the page, the type with holes is probably the best option – it can be hard to get the type with a shank on the reverse to sit flat on the page.

If a shank-type button is otherwise ideal, you may be able to attach it flat to medium-weight card by punching a hole, threading the shank through it and then pushing a bar through the shank on the reverse to hold it in place.

Buttoned tags

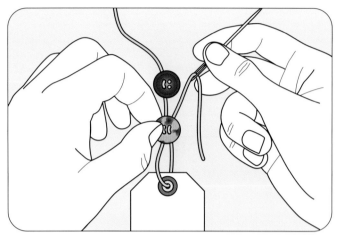 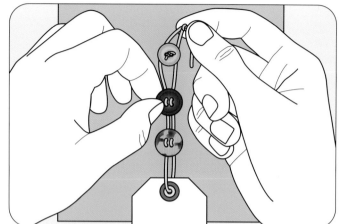

1 Thread the strings of a tag in and out of the parallel holes in a four-hole button, then slide the button down the string. When you have enough buttons threaded, knot the ends of the string. If you want to space the buttons apart, you could knot the strings between each button.

2 You can also use a button to attach a tag or other hanging element to the page. Stitch the button to the page as described on page 68. Hang the loop of the tag or other hanging element over the stitched-on button.

Button carrying an image

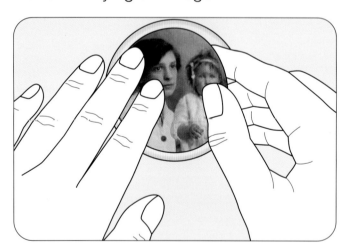 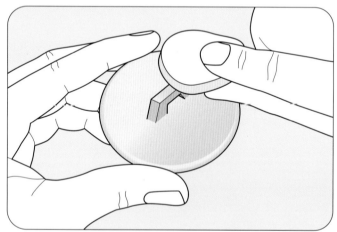

1 Cut out a circle from a photocopied image to fit inside the rim of a button. Using a suitable adhesive, stick the image to the front of the button.

2 If the button has a shank, push the shank into a thick adhesive dot or foam pad. If it is flat, use an adhesive dot, then stick the button to the page.

Attaching tags

1 A tag can be hung from an eyelet – see page 167 for information on setting eyelets. Make sure the hanging tag will not be damaged when the page is turned – if it is only decorated on one side, it can be held in position with an adhesive dot.

2 A single-sided tag can also be held in place using a brad – see page 168 for information on using brads. Make sure that the head of the brad is larger than the hole in the tag. If the tag is round, you could consider making a hole in the centre for the brad.

3 A double-sided tag that needs to be removable can be placed in a pocket – see pages 169–171 for information on making pockets.

Tags

Purchased tags come in many different sizes and shapes, but usually a rather limited range of colours. For techniques on how to make your own tags, see pages 146–147.

There are more interesting methods of attaching the tag to a page than just sticking it down with adhesive or foam pads – see below for some alternative techniques.

4 A removable tag could also be held in place using a decorative paper clip – these now come in many attractive shapes, sizes and finishes.

5 Tie the tag around another item on the page using interesting fibres – fibres are increasingly popular in scrapbooking and can be chosen to coordinate with the colours on the page.

adding found material

Scrapbook pages that commemorate an event may incorporate found material, which may not be flat and can be fragile – such as shells. Here is a technique for mounting and protecting such items.

Shells

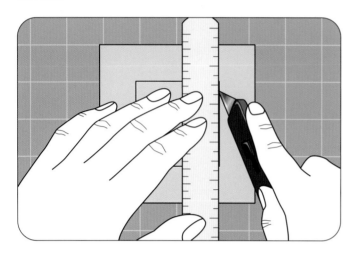

1 Cut a rectangle or square in paper to coordinate with the shell. Cut an opening in the paper, centred top to bottom and side to side, that is large enough to hold the shell.

2 Cut a piece of thick cardboard slightly smaller than the piece of paper and cut an opening in the centre that is 1cm (½in) larger all round than the opening in the paper.

3 Stick the paper to the cardboard using double-sided tape, then stick the frame in position on the page. Using adhesive dots, stick the shell carefully inside the frame.

Botanicals are items of plant origin, and these are often collected to add to a scrapbook page as mementoes of a special day or place. Never collect rare or protected species.

Fresh-picked leaves and flowers should be pressed before use – use a flower press or place them between layers of absorbent paper underneath a pile of heavy books. They are often quite fragile, so handle with care and use an adhesive that will not drag the surface as it is applied, or discolour with time.

For additional protection, try laminating botanicals by applying an area of white craft adhesive to the page, adding the botanical and then applying another layer of craft adhesive over the top to seal the item into a little pocket.

Seeds and other small particles can be stored in small fabric pockets – see page 171.

When mounting botanicals, try to choose a background paper in sympathy with them – perhaps a paper with inclusions, natural fibres or even wood veneer.

Found material is ideal to bring back memories of a special day.

papercutting

The universal art of papercutting is a well known, traditional folk craft; garlands, silhouettes, paper lanterns and purely decorative items can all be made in paper. Recycling is an important element – finding, collecting and using small scraps of discarded paper to incorporate into new artworks.

papercutting tools and techniques

Part of the appeal of papercutting is that it is inexpensive and the tools and specialist techniques are kept to a minimum. To make most projects all you will need are a pencil and ruler and perhaps tracing paper for transferring the design, and cutting tools such as sharp scissors or a craft knife and cutting mat.

Garlands

Garlands are one of the simplest forms of papercutting – many will have tried this technique as a child. However, even though the basic technique may be simple, designs can range from fairly plain to very complex, so there is something for all skill levels.

People garland

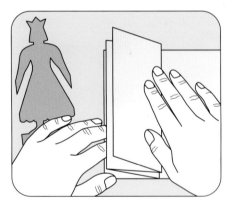 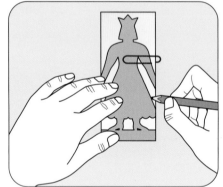 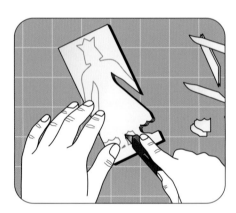

1 Cut a long strip of cartridge paper 20 x 85cm (8 x 34in). Lay one of the templates on page 293 on one end of the strip and mark the width of the template base on the paper. Pleat the paper concertina-style into ten sections, using the marked width of the template base as a guide.

2 It is important that the paper is folded evenly to the exact width of the template base. Cut off any excess paper at the end. Lay the template on top of the folded paper and secure with paper clips. Draw around the outline of the shape neatly with a sharp pencil, moving the paper clips as necessary.

3 Place the folded paper on a cutting mat and carefully cut away the surplus paper outside the outline of the template with a craft knife. It may not be possible to cut through all layers in one go, but the pressure of the knife should mark cutting lines clearly so two or three layers can be cut at once.

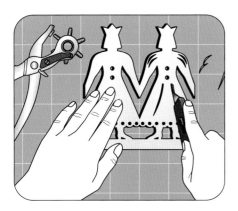

4 Use a medium-size hole punch through all layers to make the buttonholes in the bodice. Use a small hole punch to add other details, such as skirt hem design and the boot and cuff buttons. Cut the strip details with the craft knife, using the photograph below as a guide. Open out the garland.

The papercut figures can be decorated in many different ways.

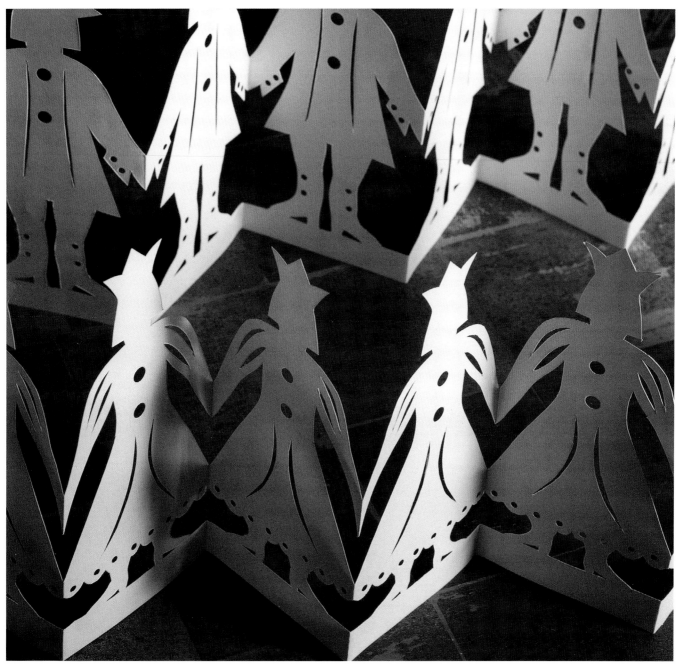

Shelf edging

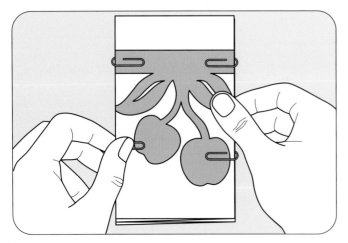

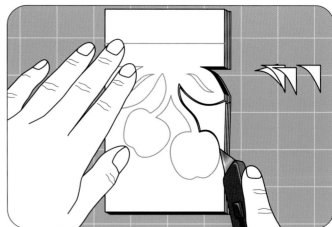

1 Cut a long strip of copy paper 11.5cm (4½in) deep for the cherry or leaf border and 15cm (6in) deep for the house design. Lay one of the appropriate templates on page 299 on one end of the strip and mark the width of the template top on the paper. Pleat the paper concertina-style into as many sections as possible, using the marked width of the template base as a guide. It is important that the paper is folded evenly to the exact width of the template top. Cut off any excess paper at the end. Lay the template on top of the folded paper and secure with paper clips or staples above the design.

2 Draw around the outline of the shape neatly with a sharp pencil, moving the paper clips as necessary. Place the folded paper on a cutting mat and carefully cut away the surplus paper outside the outline of the template with a craft knife – it should be possible to cut through all layers in one go.

Extra colour

Try sticking the finished garland onto a contrasting strip of coloured paper using spray mount. Trim the coloured paper so a narrow border is left at top and bottom. You could also try colouring in some of the repeated elements instead.

3 Open out the garland. Make as many garlands as required to run the entire length of the shelf edge. Either pin or use double-sided tape to fix the garlands in a continuous strip to the edge of the shelf – the join between separate sections should fall exactly on a fold line, so it will not be obvious in the finished design.

Mexican ceiling banners

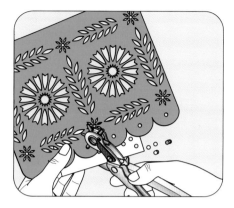

1 Enlarge the template on page 294. Fold three different colour sheets of tissue paper in half – each folded sheet must be slightly larger all around than the template. Stack the folded sheets with the fold at the bottom edge. Use tape or staples to secure the layers together along the two side edges. Lay the template onto the layers with its top edge aligned with the top cut edges. Draw around the outlines of the template with a fine pen.

2 Remove the template, place the tissue layers on a cutting mat and carefully cut away all the internal shapes of the design with a sharp craft knife. Tissue paper is very fragile, so you need to take great care when cutting – it helps to turn the paper rather than the knife when cutting different angles. Do not cut the small round holes in the flower centres and the scalloped edge at this stage.

3 When all the internal flower petals and leaves have been cut away, carefully cut the scalloped edge along the bottom with sharp scissors. Because tissue paper tears so easily, to cut the small round holes place a scrap of thin cardboard under each before cutting with a hole punch. Lastly, cut the straight sides of the banner with the craft knife or scissors, which will also separate the sheets into individual banners.

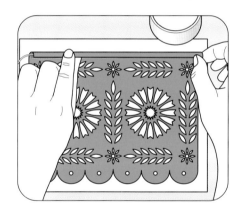

4 Separate the layers and lay one on a piece of scrap paper. Brush a line of paper adhesive about 1cm (½in) wide along the top edge of the banner. Leaving a long end to one side as a tie, lay a length of thread along the sticky strip. Fold the top edge of the banner over the thread, pressing in place firmly. Leave a gap about 3cm (1¼in) and then add the next banner. Leave another long tie at the end. Leave to dry, then hang the banners.

Brightly coloured tissue paper is ideal for banners.

papercut cards

Many papercutting techniques can also be used to make unusual cards and gift tags. The glove gift tag in this section is inspired by American folk art designs from the mid-nineteenth century – the hand shape is very appropriate in this instance because an open hand traditionally signifies friendship and generosity.

Change of address card

1 Enlarge the template on page 288 as indicated. Place it onto a piece of ivory cardboard and secure in place with paper clips. Draw around the template with a sharp pencil.

2 Place the cardboard on a cutting mat and carefully cut around the marked lines with a sharp craft knife, using a metal ruler as a guide.

3 On the wrong side, score fold lines down the tree centres, across the base of the roof and on each side of the house. Turn the card over and score the remaining lines.

4 With right side facing, bend the scored lines to create the three-dimensional effect of the card. Write change of address details on the reverse.

This design would also make an unusual Christmas card.

Paper lace card

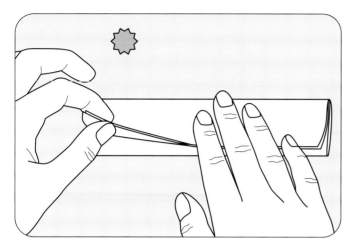

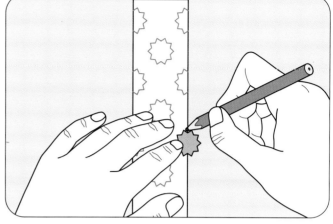

1 Trace a suitable star shape onto cardboard and cut out to make a template. Cut a piece of tracing paper or baking parchment 17.5cm (7in) square and fold in half. Fold it in half again, folding in the same direction. Crease the paper quite firmly each time.

2 Position the template in the middle of the folded parchment and draw around it in pencil. Position the template just above the first outline, with half of it overlapping the folded edge of the parchment. Draw around it as before. Re-position it on the other edge of the paper and draw around it again.

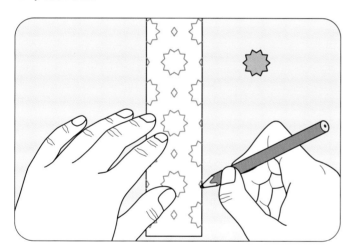

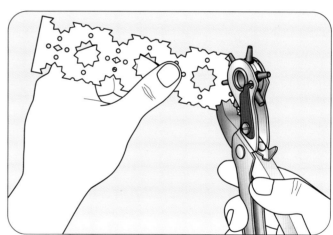

3 Continue in this pattern of whole and half outlines. Work up to one end of the paper, then work down from the middle to the other end. Draw a freehand diamond between each central outline, and half-diamonds between each half outline. The final pattern should look like this.

4 Use the tips of sharp, pointed scissors to cut a slit in the middle of each shape, then cut out to the edges and around the outline. Make sure that you keep the folds in the paper on top of one another all the time you are cutting. Use a leather punch to punch the small holes between the cut outs.

papercutting

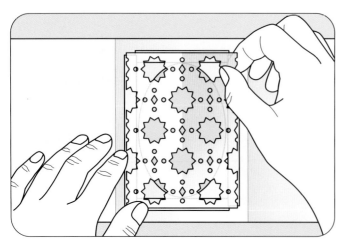 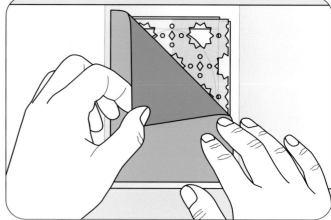

5 Carefully unfold the parchment to reveal the lacy pattern. Lay a piece of scrap paper on top and firmly rub to flatten the creases as much as possible. The lacy paper will make two cards, so cut it slightly smaller than the centre panel of an aperture card blank. Stick double-sided tape around the edges of the centre panel. Peel off the backing and lay the lacy paper over the tape, centring it so some tape is still exposed.

6 Cut a piece of coloured paper slightly smaller than the lacy paper. Lay the coloured paper over the lacy paper, pressing it down onto the tape showing through the lace cut outs, ensuring that it fills the whole aperture. Fold the card closed, pressing the covering panel down onto the remainder of the exposed tape.

Papercut designs

The basic technique for the paper lace card can be adapted in many different ways – any repeating pattern that is simple enough to cut out easily will be suitable.

The basic paper lace design can also be embellished in any way you choose.

As an alternative, you could mount a collage of snowflake circles (see page 204) on a coloured ground and use this behind the window of the card for an unusual Christmas card.

The finished effect is pretty and delicate.

Gift tags

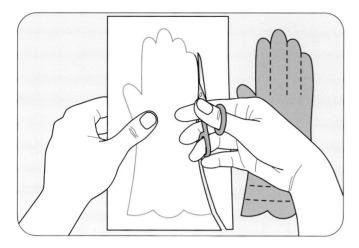

1 Enlarge the templates on page 295 as required. Place the glove template on ivory handmade paper, hold in place with paper clips and draw around it. Remove the template and cut around the glove outline only with sharp scissors.

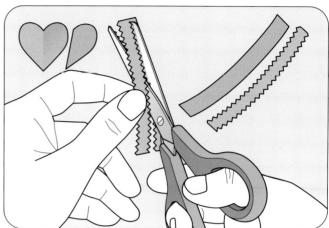

2 Fold a sheet of recycled pink paper in half and place the straight side of the heart template against the fold. Cut out the heart, and also cut the two curved strips from the pink paper. Cut a zigzag edge along each strip using pinking shears.

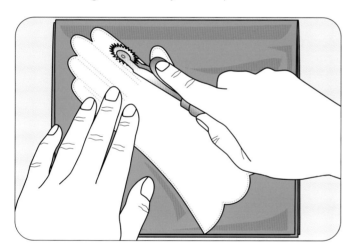

3 Place the glove on a soft surface such as a wad of tissue paper. Using a tracing wheel, press firmly while wheeling it around the edge of the glove. Make two parallel lines in the same way between each finger.

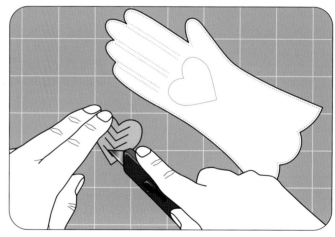

4 Open the heart and place on the back of the glove with the point facing the cuff. Lightly draw around it with a sharp pencil. Cut four parallel V-shaped slits across the centre of the heart, with each arm about 1cm (½in) long.

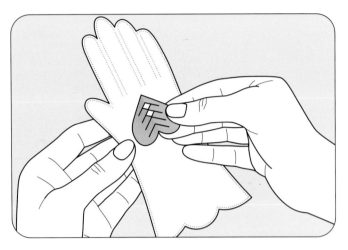

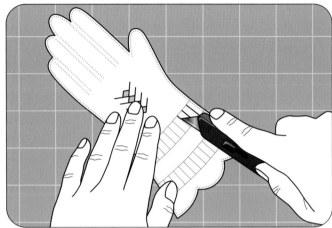

5 Cut matching slits in the heart shape on the back of the glove. Rub out the pencil heart outline on the glove. With the tip of the pink heart now facing the fingers, carefully interlock the points of the slits to fix the heart in place.

6 Lightly mark the four parallel lines on the cuff of the glove in pencil. Place the glove onto a cutting mat and cut 12 evenly spaced slits between the lower pair of lines and ten slits between the upper pair of lines nearest the fingers.

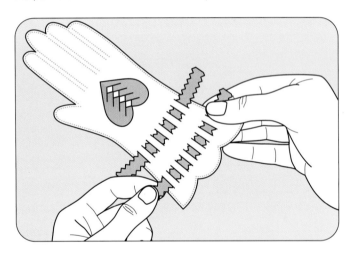

7 Turn the glove over to the right side and carefully slot the pinked strips in and out through the slits. Trim the ends so that 1cm (½in) overlaps the edge and turn this under to the back of the glove. Stick in place with paper adhesive.

8 Still working from the wrong side, place the glove on the soft surface again. Using a larger tracing wheel mark each side of the strips on the cuff and along the centre of each finger and the thumb. Punch a hole in the cuff for the ribbon.

Interlocking

The interlocking method used to attach the heart to the back of the glove could be developed to produce a more intricate and decorative pattern. It is a pretty and functional way to attach two pieces together without using any adhesive, which could also be used on cards or scrapbook pages.

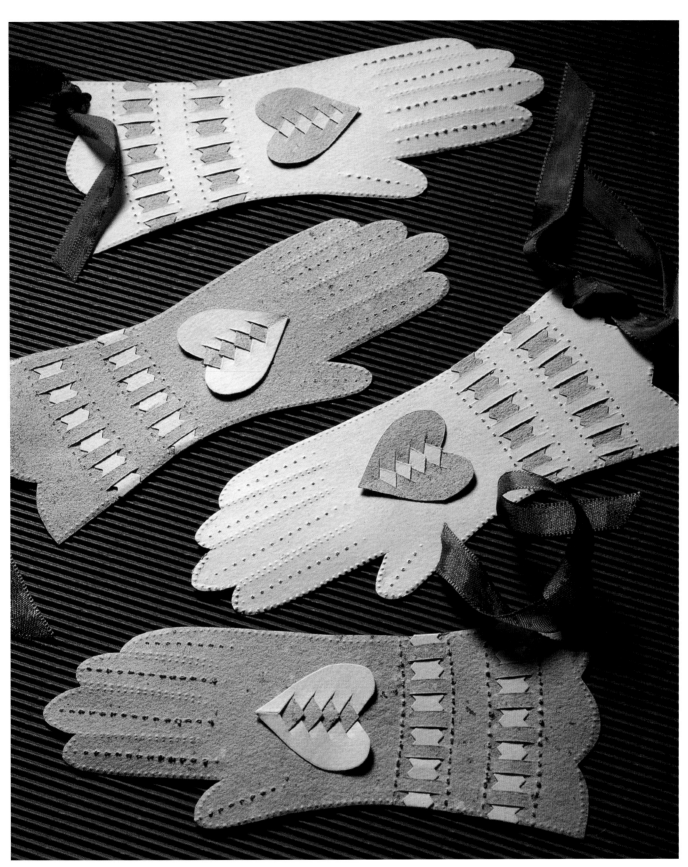

The textured surface of the handmade paper makes the gloves look as if they are made from suede.

lanterns

Paper is ideal to create decorative and inexpensive lanterns, and different types will produced wonderfully varied effects. Use papercutting to create patterns for the light to shine through.

Punched and pierced lanterns

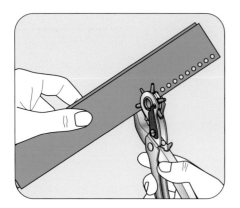 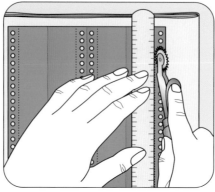 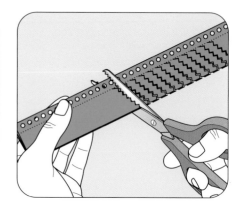

1 Fold the paper into four lengthways, making three fold lines to create a concertina. Use a hole punch to make a line of holes along the side of the folded paper that has one fold and two cut edges. When you open up, this makes a single line of neat holes at each cut edge and a double line along the middle fold.

2 Using a wad of tissue paper as a yielding base, place the punched paper on top and make raised dotted lines by wheeling the tracing wheel along the side of the ruler. These lines should be placed so that they run beside each line of punched holes.

3 Fold the paper again along the original folds, then use pinking shears to cut a series of cuts at a slant along the edge with a double fold. These need to stop the same distance away from the dotted line as that line is from the punched holes, and about 2cm (⅞in) from each end.

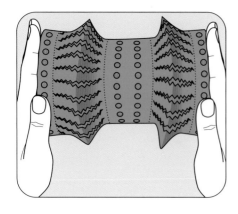

4 Cut a length of double-sided tape and stick it along the inside edge of one end of the lantern. Roll the cylinder over and carefully stick the ends together. Using both hands, gently press the two ends towards each other to accentuate the pinked folds.

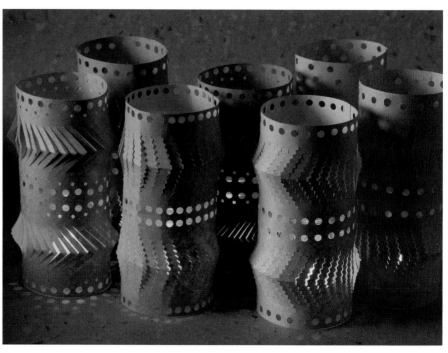

The lanterns can be papercut in many different ways.

Dahlia candle shades

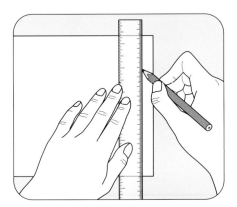 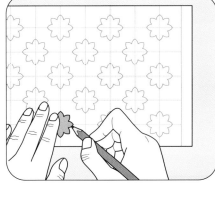 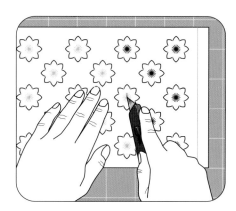

1 Cut a piece of parchment or thick translucent paper 25 x 36.5cm (10 x 14½in) – it needs to be paper that will look good lit from behind. Use a pencil and ruler to mark off a 2cm (⅞in) wide strip along each short edge.

2 Work out a grid for the flower positions between the end strips – here four vertical rows of three flowers, with three rows of two flowers between. Trace the flower template on page 289 and transfer onto the paper.

3 Cut the flower outlines, leaving a small area uncut where each petal meets the next so the whole flower is not detached. Cut a 16-point star into the centre of each flower – mark it first if you are not confident cutting freehand.

4 Rub out all pencil marks. Carefully pull up each petal and curl so it stays raised. Push gently from behind the flower centre to create raised stamens. Roll the paper into a cylinder shape and stick together along the strip marked in step 1.

Fire safety

When placing a paper lantern over a candle or nightlight, put the candle in a glass jar or nightlight holder then put the shade around the jar to avoid the risk of fire.

Using translucent parchment paper, or paper with inclusions, adds an extra dimension to a paper shade when it is lit up from behind.

A group of lanterns is very effective.

papercutting

Star light

1 Enlarge the template on page 298 as required. Trace it five times onto a piece of cardboard, making a tiny mark where the fold lines meet. Cut the outlines out with sharp scissors.

2 Score all the internal lines shown on the template that mark the fold lines for the edges and for the fold-in tabs. Fold up one section to make one point of the star. Fold the tabs inward as shown.

3 Press and hold the two long folded sides together and use a hole punch to punch an even row of holes just inside the fold line. Repeat steps 2 and 3 on the other four star pieces.

4 Fold a star point back into shape. Stick a length of double-sided tape onto the folded over tab. Push the tab under the opposite side and stick both sides firmly together. Use your fingers to gently press the join from the outside.

5 Make up the other four points in the same way. Place two points together so that the punched sides align and staple the matching tabs three times along each side, or stick with double-sided tape. Leave the last join open.

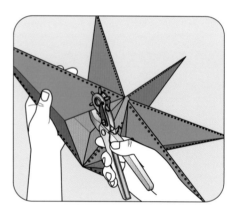

6 The open last join will allow the star to open so an electric cable and bulb can be inserted. Make two larger fixing holes with a punch, exactly opposite each other, on either side of the last join opening.

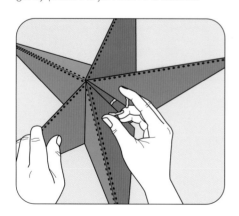

7 Thread a small 40W bulb on the end of an electric cable through the open join, so the bulb sits inside the star light. Hold the join closed by threading a pipe cleaner through the two holes and twisting the ends together to secure.

Using electricity

For safety, always make sure that any wiring for electric light bulbs is carried out by a fully-qualified electrician.

You could hang this star light as a shade onto a fixed bare pendant ceiling bulb, as long as the bulb is a low-temperature type.

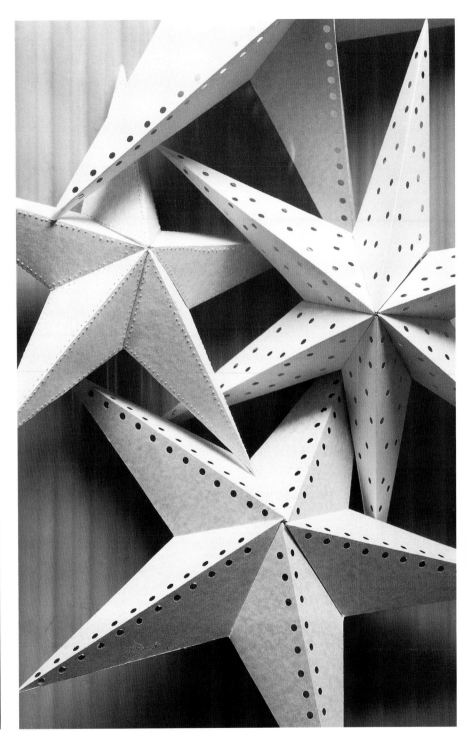

The same basic star can be made to look quite different by changing the design of the punched decoration.

papercut decorations

Papercut decorations that feature folding and cutting paper into symmetrical designs can be made in all shapes and sizes. Most of the decorations in this section can either be hung up or applied to windows, walls or other surfaces.

Snowflake circles

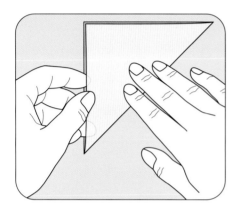

1 Cut a piece of either textured or patterned paper to around 10cm (4in) square and fold in half diagonally, to make a triangle.

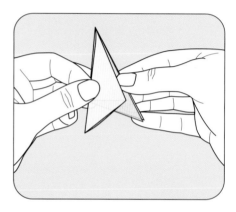

2 Next fold the piece of paper in half again down the middle of the triangle, to make a smaller triangle.

3 This time accordion-fold the triangle into three sections, aligning the long straight edges perfectly each time.

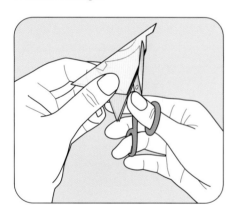
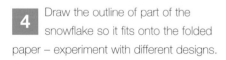

4 Draw the outline of part of the snowflake so it fits onto the folded paper – experiment with different designs.

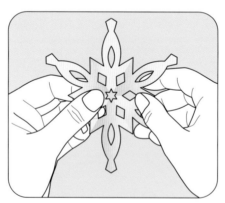

5 Unfold the paper carefully to reveal the cut snowflake. Make several more snowflakes in a range of different sizes and shapes.

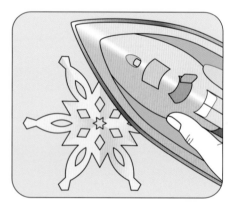

6 Set the iron to warm and press each snowflake gently to remove as many of the folding creases as possible.

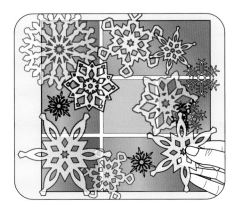

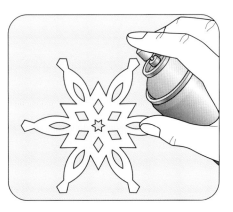

A great way of using these snowflakes would be to thread them at random onto several very long lengths of thread, which you could then hang against a wall or a window to create your own paper snowstorm.

7 If you are planning to stick the snowflakes down arrange them in a suitable design, shifting them around until you are happy with the overall look.

8 Remove the snowflakes one at a time and spray one side with adhesive. Stick each one down in turn, being careful not to disturb the overall arrangement.

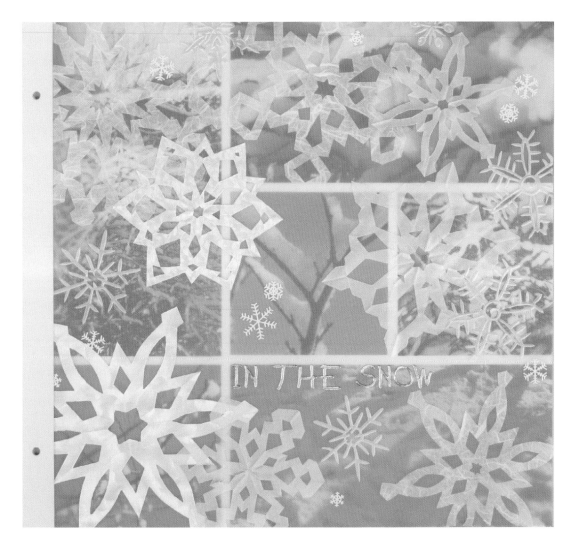

It's easy to make many different designs.

Girandole

1 Twist a length of 1.5mm (¹⁄₁₆in) thick galvanized wire into a ring measuring 30cm (12in) in diameter. Cut a long strip of crêpe paper 3cm (1¼in) wide. Make a series of snips 2cm (⅞in) deep all along one side.

2 Secure one end of the fringed crêpe paper onto the wire ring with adhesive and then tightly wind the rest of the strip over the ring. Wrap towards yourself, with the unsnipped side facing, so the frills show. Secure ends with adhesive when they meet.

3 Use scissors to cut the flower template on page 289 from several folded layers of both lilac and purple crêpe paper. Cut slits between petals as indicated by dotted lines. Fold up the sides of each petal by pressing firmly between finger and thumb. Set aside.

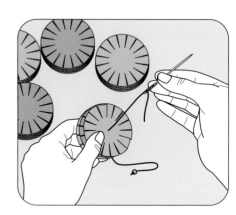

4 Using the large round template on page 289, cut two piles each of pale and dark yellow and pale and dark orange crêpe paper, and three piles of purple and bright pink crêpe paper. Snip into the edge all around each. Use the small circle template to cut 30 each in orange, yellow and pale pink crêpe paper.

5 Cut another 15 small circles for the central stem of the girandole. Cut 30 pieces of coloured plastic straw in pink, orange and yellow each 3cm (1¼in) long. Cut a further 15 lengths in orange for the central stem.

6 For the pom-pom, cut a 60cm (24in) length of strong thread, thread into a needle and tie a knot at the end. Slip a small bead onto the thread above the knot. Start to thread alternate layers of large pale and dark orange circles until you have used up one pile of each colour.

A girandole with added garlands made in the same way.

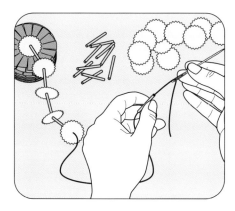
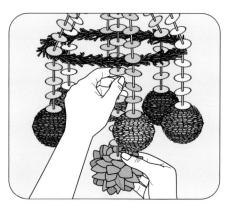
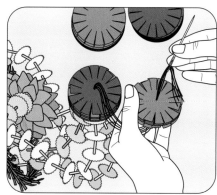

7 Put a dab of adhesive in the centre of the top circle and thread a small yellow disc on top, pushing it down to hold the pom-pom together. Thread 15 alternate pink straws and small yellow discs onto the thread. Make up the other pom-pom strings in the same way.

8 Wind a pom-pom string around the wire ring so that four of the discs hang below it. Place each two of the same colour pom-poms opposite each other, suspending the girandole so you can hang them evenly.

9 Thread the purple and lilac petals to make a flower pom-pom, threading orange straws and pink discs above it. Suspend in the centre, gathering all the threads at the top and threading them through the final purple and pink pom-pom. Stick the threads together with adhesive to make a hanging loop.

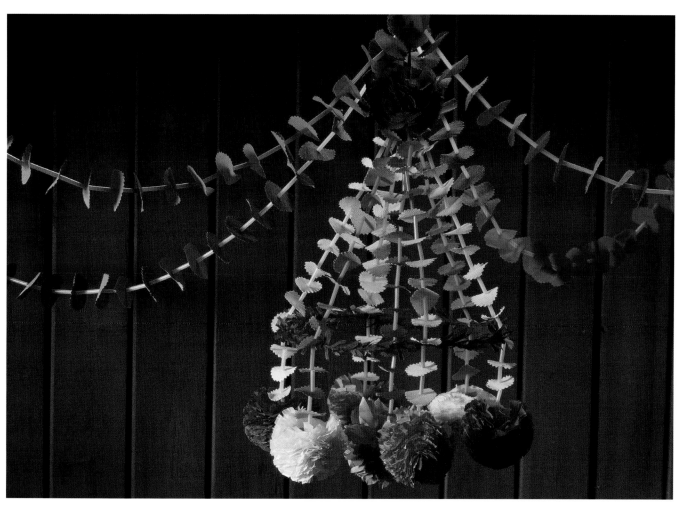

Papercut decoupage tray

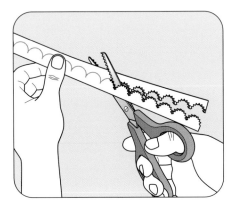

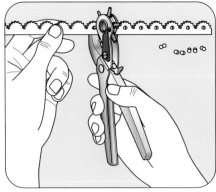

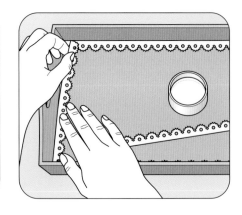

1 Cut a strip of white paper 5cm (2in) wide and slightly longer than the longer side of the tray. Fold the strip in half lengthways and trace around a small circular lid to make a line of semi-circles along one edge. Cut the scallops with pinking shears.

2 Use a hole punch to punch a hole in the centre of each scallop. Cut along the folded edge with scissors or a craft knife. Repeat with a second strip cut slightly longer than the shorter side of the tray. Trim the strips to exactly fit the edges inside the tray.

3 Using wallpaper or paper adhesive, smear a light layer of adhesive along the edges of the tray base and the underside of the strips. Lay the strips in place along the edges of the tray, pressing them firming into place with your fingers.

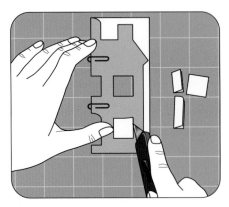

4 Enlarge the house template on page 288 as required. Fold a piece of white paper in half and place the template along the fold as indicated. Place on a cutting mat and cut out the house shape with a sharp craft knife. Mark the centre of the tray.

5 Smear a little of the adhesive on the tray where the house will be positioned. Unfold the house and add a thin layer of adhesive to the back. Place the house in position and smooth out any air bubbles – the paper may stretch but will dry smooth.

6 Enlarge the templates for the trees and the birds and cut them from white paper in the same way. Stick in position on either side of the house. Cut the bird wings freehand from scraps of patterned paper and add one on top of each bird.

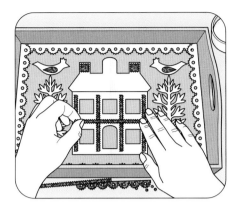

7 Use pinking shears to cut 1cm (½in) wide strips of patterned paper to decorate the front of the house. Cut a scalloped and punched strip for the eaves and squares for the chimney pots. Save a couple of the punched out circles to use for doorknobs.

8 Cut glazing bars for the windows from white paper using pinking shears. Stick all the decoration in place, using the photograph below as a guide. Leave the glue to dry thoroughly. Rub out any pencil marks and apply two coats of clear varnish.

Adapt the design as required to fit your tray.

3-dimensional shapes

Papercutting techniques can also be adapted to make exciting three-dimensional items. Here are three alternative ways of creating beautiful items in paper that can be displayed in the home.

Papercut bird

1 Copy the template on page 293 onto thin ivory or white cardboard, or thick cartridge paper, and cut out two identical bird shapes.

2 Stick the two bird bodies together using paper adhesive, but do not put any adhesive on the wings, crown or tail. Press together firmly.

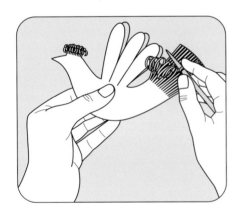

3 Using small sharp scissors, cut thin parallel strips into the crown and the tail through both thicknesses of the cardboard.

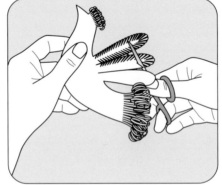

4 Roll each strip on both the crown and tail tightly around a knitting needle to produce a curl. Arrange the curls evenly on each side of the bird.

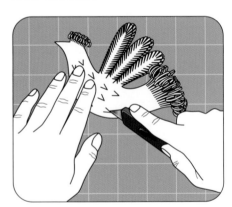

5 Using the scissors, make tiny angled cuts all around the edges of the three sections of the wings, cutting through both layers of cardboard.

6 Place the bird on a cutting mat and make tiny V-shaped cuts arranged along the body and all pointing towards the tail.

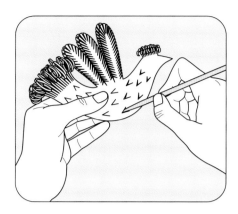

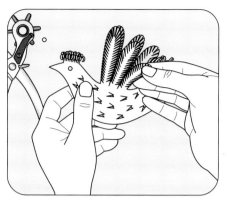

7 Holding the bird away from the surface, use the tip of a knitting needle to push all the V-shaped sections towards the front of the bird.

8 Punch a hole for the eye. Pull the wings apart slightly, arranging them into a flying position with three sections on each side.

Flying birds

The birds have been used here to decorate an Easter nest, but they would be lovely made up into a mobile to suspend over a baby's crib.

At Christmas, place a glittering sequin in each bird's beak to catch the light and use to decorate the tree.

The papercut birds can be used for decoration in many ways, or adapted to decorate a card.

papercutting | **211**

Picture frame

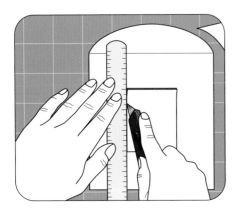
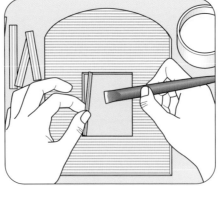
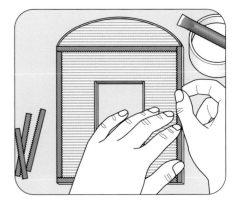

1 Cut a 34 x 25cm (13½ x 10in) piece of white corrugated cardboard. Measure 27.5cm (11in) up along the two long sides and draw an arc from these two points across the top of the cardboard, using a plate as a guide. Cut the top into a curve. Measure a 7.5cm (3in) border all around the rectangular section of the frame and cut out a central aperture.

2 Repeat step 1 using a piece of plain scrap cardboard. Use double-sided tape to stick this to the reverse of the corrugated cardboard to stiffen it. Cut narrow strips of white corrugated cardboard to cover the raw edges around the inside and the outside of the frame. Stick in place, being careful not to get adhesive on the front of the frame.

3 Cut narrow strips of pink cardboard 1.5cm (⅝in) wide and trim one edge with pinking shears. Stick around the rectangular section of the frame and around the aperture with the zigzag edge facing inwards. Enlarge all the templates on page 295 as required. Copy them onto the pink cardboard and cut out all the shapes.

4 On the back of the pink cardboard shapes, score all the dotted lines indicated on the templates. Gently bend the shapes along the scored lines to create a three-dimensional effect. Using dabs of adhesive, stick the urn and two leaves to the top semi-circle of the frame and the scrolls onto the borders around the aperture.

The finished frame is very dramatic.

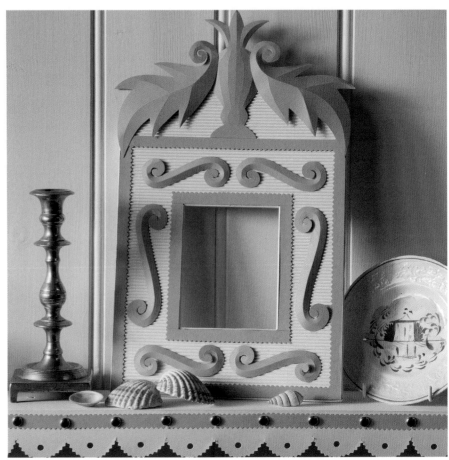

Alphabet cubes

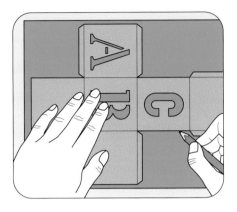

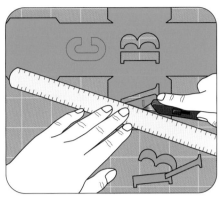

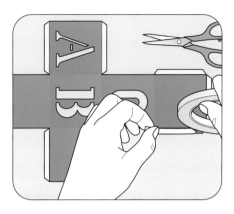

1 Enlarge the template on page 289 as required and copy it onto thin coloured cardboard or thick cartridge paper. Cut around the outline.

2 Place the cardboard on a cutting mat and cut out around the letter shapes. Use a metal ruler on straight sections and cut curved sections very carefully freehand.

3 Score the lines between sections and along each side that has a tab. Stick a narrow strip of double-sided tape along each tab.

4 Bend along all the scored lines to fold the cardboard into a cube. Remove the backing from the tape and press the tabs firmly into position.

The alphabet cubes could be used to spell out a name or other word.

origami

Origami is a traditional Japanese technique of folding paper into representations of flowers, birds, animals and even little gift containers. Most designs are folded from a simple square of paper – special origami paper often has a different colour on each side – without cutting or adhesive.

origami materials and symbols

Almost any kind of paper is suitable for origami – although some projects work better with thinner paper, others with thicker, so it is worth experimenting when folding a new design. Dyed colour paper is the same colour on both sides and all the way through, while commercial origami paper is usually only printed with a colour or design on one side.

Cutting squares from rectangles

Origami paper usually comes in squares, but most other suitable paper, including dyed paper, comes in rectangular sheets so you will need to cut them down to a square.

Creasing method

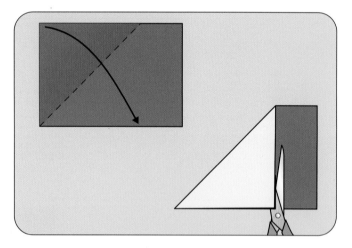

Fold the left-hand edge onto the bottom edge. Hold the edges together and crease firmly all along the diagonal fold line. Holding the bottom point of the triangle firmly, cut upwards with scissors using the vertical side of the triangle as a guide. Unfold the square.

No-crease method

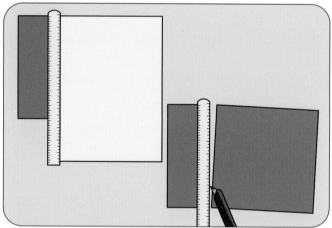

Line up the top and right-hand edge of two identical pieces of paper, one horizontal and one vertical, on a cutting mat. Holding firmly in place, lay a metal ruler along the left-hand edge of the upper sheet. Remove the upper sheet and cut along the right-hand side of the ruler with a craft knife. With a sharp knife, it is possible to cut several sheets at once.

basic techniques and folds

Origami diagrams show before and after in sequence, so look ahead to see what the finished fold should look like. All diagrams have written instructions so read these first – it's easy to unfold an incorrect fold, but your design will look better if only folded as necessary. In the diagrams, edges of the paper are shown as solid lines, dash lines indicate folds or creases made in the current step; folds made in a previous step are shown as a narrow solid line. Dotted lines indicate edges hidden behind the model, imaginary lines or the shafts of fold arrows that pass behind the paper.

Common origami symbols

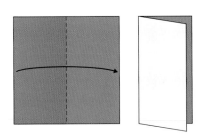

▲ Fold towards you (valley fold)

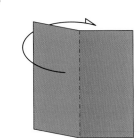

▲ Fold away from you (mountain fold)

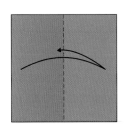

▲ Fold, crease firmly, then unfold

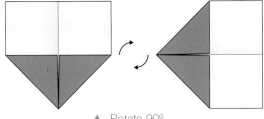

▲ Rotate 90°

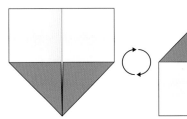

▲ Rotate 180°

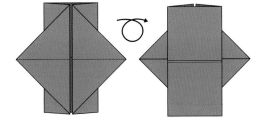

▲ Turn paper over

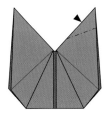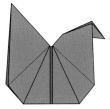

▲ Push here

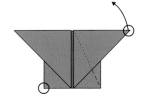

▲ Hold here

Reverse fold

Many of the models use a technique called the reverse fold, in which the end section of the fold is reversed.

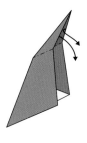

◄ Fold over at the point you want the reverse fold to begin. Hold the original fold line just below this point, open out the fold above the point slightly and push down.

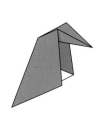

◄ The finished reverse fold. Part of the model is now enclosed between two outer layers of paper and a section of the fold now folds the other way.

flowers

There are countless different flower variations that can be folded, but here is a simple traditional blossom with a variation to turn it into a more complex waterlily. For the waterlily version, try using two different colour papers for the different sections to add extra interest.

Blossom

1 Use a square of 15cm (6in) origami paper coloured on one side, with the white side up. Fold the square in half horizontally.

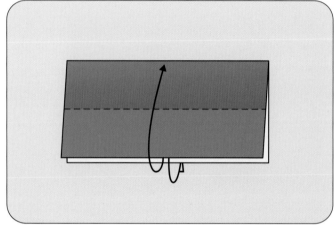

2 Fold the cut edge at the bottom over to meet the fold at the top. Repeat on the other side.

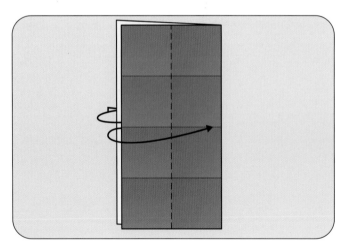

3 Completely unfold the paper and repeat the folding sequence in steps 1 and 2, but this time folding vertically.

4 The paper is now folded into a grid of 16 squares, with a central cross of valley folds and an outer grid of mountain folds.

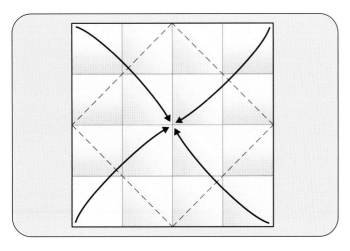

5 Still with the white side of the paper facing up, fold each of the four corners into the centre.

6 Unfold the paper completely again and turn it over.

7 The coloured side is now uppermost, and the quarter creases are valley folds. Begin to fold on these creases.

8 At the same time push in on the centre of each side so the square begins to collapse in on itself.

Paper flowers

When folding an origami design for the first time it may be worth trying it out on a piece of spare paper first. Although incorrect folds can be unfolded, they do leave a lasting mark that may look untidy on the finished item.

Ordinary photocopier paper is ideal for test models, because it takes a good crease.

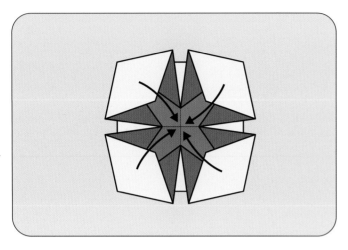

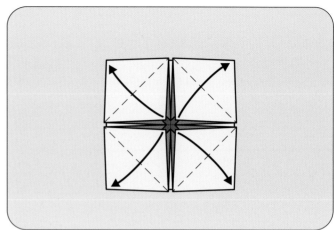

9 Press the folded paper flat so the front face shows four equal white squares and the coloured face is inside. At this point you have created a traditional origami base known as the Froebel Pattern Fold.

10 Take the centre corner of each of the small squares and fold it back to the outer corner.

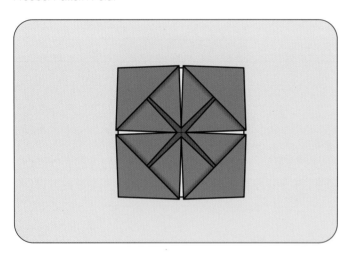

11 The completed blossom, one of the traditional flower shapes that is based on the Froebel Pattern Fold. Try experimenting with folding back the different flaps for variations on this basic design.

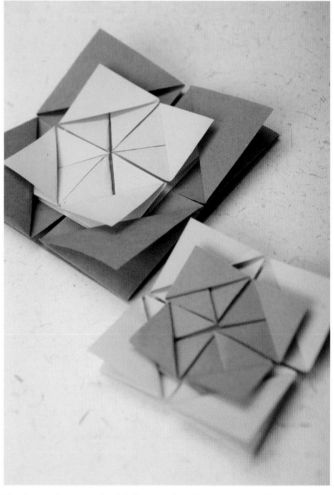

The flower shape can be left flat or curl up the outer petals for a more three-dimensional look.

Waterlily

1 Make a blossom as shown on pages 218–220. Now repeat all the steps for the blossom again, but using a square of 10cm (4in) origami paper coloured on one side.

2 You now have two blossom flowers of different sizes. Hold each at the two opposite corners as indicated and pull them slightly open.

3 Nest the smaller flower inside the larger flower so the two flowers will interlock.

4 The finished waterlily – when you flatten the unit, make sure the tips of the inner flower petals remain outside the flower.

origami

birds

Origami also has many traditional bird designs. Here are two of the easy ones, the swallowtail chicken – which has two secret compartments for hidden messages – and an elegant swan. Both these designs are made in ordinary coloured paper, with the same colour on both sides.

Swallowtail chicken

1 Fold the square of paper in half horizontally, crease firmly and then unfold.

2 Turn the paper over so the valley fold made in step 1 is now a mountain fold.

3 Fold the cut edges at the top and the bottom over to meet the fold across the centre.

4 Fold each corner over so the point aligns with the centre fold, as shown above.

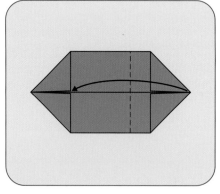

5 Fold the right-hand point over to meet the tips of the opposite triangles, as shown.

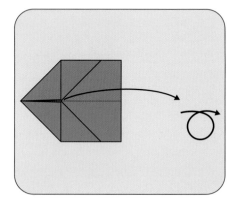

6 Open out the fold you just made and turn the paper over.

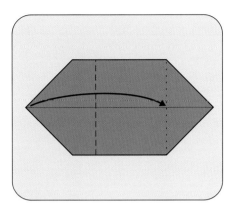

7 Fold the left-hand point over to meet the imaginary line across the tips of the opposite triangles on the other side, as shown.

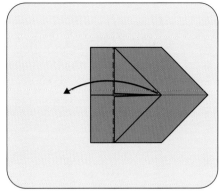

8 Fold the top pair of triangles back along the line across their tips, as shown.

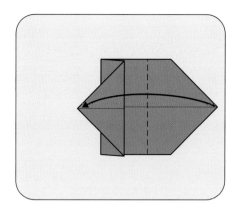

9 Fold the right-hand point over to align with the left-hand point. Crease into place firmly.

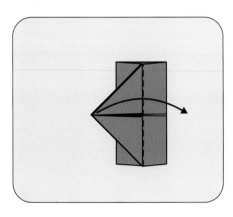

10 Fold the right-hand point back out to the right, again using the line across the tips of the triangles as a guide for the fold line.

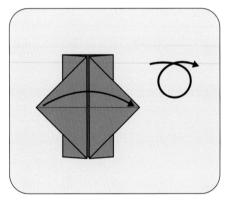

11 Turn over the unit you have made.

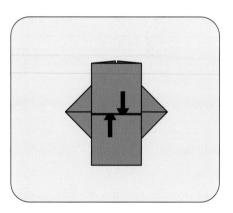

12 The chicken has two pockets on this side to conceal messages.

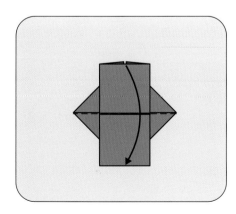

13 Fold in half from top to bottom to conceal the pockets.

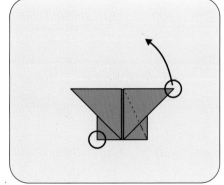

14 Hold the bottom left-hand corner and pull upward on the right-hand point to fold it outwards.

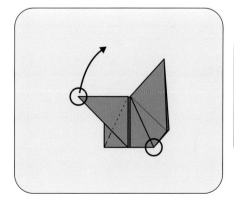

15 Repeat step 14 in reverse on the opposite side.

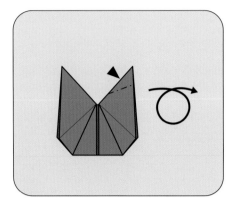

16 Fold either of the top points inside out in a reverse fold to form the head and beak.

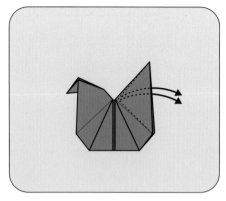

17 Carefully pull out both tail flaps on the opposite side to the head.

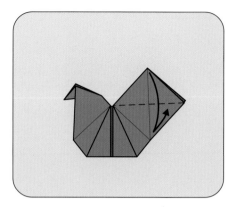

18 Fold the tail over in half, crease firmly and then unfold.

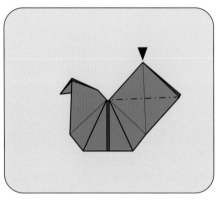

19 Push down on the top point of the tail to turn it inside between the layers in a reverse fold.

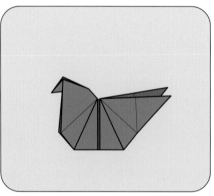

20 Spread the tail out and stand the chicken up.

Origami birds

The basic chicken can be adapted to make similar birds – once you have folded it correctly a few times, experiment to see what else you can make using similar steps. You could also try folding the chicken in paper coloured on one side only for a different effect.

Water birds, such as the duck, swan or crane, are considered to be symbols of romantic love in Japanese folklore, because these birds mate for life.

Swan

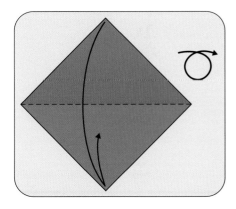

1 Fold the square of paper in half diagonally, crease firmly and then unfold. Turn the paper over.

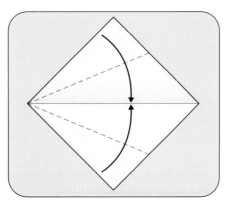

2 The fold you have just made is now a mountain fold. Fold the top and bottom edges in towards the central crease. Leave a tiny gap between the edges but try and keep the left-hand corner sharp.

3 Fold the two outer edges of the new shape in towards the centre crease.

4 Fold the full shape in half along the central crease – the small gap left in step 3 should mean you can do this without splitting the paper.

5 Fold the front point across to the right – there is no location point for this, so do it by eye referring to the diagram. The point should align with the slope of the tail, as indicated by the dotted lines.

6 Open out the fold made in the previous step. Push inward to reverse fold the body into the front point using the creases just made.

Paper size

The swan has a long neck, so you will need to begin with a fairly large piece of paper. Use thin paper as the head requires many tiny folds that will be hard to achieve in thicker paper.

origami

7 Continue to form the head and neck by folding over the front point as indicated.

8 Open the fold out and make another reverse fold into the front point as before. Crease firmly.

9 Open out the reverse folds made in steps 6 and 8 and the fold made in step 4. Fold over the very tip of the front point to the nearest crease to begin forming the beak.

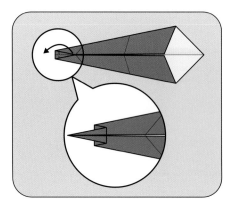

10 Fold the tip of the beak back again. Remake the folds from steps 5, 8 and 10.

11 The head of the swan should now look like this. Refine the shape of the head by making two more tiny folds on either side and reverse fold the front of the head into the neck.

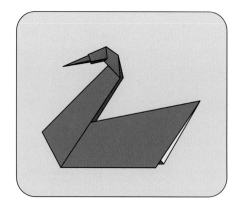

12 The finished swan. You could also reverse fold the tail at this point if you prefer.

animals

In this section, the bull's head is made using two-sided origami paper – the different colours are used to create additional detail in the shape. The jumping frog that follows it is one of the most popular origami designs in the world.

Bull's head

1 Use a square of origami paper coloured on one side, with the white side up. Make a small pinch fold in the centre of the bottom of the square.

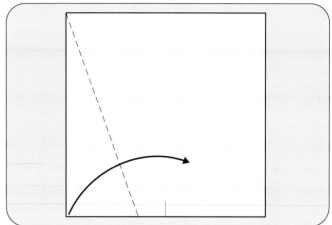

2 Fold the bottom left-hand corner across as shown, using the pinch fold made in step 1 as a guide for positioning.

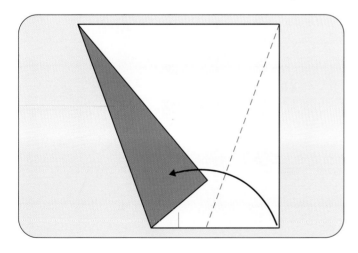

3 Make a second fold on the other side as a mirror image of the fold made in step 2.

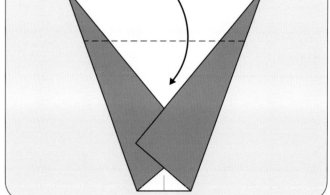

4 Fold the top edge downward as shown – refer to step 5 as a guide for positioning.

origami

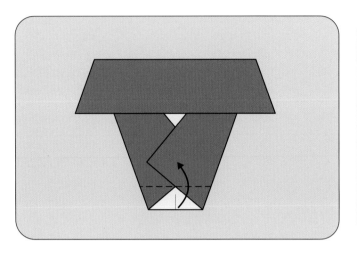 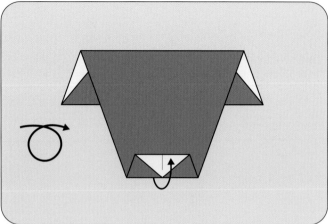

5 Fold the bottom edge upwards – the fold should come very slightly above the point of the white triangle.

6 Swing the bottom flap that you just made over to the other side and turn the finished bull's head over.

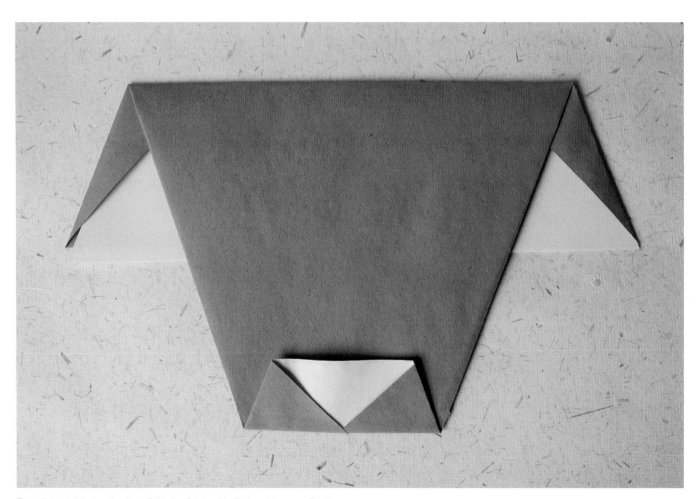

Even though it is so simple to fold, the finished bull's head is very effective.

Jumping frog

1 Take a square of coloured paper and fold in half vertically. Crease firmly and then unfold again. Turn the paper over.

2 The fold you made in step 1 is now a mountain fold. Fold the paper in half horizontally, crease firmly and unfold.

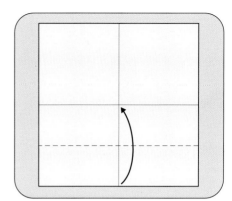

3 Fold the bottom edge up to meet the crease made in step 2. Crease the fold firmly.

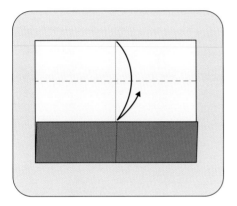

4 Fold the top edge down to meet the crease made in step 2. Crease firmly and then unfold again.

5 Fold the left and right-hand edges in to meet the crease made in step 1. Crease firmly.

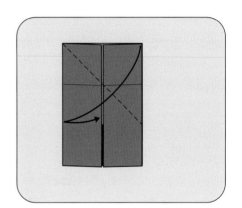

6 Fold the top right-hand corner diagonally down to align with the left-hand edge. Crease firmly and then unfold it again.

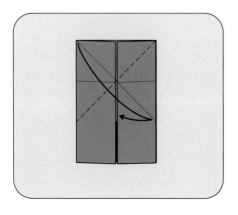

7 Fold the top left-hand corner diagonally down to align with the right-hand edge. Crease firmly and then unfold again.

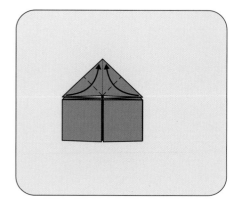

8 Push the sides inward as indicated so they meet at the centre and the top folds down into a triangle.

9 Fold the left and right corners of the triangle up to meet the top corner.

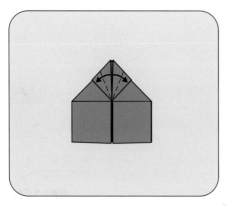

10 Fold the central edges of each small triangle outward again as indicated, folding the small triangles in half so the points protrude.

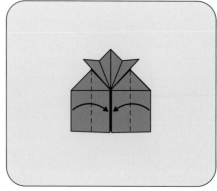

11 Fold the left- and right-hand edges into the centre. Make sure all the creases are sharp.

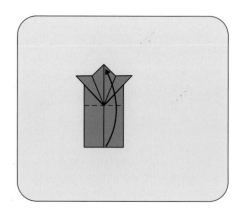

12 Fold in half so the bottom edge aligns with the top point.

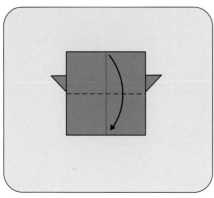

13 Fold the top half back down again to align with the bottom. Only crease gently.

14 Allow the creases to spring apart slightly. Turn the frog over.

15 Stand the frog as shown. Press on the back edge as indicated to make the frog jump forwards.

Different origami models can be combined for a bright and colourful display.

mini-origami

Small origami forms are ideal as decorative motifs for envelopes, notelets, cards or as decorative containers to present small gifts.

Leaf notelet

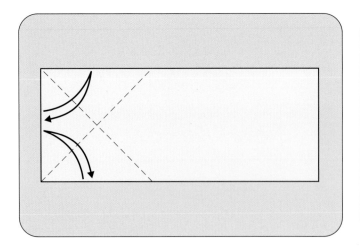

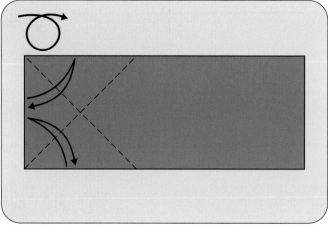

1 Use a piece of writing stationery or double-sided paper around 10 x 25cm (4 x 10in). With the white side uppermost, fold over one corner diagonally and unfold. Repeat with the other corner at the same end to make an X-shape crease.

2 Turn the paper over. Refold the same creases the opposite way on this side.

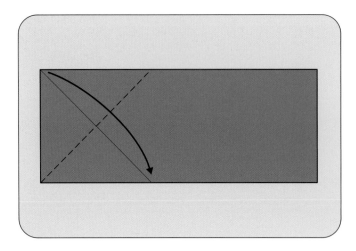

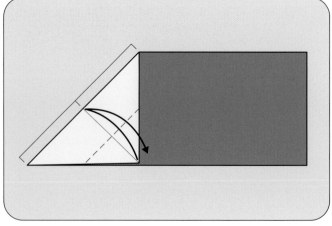

3 Fold the top left corner down to the bottom edge along the existing crease.

4 Fold the point of the triangular flap just made to the centre of the folded edge. Crease sharply and then unfold.

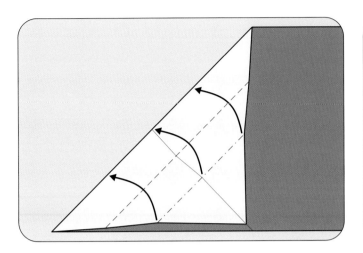

5 Recrease the fold just made to change it from a valley fold to a mountain fold. Fold this mountain fold up to the outer edge fold.

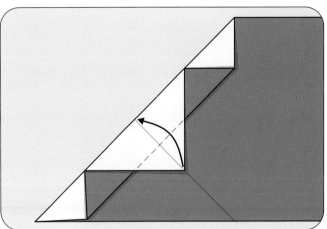

6 Fold the corner of the triangle up to the centre of the outer fold edge to make a row of equal triangles.

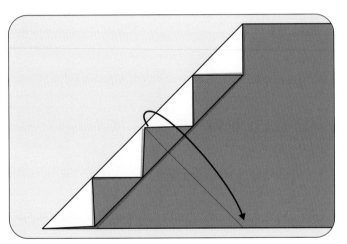

7 Unfold the edge again – you will now have a triangle folded into four equal strips.

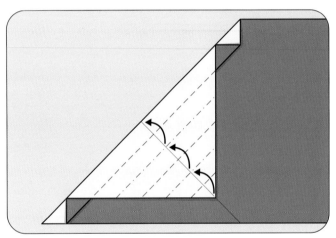

8 Recrease all three folds to change them from valley folds to mountain folds. Fold each mountain fold up to the adjacent fold, creating a new valley fold between each pair.

Folds and creases

The leaf notelet requires lots of narrow pleats, so accurate folding is essential.

Size the notelet to fit a standard envelope and fold a set of unusual stationery to give as a gift.

9 Unfold the edge again – you will now have a triangle folded into eight equal strips.

10 Recrease any valley folds to make them into mountain folds. Fold each mountain fold up to the adjacent fold again, creating a new valley fold between each pair. The triangle will now be folded into sixteen equal strips.

11 Take hold of the band of pleats at each end and fold it over to the reverse of the paper.

12 Fold the bottom left corner along one of the original diagonal creases so it meets the top corner.

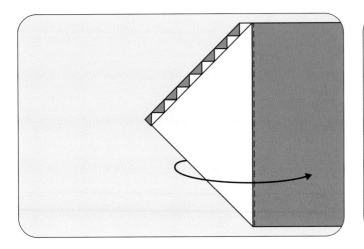

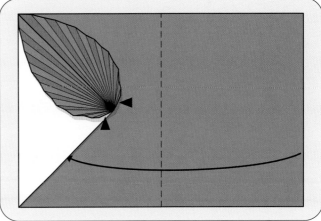

13 Fold over the entire triangle to the right along the base of the triangle, flattening the leaf against the front of the notecard.

14 Fold the right-hand edge of the notecard under the leaf to align with the left-hand fold.

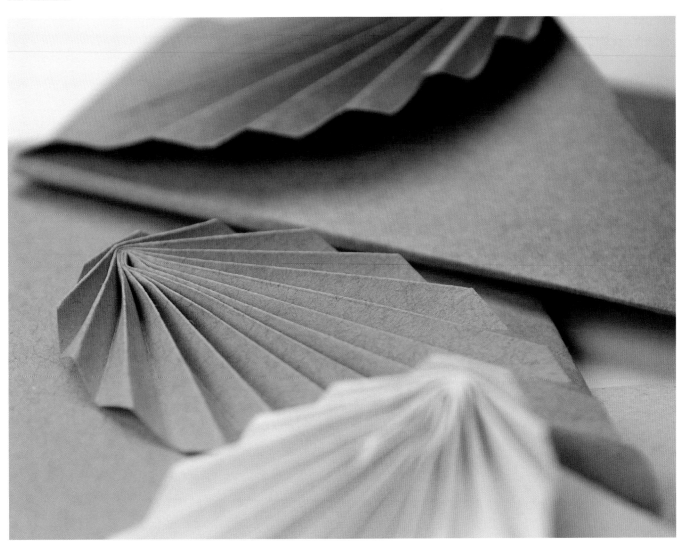

The finished leaf notelet is very three-dimensional creating an interesting display of light and shadow.

Pinwheel pouch

1 Use two squares of origami paper coloured on one side, with the white side up. Fold the first square in half diagonally and unfold. Repeat in the other direction.

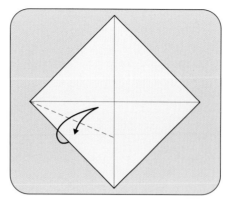

2 Fold the bottom left edge up to the horizontal crease line, but only crease from the left corner to the vertical crease line.

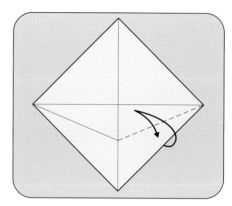

3 Fold the bottom right edge up to the horizontal crease line, but only crease from the right corner to the vertical crease line.

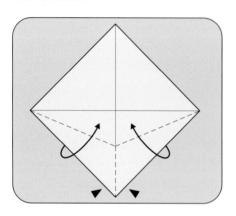

4 Pinch in the bottom vertical crease, pushing upward along the folds made in steps 2 and 3.

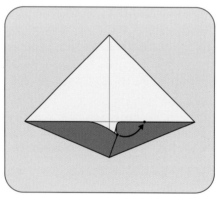

5 As the paper folds upwards, push the point to the right to make a vertical pleat.

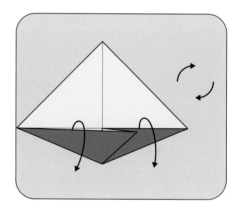

6 Unfold the folded corner and rotate the paper 90° to the right.

Paper purse

The pinwheel pouch can hold a small flat gift and opens out like a traditional Moroccan purse.

Several versions folded in different pairs of colours would make unusual decorations for a party or for the tree at Christmas.

Place one by each place setting hiding a small gift for a special dinner party surprise.

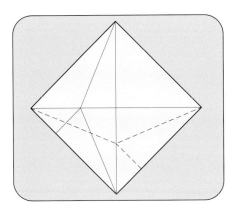

7 Repeat steps 2 to 6 on the new corner and on the other two, each time folding the point to the right.

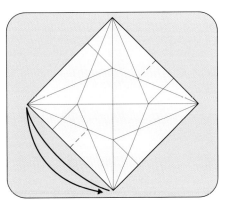

8 There will now be an octagon shape in the middle of the piece of paper. Fold the square in half, but only crease the fold from the edge of the paper to the nearest point of the octagon.

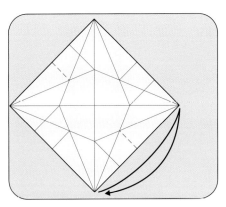

9 Repeat step 8, folding in the opposite direction.

10 Refold all the creases around the edges of the octagon and the eight creases running from the edges of the paper to the points of the octagon. Repeat steps 1 to 10 using the second piece of paper.

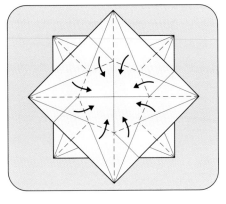

11 Place the second square over the first square, aligning the octagons as shown above. Pinch the outer points of each square together, pushing them inwards and down towards the centre of the octagon.

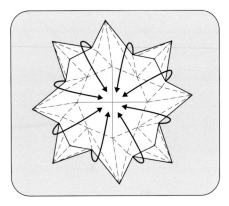

12 As the shape begins to collapse into the centre, begin to flatten each point to the right, working around the shape anticlockwise.

13 The finished pinwheel can be opened to take a small item, or used to decorate a card or gift.

other papercrafts

Paper has amazing creative potential and is readily available in many different forms, so it is not surprising that there is a wide range of different papercrafts. This chapter takes a brief look at some other ways of using paper, from decoupage to quilling – and even covers the basic techniques to make your own paper.

papier mâché

The technique of papier mâché was developed over 200 years ago, but at the same time is right up to date because it is an ideal way to recycle paper into new objects. One of its big advantages is that it can be used to make objects that are both strong and very lightweight.

Adhesives

Traditionally papier mâché is made with flour and water paste – a recipe is given for this below. You can also use wallpaper adhesive, mixed according to the manufacturer's instructions, but this often contains a fungicide so is not suitable if you are working with younger children who may accidentally swallow small amounts. An alternative would be water-soluble paste, which comes in jars or squeezable containers – spills can be removed with water. Watered down white PVA adhesive is fine too – but this can be an expensive option for a large project.

Flour and water paste

Mix plain flour into water at a ratio of 1:4 to make a thick cream. Dilute with about five times as much boiling water, stirring into the mixture so the paste becomes translucent and thickens. Allow to cool a little and dilute further as required; stir in 1 tablespoon of salt for every six cups of paste to stop it from hardening too quickly. The paste will keep in the refrigerator for several days.

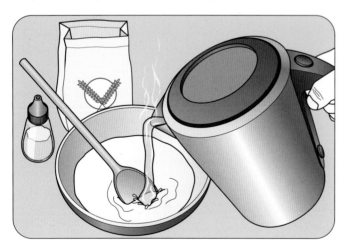

Paper

Newspaper is an ideal material for papier mâché – it is inexpensive and readily available. Other suitable papers for the foundation include computer printout paper and recycled items such as envelopes, letters, paper bags or typing paper.

To create a smoother top layer ready for finishing, use tissue paper or paper handkerchiefs. Decorative papers such as giftwrap and crêpe paper can also be used to add final embellishments to the item.

Moulds and armatures

Many items can be used as moulds – bowls, plates, cups – depending on the final shape required and which papier mâché technique you are using. The mould must be lubricated with a release agent, such as petroleum jelly, so the papier mâché can be removed easily. You can also cover the mould in cling film, although this may leave crinkle marks on the final object. Alternatively, just make the first layer with water instead of paste so it will come away easier.

To make a framework base for the papier mâché – known as an armature – plastic-coated garden wire is ideal; it is flexible and the plastic coating will protect the wire from the moisture in the adhesive so it will not rust. For bulkier shapes, wire netting can be cut and bent into many different forms and then covered with papier mâché. Some shapes can be built up on cardboard or on plastic containers – consider the final shape required when choosing what to use.

Finishing materials

Fine sandpaper can be used to smooth rough edges before the final finish is applied – smooth the surface as much as possible first by adding a couple of layers of a fine paper, such as tissue.

As an initial inexpensive undercoat – particularly if the base is made of a printed paper such as newsprint – ordinary white household emulsion paint is perfect. Acrylic paints are ideal to colour the finished item; they are mixable with water while working, but dry to a silky, waterproof finish and are available in a wide range of colours. Other suitable paints for colouring include poster paint, watercolour and gouache.

Add at least two top coats of a suitable varnish to seal the surface – but remember not to use a water-based varnish on top of water-based paint, or the colours will smear.

Ending up

Allow the papier mâché to dry completely before beginning to decorate.

If the finished papier mâché is hard to remove from the mould, gently loosen it away from the sides with a palette knife.

If painting small round objects – such as paper mâché beads – try threading them onto a knitting needle and then balance the needle across a pair of mugs or jars.

Other tools

Scissors and a craft knife are useful for trimming edges and general cutting.
Masking tape, sticky tape or parcel tape will be needed for constructing foundation shapes.

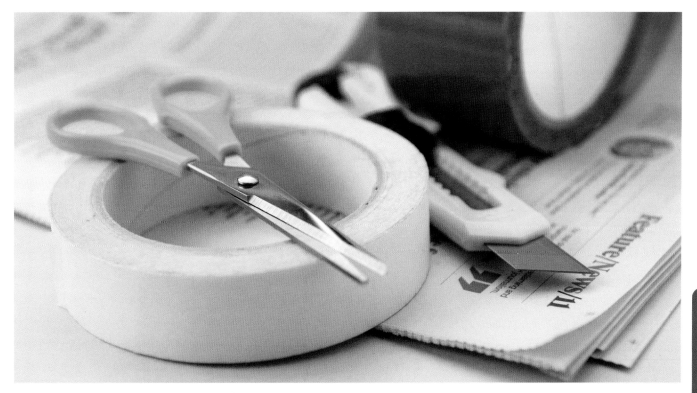

The tools and materials required for papier mâché are everyday items.

Basic techniques

There are two basic papier mâché techniques: layering and moulding. Papier mâché can also be made by shaping paper pulp, either in a mould or sculpting with it like clay.

Different layers

Use different colours for alternate layers or layer the paper in a different direction so it will be easy to see when you have completed a layer.

Layering

1 The simplest papier mâché technique is layering, in which pieces of paper are torn into strips, squares and triangles. The pieces are torn and not cut, because rough uneven edges blend together more smoothly than regular straight edges will.

2 Paste the pieces over a mould and allow to dry. Remove the mould leaving a hard papier mâché shell. Alternatively, cover a framework of the basic shape – in this case the framework remains in place under the paper.

Moulding

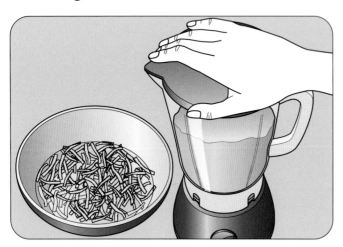

1 Soak torn up newspaper in water overnight. Drain then boil in clean water for 30 minutes, until the fibres begin to break up. Whisk the pulp in batches in an old food processor. Sieve the pulp, squeezing out the excess water.

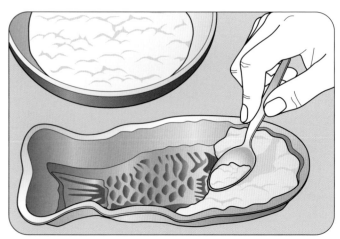

2 When you have enough pulp, mix in the adhesive to form a clay-like consistency. Mix ready-made dry paper pulp with water, following the directions on the bag. Press the finished pulp into a mould, or use it to build up a shape as you would with clay.

Making armatures

Although it is possible to build up many shapes just using papier mâché, in most cases it will be easier and quicker to create a basic framework to work on.

Animals and figures

1 Sketch the outline if necessary, or use a photograph as a guide. Bend lengths of wire and twist together securely to form the shapes. The different lengths used to make up these figures are shown here in different colours for clarity.

2 To start rounding out the basic shape, wrap the wire framework with fairly large pasted strips to create a bulkier outline where required. Add further detail in selected areas using smaller pieces of paper.

3 For a much bulkier finished figure the armature can be bulkier too – the basis for a doll can be made by wiring lollipop stick arms and legs to a cardboard roll body, and gluing a ping pong ball head on top.

Working with wire

Plastic coated wire is best for the armature because it is easy available, inexpensive and will not rust when the papier mâché is added.

For another way to make a base, see the cat on page 245 – you can use anything that will hold the right sort of shape because the base will not show at all when the model is finished. The plastic bottle is ideal in this case because it can be filled with sand to weight it if the finished item needs to be heavier.

Puppet head

1 Crumple newspaper into a rough oval ball, wrap another large piece of newspaper over the top and tape in place. Push a short stick into the base of the head and tape the head securely to it.

2 Mould papier mâché pulp onto the ball shape to create the features of the puppet head – you will probably have to create this over several sessions, allowing the layers to dry completely each time.

Building up flat shapes

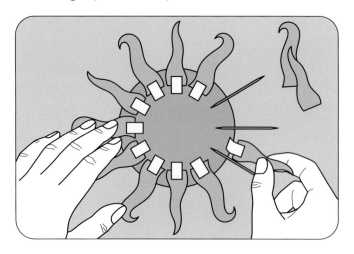

Cut the main shape from thick cardboard. If you want to add narrow pieces protruding from this, support them underneath with toothpicks or short lengths of wire and tape everything in place using masking tape. Mould papier mâché pulp on top to create the desired shape.

Working to size

If size is critical, remember to make the armature slightly smaller than the finished item is to be to allow for the layers of papier mâché to go on top.

Although large items in papier mâché are both light and strong, the starting base will need to support the weight of the wet paper, which can be quite heavy until it dries.

Always start with a base of about the correct size and shape – this will avoid you having to add many, many layers of papier mâché just to achieve the correct size.

Handles and spouts

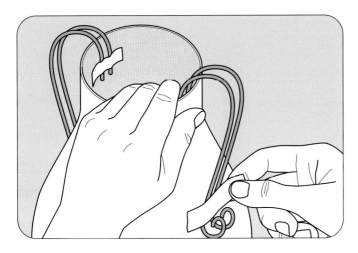 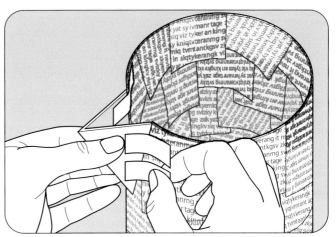

1 Make the main shape using your chosen method of papier mâché and trim the top edge straight. For handles, create the basic shape in wire and tape to the side of the main item. Cover in papier mâché as normal.

2 To make a spout, cut a triangular piece out of the top edge of the main shape. Cut a larger triangle of cardboard, fold in half and then open out. Tape this triangle securely over the cut away triangle as shown to form the spout.

Papier mâché model

The steps to create this cat illustrate the complete papier mâché process; cat lovers will love a life-size model.

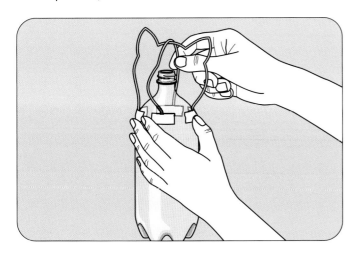 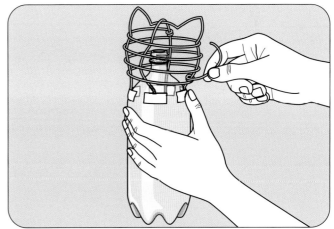

1 Using the head templates on page 297, bend two lengths of plastic coated garden wire into the two outlines of the head and tape these securely to the top of the plastic drinks bottle at 90° as shown.

2 Use finer plastic-coated florists' wire to build up the rounded shape of the head by wrapping it around the initial frame several times. Secure the ends by twisting inside the head.

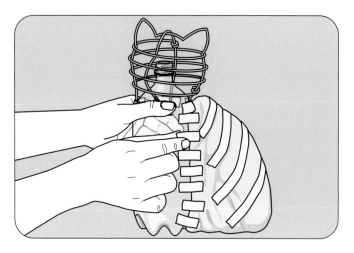

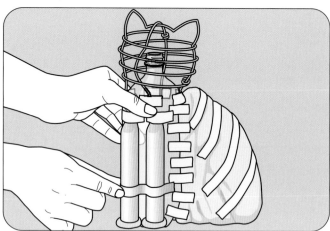

3 To create the shape of the body, stuff crumpled newspaper into a plastic bag. Refine the shape by adding strips of tape across the outside of the bag to shape it. Stick the shape behind the bottle.

4 Cut two 11.5 x 7.5cm (4½ x 3in) lengths of thin cardboard and roll into tubes. Flatten the top end of each tube and stuff the bottom end to create the feet. Stick to the front of the cat as legs.

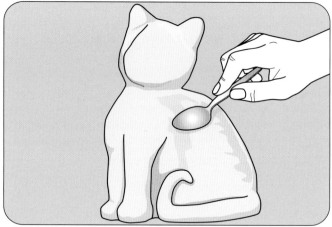

5 Roll a sheet of newspaper diagonally fairly tightly. Tape in place to make the tail, curving it around at the end and cutting off any excess paper.

6 Using the layering technique, cover the entire cat with a thick layer of papier mâché. When you have finished, smooth over the surface with the back of a spoon.

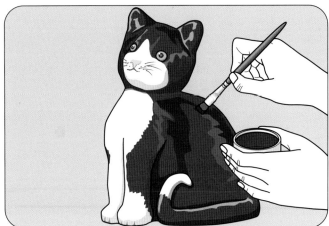

7 Leave the papier mâché cat to dry completely. Do the detail work to build up the ears, muzzle and other features. Add glass toy eyes to the face for a realistic look.

8 When the shaping is completely finished and has dried out thoroughly, brush two coats of PVA adhesive over the entire area. Paint the cat as required.

Cat model

The cat shown here is decorated in simple black and white but you could paint it in colours or markings to match a real-life animal.

If you place a quantity of sand inside the plastic drinks bottle before adding it to the rest of the armature, the cat could also be used as a decorative and functional doorstop.

When modelling animals – or people – you will achieve a more realistic effect if you can create a really natural-looking pose. Collect several photographs and images of what you want to model and use these for reference as you build up the basic shape.

For extra strength, lay the newspaper strips in many different directions as you work. An interesting final texture can be created by using paper towels for the final layer of your creation.

paper flowers

The art of making paper flowers seems to be far more popular in the Far East than it is in the West, but it's easy to create striking blooms. The finished flower can be made to look quite realistic, but in some cases – such as the pleated sunflower – the aim is to produce an interesting effect rather than faithfully copying nature.

Roses

This is a very traditional way of making flowers using crêpe paper, which is available in a very wide range of both bright and pastel colours. Duotone paper is a darker shade or colour on one side, so it is ideal for these roses.

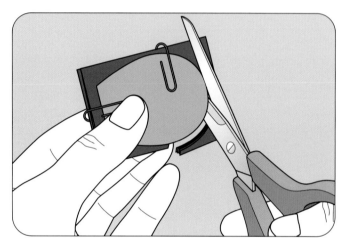

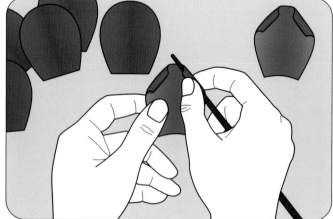

1 Enlarge the templates on page 297. Cut a 10 x 75cm (4 x 30in) strip of crêpe paper for the petals with the grain of the paper running parallel to the short edge. Fold the paper in a concertina of ten layers each 7.5cm (3in) wide. Secure the petal template on top and cut the petals with scissors.

2 Take three of the petal shapes and push both thumbs into the centre on the darker side – if using duotone paper – to create a three-dimensional effect. Roll both sides of the top end of the petal back over a tapered chopstick, which will cause the darker side of the paper to curl over to the lighter side.

Rosebuds and catkins

To make the rosebuds shown in the photograph on page 250, take a continuous length of crêpe paper and roll over one edge along the entire length. Wind the strip tightly along the other edge, gathering and pinching as you wrap it around the wire stem. Add sepals and bind the stem as for the roses.

Make the catkins by cutting a length of paper 2.5 x 120cm (1 x 48in). Using a needle and matching thread, sew running stitch along the middle of the strip. Pull the thread to gather the strip very tightly and then glue one end to the end of a wire stem, so the catkin hangs down. Bind the very end of the catkin and the stem as for the roses. To finish, hold one end of the gathered paper and twist clockwise into a spiral for the catkin effect.

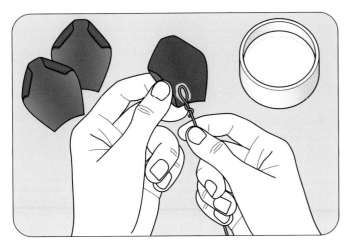

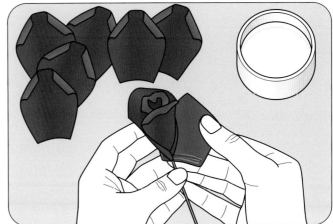

3 Form a small loop at the end of a length of soft wire and dip the loop in PVA adhesive. Take one of the three petals and wrap around the end of the wire, dark side innermost. Add the other two petals, wrapping them around the first to create the deeper colour centre of the rose.

4 Repeat step 2 on the remaining petals, but in reverse so the light side curls over the dark side. Add these petals to the rose as before, with the lighter side facing inwards. When all the petals are attached, pinch the base of the flower firmly to make sure they are all securely fixed to the wire.

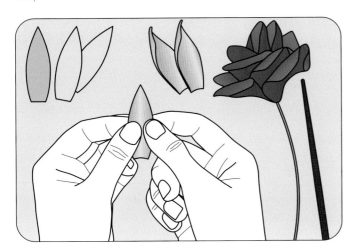

5 Using the sepal template, cut five sepals from green crêpe paper with the grain running the length of the sepal. Push both thumbs into the centre to shape the sepal into a curve and roll one side of the tip the other way, so it looks as if it has just unfurled. Repeat for all the sepals.

6 Attach the sepals to the wire around the base of the rose, in the same way as the petals were attached. Cut a long strip of green crêpe paper 2cm (⅞in) wide to bind the stem. Stick one end just below the flower and wrap the strip tightly down the full length of the stem, adding dabs of adhesive at intervals to secure.

other papercrafts

Vary the size and colour of the roses for a more natural effect.

Sunflowers

These fold-out pleated flowers are usually made with tissue paper so they are rather fragile, but this version is made in duotone crêpe paper to create the contrast colour centre.

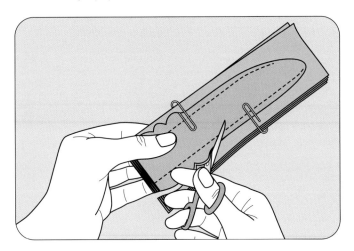

1 Enlarge the template on page 295 as required. Cut a length of duotone crêpe paper wide enough to cover the template from top to bottom and long enough to give at least eight layers when pleated. Pleat the paper into a concertina, fix the template to the top with paper clips and cut out the shape. Repeat until you have at least 50 pieces.

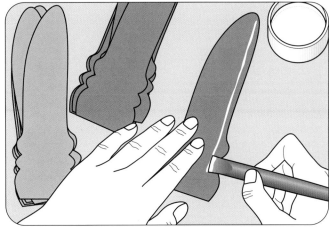

2 Lay the petals in two separate piles of identical petals. Take a petal from the first pile and apply a thin line of adhesive along the dotted line, as indicated on the template, along the straighter side of the petal. Be very careful to keep the adhesive in a narrow line and do not allow it to spread across the scalloped section at the base. Lay a corresponding petal from the second pile on top, making sure same colours are facing.

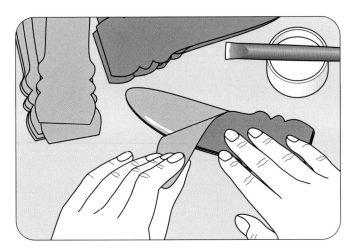

3 Now the reverse colour on the duotone paper will be uppermost. Apply another thin line of adhesive as before, but this time follow the dotted line as indicated on the template on the more curved edge of the petal. Lay a petal from the first pile on top, again making sure that same colours are facing.

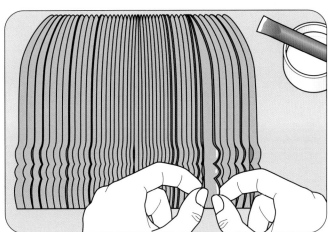

4 Continue in this way until approximately 50 petals are joined together. Leave the adhesive to dry thoroughly. Carefully turn the paper over so the lighter side of the duotone paper is uppermost. Stick the edges of the scalloped sections only together, light side to light side so on this side of the flower the darker colour only will show at the centre. Use just a dab of adhesive on the tip of each scallop.

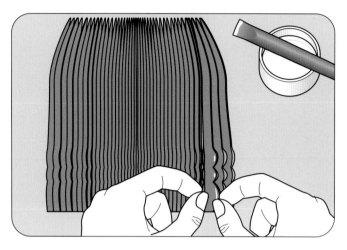

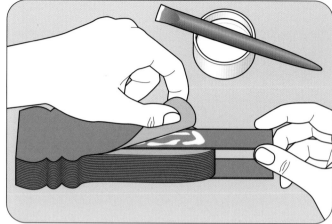

5 Leave the adhesive to dry thoroughly. Carefully turn the paper back over again so this time the darker side of the duotone paper is uppermost. Stick the edges of the scalloped sections only together, dark side to dark side so on this side of the flower only the lighter colour will show at the centre. Use just a dab of adhesive on the tip of each scallop.

6 Cut two 2 x 25cm (⅞ x 10in) strips of cardboard in a matching colour to the flower. Dab some adhesive onto one side of one strip and stick it to the outside of the last petal at one side, aligning one end of the strip with the straight edge at the base of the petal. Slot the other strip of cardboard between the last two petals on the other side to match the position of the first strip and secure with a dab of adhesive. Leave the adhesive to dry thoroughly.

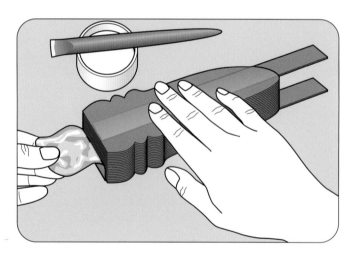

7 Cut a small rectangle of crêpe paper slightly narrower than the base of the petals and long enough to wrap completely around the end of the glued petals and reach 4cm (1½in) up each side. Round off the ends of the rectangle and glue into place as shown, using a little adhesive. Leave the adhesive to dry thoroughly.

8 Punch a hole through both free ends of the cardboard strips. Holding the cardboard strips at the punched end, open out the flower by taking the strips right around until the opposite sides are touching. Thread a length of string or ribbon through the punched holes and tie together to keep the flower open. The tie is also useful to hang the flower if you wish.

Although they are by no means naturalistic, the finished item does give the impression of a colourful flower.

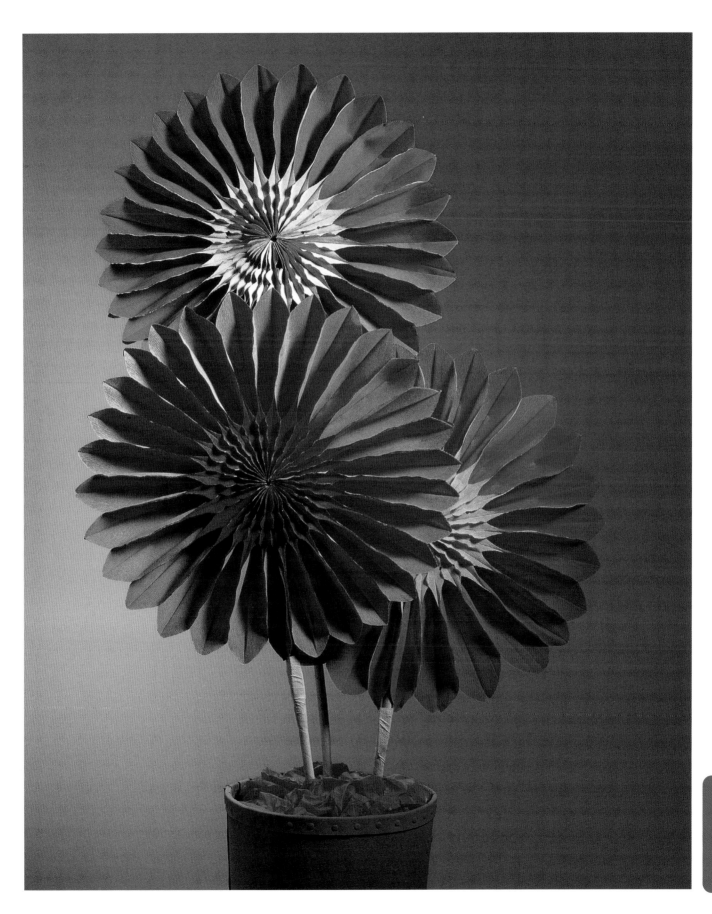

Christmas roses and ivy

Trailing stems of ivy and Christmas roses are ideal to decorate a festive wreath or to lie along a mantelpiece to add a touch of seasonal colour.

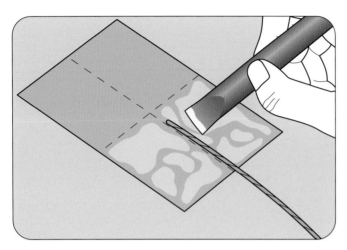

1 Cut short lengths of wire and bind with green florists' tape. For the largest leaf, cut a 6cm (2½in) length of dark green paper ribbon or paper and coat half with a thin layer of adhesive. Lay the bound wire onto the centre of the sticky half and fold the top half of the paper down over the wire. Press firmly in place.

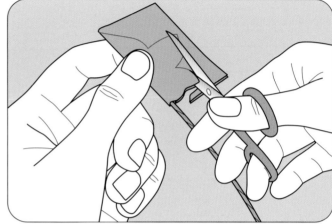

2 Fold the paper in half again the other way, so the fold runs along the wire stem. Trace the three leaf templates on page 292 onto thin cardboard. Place the large leaf template with the straight edge against the fold, draw and then cut out the leaf shape. Make several leaves in each of three sizes in the same way – use smaller pieces of paper for smaller leaves.

3 To join the leaves into a spray, take three small leaves and twist the stems together. Wire in a medium-size leaf below these and then another, so the stem gradually lengthens. Add the largest leaves at the base of the spray. Arrange the spray into a natural looking shape by adjusting the leaves.

4 Trace the two flower templates onto thin cardboard and use this to cut flower shapes from white crêpe paper, with the grain running towards the tip of the petals. Mould each petal slightly by gently stretching sideways between two thumbs. Spread a little adhesive along the edge of the V-shape darts and bring the dart edges together to shape the flower. Colour the centre of the flower lightly with a gold marker pen.

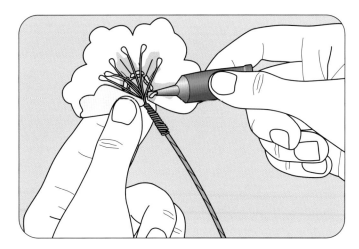

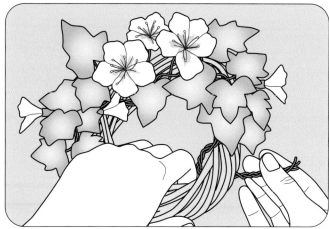

5 Cut several lengths of wire for the flower stems and bind with green florists' tape. Fold six (three for smaller flowers) pearlized flower stamens in half and twist the ends together to secure. Bind to the end of the wire stem. Add a little adhesive along the base of the flower, gather it around the stamens and press to stick. Bind in place with florists' tape.

6 Wire the ivy sprays and the Christmas roses into the top of a gold-sprayed cane wreath by twisting the stems into the cane. You could also wire a collection of ivy sprays and flowers together to make a green swag for the mantelpiece or to decorate across the top of pictures.

Ivy leaves

Ready-made pearlized flower stamens can be bought from hobby craft stores, or make your own stamens by sticking a tiny bead to each end of a very short length of wire.

Dark shiny paper ribbon is ideal to make the ivy leaves, but you could also use a rich green cartridge paper and mark the leaf veins in a darker green pen.

For a really festive look, use a ring of ivy and Christmas roses to decorate the base of a pillar candle as a table decoration – but be very careful not to let the candle burn down too close to all the paper.

Extra sparkle can be added with a little gold glitter on the leaves or the flowers.

Realistic stamens can make the paper flowers look quite natural.

using tissue paper and wire

Tissue paper is a fantastic material to use – it's light and translucent but crisp at the same time, and comes in a wide range of glorious bright colours. In this section its translucency is used to create two stunning lights using a wire framework as a support.

Light garland

A garland of plain white light bulbs can be made much more exciting by adding a wire and tissue shade to each one. You can either make identical shades for each bulb, or use different colour tissue paper on each – or even make each shade in a totally different shape.

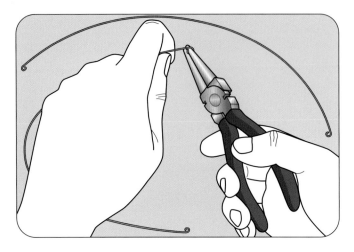

1 Cut two 70cm (28in) lengths of wire – ordinary galvanized wire is fine. Form a small loop at each end of the wire.

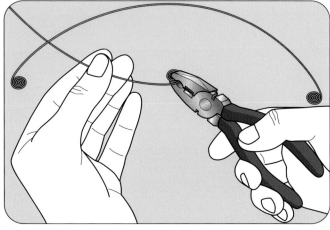

2 Use a pair of flat pliers to grip a loop and then wind the wire end around into a flat spiral, keeping it taut at all times. Repeat at each end.

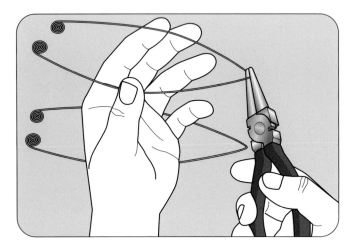

3 Hold one of the pieces of wire in the centre with a pair of pliers and push the ends together to bend the wire into a large V-shape.

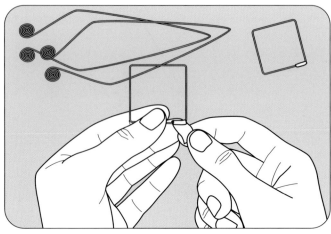

4 Bend an angle in each arm slightly above halfway. Bend two more lengths of wire into 4cm (1½in) and 5cm (2in) squares. Overlap the ends and tape together.

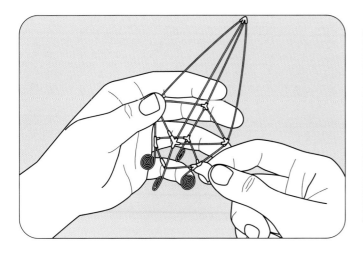

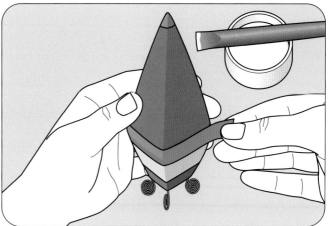

5 Thread the larger square over one bent wire and tape two opposite corners to the angle made in step 4. Add the other bent wire in the same way. Tape the smaller square on nearer the spirals.

6 Paste different colour pieces of tissue paper over the base and the top half of the wire framework. Add bands of contrasting tissue around the top edge, around the middle and at the bottom tip.

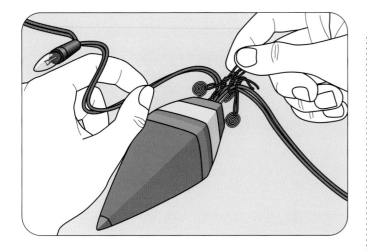

Light fantastic

Christmas-style lights are best for these tissue shades because the bulbs are small and do not generate much heat.

The flower candle holder (see page 258) could also be adapted to make a garland of flower lights.

7 Insert short lengths of plastic covered wire carefully through the wire spirals, being careful not to distort the shape, and wire the shade onto the electric cable so it covers one light on the garland.

Flower candle holder

This exotic flower is designed to hold a small nightlight – but place the nightlight inside a glass holder with tall sides before positioning it inside the flower to avoid any risk of fire.

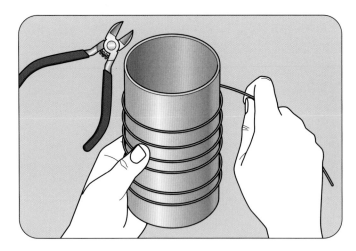

1 Cut approximately 3m (10ft) of galvanized wire and wrap it six times around a suitable cylindrical former. Remove the former.

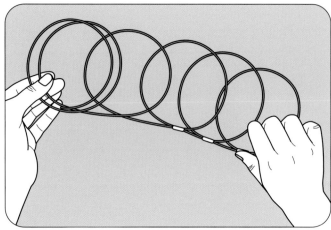

2 Spread the wire loops out so that they lie side by side. Tape the crossover point at the bottom of each loop to hold it in place.

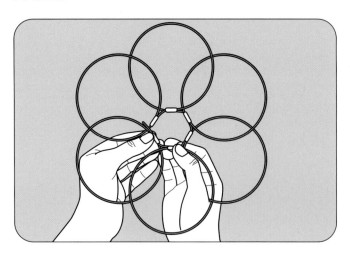

3 Bend the loops around in a circle to form a flower shape and tape the overlapping ends to hold in shape.

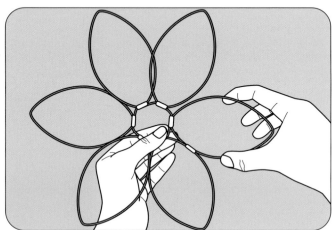

4 Gently squeeze the sides of each loop into an oval that is pointed at the tip. Tape the sides of the petals together near the base so they do not overlap.

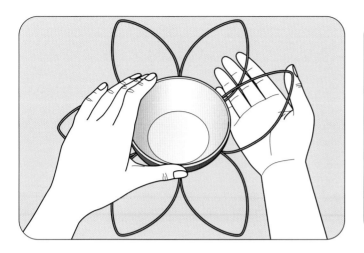

5 Place a small bowl in the centre of the flower shape and gently bend the petals up all around it to form a curving bell shape.

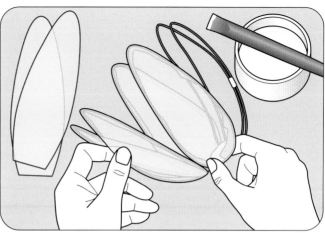

6 Cover the outside of each petal with a piece of tissue paper, wrapping the edges around the wire and pasting down on the inside.

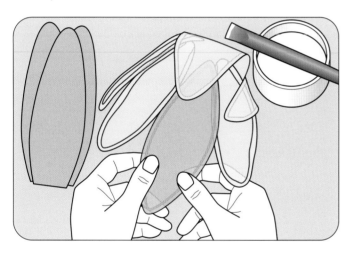

7 Cover the inside of each petal with a second piece of tissue – you can use another colour if you prefer. Allow to dry completely.

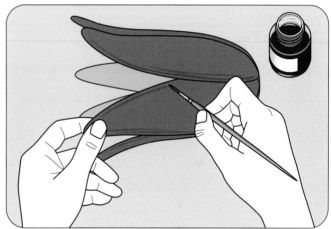

8 Paint some detail veins on the petals using watercolour ink and curl the ends of the petals slightly outwards. Add a nightlight in a glass holder to the centre of the shade.

other papercrafts

decoupage

Decoupage involves cutting out paper images and sticking them to objects, but this simple technique can be used either just to add a little decoration or to create dazzling works of art. No two items will ever be identical, because different choices of images and in how to arrange them will affect the outcome.

Tools and materials

There are really no special tools required for this – you will just need sharp scissors or a scalpel and cutting mat to cut out the images, tweezers to hold small pieces and a paintbrush and perhaps a brayer to smooth the pieces down. If you need to prepare a damaged surface before beginning you may need some additional tools and materials – see the individual techniques on this spread.

Most types of printed paper can be used for decoupage – giftwrap, magazines, catalogues, old prints or maps. Sheets of decals printed specifically for decoupage are also available – the motifs are easy to use and can give a wonderful period look to new projects.

Some types of printed paper are not very stable – use spray fixative to seal the colours and to prevent the background from yellowing. This also prevents paper printed on both sides from becoming translucent when coated with adhesive.

The most widely used adhesive to stick the motifs down is PVA. Another suitable adhesive is wallpaper paste, which makes paper very pliable so it will stretch around difficult shapes – although it may also cause some papers to stretch out of shape. Spray adhesive has a delayed sticking time, which means motifs can be repositioned if necessary, and this is also the ideal adhesive to use if working on glass.

The surface of the finished decoupage should be protected with varnish – traditionally at least 20 layers so the edges of the motifs merge completely into the background. Modern varnishes make this unnecessary – eight to ten coats should be enough.

Preparing the surface

If the object you want to decoupage is old and battered you will need to restore the surface beforehand. Treat metal objects for rust even if they do not appear to have any, because otherwise it could appear after the item is finished.

Removing and preventing rust

Rub off any flaking paint and patches of rust with a wire brush. Coat the item inside and out with rust remover, allow to dry thoroughly and then wipe down with white spirit. Repeat the process if necessary; if any holes have appeared fill with car repair filler and rub down following the manufacturer's instructions. Apply a coat of anti-rust undercoat.

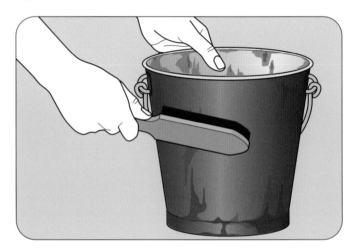

Checking for and preventing woodworm

Old furniture or other wooden items may have woodworm; check for tiny holes. Even if the woodworm do not appear to be active it is always worth treating the holes with a proprietary woodworm killer, following the manufacturer's instructions.

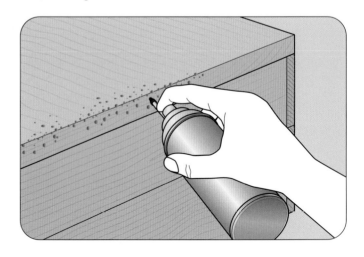

Removing old paint

It is best to remove coats of old paint before you begin; strip back to the bare wood or metal using a proprietary paint stripper and following the manufacturer's instructions. If possible, work outside and wear suitable protection. Wipe down with white spirit.

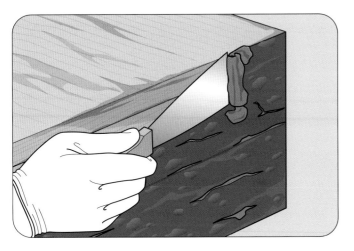

Applying gesso

Rough or pitted wooden surfaces can be made smoother by applying a layer of gesso. Several types of gesso are available for different base materials.

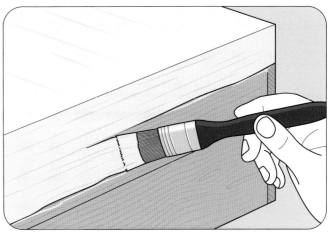

Removing old polish

To remove polish on wood, wash the item down with a mixture of water and vinegar or lemon juice and allow to dry. Sand down with fine sandpaper and then wipe down with white spirit.

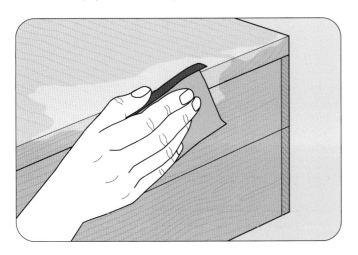

Applying undercoat and base coats

If you have applied an anti-rust undercoat or gesso there will be no need for an undercoat, but otherwise use any muted colour suitable for the base material. As a base coat, it is best to use an oil-based paint. If you must use emulsion, it must be sealed with a light coat of varnish before applying the decoupage.

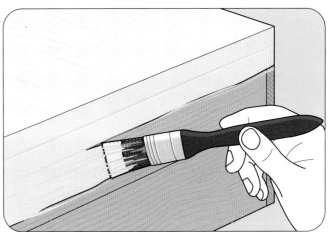

Applying decoupage

Here are the basic steps for adding decoupage motifs to a jug – here just a single motif has been added, but you can also cover the entire surface of an object to achieve a collage effect using exactly the same techniques.

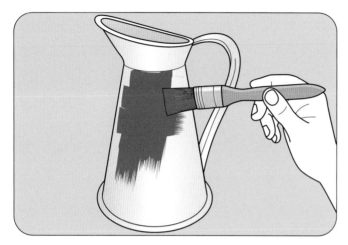

1 Choose a colour for the undercoat that will complement the motifs. If you can't find the exact colour you want, mix colours to achieve it – but don't mix oil-based and water-based paints. Apply at least two coats of undercoat, allowing the first coat to dry fully before applying the second. If using emulsion, seal with a thin coat of varnish and leave to dry completely.

2 Roughly cut away surplus paper around the chosen motif. Cut out the motif – or a selection to develop a design – using small sharp pointed scissors. Push the point of the scissors through near the design and cut carefully around the edge of the motif from below – this way you can see where you are cutting. Alternatively, cut out the motif using a scalpel and cutting mat.

3 As you work, cut off larger pieces of surplus paper or these will get in the way when you are trying to cut details. When cutting out a large motif – a complete flower with stem and leaves, for example – it is a good idea to leave small bridges of paper between some of the parts temporarily to give the cut out stability while you work on it. If necessary, spray the finished cut out with fixative to stabilize the surface.

4 Decide on the exact position for the motif or motifs by placing them on the surface and moving them around until you are happy with the effect – if you are working on a vertical surface you can hold the pieces temporarily in place with a blob of putty adhesive or by spraying a very small amount of spray adhesive on the back. Start by creating a focal point to the design, to which the eye will be drawn.

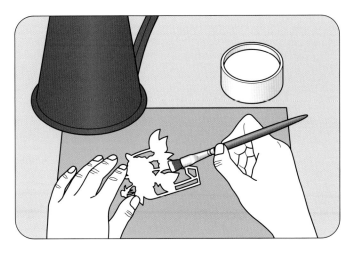

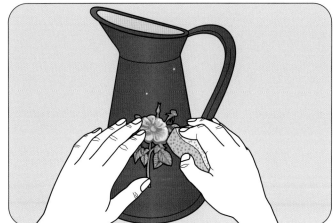

5 Pour a little PVA adhesive into a clean bowl and dilute with enough water to make a thin cream, or mix up wallpaper paste. Paint the area to be decorated with dilute adhesive, and then dip a finger in clean water and rub all over the glued areas. Wash your hands and then place the cut outs face down on a clean surface and paste the reverse with adhesive – this process ensures there are no glue-free spots underneath the decoupage.

6 Position the first cut out in place – usually this will be the focal point of the design. Gently move it with your fingers if necessary until it is in exactly the right position – make sure your fingers don't have any adhesive on them at this stage or you may tear the paper. Carefully remove any temporary bridges of paper. Smooth down gently from the centre with a clean sponge or brayer to make sure the motif is firmly in place all around.

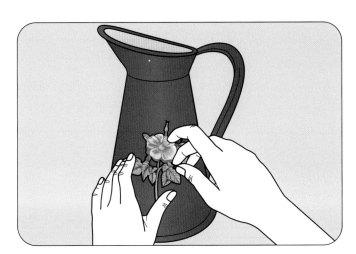

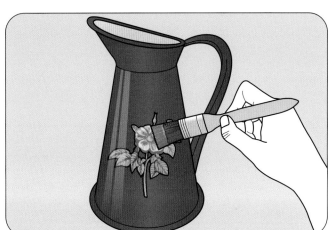

7 Add more motifs if necessary. Use your fingernail to check that all the edges are firmly stuck and also check there are no bumps of glue or air pockets under the motifs. Gently wipe away any excess glue with a clean damp cloth. Allow the decoupage to dry thoroughly for at least twenty-four hours – don't be tempted to apply varnish too soon because if there are still any damp patches they will show though the varnish.

8 When varnishing, use a good quality brush that will not shed hairs and work in a well-ventilated dust-free area. Apply the varnish from the centre outward, making sure each coat is even because thicker areas will drip. Make sure the entire object is fully covered and then leave to dry for the manufacturer's recommended time. Repeat until you have applied enough coats so the edges of the decoupage no longer appear raised.

other papercrafts

9 To achieve a finely lacquered finish, sand down the top coat of varnish with a fine sheet of wet-and-dry sandpaper using a circular motion. The decoupage should be safely protected beneath many layers of varnish so should not be damaged by this process. When you have a perfectly smooth surface, wipe over it with a clean cloth sprinkled with a mixture of white spirit and varnish. Leave to dry and then apply the final coat of varnish.

Final finishing

To achieve a bright shine you can polish over the final coat of varnish using any good quality wax polish. Buff to a shine with a soft cloth. If you continue doing this regularly the surface will be more durable.

For an antique look, a special crackle varnish is available – it comes in two parts that react with each other to create the crackle effect. Using a hairdryer speeds up the process and afterwards you can apply antique wax to emphasize the effect.

Decoupage can be used to give a desirable vintage look to modern everyday objects.

quilling

Quilling, or paper filigree, is a craft in which strips of paper are rolled, shaped and glued together to create decorative designs. The paper strip is wound around a quilling needle to create a basic coil, which can then be shaped and arranged to form flowers, leaves or ornamental patterns similar to ironwork.

Tools and materials

When you first begin quilling you will find it easier if you use a slotted quilling tool that holds the end of the paper firmly as you roll it. This tool does create a slightly larger hole at the centre of the coil, so when you become more skilled you may prefer to simply roll between your fingers or use a needle tool or a toothpick instead.

The best adhesive to use for quilling is PVA – a bottle with a fine tip applicator is ideal. You will also need small sharp scissors for trimming ends, while toothpicks or a pair of tweezers are useful for picking up small coils.

Paper for quilling needs to be cut into very narrow strips. You could cut these yourself, but it would be a very boring and laborious process – packs of paper strips are available ready-cut from specialist outlets or good craft stores. As well as a wide range of colours, from pastels to vibrant shades and either plain or shaded in tone, the strips also come in different widths – the 3mm (⅛in) size is the best width for beginners. The strips are normally around 45cm (18in) in length and come packed in a loose figure of eight.

Rolling the paper

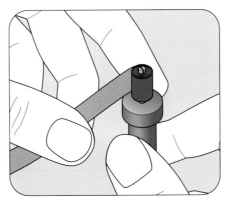

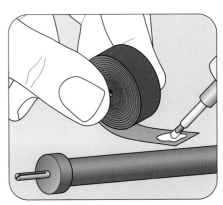

1 Take half a strip of quilling paper and gently thread one end into the slot in the tool. Make sure that only a very tiny end of paper protrudes on the other side of the slot. Hold the strip between thumb and index finger to keep some tension on the paper as you roll, but don't pull too hard or the paper may tear.

2 Slowly turn the quilling tool so that the paper winds evenly around the tip, keeping the edges aligned. When using the slotted tool turn the tool to roll the paper, but if using a needle tool roll the paper around the tool, keeping the tool still. When the strip is all wound hold in place for a moment so that the paper will remember its position.

3 Let go and turn the tool upside down, allowing the quilled coil to fall off onto the table. The paper will begin to uncoil a little; leave it to relax until it stops uncoiling. Place a dab of adhesive on the end of the paper and press gently in place. Hold the paper together for a moment or two until the adhesive dries.

other papercrafts

Making shapes

Although sometimes you will want to leave your coils as perfect circles, often you will squeeze and manipulate them into different shapes to build up a design. Here are a few of the most common shapes.

Tight coil or peg

Wrap the strip around the quilling needle tightly and before removing it from the tool stick the end in place with a dab of adhesive. Let the adhesive dry before gently releasing the coil from the tool.

Loose coil or open circle

Coil the strip as normal; remove from the tool and leave to relax. Either stick the end down or leave loose. Using open coils can add a light and delicate look to a quilled design.

Teardrop

Pick up the coil with thumb and index finger and gently pinch together at one end, leaving the other end rounded. This is an ideal shape for petals; to refine it, gently press the pointed end towards the centre to create a curve to one side.

Leaf

Make a marquise; after pinching the ends push both of them in towards the centre to curve them in opposite directions and create a twisted leaf shape.

Crescent

Pinch a loose coil at each end to form points, while pushing in on one side with the tip of a finger or the rounded end of the quilling tool to create a half-moon shape.

Square or rectangle

Hold the coil between both thumbs and both index fingers and gently press into a square or rectangle shape. Pinch each corner into a point.

Marquise or diamond

Hold the coil on opposite sides between the thumb and index fingers of both hands. Pinch tightly on each side to form points at each end. This shape is one of the most useful in quilling.

Triangle

Hold a loose coil between the index fingers of each hand and push the bottom up with your thumbs to create a triangle. Pinch the three corners but try to keep the centre as round as possible.

Tulip

Make a teardrop shape, but before etting go of the pinched end push it back towards the centre to create another point on either side. Pinch the two outside points or leave them more rounded.

Closed heart

Create a triangle, and then push down in the centre of the top side to create the indentation for the heart shape.

Star

Make a marquise, then turn the shape 90° and pinch two more points to make a star. Pinch the tip of each point firmly to sharpen up the shape.

V-shape

Fold the strip in half and roll each end into a coil away from the centre crease.

S-shape

Roll the strip from both ends to meet in the middle, starting on opposite sides of the strip.

Open heart

Fold the strip in half and roll each end into a coil towards the centre crease.

Perfect rolls

Tear quilling paper to length – don't cut it with scissors or a craft knife because a sharp cut edge will be more noticeable in the finished shape; a soft, torn edge is less visible.

A paper adhesive that dries clear is the best type to use for quilling.

It is better to use too little adhesive than too much – you can always add a little more if the coil is not secure, but it's much harder to remove excess adhesive. Apply the adhesive with a toothpick or needle to avoid getting large blobs.

A quilling board will help you to achieve equal-size coils or other shapes for more complex projects.

To use a design template as a guide when assembling, cover it with a sheet of waxed paper, wrapping the edges around the board and fixing on the back. This protects the surface from adhesive, so it can be used again.

Making a picture

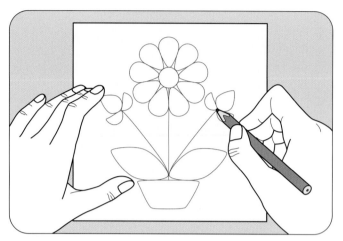

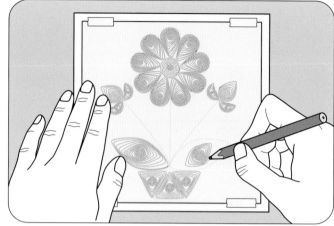

1 Select a suitable pre-drawn design template or draw your own design. Quite complex quilling designs can be made up using a combination of simple shapes such as triangles, squares, circles or crescents. When creating your own designs, think about how these basic shapes can be put together to create the right effect.

2 If you are creating a new design, lay a piece of tracing paper over the template and sketch different quilling shapes into different areas to create the shapes. For a flower, there might be one shape for the petals, another for the centres and one for the leaves. For a lively effect combine both loose and tight rolled coils and different shapes. Using some filigree shapes will give a more open look to some parts of the design.

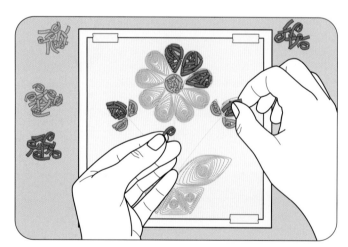

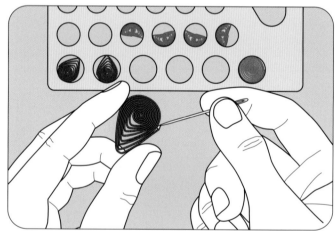

3 Choose the colours for each section of the design either by laying a few coils in different colours on the different areas or just by criss-crossing a few strips in each colour to see how they work together. Move things around and try substituting variations if necessary, until you are happy with the overall effect.

4 Using a ruler, tear the paper to suitable lengths to create the coils. A quilling board is useful to achieve equal-size coils for similar areas. If you are creating a complex design, place the torn strips into a container marked with the colour and length so you can find the right one easily when you need it. For a simple design you can just create all the different coils ready to put the shapes together to form your picture.

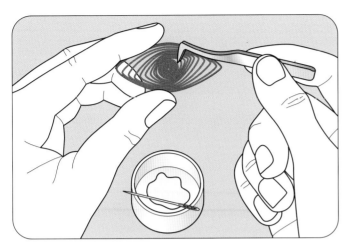

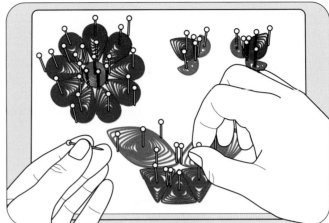

5 Before beginning to stick everything together, dry fit the quilling shapes by placing them on the template without gluing them in place; check the overall design and adjust it if necessary. Hold the pieces with tweezers to apply glue and to place them in position. Tweezers are also useful to pull the centre of a coil toward the edge to create concentric coils.

6 For a large design, glue small elements together first and then assemble these into the larger design. Use pins pushed into a soft surface – such as thick cardboard or Styrofoam – to hold the different parts of each element together if necessary while the glue dries. The finished glued shapes should be very sturdy.

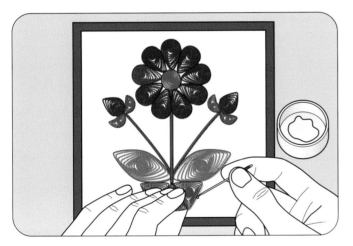

7 The finished shape can be placed on a background by putting it in position and then lifting one edge at a time to add a dot of adhesive underneath. Larger shapes can be very flexible and can even be manipulated into three-dimensional shapes. Do not use pins to secure the design to the background at this stage because they will create permanent holes.

8 Another way to create a three-dimensional shape is to build up the design in layers – for this flower, the outer petals are laid directly on the background with a loose coil in the middle to support an inner ring of petals on the next layer. Another loose coil in the centre of the second layer supports the top layer of petals and the flower centre.

paper decorative items

Paper is ideal to make decorative objects to use every day – why use a boring beige expanding file when you can have a gloriously patterned one? This section covers a few ways of using paper to create items for the home.

Paper beads

Almost any type of paper can be used to make these beads, which are lightweight but surprisingly strong. Make them up into necklaces, earrings and bracelets by threading onto bead stringing thread and adding suitable jewellery findings.

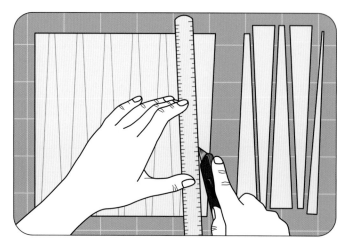

1 Using the template on page 288 as a guide, mark out the shape on the reverse of a sheet of printed paper – giftwrap is ideal. Cut the paper strips out; each finished bead will be the length of the wider end of the strip.

2 Smear a little petroleum jelly on a knitting needle as a release agent. Starting at the widest end of the strip, begin rolling it tightly around the needle. Make sure it is rolling centrally and evenly. Put a dab of paper adhesive on the end and press down for a few seconds to hold the bead in place.

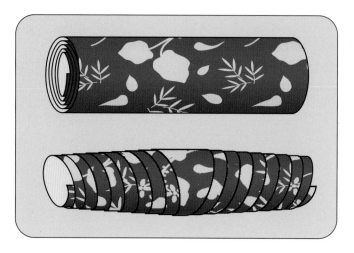

3 Using tapered strips of paper will give shaped beads and the longer the strip the fatter the bead will be. If you prefer tubular beads, cut the strips to an even width along the length of the strip. When the beads are fully dry, slide them off the needle and use as required.

Paper mobile

This pretty mobile is made from cartridge paper coloured with felt-tip pens and hung from wire – it couldn't be easier to make.

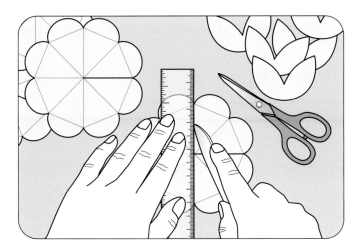

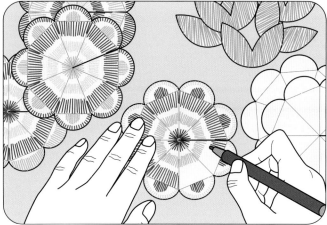

1 Trace the flower and leaf templates on page 291 onto cartridge paper and cut out two flower shapes to make each flower and two for each pair of leaves – that will be twelve of each shape in total. Cut along the marked line into the centre of each flower and score all the fold lines.

2 Using felt-tip pens or coloured pencils, colour in one side of each of the flowers in a range of bright colours – for a balanced effect try to use a little of each colour in each flower. Colour all the leaves green on one side – the colouring can be quite rough, it will all add to the charm.

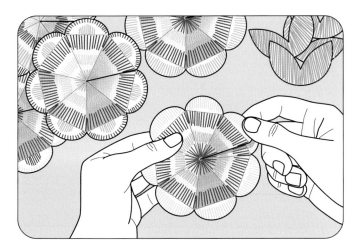

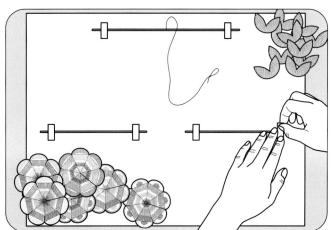

3 Spread adhesive on the front of one flower triangle that has a cut edge. Fold the flower into a flat cone shape by sliding the glued triangle under the adjoining triangle. Press firmly to stick; repeat on all the flowers. Add a little adhesive to the reverse of the scallops and stick two flowers back to back. Repeat for the remaining flowers.

4 Cut a 26.5cm (10½in) length of wire and two 19cm (7½in) lengths. Place the long wire horizontally, with the short wires parallel but about 18cm (7¼in) below and centred on each end; tape in position. Tie a 40cm (16in) length of invisible thread securely to the centre of the longest wire and add a dab of glue to secure. Make a hanging loop at the other end of the thread.

5 Thread a needle with a length of invisible thread and push through the scallop of a flower, then knot the thread in place over the edge of the flower to secure. Position the flower 7.5cm (3in) below one end of a short wire and knot the thread onto the wire. Trim the thread ends and add a dab of adhesive to the knot to secure. Repeat at the other ends of the short wires.

6 Hang the last two flowers 15cm (6in) below the centre of each short wire, but use a longer thread and after knotting onto the wire take the thread end up to the end of the long wire and knot here too; trim thread ends and secure all knots with a dab of adhesive. Add adhesive to the reverse of each pair of leaves and stick back to back above each flower. Remove the tape holding the wires in place and hang the mobile.

Expanding file

Vibrant colours make this useful expanding file much more cheerful than the boring beige variety. You could even cover it with wallpaper to match the room.

1 Cut two 25 x 33cm (10 x 13in) rectangles from thick cardboard. Spray giftwrap or your chosen patterned paper with spray adhesive and use it to cover one side of each piece of cardboard, folding the corners diagonally across and then folding each side inward neatly.

2 Cut a 33 x 8cm (13 x 3¼in) strip of cartridge paper for the spine and a piece of self-adhesive plastic 33 x 12.5cm (13 x 5in). Peel the backing from the plastic and stick the piece of cartridge paper in the centre. Position on the wrong side of the covered cardboard sheets as shown to make the spine lining.

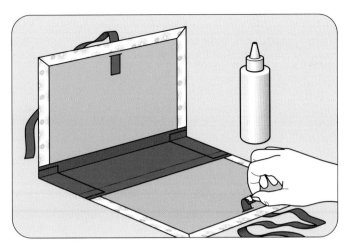

3 Cut another strip of self-adhesive plastic 40 x 11.5cm (16 x 4½in). Turn the file over, peel the backing from the plastic and stick down the centre to make the outer spine. Fold the ends over to the inside. Cut two 45cm (18in) lengths of wide ribbon as ties. Cut slits in the centre of each side of the file at 3cm (1¼in) down from the edge, as shown. Thread one end of each ribbon through and secure with adhesive.

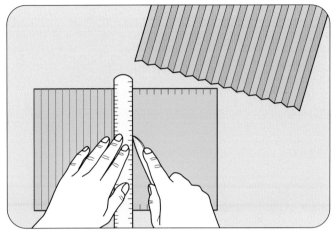

4 Cut two 24 x 32cm (9½ x 12½in) pieces of coloured paper, spray with adhesive and use to line the inside faces of the file. Cut two 21.5 x 39cm (8½ x 16¼in) pieces of coloured paper. Mark each long side every 1.5cm (⅝in) and score the lines across. Fold along the lines to make two concertina folded ends for the file.

5 Cut four 5 x 39cm (2 x 16¼in) pieces of self-adhesive plastic. Open out the pleated paper and fold the strips in half over each long edge. Press the concertina pleats firmly into the plastic. Cut eleven 15.5 x 30cm (6¼ x 12in) sheets of divider paper or cardboard and edge one long top edge of each with folded plastic strip in the same way.

6 Run a line of adhesive down the short edges of a divider and, starting at the second complete pleat in as shown, position it between two pleats aligning its top edge with the lower edge of the edging on the pleat. Repeat to insert the other dividers. Pinch the pleats closed and leave under a pile of books until the adhesive is fully dry.

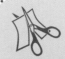

Perfect pleats

The key to creating prefectly aligned pleats is accurate measuring and creasing. Press each crease firmly with a bone folder on a hard surface before starting to fold the next pleat.

The size of the pleats can be adjusted as required on these projects, but fairly small ones will work better for the pleated lampshade.

7 Open the folder and position the pleated section centrally on the spine. Run a line of adhesive down the last two pleats on one side of the pleated section and press to one side of the file. Repeat on the other side. Leave the file under a pile of books until the adhesive is fully dry.

Pleated lampshade

Concertina pleats are very easy to make and are ideal for shaping into lampshades because you can adjust them to fit most types of light.

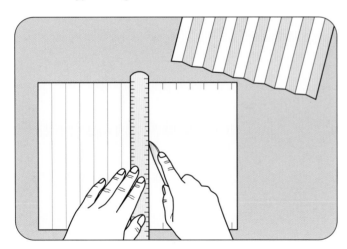

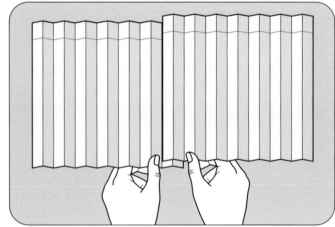

1 Cover one side of a sheet of cartridge paper with giftwrap using spray adhesive. Repeat with another two sheets. When dry, trim the sheets so they are all 35cm (14in) deep. Turn each sheet over and mark out 2.5cm (1in) pleats across the full length. Trim the last pleat to a matching size if necessary.

2 Still working on the reverse of the sheet, mark a line across the back of each sheet 2.5cm (1in) down from one long edge to indicate the gathering line. Score all the pleat fold lines and fold each sheet up into concertina pleats. Join the three pleated sheets together by overlapping the last pleat on each.

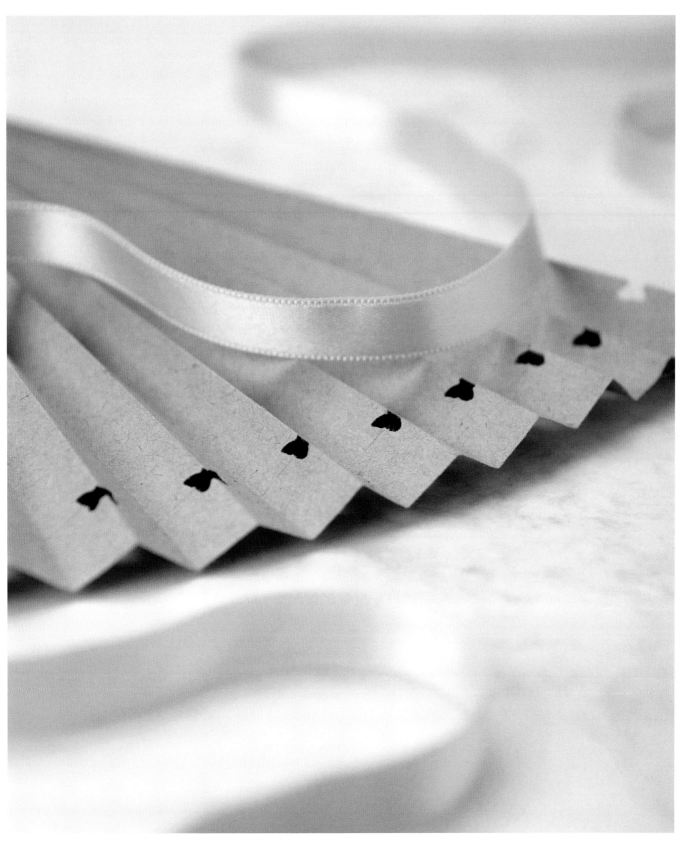

Pleating paper is a simple but effective technique, which can be used to create an interesting play of light and shade.

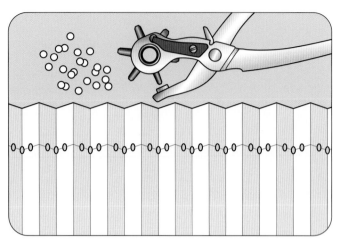

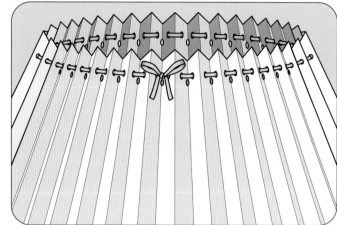

3 Still working on the reverse of the sheet, use a hole punch to punch a hole through the middle of each pleat centred on the marked line made in step 2. On every alternate fold (the fold that will point towards the light when the shade is in place) punch a hole centred on the fold line and on the marked line – this will create an indent around the top of the lampshade to sit on the top ring of the frame.

4 Run cord or ribbon through the holes in the centre of each pleat and gather the shade into a cone. Check the fit on the shade frame – if necessary add more pleated paper at this stage for the required fullness. If the fit is good, remove the pleated paper and stick the ends of the strip together, adjusting the punched holes if necessary. Rethread the cord or ribbon and tie in a bow.

Making adjustments

The instructions here are to make a shade to fit a purchased frame that is about 40cm (16in) in diameter at the base, 10cm (4in) in diameter at the top and about 20cm (8in) high. Simply increase the length and depth of the pleated paper to fit a larger size frame.

This technique can be used to cover an existing plain lampshade cover – just slide the pleated cover over the top.

For extra interest the pleats on the lampshade can also be decorated with papercutting techniques and punching – see pages 200 and 201 for some ideas.

If you use cord around the top of the lampshade, you could try decorating the ends with small tassels (see page 182).

Paper lace picture

You can use the piercing technique described on page 73
to create a paper lace picture as well as to personalize
stationery – or other items – with motifs and borders.

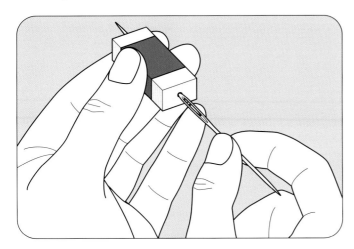

1 Trace the template on page 296 onto a sheet of tracing
paper, enlarging it beforehand if necessary so you have
a full size template. The piercing process will be easier to follow if
you use two different colour pencils for the tracing, one for holes
pierced from the front and the other for holes to be pierced from
the reverse. To vary the size of the holes to create an impression
of depth, use different size needles – make a handle for these
by embedding them into opposite ends of an eraser.

2 Lay a sheet of cartridge paper wrong side up on a padded
surface that is firm enough to support the paper but soft
enough allow the needle to pierce through. Place the tracing
paper wrong side up on top. Use the thicker needle to prick out
bolder outlines such as the large clouds, lamb and cottage roof.
Use a thinner needle to prick out less definite outlines, such as
the bushes, birds and sun. When you have finished piercing from
this side, turn the paper and tracing paper over and prick the
lines to be pierced from the reverse.

Hole story

Different effects can be produced by using different size needles and by piercing from front or back.
Holes pierced from the wrong side stand up in relief so have higher definition, holes pierced from the
right side are less obtrusive and this can be used to add a sense of perspective to the design.

You can save quite a bit of time by piercing along any reasonably straight lines in the design using
a dressmakers' tracing wheel.

Suitable designs for this technique can be traced from magazines, giftwrap, books or wallpaper. Simplify
the lines, if necessary, before you begin piercing.

Mount the finished paper lace picture onto a contrasting sheet of paper so the colour will show through
the holes – but nothing too dark or very bright since this would distract from the subtlety of the design.

papermaking

No book on papercrafts would be complete without a brief section on how to make your own paper. Hand-made paper from fruits and vegetables has a beautiful texture and can be varied with inclusions or by adding colour. The finished product can be used in cardmaking and scrapbooking – or simply used as unique stationery.

Equipment and materials

Most equipment used for papermaking can be found in kitchen or hardware stores. Only use stainless steel, glass, wood or unchipped enamel equipment – aluminium, tin and iron can cause unattractive brown spots on the finished paper. You will need large pans, a measuring jug, cups and spoons, glass bowls, a blender, and a large deep plastic tray that is big enough to take the sheet mould with room to spare. You will also need garden shears, a hotplate and a strainer when preparing the fibre, and a board with a smooth surface for drying papers on.

For instructions on how to make a strainer bucket, sheet mould and deckle and liquid starch, see page 279. Alternatively you can buy a sheet mould and deckle and the liquid starch if you don't want to make your own.

Since cellulose is one of the main ingredients, most types of fruit and vegetables can be made into paper – use the inedible parts of the plant that are normally removed and discarded.

In addition, you will also need washing soda (sodium carbonate) to cook the fibres. To strengthen homemade paper you will need to add abaca (the fibre from the leafstalk of the banana), which is available in sheets of partly processed fibre. If you want to colour your paper you will need colourants – see page 282 for further details.

Safety

Some of the chemicals used in papermaking can be harmful, so always follow the following safety guidelines.

- Do not work with chemicals used for papermaking in areas that are also used for food preparation. Kitchen equipment used for papermaking should never be utilized for food again afterwards.
- Separate cooked fibres from food in the refrigerator or freezer and label clearly. Store all chemical products in accordance with manufacturer's safety guidelines.
- Clean up thoroughly after working, using a sponge and a wet mop – don't use a vacuum as small particles can pass through the filters.
- Some dyes can be toxic – read the guidelines on the packet and wear gloves and respiratory protection if necessary. Only use colours for airbrushing if they are approved for that use.
- Hydrogen peroxide, used for lightening papers, can burn the skin or eyes if it comes into prolonged contact. Washing soda (sodium carbonate), used in cooking the fibres, is corrosive to skin, eyes and the respiratory tract. Wear suitable protection when using these chemicals. Always add washing soda to water, rather that the other way around, and do not heat it in aluminium, tin or iron pots as this causes a gas to form – use stainless steel or enamel pans.
- Wear protective gloves for all stages of papermaking.

Making a strainer bucket

The strainer bucket is used to rinse cooked fibre outside using a garden hose. Drill three 2.5cm (1in) holes around a plastic bucket, evenly spaced and about two-thirds of the way up from the base. Line the bucket with a nylon paint strainer or a similar strainer mesh, held in place around the rim with clothes pegs.

Making a page mould

This is simply a wooden frame with a screen over it to form the sheet of paper, while the deckle is a frame the same size but without the screen, which is placed on top of the mould to stop the fibre running off. The deckle produces the characteristic deckle edges of handmade paper. Using waterproof glue, make up wooden stretcher bars from an art store into two frames; the area inside the edges will be the size of your paper. Tightly stretch a piece of brass strainer screen with 30 or 40 mesh (available from a hardware store) across one of the frames and staple all around the frame to hold it in place. Cover the edges of the mesh with duct tape.

Liquid starch

For enough liquid starch for a 19-litre (5-gallon) bucket of well-sized pulp, stir 4 tablespoons of cornflour into 4 tablespoons of water until dissolved. Bring 900ml (3¾ US cups) of water to the boil and gradually add the cornflour mixture while stirring. Simmer and continue stirring for two minutes until the mixture is lump free. Use immediately, or reheat to boiling point just before using.

Caring for the page mould

Over time the screen on the page mould may begin to sag. If this happens, simply replace the mesh with a fresh sheet.

If you don't want to use wooden stretcher bars you can make up the frames for the mould and deckle using marine ply.

Preparing the fibre

The non-cellulose parts of inedible fruit and vegetable pieces must be removed before making them into paper – this is done by cooking with washing soda.

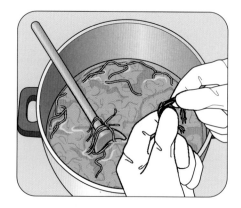

1 Cut the inedible fruit and vegetable pieces into 5cm (2in) pieces with garden shears or kitchen scissors. Rinse the pieces if there is excess debris – you can also soak them in water for 24 hours to reduce the cooking time required.

2 Put the fruit and vegetable pieces in a large cooking pot, filling it half full. Add water to the three-quarters mark. In a small pan heat 240ml (1 US cup) of water, but before it boils add 8 tablespoons of washing soda. Stir until dissolved then add to the large pot.

3 Put the large pot onto a hot plate in the open air. Cover and bring to a simmer. Cook, stirring occasionally, until the fibre is mushy and slightly slippery – about 2–5 hours after it begins to simmer; it should tear easily. Remove from the heat and allow to cool.

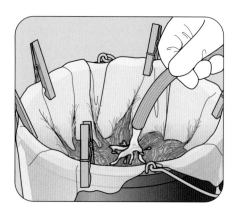

4 Rinse the fibre in the strainer bucket with cold water from a hose for 2–3 minutes. Remove the nylon strainer from the bucket and squeeze out the water. Put the strainer and fibre back in the bucket; rinse and squeeze again several times until the water runs clear.

Paper fibre

The fibre can be used as soon as it has been prepared, stored in a clearly labelled bag in the refrigerator for up to a week, or deep frozen for an indefinite period.

Always cook the fibres outside in the open air on the hotplate and do not stand over it breathing in the fumes.

See the safety instructions on page 278 for working with washing soda.

Making the pulp

Since fruit and vegetable fibres are usually quite short, paper made with them will be fragile, but by adding abaca – the fibre from the leafstalk of the banana tree – you will be able to make much thinner and stronger paper.

1 For enough to make around 40 sheets of paper when combined with your fruit and vegetable fibre, soak around 150g (5oz) of abaca in a bowl of water for at least half an hour. Tear it into 2.5cm (1in) pieces.

2 Put a handful of torn pieces into a blender and fill two-thirds with water. Run the blender on high speed for 30 seconds, stopping briefly every 10 seconds to rest the motor. Add a handful of prepared fruit or vegetable fibre and blend for another 5–30 seconds.

3 Test whether the pulp is properly blended by putting a teaspoon into a jar of water. Cover the jar and shake – if the fibres have been reduced to an even consistency the pulp is ready. If there are still clumps it needs to be blended longer.

4 Repeat steps 2 and 3 until all the pulp is blended. Stir in either 475ml (2 US cups) of concentrated commercial liquid starch or 950ml (4 US cups) of homemade liquid starch (see page 279) as a size to make the pulp water resistant. Leave to stand for at least 30 minutes before forming the sheets.

Paper pulp

The amount of size given in the steps is suitable for stationery but papers for other uses may need less or no size at all.

For perfumed paper, you can add a few drops of essential oil to the pulp.

To make pulp without the fresh plant fibre, follow the same directions but replace the plant fibre with shredded newspapers, telephone directories and egg cartons and run the blender for 10–15 seconds afterwards.

other papercrafts

Colouring

Although fruit and vegetable fibres usually have a colour of their own it tends to be very subtle. To increase the colour range use commercial or natural dyes, or a combination of the two.

Lightening the pulp

Some plant fibres produce very dark paper or you may want to strip the colour completely from lighter fibres. To do this, soak the pulp in a solution of hydrogen peroxide. Pour 237.5–475ml (1–2 US cups) of hydrogen peroxide into a large bucket of pulp, stir well and then leave in a cool place away from direct sunlight until the pulp is light enough – this can take 1–5 days. Rinse the pulp thoroughly in the strainer bucket, as described on page 280, before colouring or forming sheets.

Mordant

A mordant is a substance that allows the dye colour to fix to the pulp. When using most natural substances and some commercial products to colour pulp, the pulp must be soaked in a mordant first. The most common mordants for home use are ammonium aluminium sulphate – used in home pickling – or alum in the form of aluminium acetate. Alum works for more types of fibre and produces stronger colours. Dissolve 8 tablespoons of alum into 470ml (2 US cups) of hot water and stir this into a batch of pulp in a 20-litre (21-quart) cooking pot. Reduce the quantity of alum for smaller amounts of pulp. Leave to stand for a few hours or overnight.

Rinse the pulp well in the strainer bucket – see page 280. Return the pulp to the cooking pot, fill the pot with fresh water and colour the pulp with any suitable dye method that requires a mordant (see tip box below).

Built-in mordants

Some natural substances already contain a mordant so it is worth checking before adding it to the mix.

Pigments

To use commercial pigments and dyes, follow the manufacturer's instructions. Other things you can use to colour the pulp include:

Paper napkins – add one or two solid colour napkins to each blender load of pulp in the last 5–10 seconds of blending.

Inks and paints – add the desired amount of ink, watercolour or acrylic to mordanted pulp and then heat the pulp to just below boiling for about one hour. Strain as usual.

Food colouring – add small amounts of the colouring to 475ml (2 US cups) of boiling water. Pour 1 tablespoon into mordanted pulp, stirring constantly. Add more until the desired colour is achieved and then heat the pulp to just below boiling for about one hour. Strain as usual.

Powders and extracts – natural dyes such as cochineal, madder and indigo are available in concentrated powder and extract forms. Follow the manufacturer's instructions to make up and then use as for food colouring.

Plants and insects – some plant material and insects are sources of natural dye. Put into an appropriate pot and fill two-thirds full of water, bring to the boil and simmer for an hour. Add to the pulp and bring to just below boiling point. Turn off the heat, leave for several hours and then strain.

Soil – use soils with a rich colour; put a layer in a large glass jar and fill with hot water. Leave to stand in sunlight for at least an hour, then pour off the coloured water and reserve. Repeat with fresh soil and water until you have enough coloured water. Add to the pulp and bring to just below boiling point. Turn off the heat, leave for several hours and then strain.

Forming sheets

Having prepared the pulp and added any colouring, you can form sheets of paper. This technique avoids the high shrinkage usually associated with fruit and vegetable fibres.

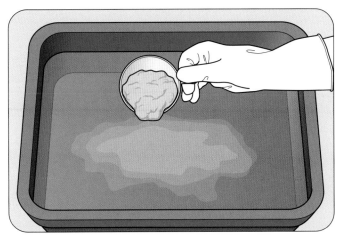

1 Place newspapers down to catch drips if necessary. Place the large plastic tray down on top and fill about two-thirds full of water, then add about 1.9–2.25 litres (8–10 US cups) of pulp; the more pulp you put in the water, the thicker the paper will be, so you may need to experiment to get the proportion correct. Use more pulp if you do not have abaca or some type of partially processed paper in the mix.

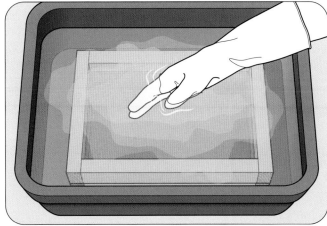

2 Wet the screen on the sheet mould by dipping it into the water and removing. Ready the mould by placing it screen side up with the deckle aligned over the top. Stir the pulp in the tray with your fingers spread wide for 15–20 seconds, stirring lengthways so the water does not splash out. The pulp tends to settle on the bottom but it must be evenly dispersed through the water before forming the sheet.

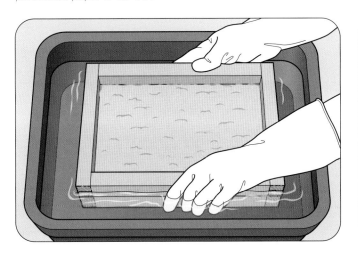

3 Holding the mould and deckle together in both hands, push the leading edge almost vertically into the water but then level them out into a horizontal position when fully submerged. Keeping the mould and deckle horizontal, bring them slowly to the surface with a thin layer of wet fibres. Give a quick but gentle shake in each direction to interlock the fibres and allow excess water to drain away.

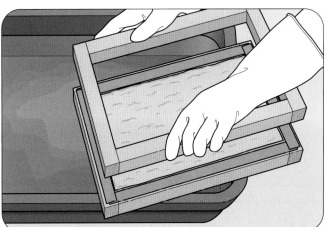

4 Rest the mould and deckle on the edge of the tray and carefully remove the deckle, lifting it horizontally and keeping it level so water does not drip onto the mould below and mark the finished paper. If the paper does not look even or you are not happy with the result, just place the mould back in the water screen side down and the pulp will float off into the water so you can repeat step 3.

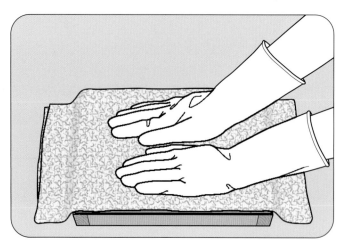

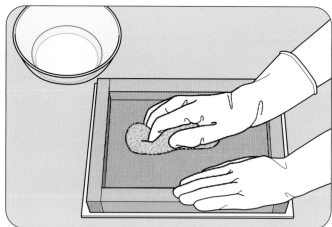

5 Remove the mould to a flat surface, still screen side up. Fold a towel in half and gently place it over the fibre on the screen. Lightly press across the surface to remove some of the water – don't drag the towel or press too hard. Removing water from the fibre at this stage results in a stronger paper, but don't remove too much or the paper will dry too quickly and the edges will crinkle.

6 Using water in a spray bottle, spray an area for the sheet on the drying board. Flip the mould over onto the damp board fibre side down. Remove more water from the fibre by pressing on the reverse of the screen with a sponge, squeezing excess water into a bowl. Sponge four or five times, then remove the mould from the drying board, leaving the sheet of fibre in place. Gently press with the sponge to remove any air bubbles.

Perfect paper

Add more pulp to the water for each new sheet. Stir the water each time before making a new sheet, just for a few seconds – although if you stop working for any length of time you will have to stir for longer to make sure the fibres are thoroughly dispersed.

When shaking the mould after it is removed from the water do not tilt it too much or the fibres may slide over the screen.

Do not pour unused pulp water down the drain as the fibres may clog the pipes; strain the pulp away and store it.

As soon as you have finished working, scrub the screen of the page mould under running water so that pulp does not clog the holes.

Drying the paper on a very smooth surface, such as acrylic sheet, will give one smooth side suitable for writing.

Drying

Leave the sheet on the drying board inside and away from draughts for 1–2 days, depending on the type of fibres, how thick the sheet is and other variables such as the air temperature and humidity. The sheet needs to dry slowly to avoid warping and to allow the fibres to shrink naturally, which gives the paper more strength. When it is completely dry, peel it from the board starting with the two corners at one end. It should feel crisp; if it is limp it is not dry enough. If this has happened, finish drying between two paper towels under a pile of heavy books.

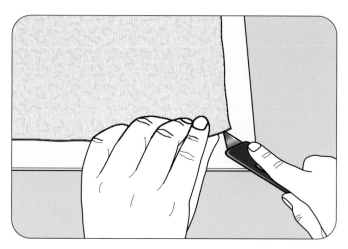

Adding to the paper

For additional texture or surface interest try adding other materials, either including them in the pulp or embedding them afterwards. You can also create sheets with a watermark.

Watermarks

1 For horizontal watermark lines, tear 1cm (½in) wide strips of duct tape and press them firmly onto the page mould screen. Make the sheet as normal – the area of paper over the tape will be thinner than the rest so will show as a translucent area when the paper is held up to the light.

2 You can achieve the same effect by cutting a motif from thin cardboard and placing it on the dry screen before the page mould is submerged. Hold it in place with your thumb as the page mould goes into the water pulp; when you lift the mould up the force of the water will keep it in place.

Floating

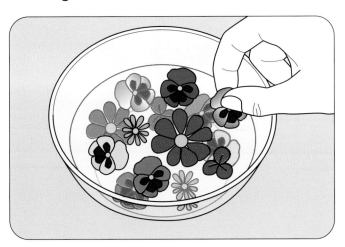

1 Natural fibres such as dried flowers, yarn, cotton, printed words from newsprint or paper confetti are ideal for this technique. Synthetic materials will not bond so well – use the embedding technique (see page 286) instead. Start by wetting the material to be added thoroughly.

2 Position the wet material onto the sheet while it is still on the page mould, before it is blotted with the towel. Continue to blot and turn the sheet out onto the drying board in the normal way. The fibres will become part of the paper.

Embedding

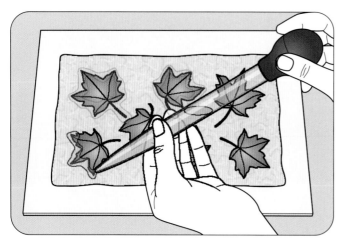 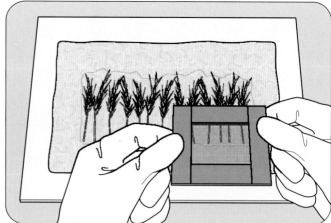

1 Lightweight or fragile objects can be partially embedded while the sheet is drying. After sponging the sheet on the drying board, lay the object on top. Fill a meat baster with pulp water, hold about 1cm (½in) above the surface and dribble pulp over or all around the edge of the object. Repeat as necessary – but be careful not to touch the surface of the sheet with the baster as you work. Dry the sheet as normal – the object will become a permanent part of the paper.

2 For heavier objects, use a mini-screen when embedding. After sponging the sheet on the drying board, lay the object on top. Dip the mini-screen in the pulp water and flip it, pulp side down, over part of the object. Press out excess water from the screen using a sponge and carefully peel the screen away. Dry the sheet as normal – part of the object will now be permanently sandwiched on the surface of the paper.

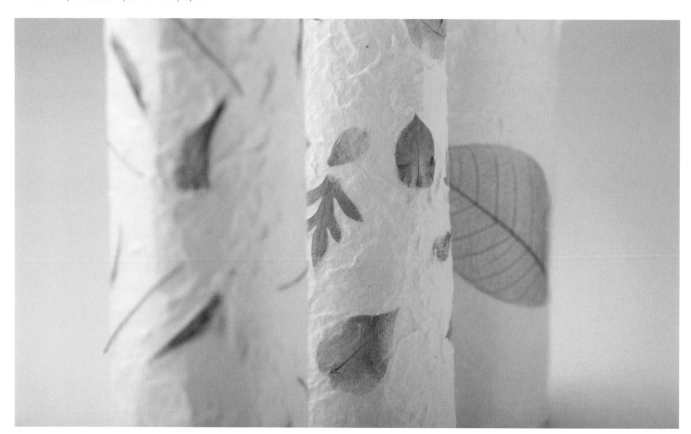

Different natural items of all shapes and sizes are very effective when embedded or laminated into hand-made paper.

Laminating

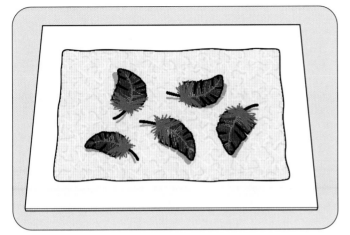

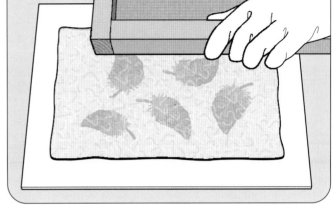

1 Use a light colour fibre to make the sheets and make them very thin and translucent. Sponge the first sheet onto the drying board and lay the objects to be laminated on top – choose flat, lightweight items such as feathers or leaves.

2 Do not add more pulp to the water before making the top sheet, because it needs to be very thin. Invert the mould directly over the first sheet on the drying board, so the top sheet will exactly cover the first sheet. Sponge and dry the laminated sheets as normal.

Additions

If essential oils were not added to the pulp you can still scent the finished paper. Soak a cotton wool ball with several drops of essential oil and put in a box big enough to hold several sheets of paper. Add the paper, seal the box and leave for several days.

Adding bits of material, such as seeds, leaves or threads, to the pulp water before forming the sheet will result in paper with a rugged texture.

For paper with additional texture that is still smooth enough to write on, add small pieces of material to the blender when blending the pulp.

templates

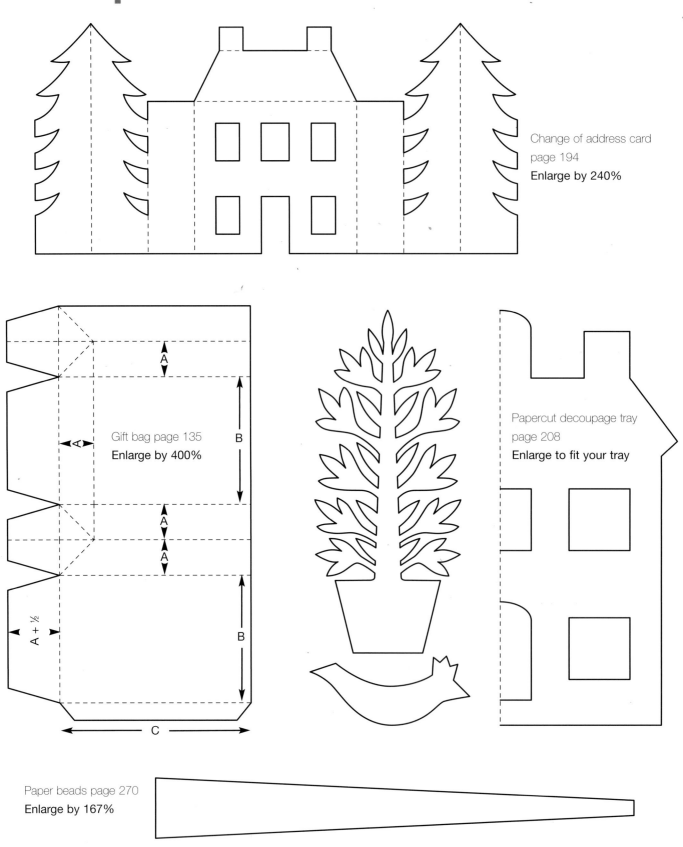

Change of address card
page 194
Enlarge by 240%

Gift bag page 135
Enlarge by 400%

A

A

B

A

A

A + ½

B

C

Papercut decoupage tray
page 208
Enlarge to fit your tray

Paper beads page 270
Enlarge by 167%

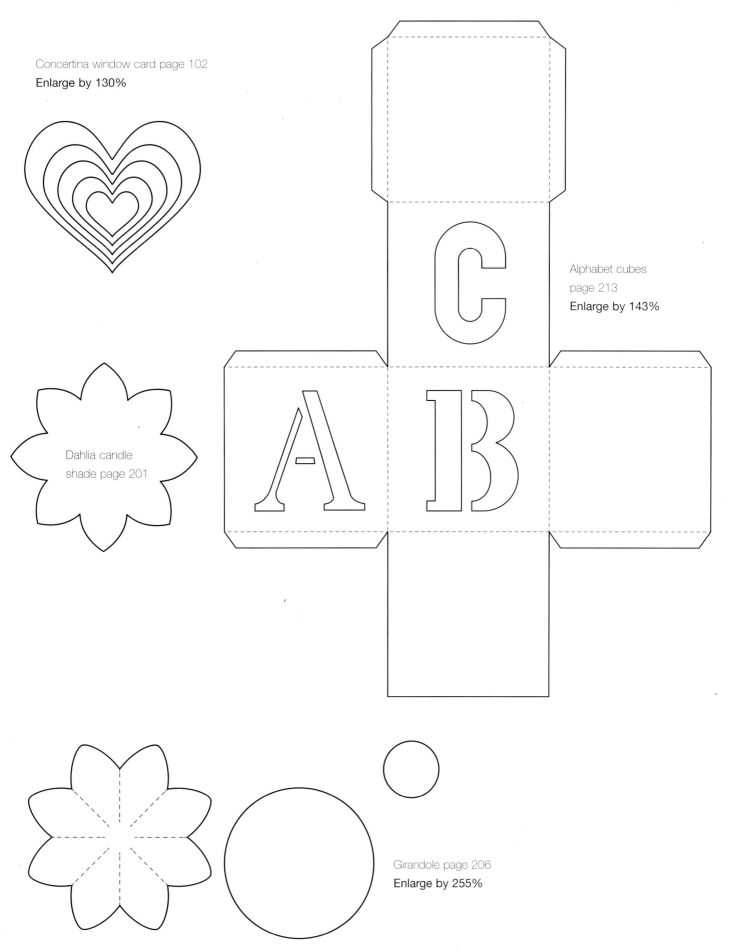

Concertina window card page 102

Enlarge by 130%

Dahlia candle
shade page 201

Alphabet cubes
page 213

Enlarge by 143%

Girandole page 206

Enlarge by 255%

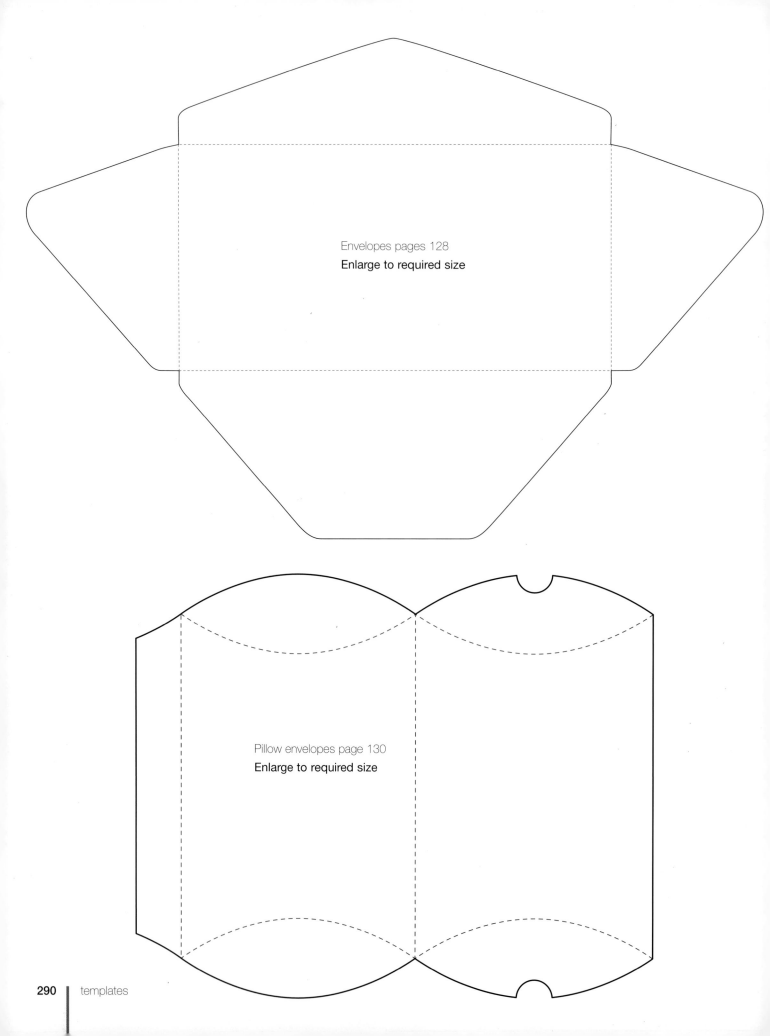

Envelopes pages 128
Enlarge to required size

Pillow envelopes page 130
Enlarge to required size

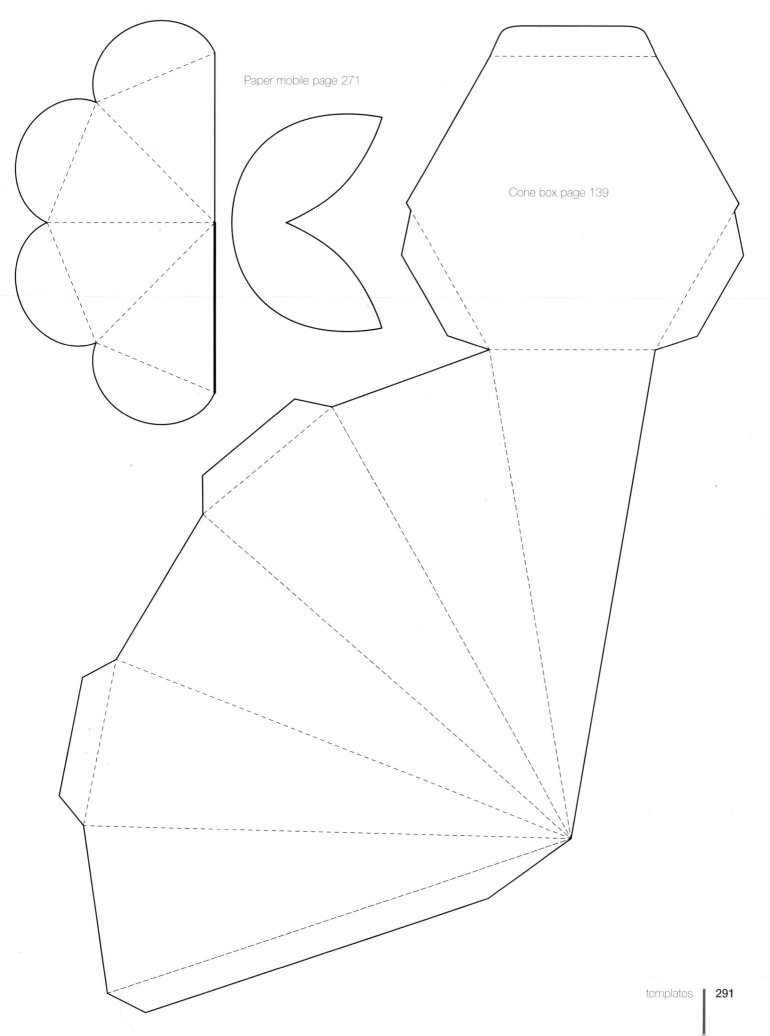

Paper mobile page 271

Cone box page 139

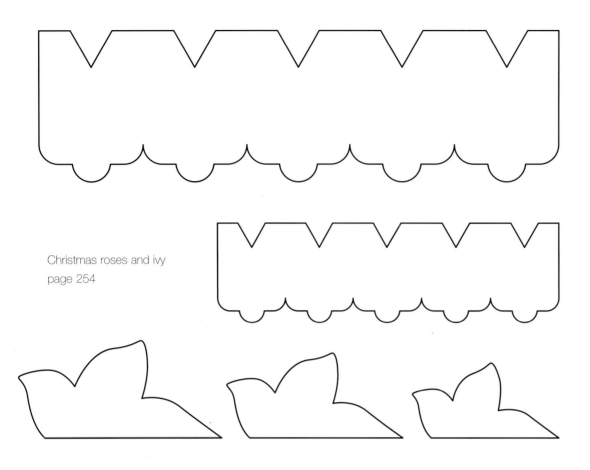

Christmas roses and ivy
page 254

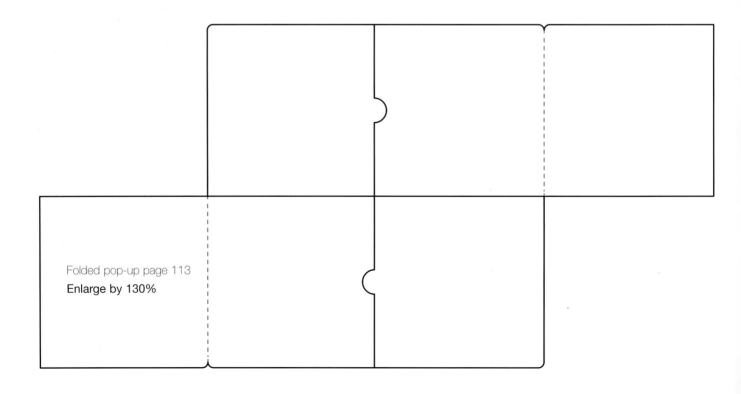

Folded pop-up page 113
Enlarge by 130%

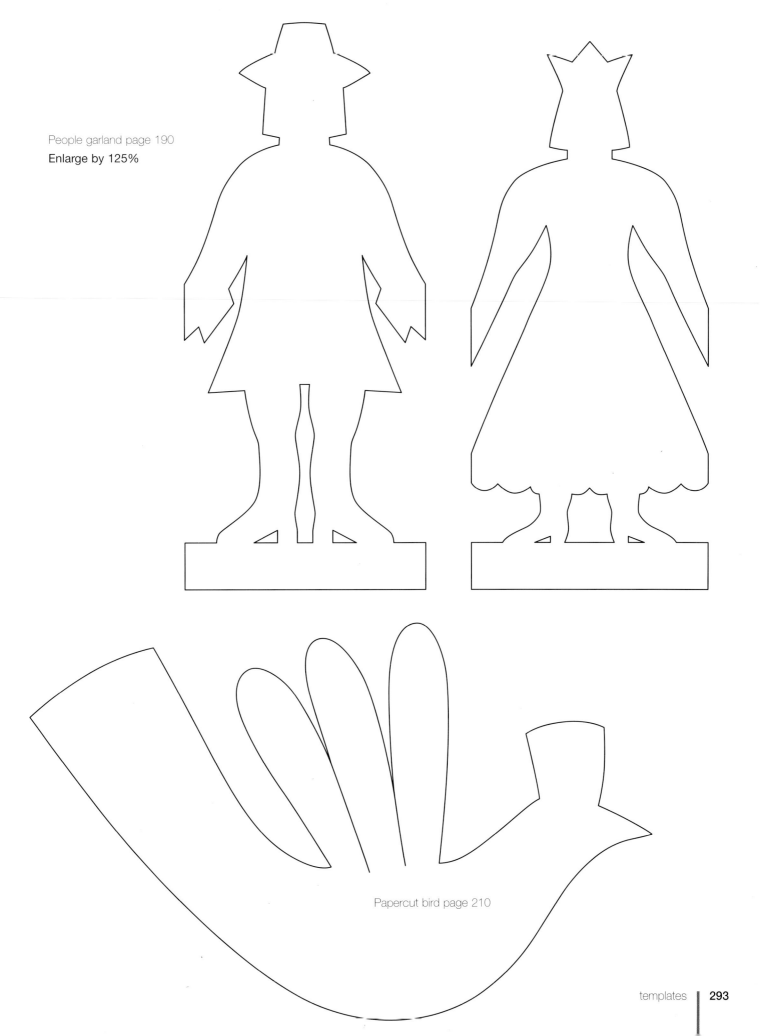

People garland page 190
Enlarge by 125%

Papercut bird page 210

Mexican ceiling banners page 193

Enlarge by 133%

Sunflower page 251
Enlarge by 160%

Gift tags page 197
Enlarge by 137%

Picture frame page 212
Enlarge by 200%

Paper lace picture page 276

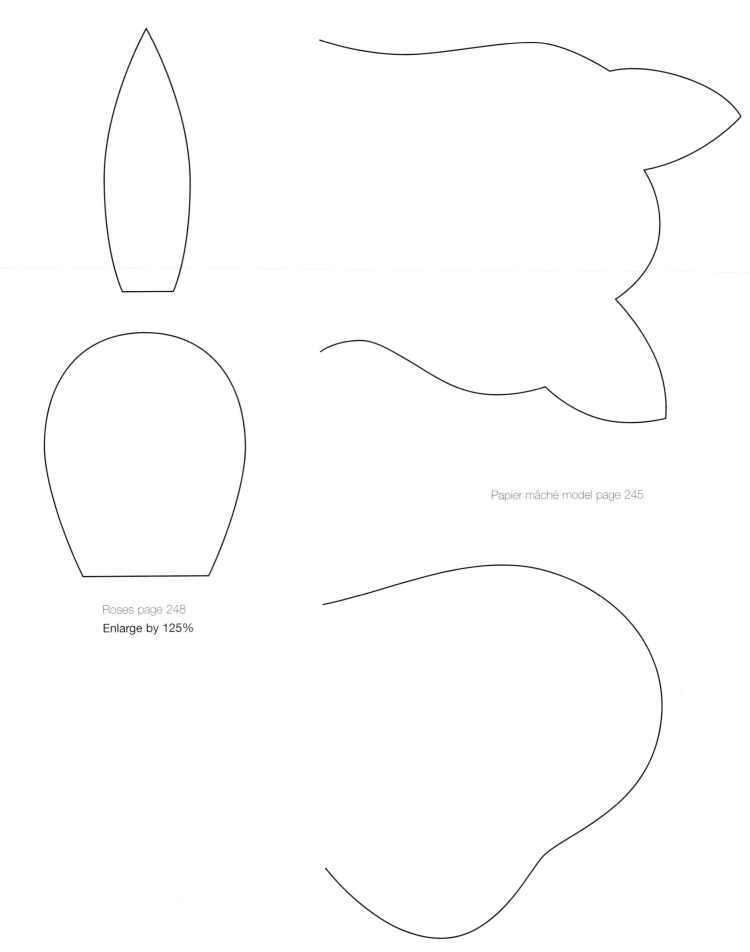

Roses page 248
Enlarge by 125%

Papier mâché model page 245

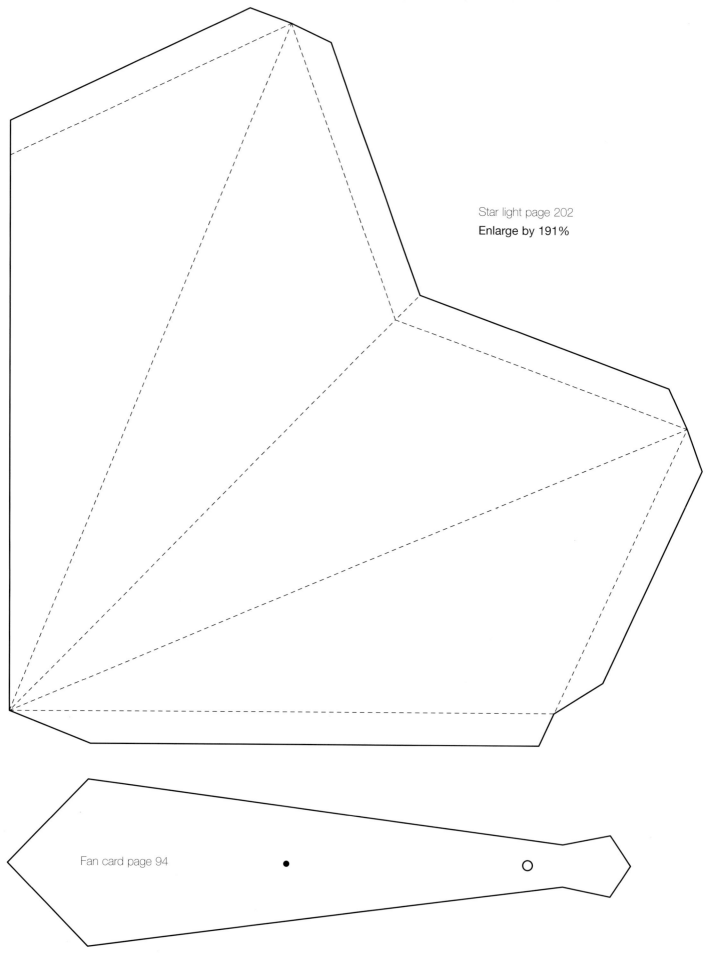

Star light page 202

Enlarge by 191%

Fan card page 94

Shelf edging page 192

websites and suppliers

UK SUPPLIERS
General papercrafting
Paperchase

Papers, envelopes and papercrafting
accessories
Stores nationwide
www.paperchase.co.uk

Total Papercrafts

Papercraft materials and tools
www.totalpapercraft.co.uk

Craft Creations

Greetings card blanks and accessories
Ingersoll House
Delamare Road, Cheshunt
Hertfordshire EN8 9HD
Email: enquiries@craftcreations.com
www.craftcreations.com

Eco-Craft

Recycled paper, card, envelopes
Unit 17a, C.E.C.
Mill Lane, Coppull
Lancashire, PR7 5BW
Email: sales@eco-craft.co.uk
www.eco-craft.co.uk

Mad About Cards

Papercraft materials, card blanks, tools
1 Towerfield Close, Shoeburyness
Southend-on-Sea, SS3 9QP
www.madaboutcards.com

Craft Site

Greetings card blanks and accessories
Unit 6i Admiral Business Park
Nelson Way, Cramlington
Northumberland, NE23 1WG
www.craftsite.co.uk

Scrapbooking and cardmaking
Memory Keepsakes Scrapbooking

Scrapbooking materials
Shakeford Mill
Hinstock, Market Drayton
Shropshire, TF9 2SP
Email: sales@memorykeepsakes.co.uk
www.memorykeepsakes.co.uk

Paper Arts

Toadsmoor Road
Brimscombe, Stroud
Gloucestershire, GL5 2TB
www.paperarts.co.uk

Funky Farm Scrapbook Barn

Scrapbooking materials
Brickbarns Farm
Hanley Road, Malvern Wells
Worcestershire, WR14 4HY
Email:
sales@funkyfarmscrapbookbarn.co.uk
www.funkyfarmscrapbookbarn.co.uk

Stamps
Craft Stamps

Stamps, inkpads
Well Road
Sheffield, S8 9UA
www.craftstampsonline.co.uk

The Stamp Bug

Stamps, inkpads
The Old Sawmill Workshops
Hatherop, Cirencester
Gloucestershire, GL7 3NA
www.thestampbug.co.uk

Stamp Addicts

Stamps, inkpads and more
Unit 5A Lyon Close,
Woburn Road Industrial Estate, Kempston
Bedfordshire, MK42 7SB
www.stampaddictsshop.co.uk

The Glitter Pot

Stamps, papercraft materials and tools
Unit D1 Sheddingdean Business Park
Marchants Way, Burgess Hill
West Sussex, RH15 8QY
www.theglitterpot.co.uk

Polymer clay, gilding
Alec Tiranti Limited

Polymer clay, gilding materials, metal leaf
3 Pipers Court
Berkshire Drive, Thatcham
Berkshire RG19 4ER
Email: enquiries@tiranti.co.uk
www.tiranti.co.uk

General craft materials
Crafts U Love

Westcoats Farm, Charlwood
Surrey RH6 0ES
www.craftsulove.co.uk

Hobbycraft

Wide range of craft materials and tools
Stores nationwide
www.hobbycraft.co.uk

Crafty Devils

Papercraft materials and tools
Units 22/23 Tawmill Business Park
Howard Avenue
Barnstaple
North Devon, EX32 8QA
Online store
www.craftydevilspapercraft.co.uk

The Craft Bug

Papercraft materials and tools
23 West View, Chirk, Wrexham
North Wales LL14 5HL
www.thecraftbug.co.uk

NORTH AMERICAN SUPPLIERS

General papercrafting

Kate's Paperie
All types of paper and card blanks
435 Broome Street
New York, NY 10013
www.katespaperie.com

The Japanese Paper Place
Specialty papers, calligraphy and
printmaking supplies
77 Brock Avenue
Toronto, Ontario
Canada, M6K 2L3
www.japanesepaperplace.com

Flax Art & Design
Papers and cardmaking equipment
1699 Market Street
San Francisco, CA 94103
www.flaxart.com

Paper Source
Paper, giftwrap, papercrafting products
Stores nationwide, online store
www.paper-source.com

Scrapbooking

Scrapbook.com Superstore
Scrapbooking supplies and accessories
www.scrapbook.com

Scrapbooking Supplies R Us
Scrapbooking supplies and accessories
www.scrapbookingsuppliesrus.com

Two Peas In A Bucket
Scrapbooking supplies and accessories
www.twopeasinabucket.com

Scrapbooking Alley
Scrapbooking supplies and accessories
www.scrapbookingalley.com

Stamps

Great Impressions
Rubber stamps, inkpads, embossing
powders
Sierra Enterprises
PO Box 5325
Petaluma, CA 94955
www.sierra-enterprises.com

Impress Rubber Stamps
Stamps, embellishments
120 Andover Park East
Tukwila, WA 98188
www.impressrubberstamps.com

Crafty Secrets
Stamps, vintage embellishments
Stores nationwide
www.craftysecrets.com

Polymer clay, gilding

Amaco
Polymer clay, modelling tools, moulds,
gilding, metal leaf
6060 Guion Road
Indianapolis, IN 46254
www.amaco.com

Polymer Clay Express
Polymer clay, modelling tools, moulds,
gilding, metal leaf
9890 Main Street
Damascus, MD 20872
www.polymerclayexpress.com

General craft materials

Pearl Paint Co Inc
Art and craft materials
308 Canal Street
New York, NY 10013
www.pearlpaint.com

Michaels
Art and craft materials
Stores nationwide
www.michaels.com

A.C. Moore
Scrapbooking and cardmaking supplies
Stores nationwide
www.acmoore.com

Crafts, etc.
Wide range of craft materials
www.craftsetc.com

Hobby Lobby
Wide range of craft materials
Stores nationwide
www.hobbylobby.com

Art Supplies Store
www.artsuppliesonline.com

Jo-Ann Fabric and Craft Store
Stores nationwide
www.joann.com

Sizzix
Wide range of craft materials
Stores nationwide
www.sizzix.com

index

adhesives 18–19, 32–4, 240
alphabet cubes, papercut 213
animals, origami 227–31
appliqué 69
armatures 240, 243–5

bag card 115
bags, gift 135–7
banners, Mexican ceiling 193
batch cards 116–21
beads and beading 30–1, 68, 98, 270
birds
 origami 222–6
 papercut 210–11
bleach, and colouring paper 42
blossom, origami 218–20
bone folders 10, 11
books see scrapbooking
botanicals 187
bows 142–4, 180
boxes, gift 138–41
brads 168
brayers 19
brushes 15
bubble printing 44
bull's head, origami 227–8
buttons 68, 183–4

candle holder, flower 258–9
cardboard 16–17, 20, 23
cards and cardmaking
 bag card 115
 batch cards 116–21
 change of address cards 118–19, 194
 child's party card 124
 circles card 88
 collage cards 88–91
 concertina cards 102–5
 envelope invitation card 125
 fan card 94–5
 fingerprint cards 116–17
 flowerpot card 90–1
 fold out cards 114–15
 folder card 114
 house card 93
 inserts for cards 86–7
 invitation cards 122–5
 number card 92
 paper lace card 195–6
 papercut 194–9
 pebble card 120–1

pop-up cards 110–13
present card 89
printed cards 82–5
shaped cards 92–5
 three-dimensional cards 106–9
 wedding invitation card 122–3
 window cards 96–101, 102–3
cat model, papier mâché 246–7
catkins, paper 248
change of address cards 118–19, 194
child's party card 124
Christmas roses, paper 254–5
circles card 88
collage 70–1, 88–91
colourdrip 41
colouring 40–57
colouring paper 282
colourwash 40
composite photographs 165
concertina cards 102–5
cone box 139
cords 181
cropping photographs 158–9, 162
cutting paper 10–11, 22–3

dahlia candle shades 201
decorating tools 14–15
decorations
 applied 58–71
 decorative edges 24–31
 paper decorative items 270–7
 papercut 204–9
 three-dimensional 72–9
decoupage 260–4
Dior bow 143

edges, decorative 24–31
embedding, papermaking 285
embellishment
 materials for 20–1
 three-dimensional embellishments 35–7
embossing 74–7
 embossed foil tags 148, 149, 174
 with stamps 50
embroidery 67
envelopes 128–31
 envelope invitation card 125
epoxy stickers 35
erasers 10
eyelets 167

fabric 20, 176–9
fan card 94–5
felt 176
files, expanding 272–4
fingerprint card 116–17
fixing and sticking 32–4, 166–71
floating, papermaking 285
flour and water paste 240
flowers
 flower candle holder 258–9
 flowerpot card 90–1
 origami 218–21
 paper 248–55
foam pads 167
foil 21, 60–1, 75
fold out cards 114–15
folder card 114
folders 131
folding paper 10–11, 23, 42, 139
fonts 172
frog, origami 229–31
fusible webbing 34

garlands 190–1, 256–7
gift bags 135–7
gift boxes 138–41
gift tags 146–9, 197–9
giftwrap 82–3, 132–4
gilding 61–2
girandole 206–7
glitter 21, 58–9

handles, papier mâché 245
house card 93

images, transferring 64–5, 178
ink 15, 20, 25, 41, 48–9
inserts 86–7
interlocking 198
invitation cards 122–5
ivy, paper 254–5

knives, craft 10

lace, paper lace picture 277
laminating, papermaking 285
lampshade, pleated 274–6
lanterns 200–3

lark's head knot 145
layering 78, 242
leaf notelet, origami 232–5
lettering 172–5
liquid starch 279

marbling 45
masking fluid 55
matting 159–63
measuring techniques and tools 10–11, 22
metal-look tags 149
Mexican ceiling banners 193
mobiles 271–2
models, papier mâché 245–7
monoprint card 84–5
mordant 282
mosaics, photo 164
motifs 83
moulding, papier mâché 242
moulds 240

notelets, origami leaf 232–5
number card 92

origami
 animals 227–31
 birds 222–6
 flowers 218–21
 mini-origami 232–7
 techniques and folds 216–17

page pebbles 35
paint 15, 241
paper filigree 265–9
paper lace card 195–6
papercutting
 lanterns 200–3
 papercut cards 194–9
 papercut decorations 204–9
 three-dimensional shapes 210–13
 tools and techniques 190–3
papermaking 278–87
papier mâché 240–7
party invitations 124
pebble card 120–1
pencils 10, 11, 14
pennants 179
pens 15, 20, 25, 77
people garlands 190–1
photographs 158–65, 166

picture frame, papercut 212
piercing 73, 200, 277
pigment 133, 282
pillow envelopes 130
pinwheel pouch, origami 236–7
pleating paper 273–4
pockets, in scrapbooks 169–71
polymer clay embellishments 36–7
polythene, fusing 63
pop-up cards 110–13
potato printing 43
present card 89
printing 43–4
punches and punching 12–13, 27, 72–3, 146–7, 200
puppet heads 244
purse, paper 236
pyramage 79

quilling 265–9

relief mounting 78, 107
resists 54–5
ribbons 20, 142–5, 180
roses
 paper 248–9
 ribbon 145
rulers 10

scissors 11
scoring 22, 136
scrapbooking
 adding found material 186–7
 covers and pages 152–7
 creating text 172–5
 fixings 166–71
 photographs 158–65, 166
 using fabric 176–9
sepia tinting 158
sequins 98
set squares 10, 11
setting mat and hammer 12
setting out 11
shaped cards 92–5
shelf edging 192
shells 186
snowflake circles 204–5
sponge stamps 53
spouts, papier mâché 245
sprays and spraying 56–7, 133
stamps and stamping 12, 48–53

gilding with a stamp 61
 letter stamps 174
 stamped giftwrap 132
star light 202–3
stencils and stencilling 14, 46–7, 74
stickers 20, 21, 35, 173
sticking 32–4
stitching 28–30, 66
string stamps 52
sunflowers, paper 251–3
swallowtail chicken, origami 222–4
swan, origami 225–6

tags, gift 146–9, 184–5, 197–9
tapes 19, 33, 34
tassels 182
templates 288–99
 scoring 136
text, creating 172–5
texture 72–9
thinners 65
thread 21
three-dimensional cards 106–9
three-dimensional decorations 35–7, 72–9
three-dimensional shapes 210–13
tissue paper 21
 using with wire 256–9
tools
 adhesives and tapes 18–19, 32–4
 decorating 14–15
 measuring, folding and cutting 10–11
 papercutting 190
 stamps and punches 12–13
tracing 11, 64
tray, papercut decoupage 208–9
trunk box 140

waterlily, origami 221
watermarks 285
wax crayons 54
webbing, fusible 34
webbing spray 133
wedding invitation card 122–3
window cards 96–101, 102–3
wire 21
 using with tissue paper 256–9
 working with 243
woven gift bags 137
wrapping presents 134

contributors

Many thanks to papercrafters Sarah Beaman and Paula Pascual, who created the majority of projects in this book.

Sarah Beaman is widely known as a professional designer, maker and author and has written a number of best-selling craft books. Originally trained as a fashion designer, Sarah's work combines diverse techniques which reflect her interest in craft of all types. Her carefully planned designs and understated style has gained many fans. www.sarahbeaman.com.

Paula Pascual is a freelance paper crafter who enjoys anything to do with paper, graphic design, photography and storage. She has regularly contributed to Crafts Beautiful magazine. www.paulapascual.com.

The publishers would also like to thank the following contributors whose work is featured in this book: Emma Angel, Pauline Butler, Ellaraine Lockie, Mary Maguire, Gay Merrill Gross, David Mitchell, Hilary More, Deborah Schneebeli-Morrell, Lindy Tristram.

Thanks also to Louise Leffler for the wonderfully clear design, Kuo Kang Chen for his usual fantastic illustrations, Martin Norris for his great photography and Laura Russell for the sympathetic styling. Special thanks to Corinne Clayton for allowing her papercrafting stash to be raided for the photography.

Consultant Editor **Marie Clayton** is a professional writer and editor and has worked on a wide variety of craft books.

the ultimates

978-1-84340-411-8

978-1-84340-450-7

978-1-84340-502-3

978-1-84340-563-4

978-1-84340-574-0

This latest volume in Collins & Brown's bestselling Ultimate series reveals all the techniques you need to begin make beautiful projects in paper. The Ultimates are a growing series of comprehensive reference guides, with everything you could possibly want to know about a wide variety of craft subjects. Each title contains clear, concise text and step-by-step illustrations, making these books the perfect companion for both beginners and experts.

All titles retail at £25 and are available direct from the Collins & Brown website: www.lovecrafts.co.uk.

COLLINS & BROWN
BOOKS FOR BUSY HANDS
WWW.LOVECRAFTS.CO.UK

Join our crafting community at LoveCrafts — we look forward to meeting you!